Royal GARDENS

PHOTOGRAPHS BY
Jean-Baptiste Leroux
FOREWORD BY
Stéphane Bern
TEXT BY
Mic Chamblas-Ploton

Royal GARDENS

Extraordinary Edens
from Around
the World

ABRAMS

NEW YORK

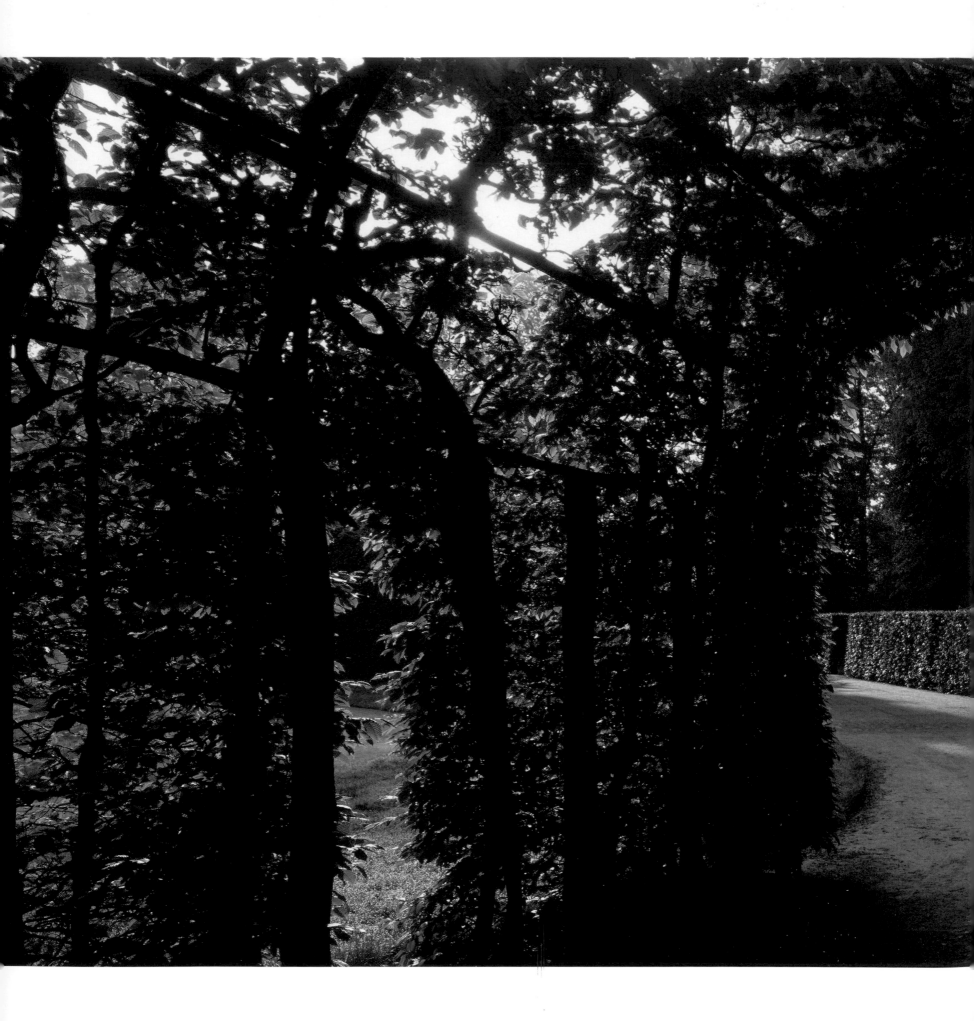

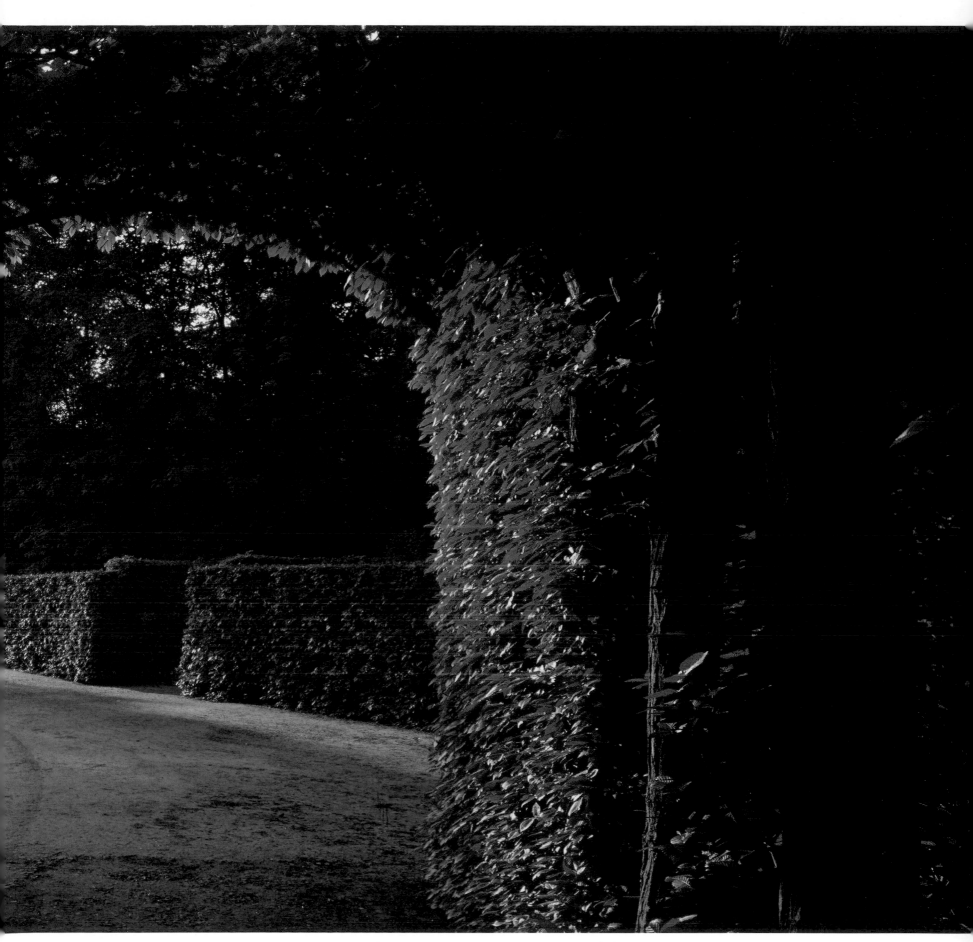

(Under the arbor of Sanssouci's Sicilian garden.)

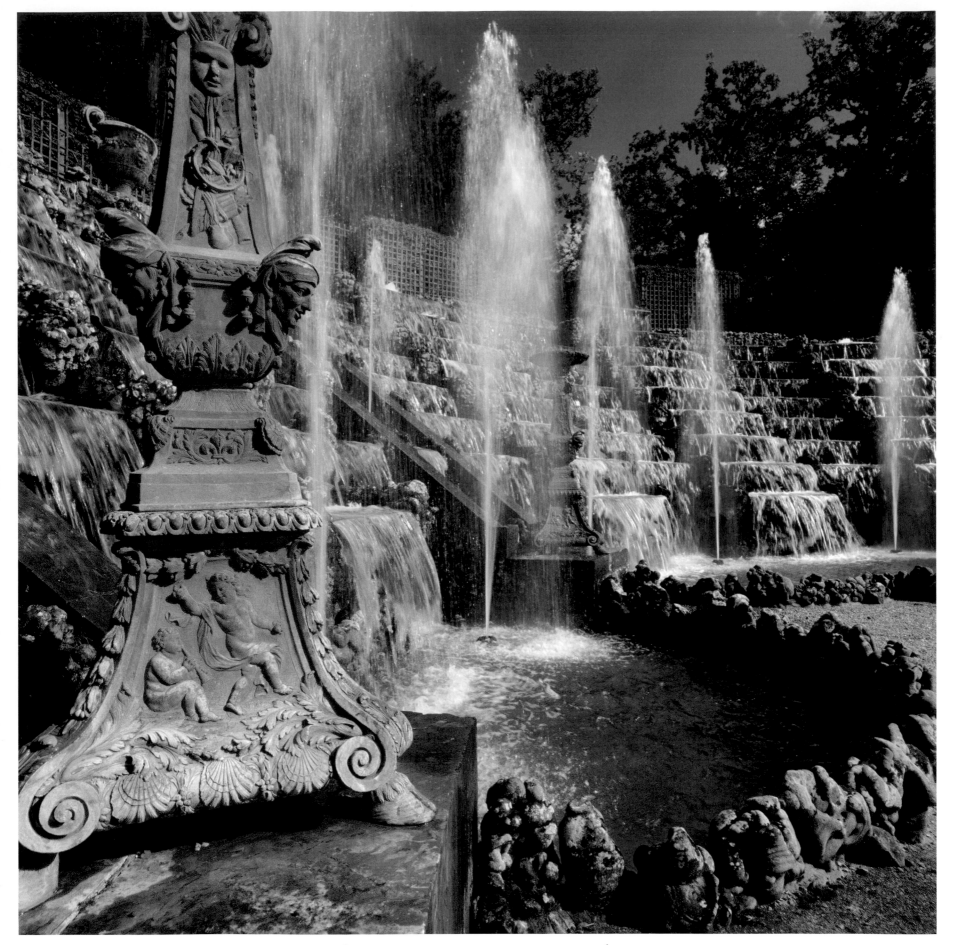

(The Rocaille Grove, or Cascade Ballroom, of Versailles.)

CONTENTS

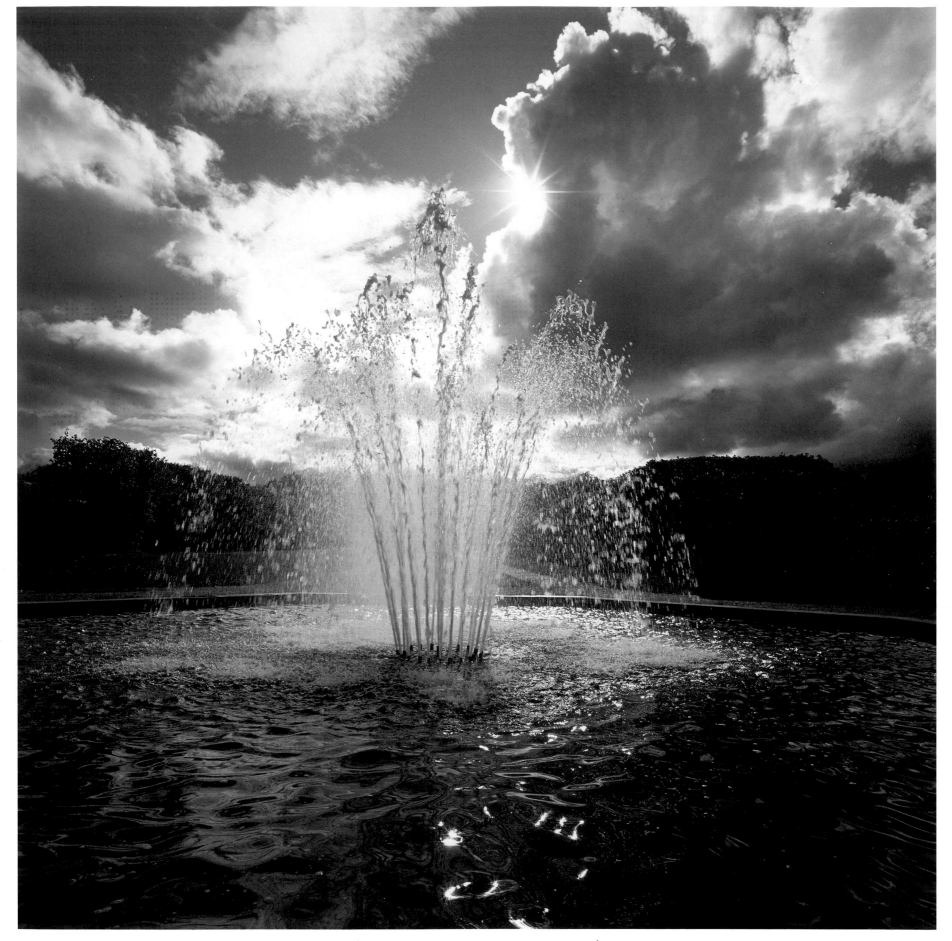

(Fountain in the gardens of Drottningholm Palace.)

FOREWORD

ROYAL GARDENS

As far back as we can go in human history, gardens have adorned the places of power. The Garden of Eden, the greatest symbol of a terrestrial paradise, often was the inspiration for the lush gardens that would not only remind the heads of state of the omnipotence of nature, but also would become a means for them to show their power, their God-like ability to tame the environment. For thousands of years, gardens enabled their sponsors to express strategies of power and seduction, which asserted their authority over nature and thereby over their fellow man. Molding nature in their image, kings created gardens that magnified and reflected their reign and their glory.

In contrast to forests that remained untamed spaces dedicated to the virile sport of hunting or military training, the garden, which was at first enclosed by walls, became a peaceful haven, a place of meditation, the refuge for intellectual exercises and games of love. An extraordinary example of an ancient garden and its connection to love, the Hanging Gardens of Babylon—given by King Nebuchadrezzar II to his wife Amytis, who was from Media and missed her homeland—no longer exist today but are still considered one of the Seven Wonders of the World. The first remnants of gardens were found by historians in the kingdom of Mesopotamia, where, in the third millennium BCE, King Gilgamesh organized parties in the gardens and orchards of Uruk. Through contact with the Orient and its sensual and perfumed gardens, the West became interested in new plants and adopted orchards and

vegetable gardens. Castles, which originally only had an enclosed courtyard, were opened up to outdoor spaces intended for walks and contemplation, new concepts not celebrated before the twelfth century.

The gardens of the feudal lords of the Middle Ages, where medicinal plants were grown, became court gardens, places for enjoyment where the beauty of nature was exalted through the five senses: the delicate perfume of flowers, the sound of rippling water, the colors of the seasons, the flavors of fruits, and the soothing essential oils of plants. The sovereign power of these lords was shown through the refinement of their gardens, and their fortunes were revealed through the presence of imported exotic plants.

During the Renaissance, gardens became a stage setting that showed the grandeur of their sponsors. This is how the Italian princes demonstrated their social position and astonished their guests, inspiring respect with their ability to create harmony and expressing their political power by shaping nature. The zenith was reached by Louis XIV, the Sun King, celestial body in the center of everything, who asked André Le Nôtre to give his Palace of Versailles a mirror of greenery, where every grove, parterre, and lacy box tree would reflect the opulent palace and consequently the reign of the most glorious king on earth. Everything there revolves around the elements: water, sun, earth, all is in harmony with the château. Louis XIV himself found the garden important enough to create a written work titled *Manière de montrer les jardins de Versailles* (*The Way to Present the Gardens of Versailles*).

In the eighteenth century, which brought the Enlightenment and the hope of liberty, philosophers instilled the desire for a return to nature, which should be allowed to reclaim its rights without any obstruction. This led to a more wild, untamed style of gardens.

A variety of styles can be witnessed in palace gardens, including French, English, and Oriental. More than simply identifying the plants to be found in each, these styles of royal palace gardens also tell a more intimate story. That of the sovereigns who were searching not just to domesticate the elements but to find an escape that would transport them from the day to day, a haven of peace and relaxation, a break from the responsibilities of their positions. Princes, like gardens, obey the movements of the times: They follow the cycle of the seasons, are installed for the long-term, incarnate the continuity and permanence of their power through successive generations. For the rulers, these gardens contain their very essence. They are links in a long chain and part of the perpetual motion of a nature that does not follow the rhythm of legislature or elections. In other words, the elements of nature in the lush greenery that surrounds their palaces can offer comfort, inspiration, and a reflection of their life's purpose.

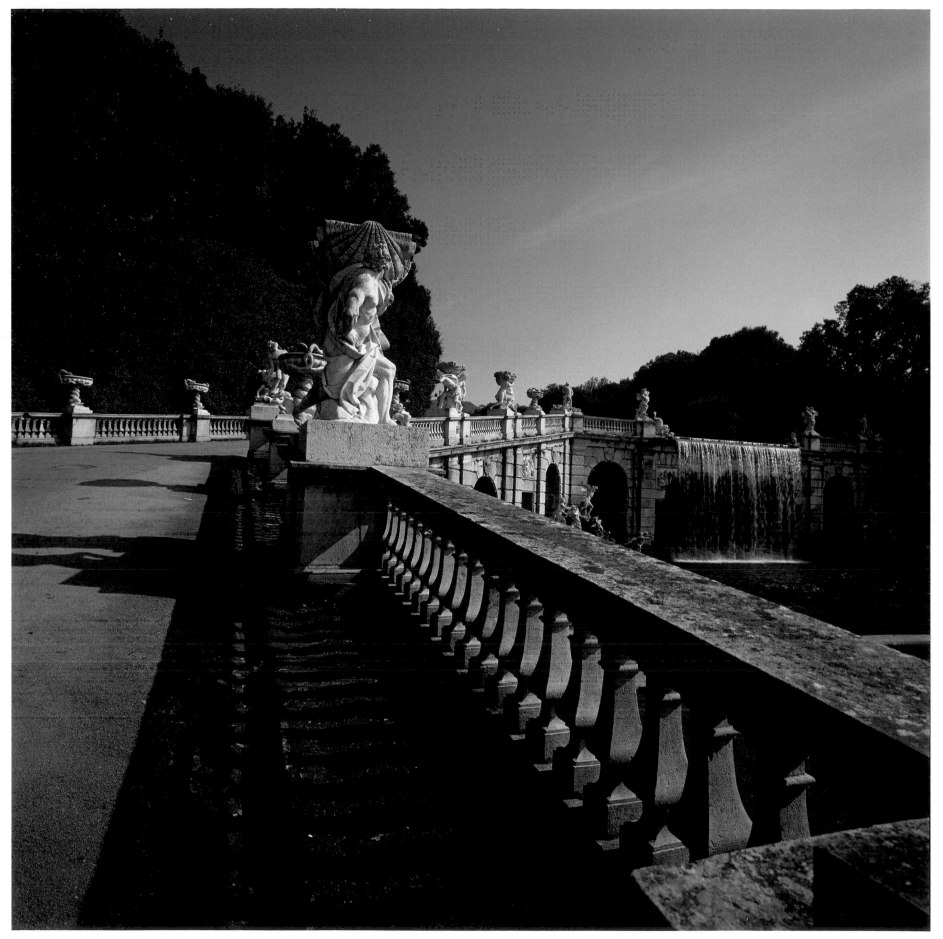

(Caserta, the Fountain of Aeolus, and the Grotto of the Winds.)

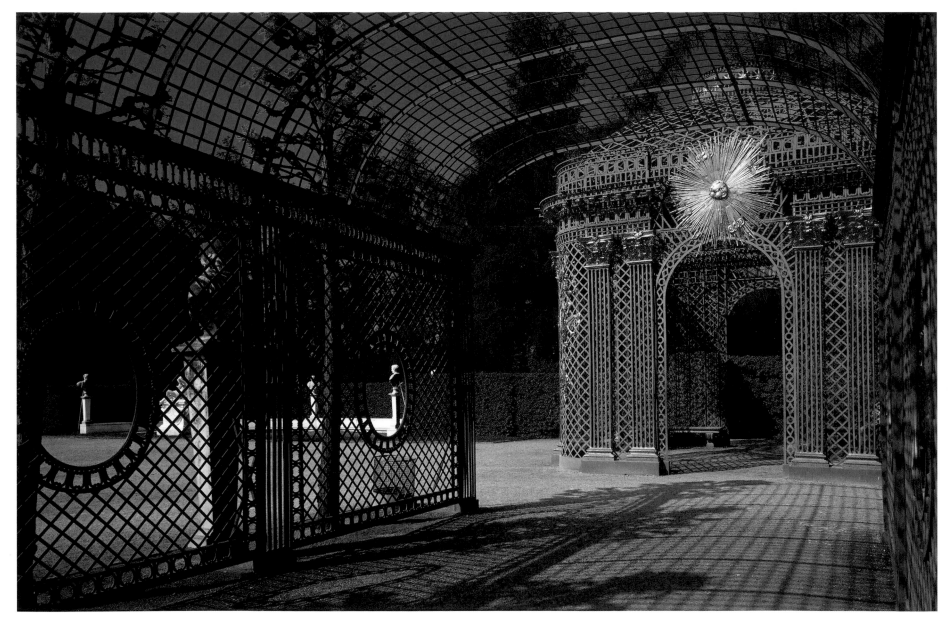

(Sanssouci, trellised gazebo at the castle's terrace.)

For example, the prince of Wales created an organic garden on his property at Highgrove that reflected his philosophy on life: to be in harmony with nature and respect mother earth.

Many monarchs throughout history have demonstrated a love of the earth, embracing it as part of their royal inheritance and living in symbiosis with nature. The Belgian king Leopold II gave his capital of Brussels outdoor spaces and gardens opened to the public. Above all, the Belgians owe him for the admirable greenhouses of Laeken, an immense collection of heated greenhouses in the park of the Royal Palace of Laeken with an extraordinary collection of exotic and rare flora. The role of the garden is also very important in Japan where the emperor honors the rhythm of the seasons with parks that showcase hundreds of flowering cherry trees. From Scandinavia to Spain, from Luxembourg and Japan, not forgetting England and Morocco, the heads of royal and imperial houses have found it important to value this heritage and embellish the gardens of their royal palaces.

The photographs in this book are very much like paintings and works of art—equal to those that decorate the walls of palaces. Jean-Baptiste Leroux has not only captured the majesty of the gardens, their bewitching mystery, their historic character, but also the nobility of the sovereigns' hands that lovingly maintained the harmony and beauty of these places. Leroux proves there is universality in the approach of those who value the future and the long-term.

In these pages, through the talent of Leroux, nature offers us a dazzling, ever-evolving spectacle that also highlights the craftsmanship of people, whether they be royalty or someone in service of the crown. These royal gardens give us a more intimate view of the royal families, while perpetuating the magic of childhood fairy tales and telling the story of the deep connection between kings and nature.

—STÉPHANE BERN

(A path near Sanssouci's Sicilian garden.)

DENMARK

FREDENSBORG
PALACE

The Baroque Park of King Frederick IV

T HIS SUMMER PALACE, ON THE EAST BANK OF ESRUM LAKE NORTH OF COPENHAGEN, DENMARK, was built by the architect Johan Cornelius Krieger in 1719 for King Frederick IV and has experienced many metamorphoses. Residences that were added for civil servants and courtiers have been repartitioned and modified over time according to needs. A second floor was built between 1741 and 1744, and four corner pavilions were added between 1753 and 1754. In the mid-nineteenth century, the baroque park—designed by Krieger and embellished for Frederick V by the French landscape gardener Nicolai-Henri Jardin—was partially transformed into an English-Romantic style garden. At the end of the nineteenth century, the main avenues were changed into winding paths that offered new views of the grounds. Today, the castle serves as the spring and fall residence of Queen Margrethe and the Prince Consort Henrik.

Emanating from the center of the palace, five paths branch out into the forest. Inspired by the Tapis Vert (green carpet, also called the Royal Walk) of Versailles, the central path is a long, rectilinear walkway adorned with statues by the sculptor Johannes Wiedewelt. The walkway farthest to the west leads to two tea pavilions. Beside the lake, a pavilion housed the pleasure boat and navigation equipment of Frederick IV. Between 1764 and 1784, Frederick V installed the Norwegian Valley, which contains a group of seventy sculptures—designed by Wiedewelt and carved by Johann Gottfried Grund—depicting peasants and fishermen, which was a real curiosity at the time when people of modest means were not typical subjects for artists.

West of the palace is a private section of the garden, open to the public only in July, where baroque elements, such as a statue garden adorned with Italian sculptures and a cascade fountain, are found next to a vast green lawn bordered with flowers picked out by Queen Ingrid and later her daughter Queen Margrethe.

A kitchen garden, restored to its eighteenth-century condition and supplemented by exotic plants and grapevines added by Prince Consort Henrik, supplies the vegetables for the royal table and the castle's floral decorations. Since 1995, a new orangery has housed a collection of Mediterranean plants and vegetables. The 250-year-old European myrtles are kept there during the winter. In the summer, they are transported to an island that once was home to a menagerie but today roses have replaced the animals.

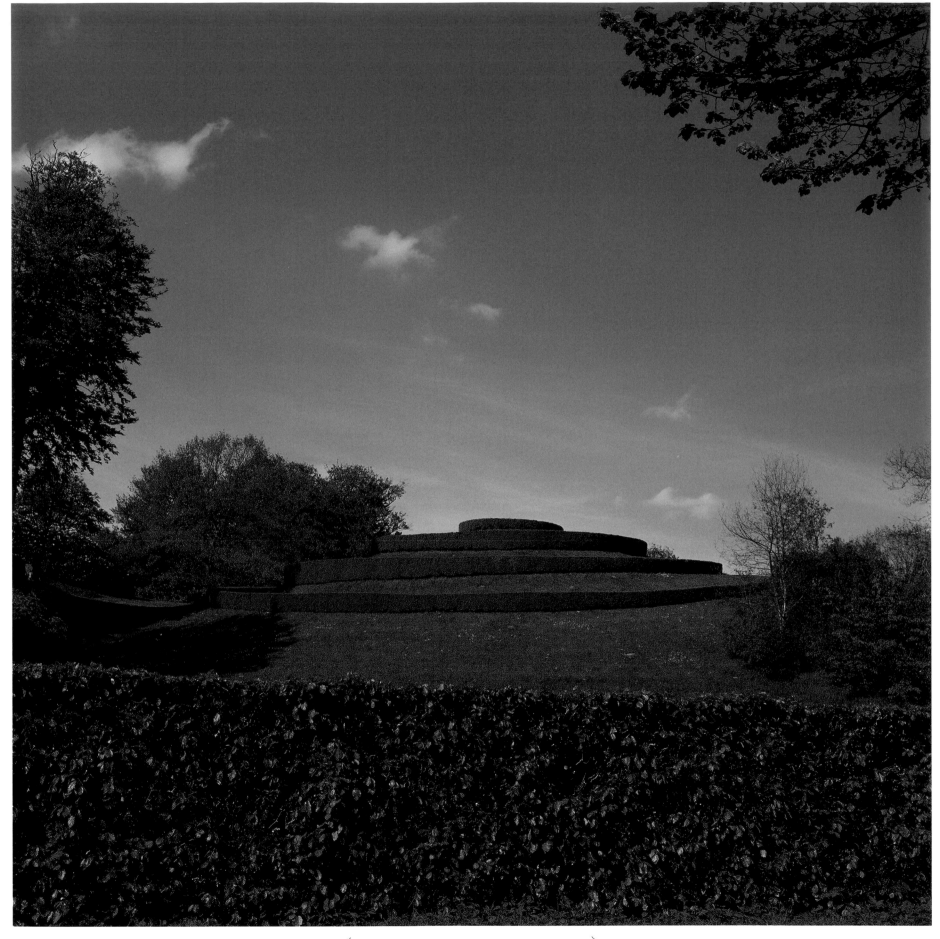

（ The maze of Snail Mound in the reserved gardens. ）

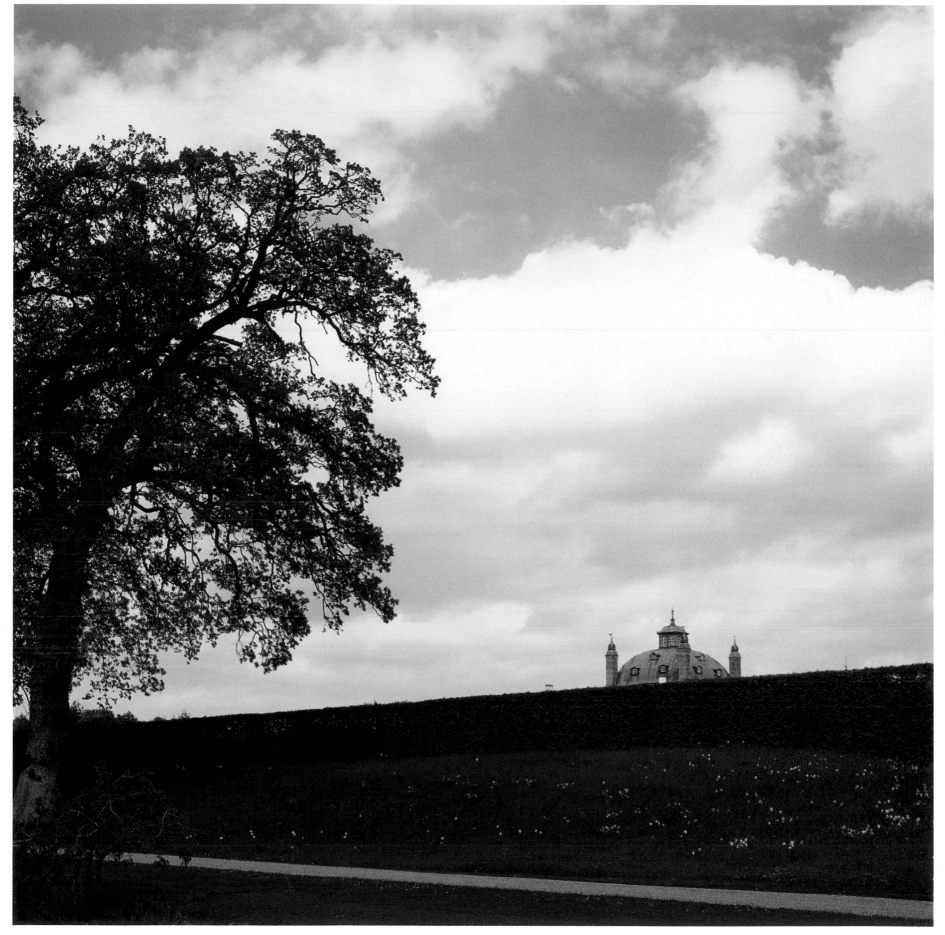

(The castle dome.)

"Fredensborg Castle"

an excerpt

The castle of peace
Brings peace to the soul.
Flowers, the music of the wind,
The evening's litanies
Will ensure a restful sleep.

While it may, at times, be a venue for tragedy
The happy laughter of comedy is much preferred.
When a pleasant stay draws to an end, a sharp diamond
Will engrave on the window's pane
Autographs of illustrious visitors
But when the fife-player signals, the celebrations are over.

Sportsmen, wanderers
Aesthetes and retirees
Come admire our home,
This ever-accessible jewel
Far from the noise of the beautiful city.

But please, dear visitor,
If you step
Onto this tapestry of history,
Do not be troubled
And stroll about with piety.

–Prince Consort Henrik

From his book of poetry *Chemin faisant*

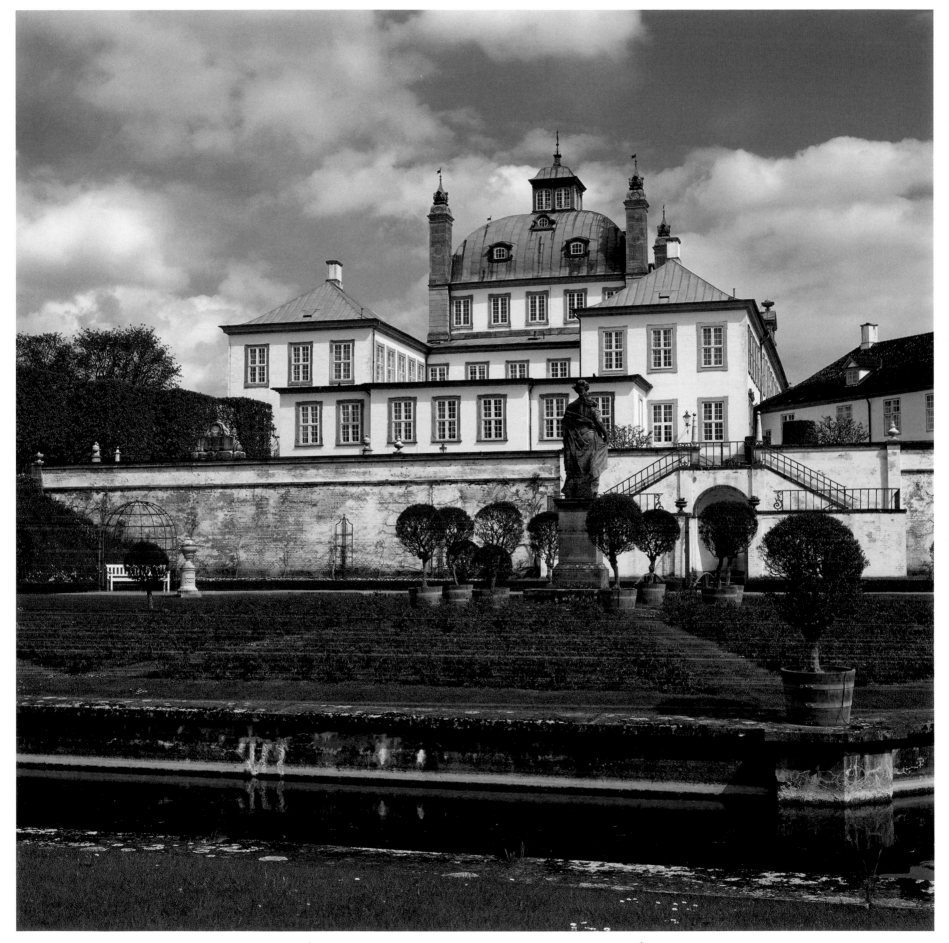

(The baroque palace was inspired by the architecture of an Italian villa.)

(On the slope of Snail Mound.)

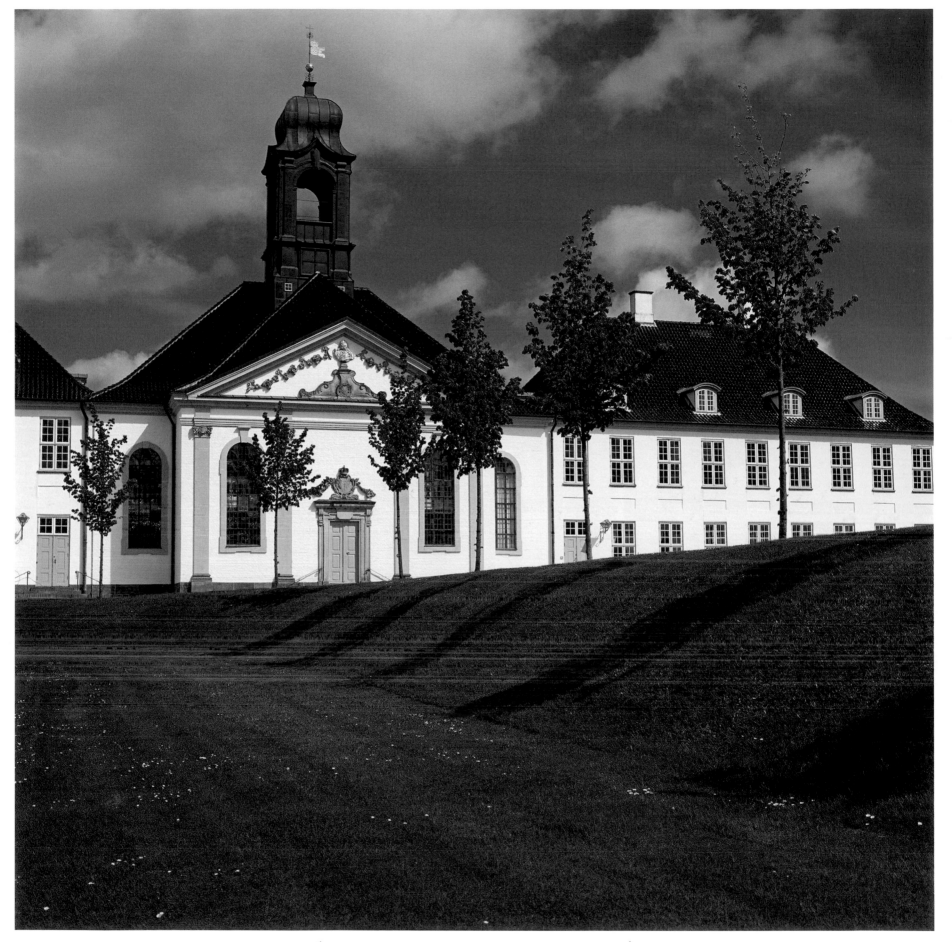

(The church, open for baptisms, marriages, and other ceremonies.)

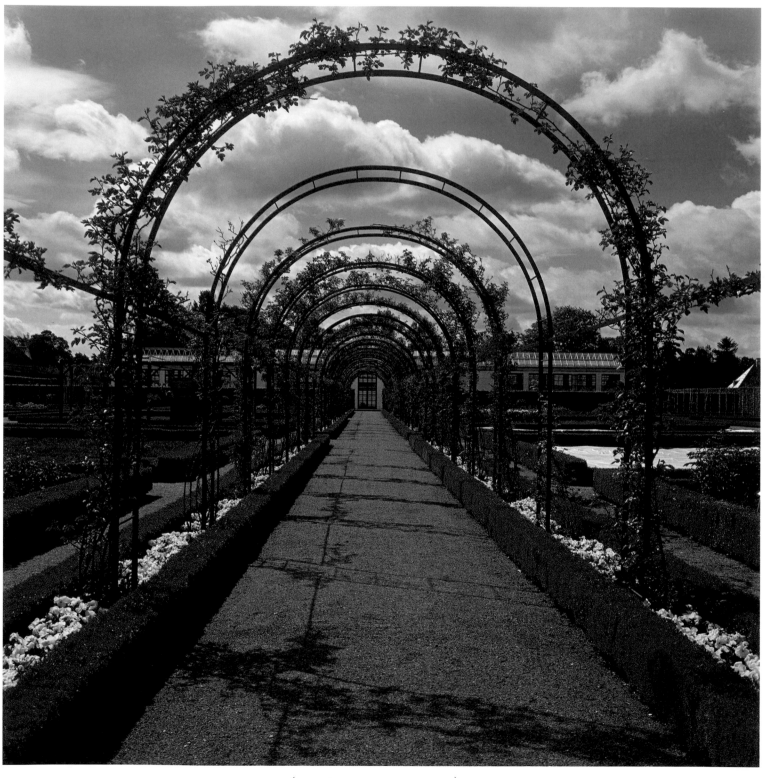

(A trestle in the vegetable garden.)

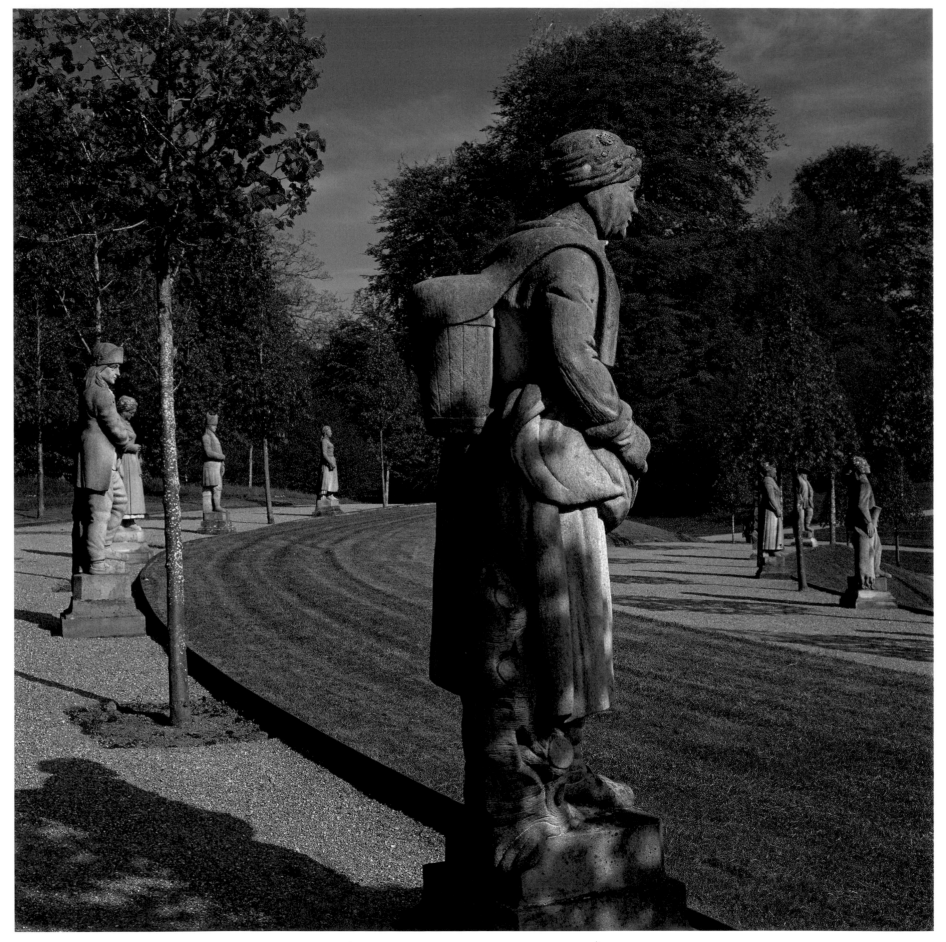

(ABOVE AND OPPOSITE In the Valley of the Norsemen.)

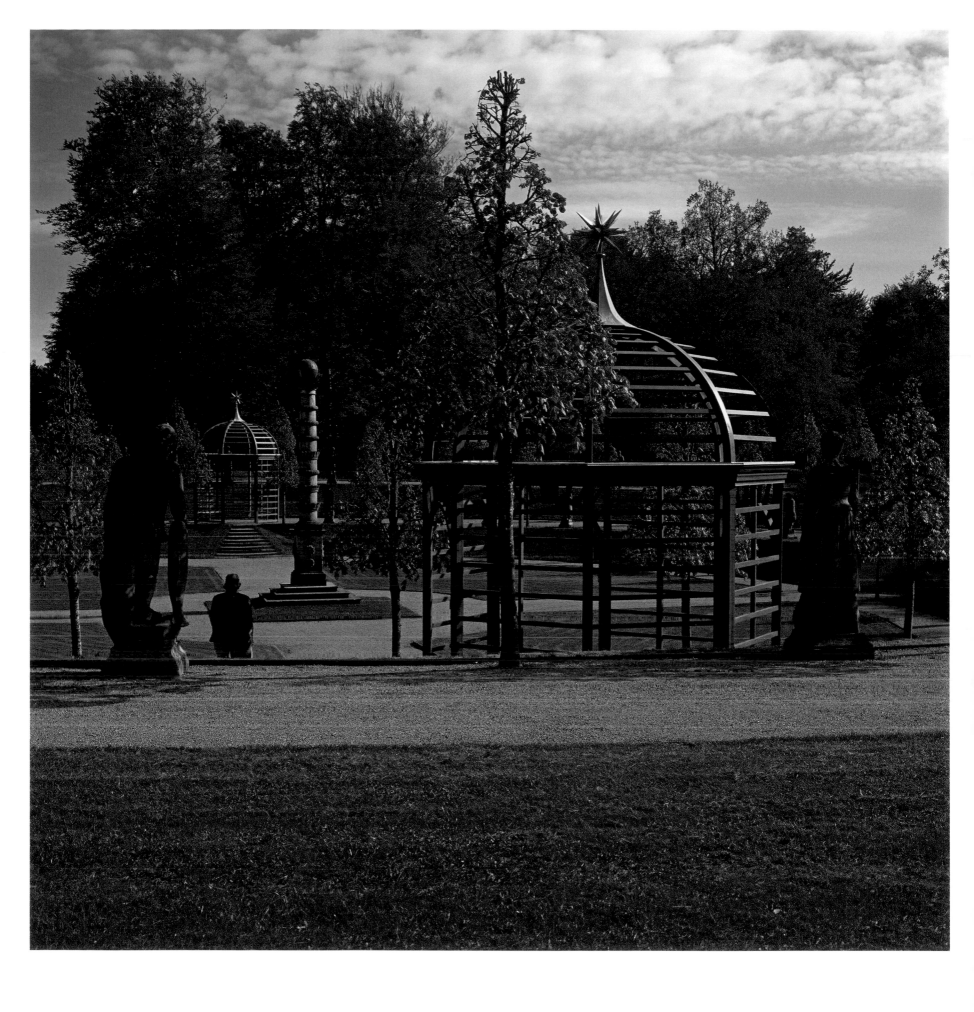

BELGIUM

CHÂTEAU
DE
BELOEIL

The Immense Garden of the Princes of Ligne

"THERE ARE MANY ORNAMENTAL LAKES, SUPERB HEDGES, NEITHER BORING NOR TIRED AS THEY are elsewhere; Italian bowers, magical and noble bowers, a charming cloister beside a decorative lake, grassy parterres, baskets of flowers, a small forest of roses in honeycomb design; all the green paths cut through the forest that leads to my garden. My land stretches for 200 arpents [about 169 acres]. There are some twenty decorative lakes that separate it into two sections which are encircled by canals...."

Coup d'Œil at Belœil, the book by Prince Charles-Joseph de Ligne, printed in 1781 on the castle's printing press, can still serve as a guide for visiting the gardens today. This immense garden covers 62 acres and is surrounded by canals that span the lengths of two parallel walkways—the allée du Doye (Dean's Walk) and the allée du Mail (Mall). The central basin that feeds the canals is 1,486 feet long and 426 feet wide. The garden is as impressive in its layout as it is attractive in its fine details. It was created largely in the seventeenth century from plans made by Prince Charles-Joseph's father, Claude Lamoral II, and the architect Jean-Michel Chevotet. It offers inviting perspectives from a series of parterres that surround the central basin, forming an upside down U. The Boulingrin (a French interpretation of the term "bowling green"), Field of Roses, Red Fish Pond, Oval Lake, Four Mirrors, Three Springs, Great Devil's Room, Quincunx, Cloister, Ladies' Lake, and Ice Lake are among the many features of the garden. They invite you to play, meditate, swim, and observe nature's beauty. Visitors follow the promenade à la française while gazing upon arbors of elms with views of the central decorative pool that contains the statue of Neptune by Adrien Henrion, the elegant Temple of Pomone, and the orangery.

"After the big ideas, there was nothing left for me but the interesting and agreeable..." wrote Prince Charles-Joseph. Of his contributions, the Rieu d'amour is a notable monument that he added to his father's park. He also designed the Deer Park—inaccessible today—with architect François-Joseph Bélanger. It is situated just below the castle, visible from the windows of his apartment. He also added follies that were made in the spirit of the Enlightenment's fascination with Greco-Roman architecture, including a Roman ruin, the Temple of Morpheus, and an obelisk, all of which take the visitor back through the centuries and to other lands.

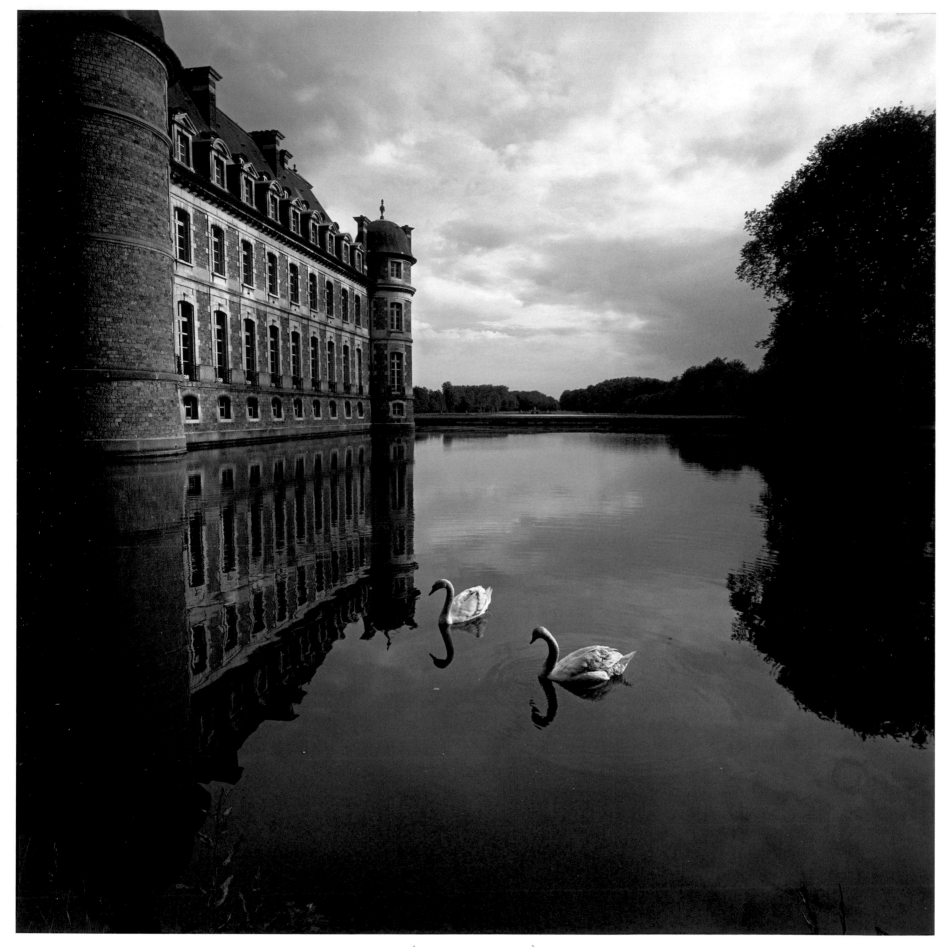

(The castle and its moat.)

Let it be known that Beloeil is entirely responsible for the happiness and joy that are mine. That those who are most unlike me should see the error of their ways or succumb to anger, knowing that there is someone who is perfectly content, and that those who are most like me should share, even when I am no longer alive, in the felicity of the creator and owner of these peaceful gardens.

—Charles-Joseph, Prince of Ligne

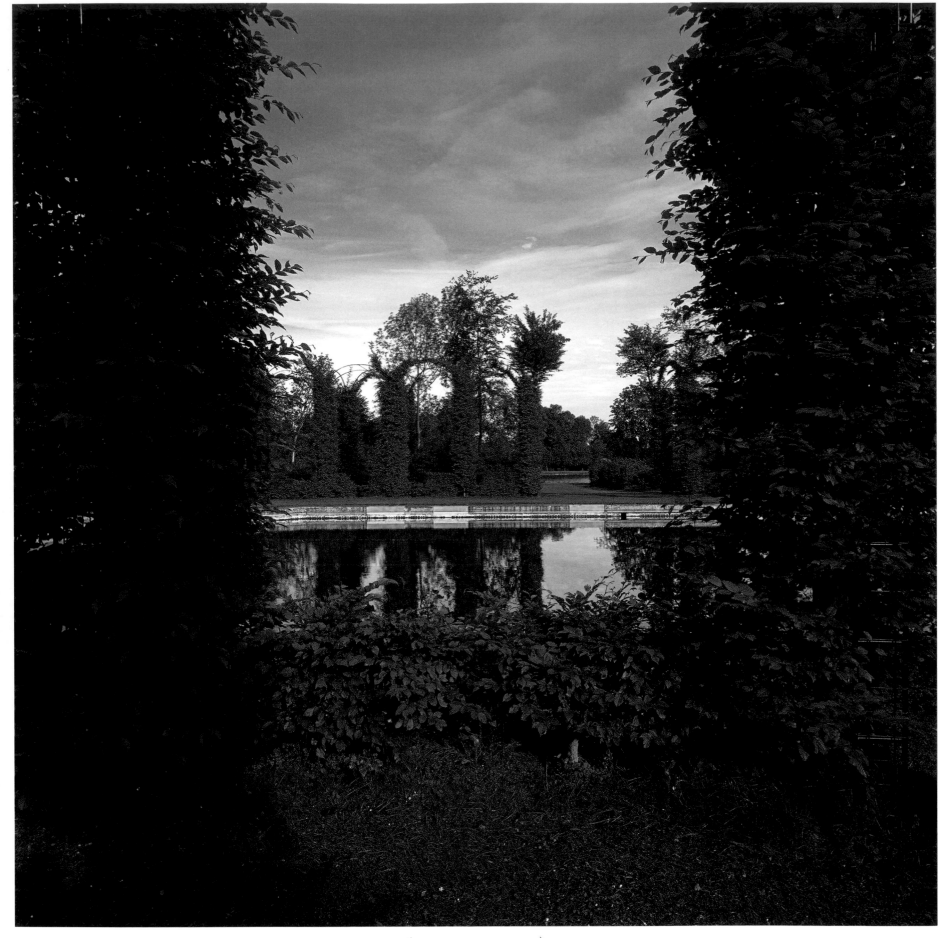

(The grove at Ladies' Lake.)

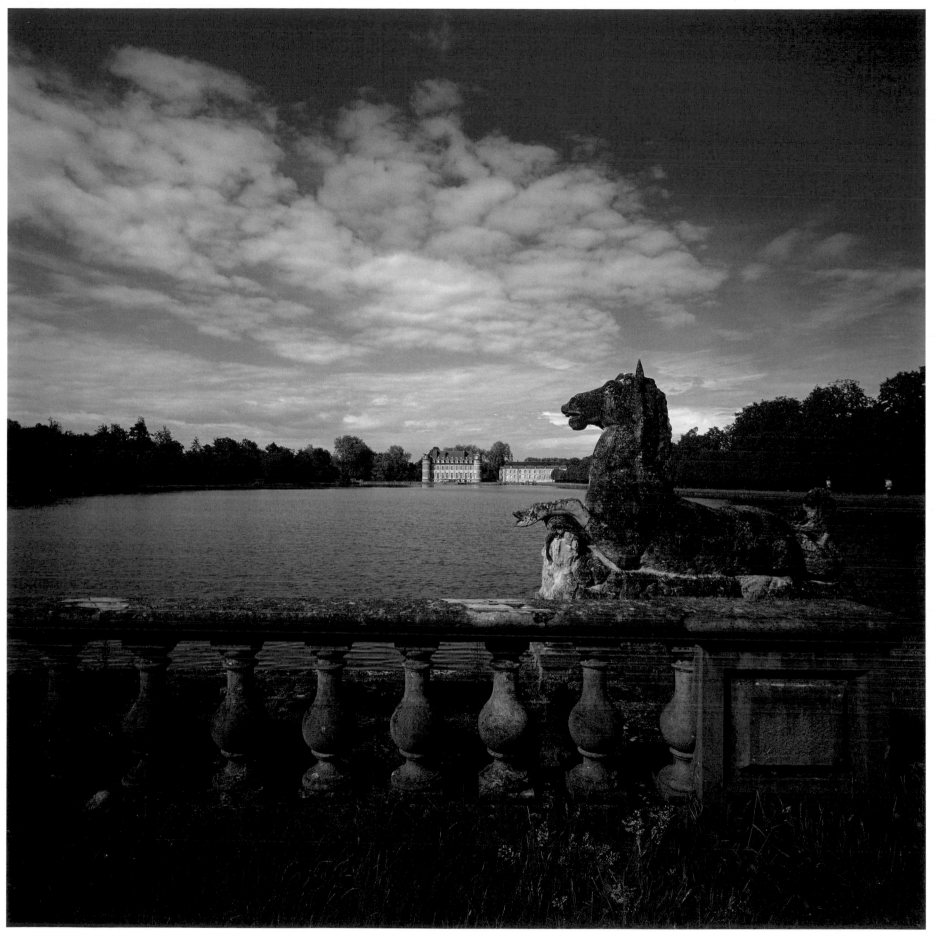

(Horse statue in front of the château's reflecting pool.)

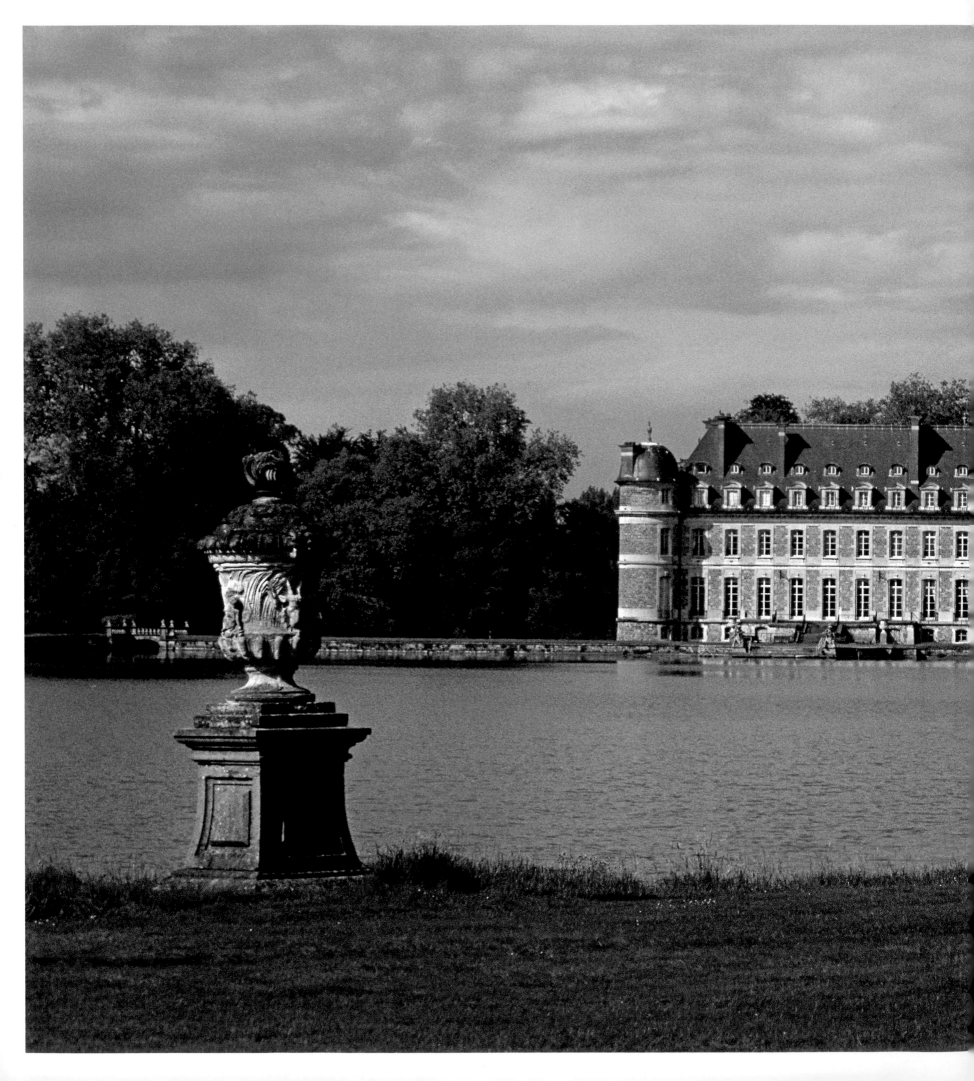

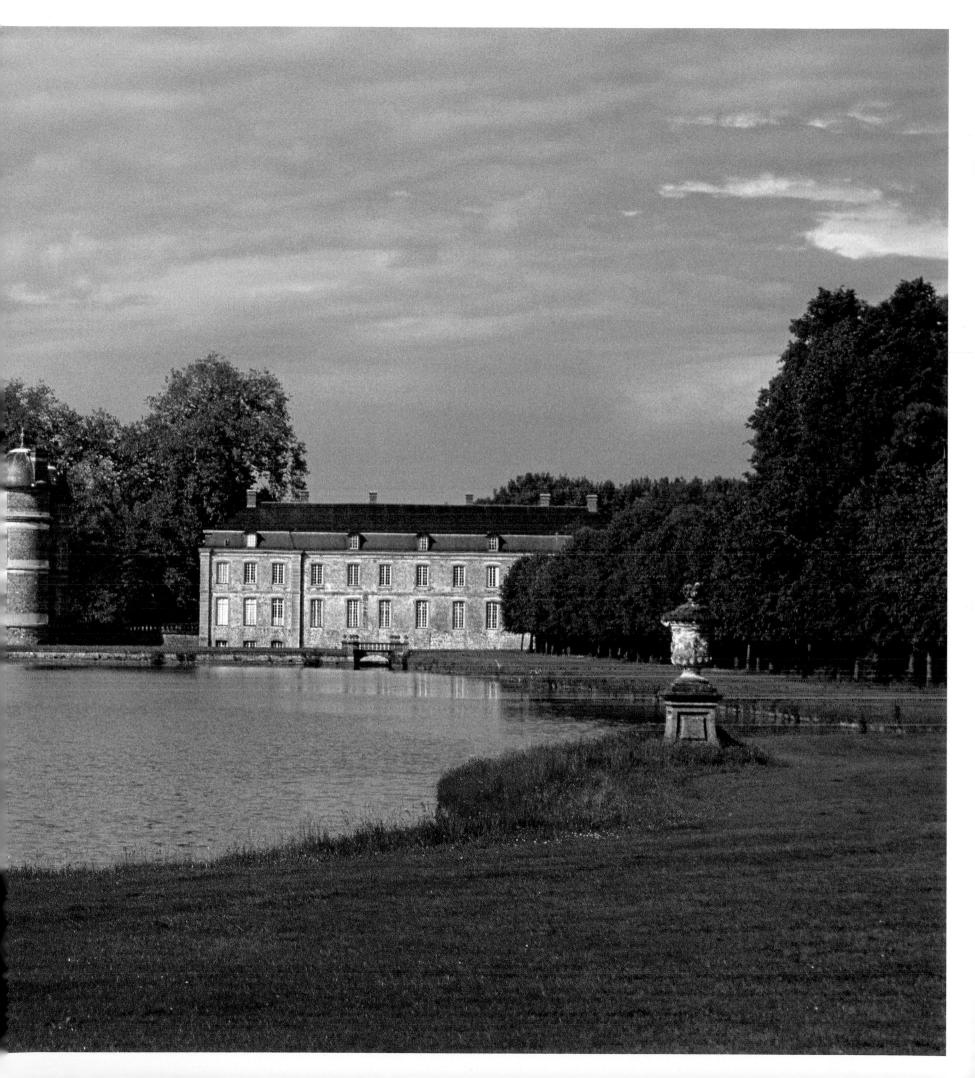

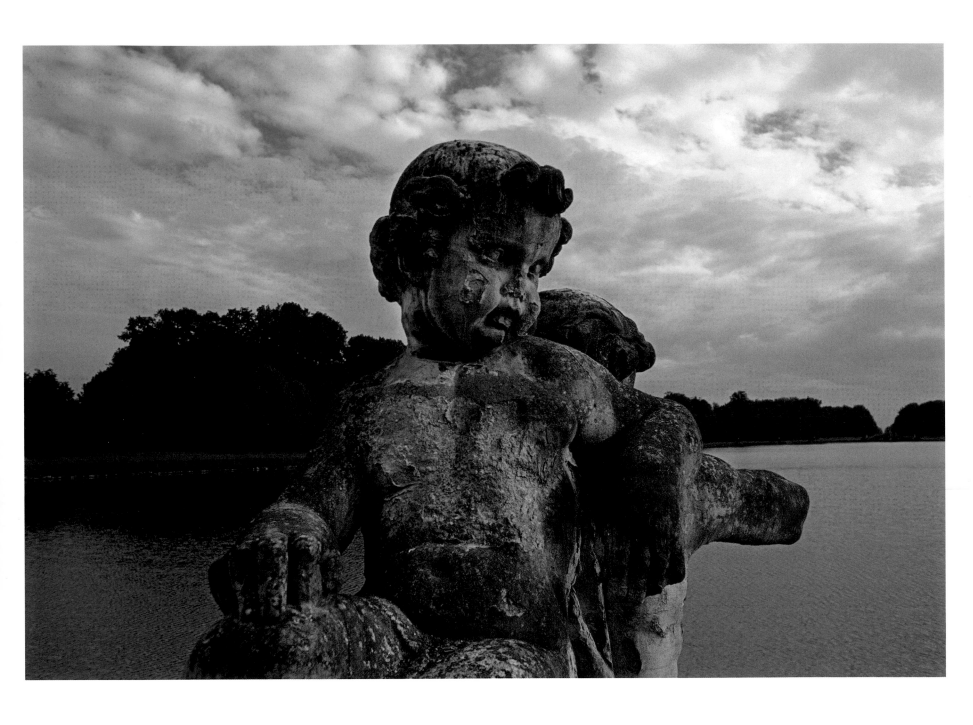

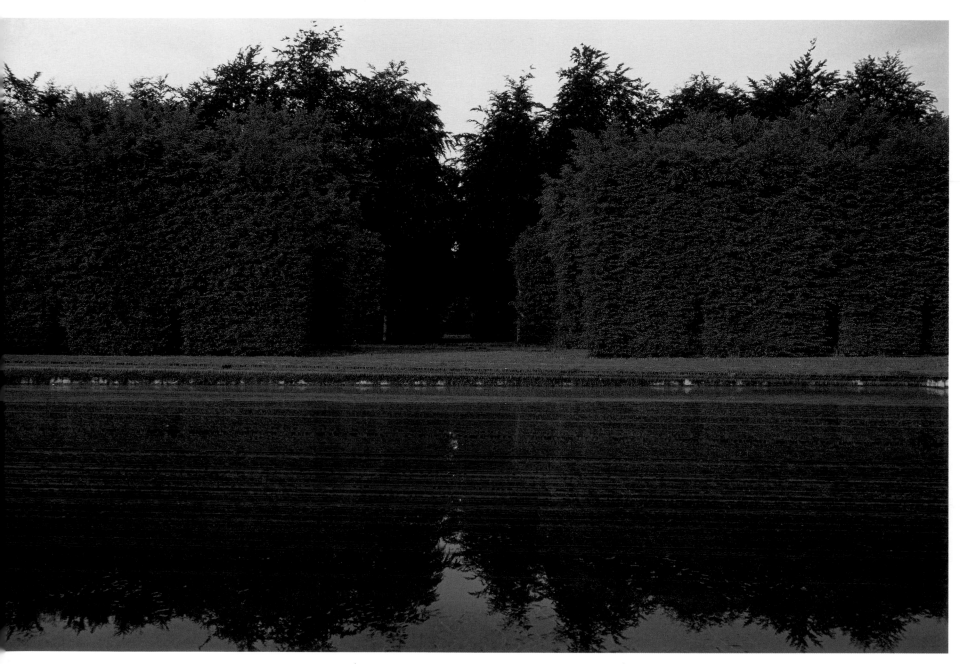

(The Cloister pool in front of the quincunx of beech trees.)

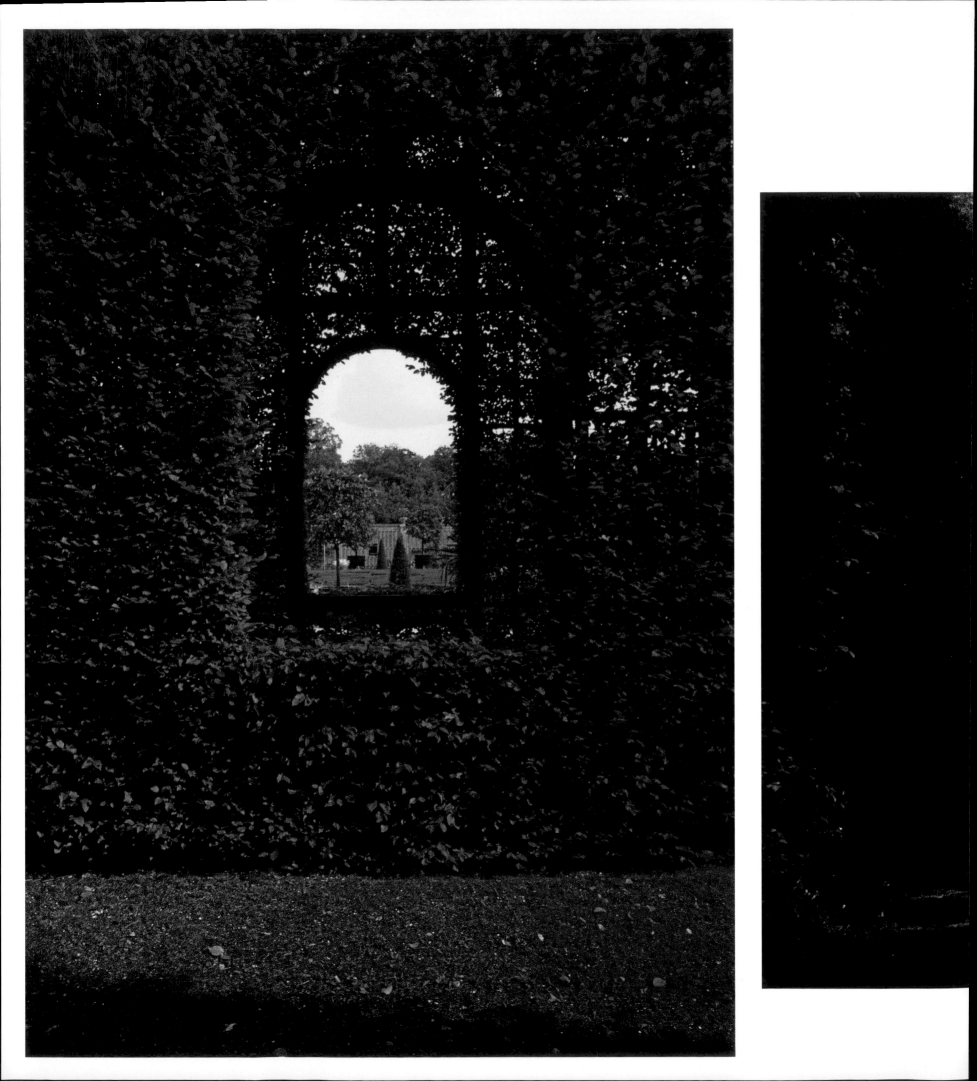

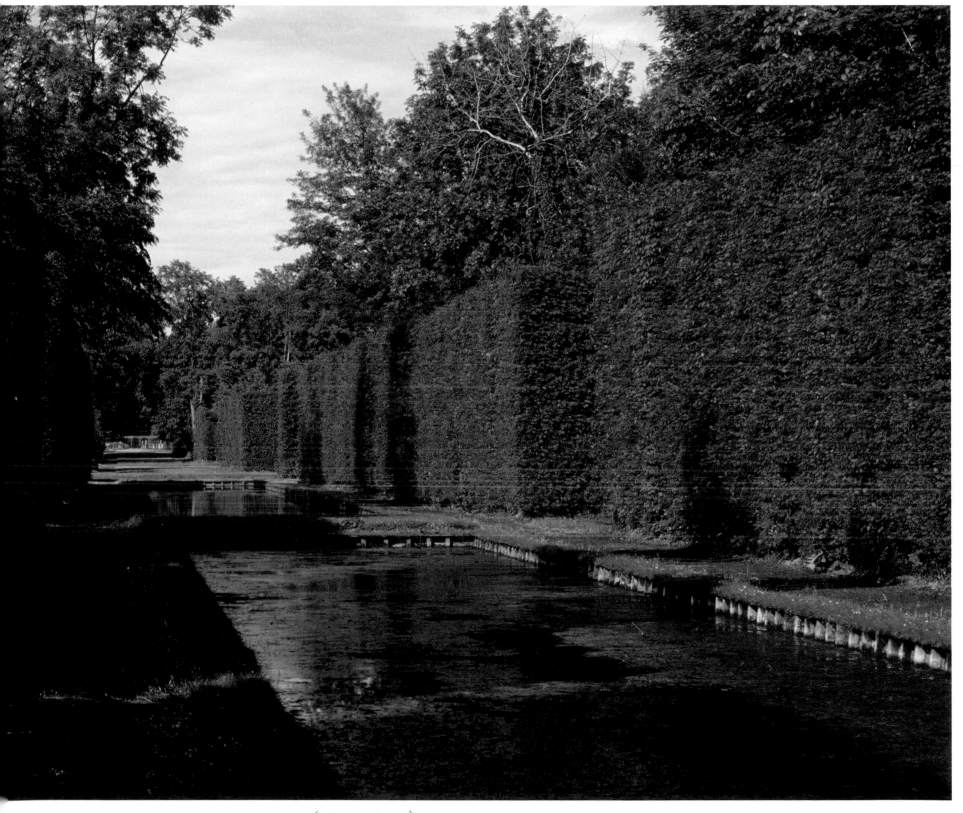

（ The Four Mirrors. ）

GERMANY

NEUSCHWANSTEIN

Ludwig II's Ode to Medieval Legend

"IT IS MY INTENTION TO REBUILD THE OLD CASTLE RUIN OF HOHENSCHWANGAU NEAR THE PÖLLAT Gorge in the authentic style of the old German knights' castles, and I must confess to you that I am looking forward very much to living there one day; there will be several cozy, habitable guest rooms with a splendid view of the noble Säuling, the mountains of Tyrol, and far across the plain... The location is one of the most beautiful to be found, holy and unapproachable, a worthy temple of the divine friend who has brought salvation and true blessing to the world. It will also remind you of *Tannhäuser* and *Lohengrin*; this castle will be in every way more beautiful and habitable than Hohenschwangau farther down, which is desecrated every year by the prose of my mother; they will take revenge, the desecrated gods, and come to live with Us on the lofty heights, breathing the air of heaven."

The thesis of the castle's design can be discovered in these lines of the young King Ludwig II written to Richard Wagner in May 1868. Here, grandiose landscapes replace the garden. From its large windows—rare at the time—the castle offers mind-boggling views on every side, views that change according to the time of day and the season. The castle was inspired by the German fortifications of Wartburg, a German icon that had fed the king's passion for medieval legends since his childhood. There he found echoes of the stories Wagner put into his operas *Tannhäuser* and *Lohengrin*. The heroes of these legends—the Knight of the Swan and his father, Parsifal, the Grail king—were models for Ludwig.

As for comfort, the castle enjoyed all the benefits of modernity: central heating, running water, electric intercoms to call the servants and the guard, telephones, and a dumbwaiter for meals. Providing a link to the grand landscapes surrounding the structure, a grotto (a small artificial cave)—located between the salon and the study, lit with different colors, and containing a waterfall—gives access to a winter garden, a conservatory with a panoramic view. In this way, the king maintained an intimate and sublime dialogue with the gods.

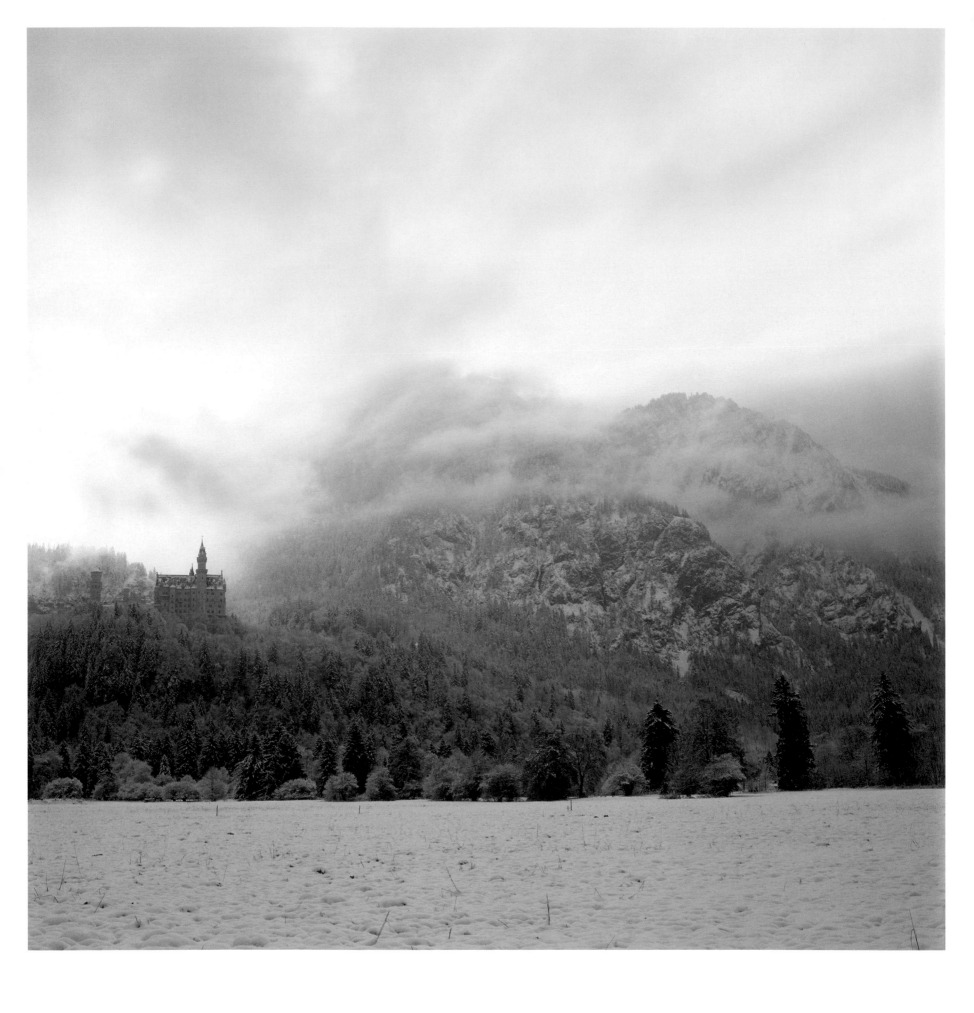

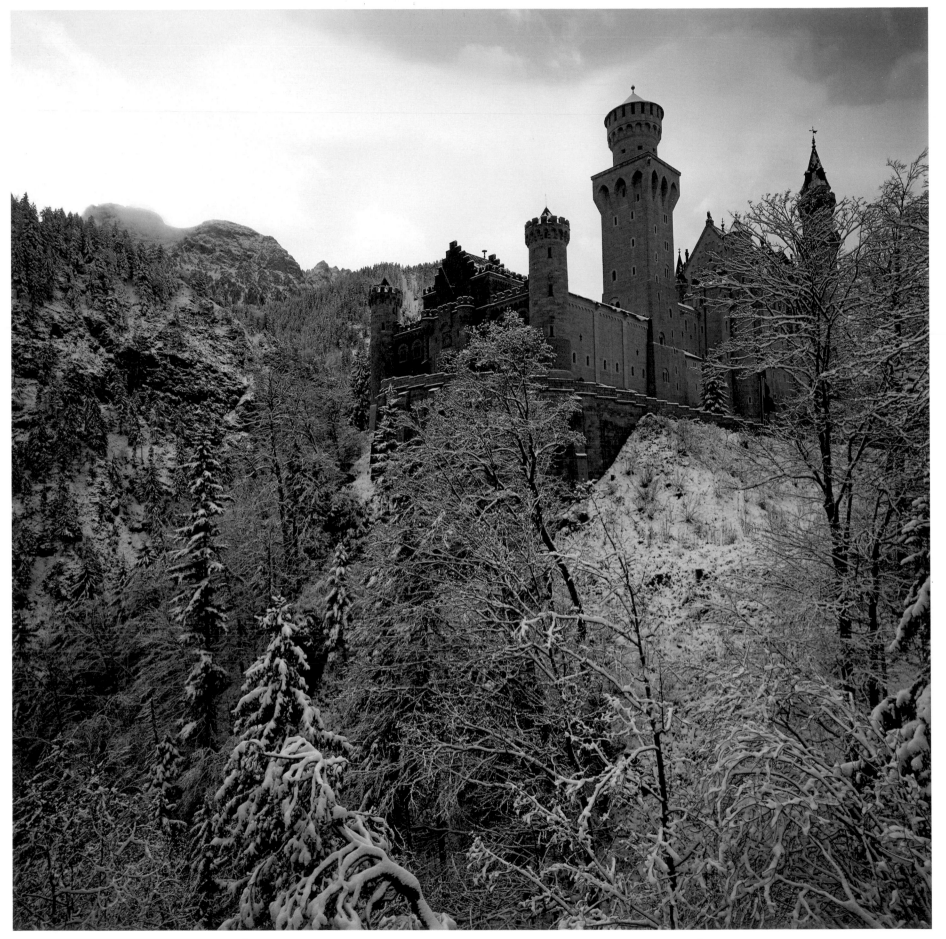

(The creation of Ludwig II is perched at the summit of a narrow ridge more than half a mile high.)

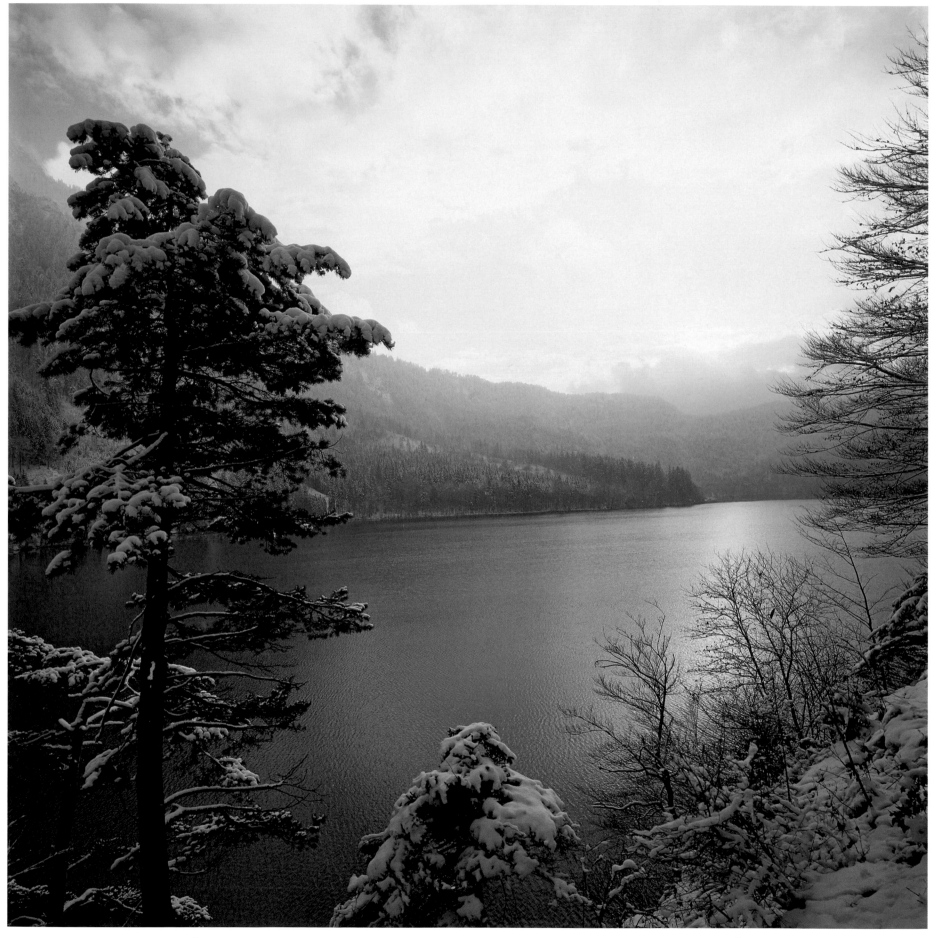

⟨ In the heart of the Bavarian Alps, the castle is located in an ideal setting for the operas *Lohengrin* and *Tannhäuser*. ⟩

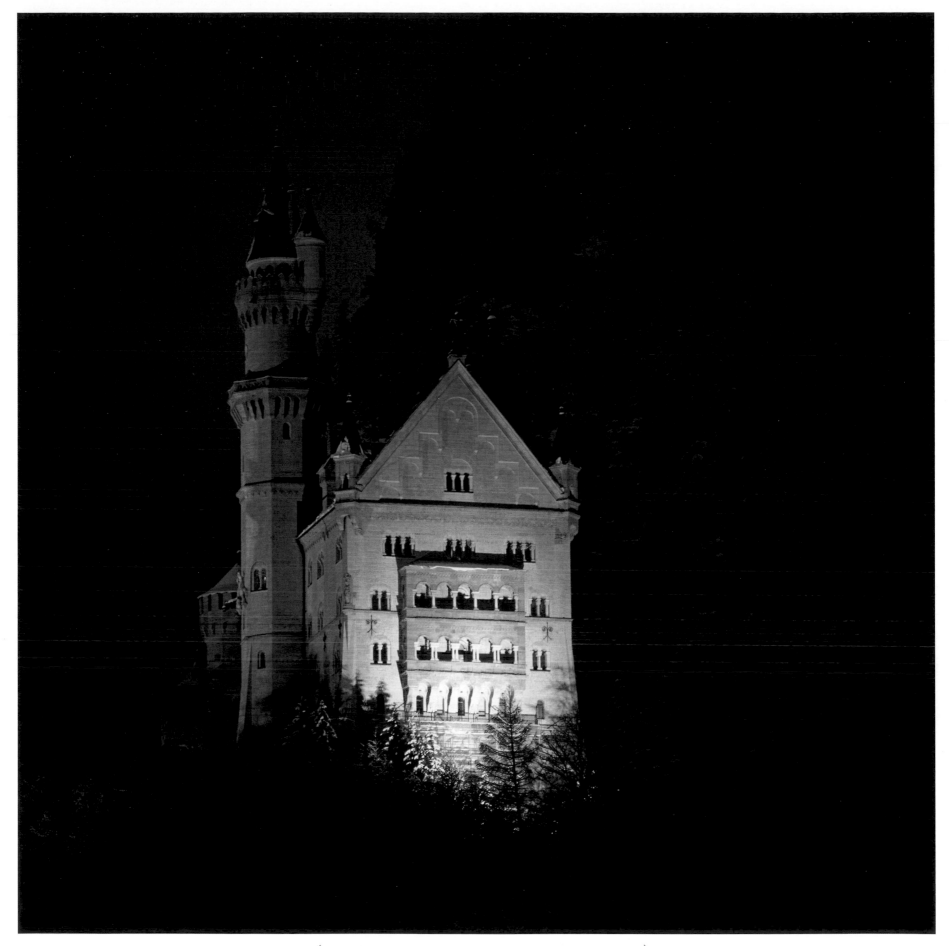

(Covered with white lime, the castle is even more impressive at night.)

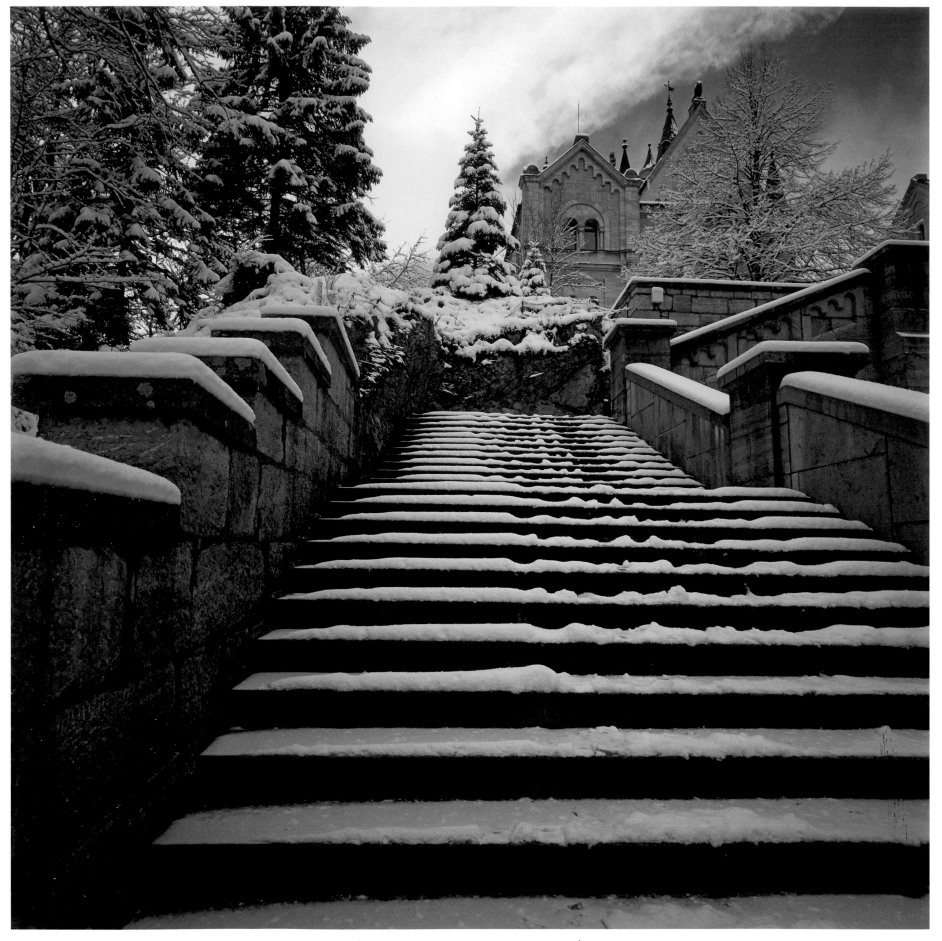

(You have to ascend by foot to get to the castle.)

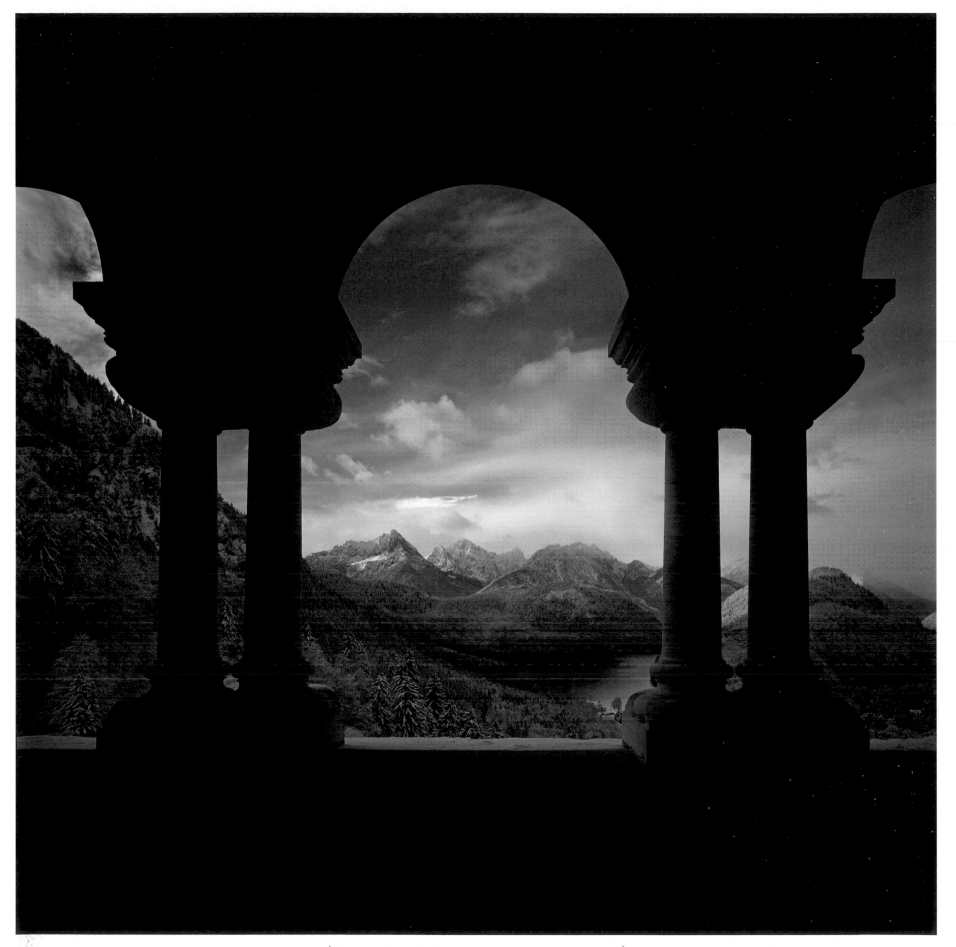

(The round-headed window openings of a Roman-style castle.)

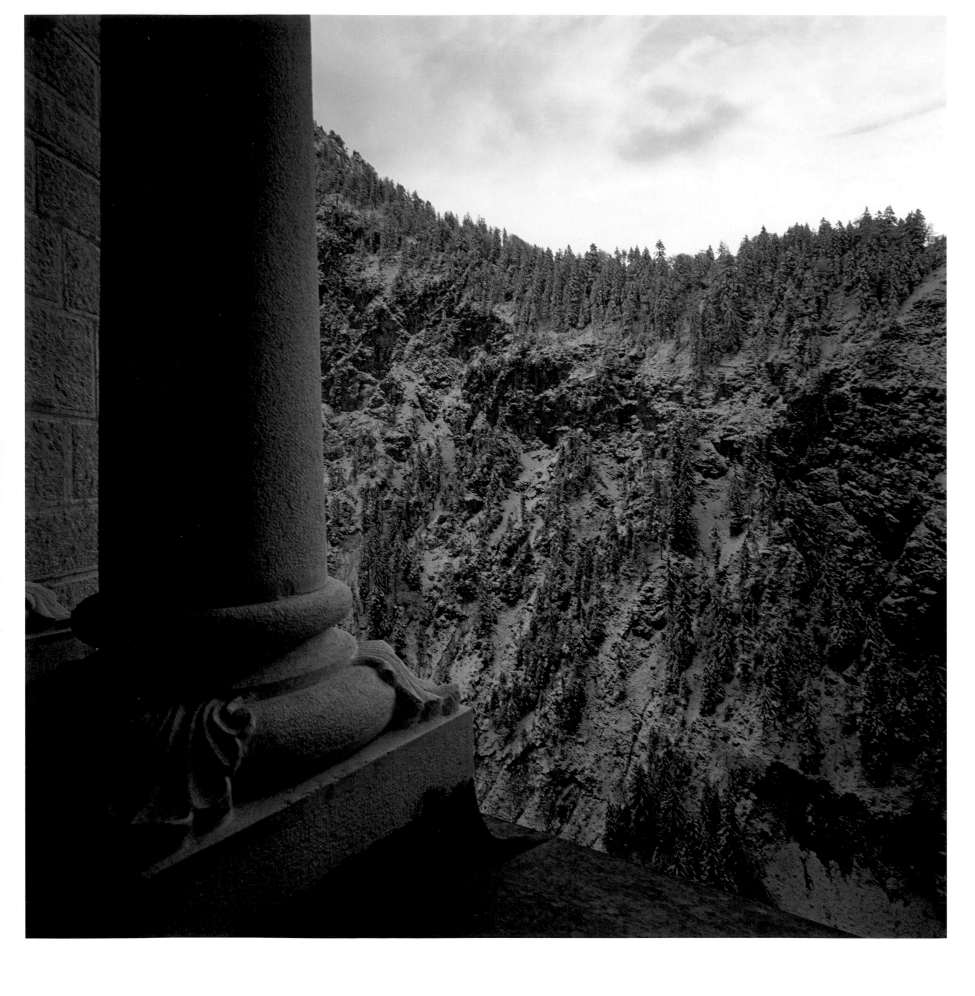

Here, grandiose landscapes replace
the garden. From its large windows—
rare at the time—the castle offers
mind-boggling views on every side,
views that change according to the
time of day and the season.

GERMANY

SANSSOUCI

The Philosophical Residence of Frederick the Great

The astonishing summer palace of Frederick II, more commonly known as Frederick the Great, sits atop a vineyard of six terraces on a hill called Wüsten Berg. It was acquired in 1744 and built entirely on one level, facing south like ancient Arcadia. It has a large round hall at its center, the Marble Hall, with five rooms on one side for the king and five on the other for his guests. On the north side, at the central focal point, is a faux antique ruin.

Like Louis XIV, who built the Trianon at Versailles, the king wanted a retreat in Potsdam where he could escape the rigors of the court in Berlin. The name of the palace, Sanssouci, is engraved on the entablature of the central bow of the façade, expressing the "no worries" motto for this retreat.

Dinners there, which were renowned throughout Europe, took place above the terraces in the Marble Room of the rotunda or in the first anteroom of the royal apartment. They brought together the most brilliant minds of Europe, including Voltaire, who was a guest at Sanssouci for three years.

Happy on his estate, Frederick refined and enlarged it. At the foot of the terraces, a French-style parterre contains a fountain and statues of Venus, Mercury, Apollo, Diana, Juno, Jupiter, Mars, and Minerva, as well as allegorical portrayals of water, earth, air, and fire. A transverse axis, bordered with arbors and dotted with statues, leads to Deer Park and its Chinese House, which was inspired by a folly at the Lunéville Castle in Lorraine, France. The gilded columns are shaped like palm trees and the house is topped with a statue of a Chinese man carrying a parasol. A central room provides access to small rooms, called cabinets, containing oriental paintings. At the very end of the garden's axis is the rococo-style New Palace, which was built for the royal family. It houses an exceptional grotto covered with seashells and crystals. A belvedere, overlooking Klausberg, is the last of the additions made by Frederick the Great. Others were carried out by Frederick William IV and the landscape designer Peter Joseph Lenné. The residence has been a UNESCO World Heritage site since 1990.

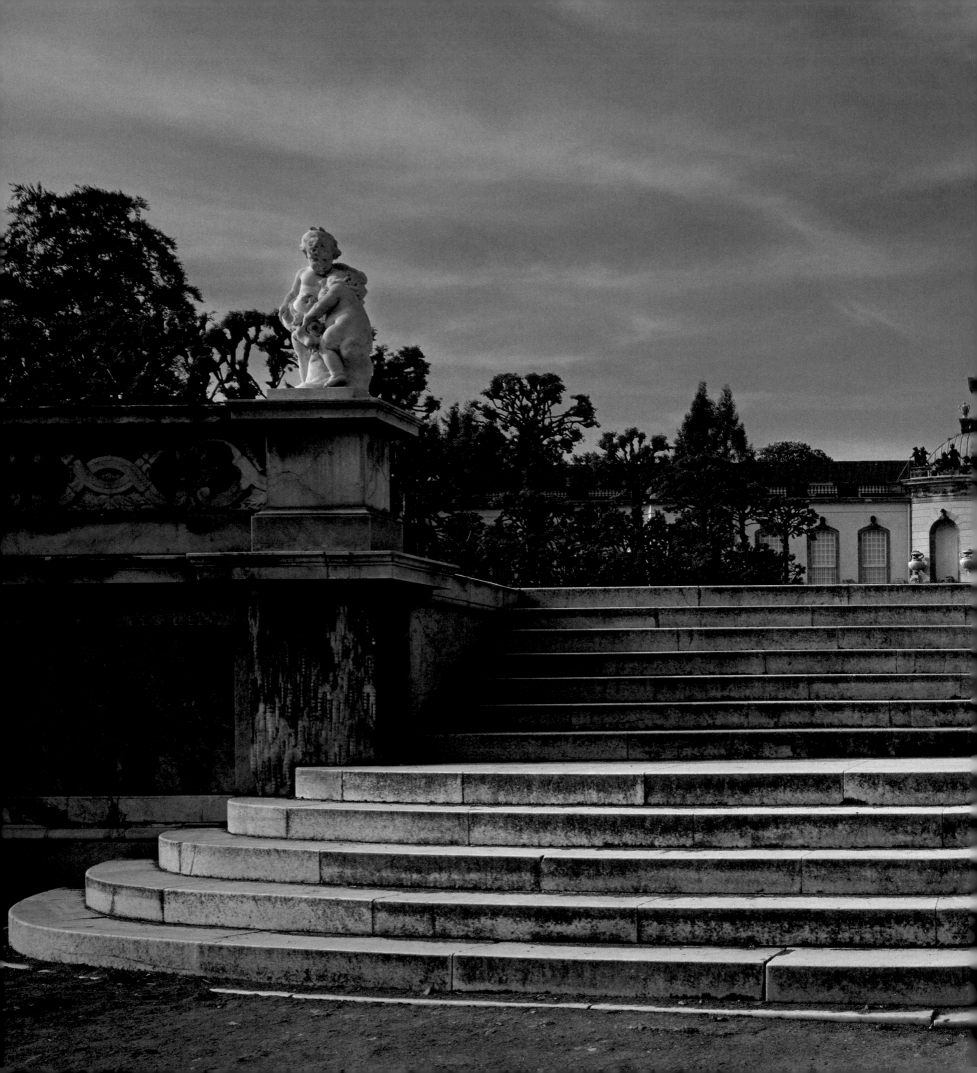

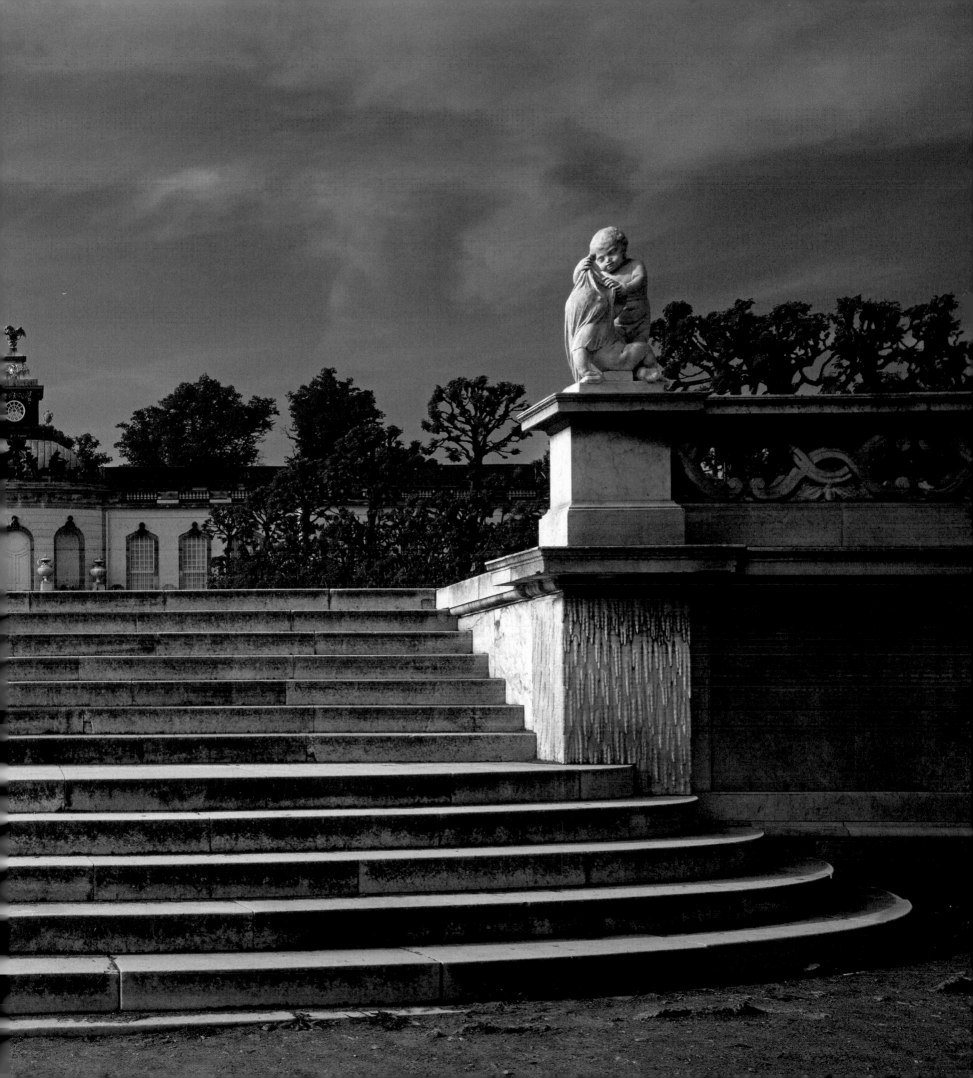

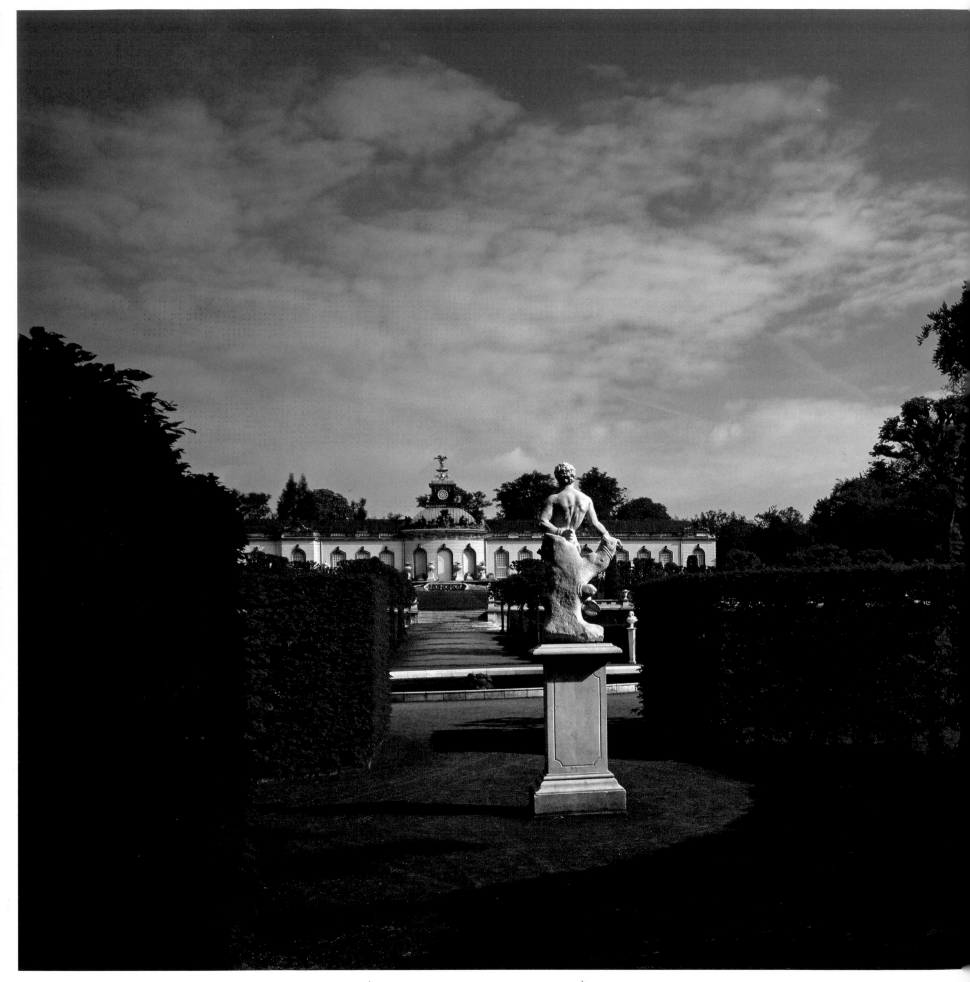

(**PAGES 52–53** Climbing to the Picture Gallery.)

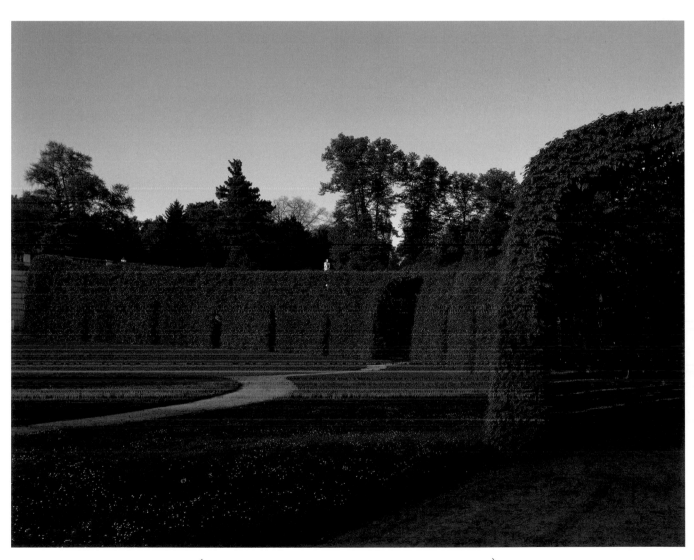

(**OPPOSITE** View of the Picture Gallery from the Dutch garden.)

(**ABOVE** Arbor of hornbeams in the Sicilian garden.)

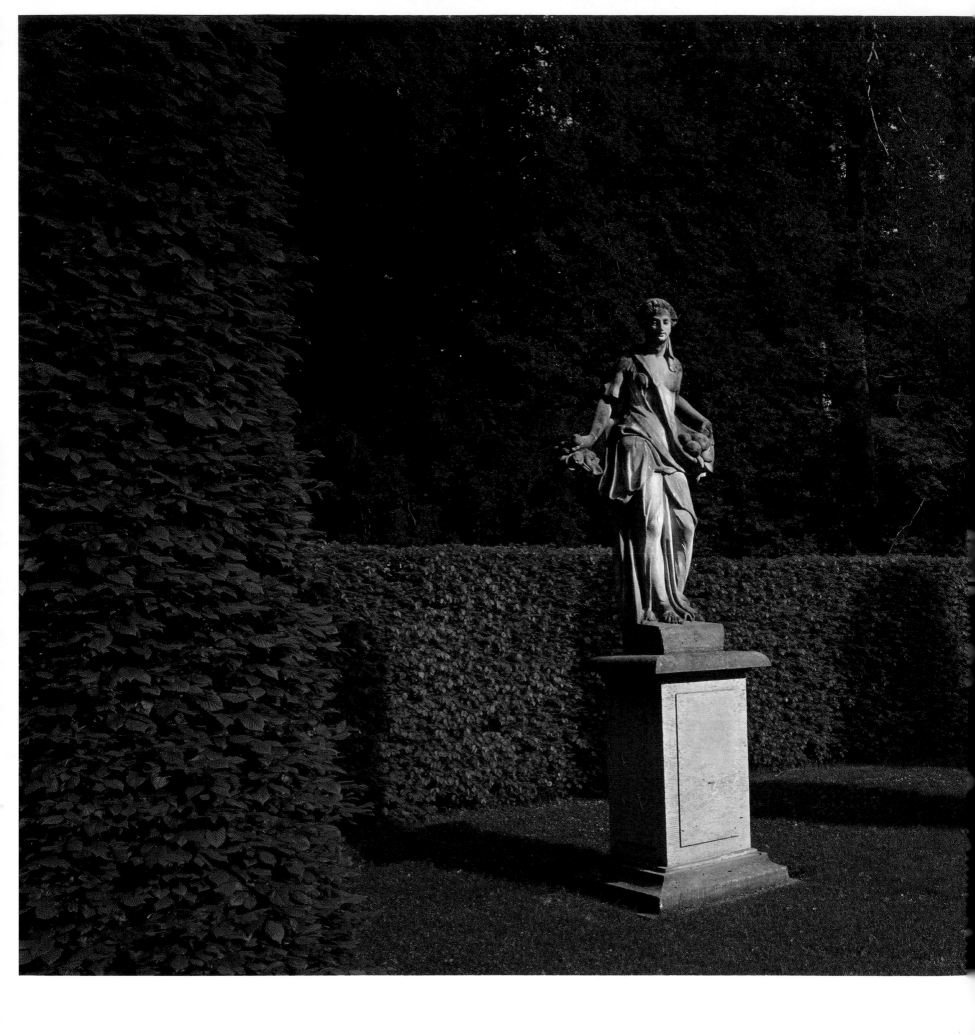

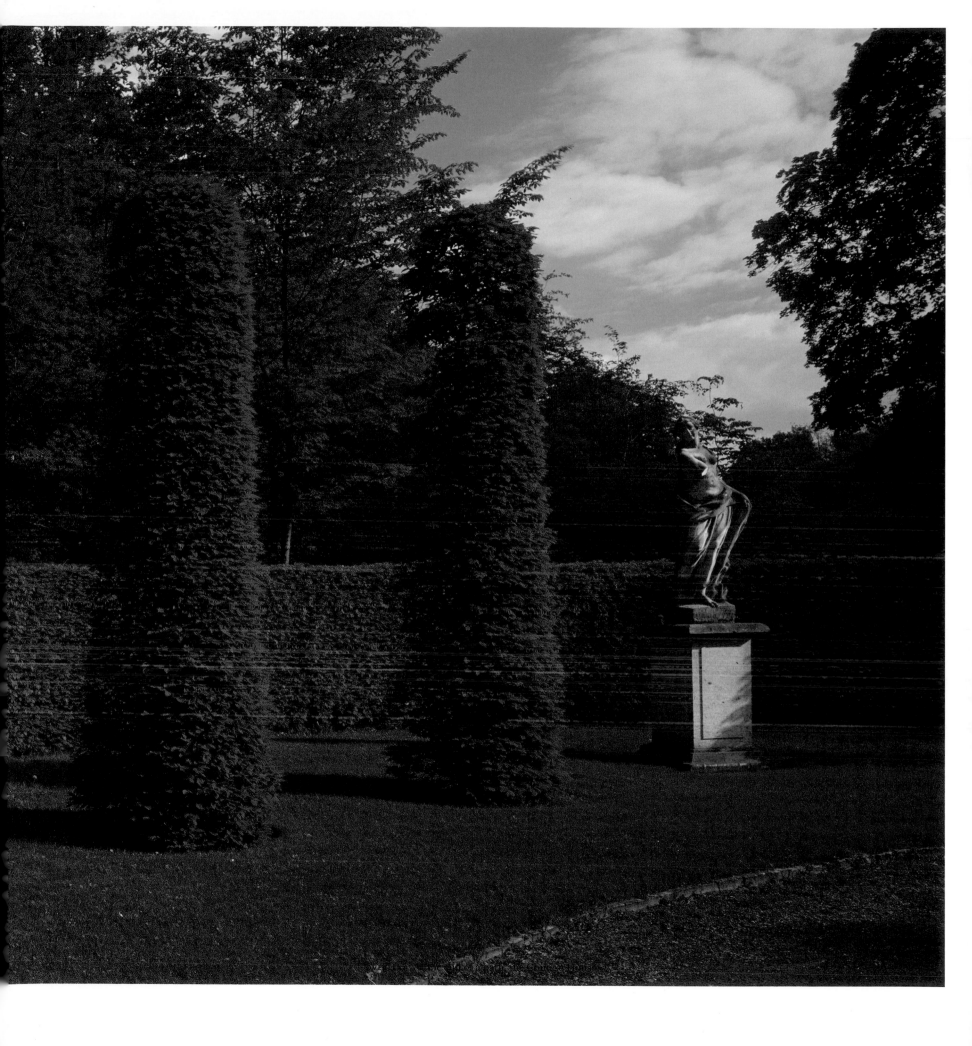

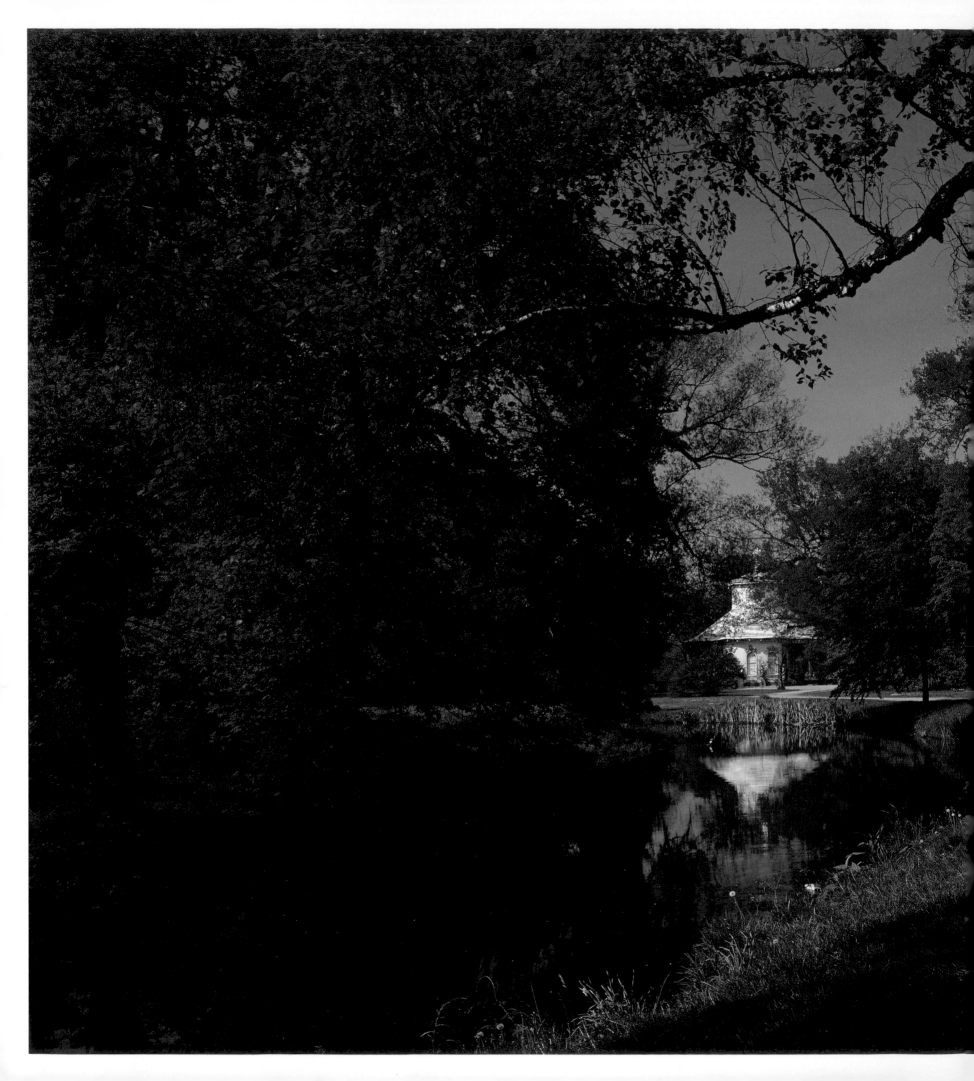

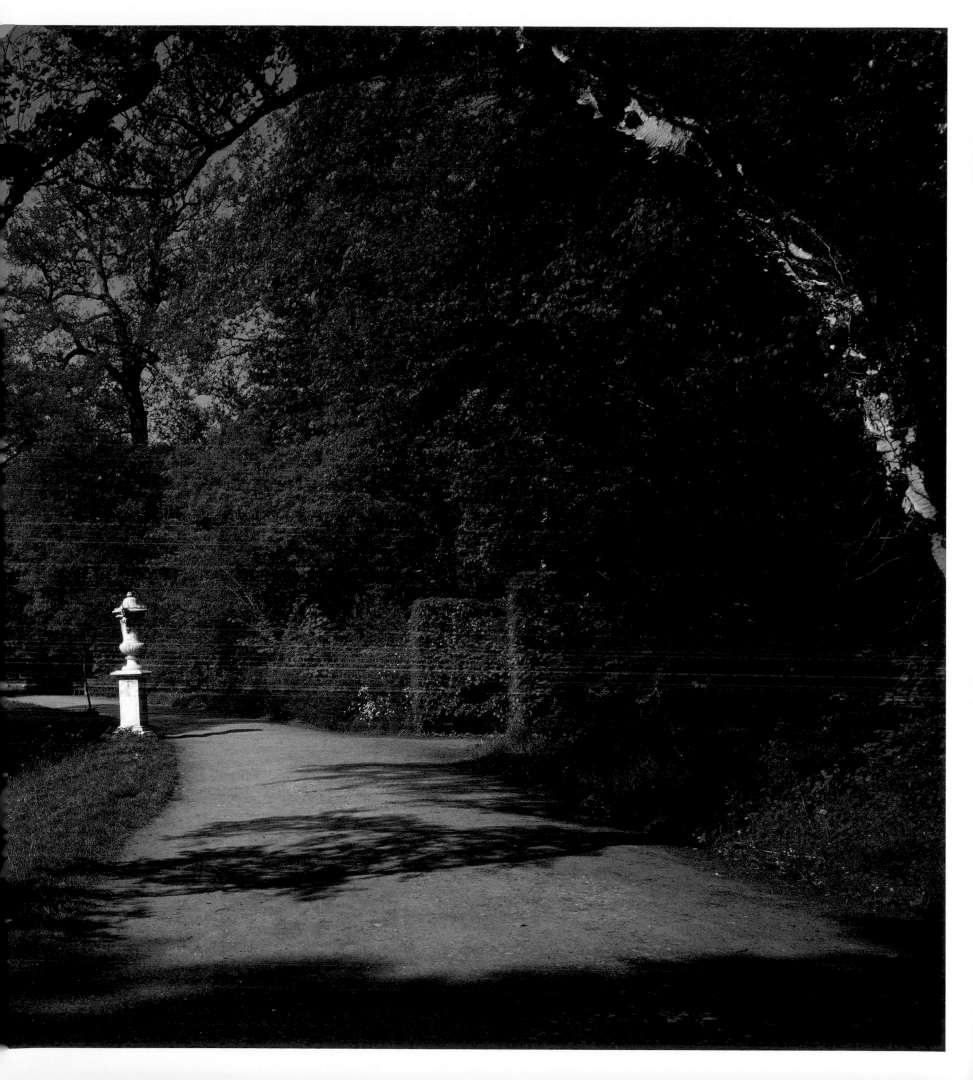

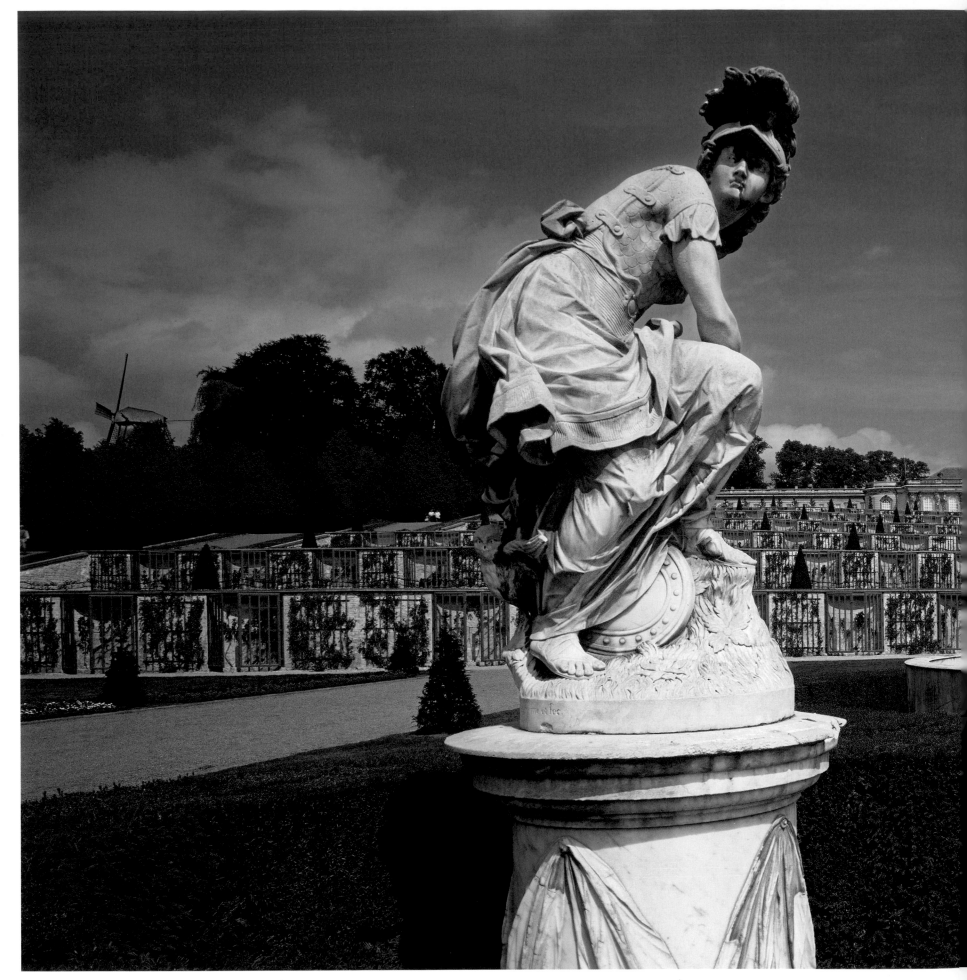

(The castle seen from the parterre with the statue of Minerva and the Four Elements.)

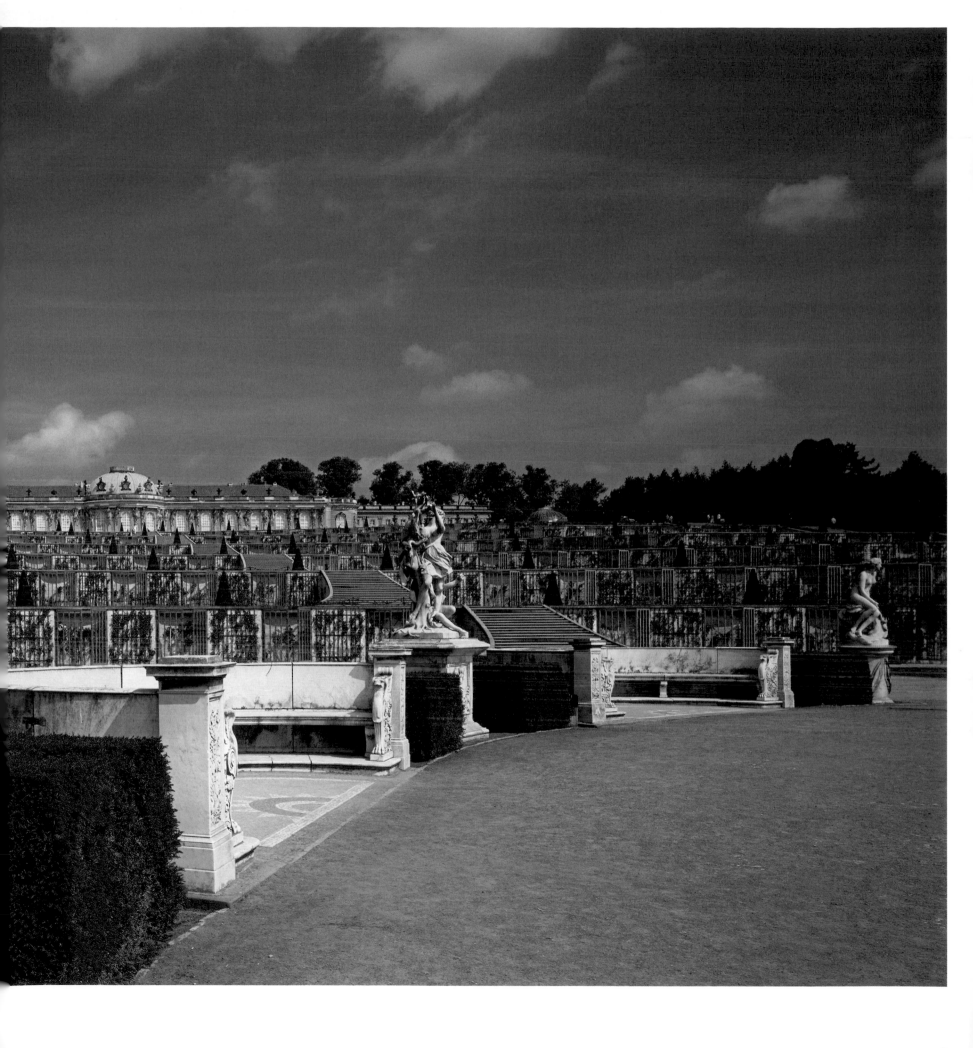

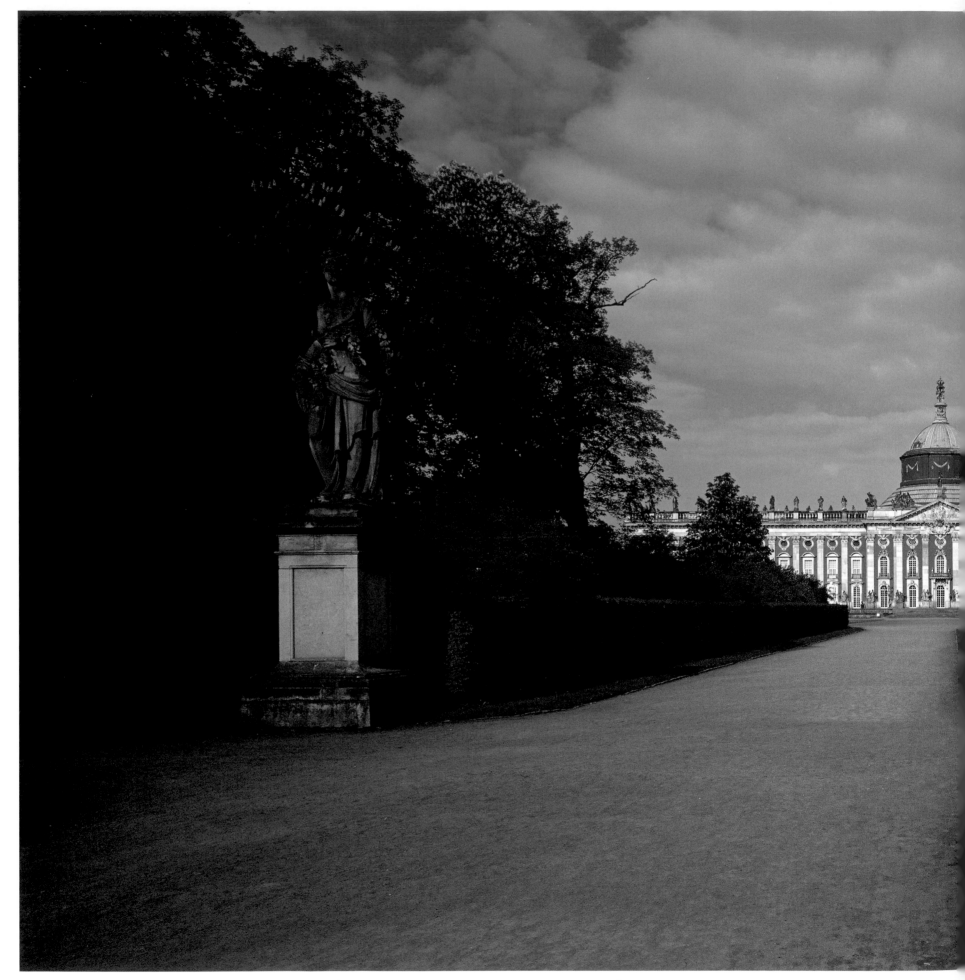

（ The New Palace at the end of the east-west transverse axis. ）

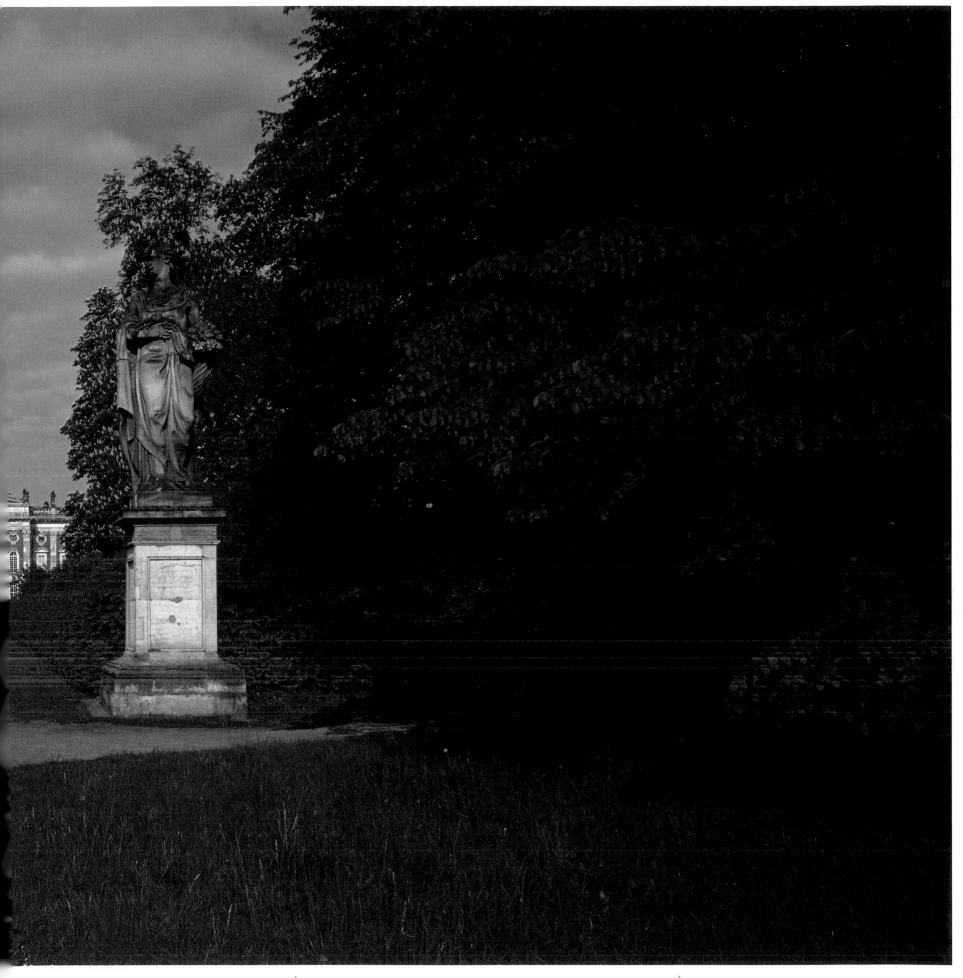

(OVERLEAF A peaceful oasis along the transverse axis that leads to the New Palace.)

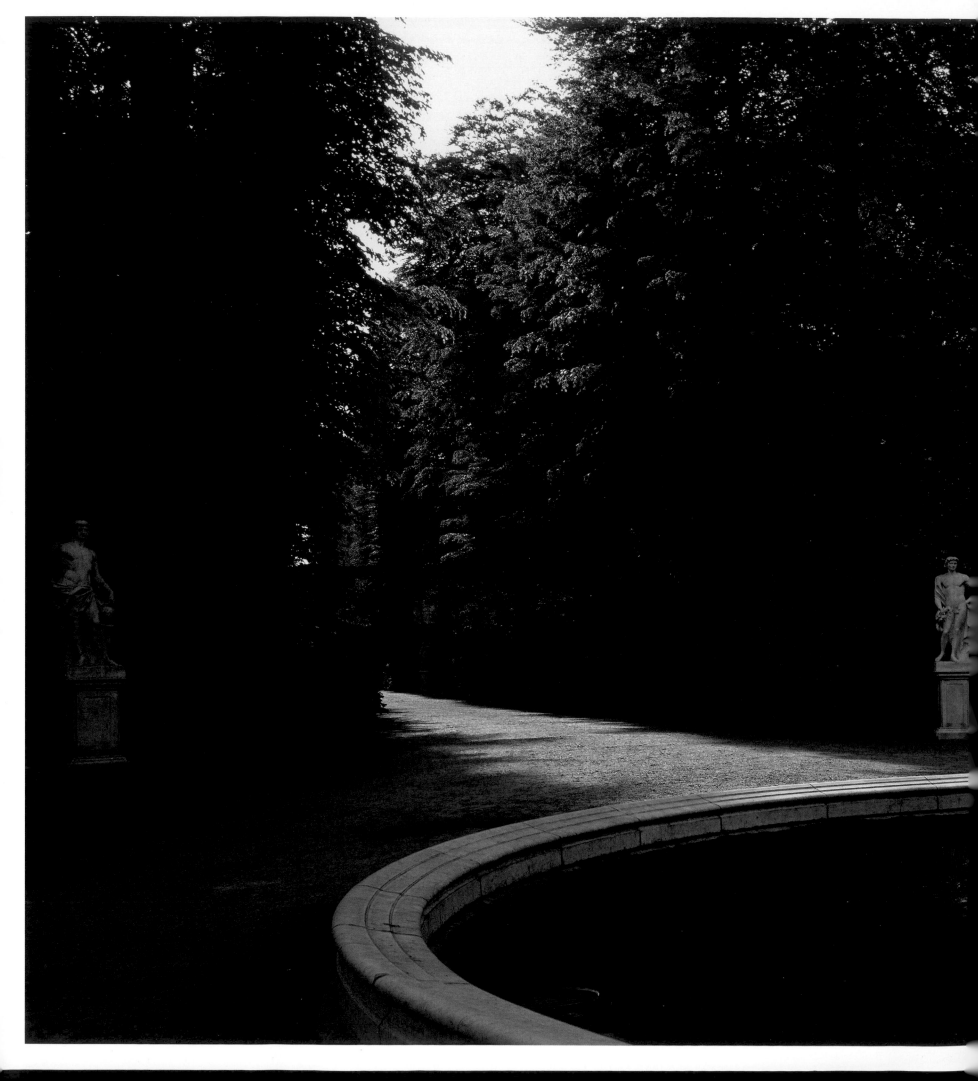

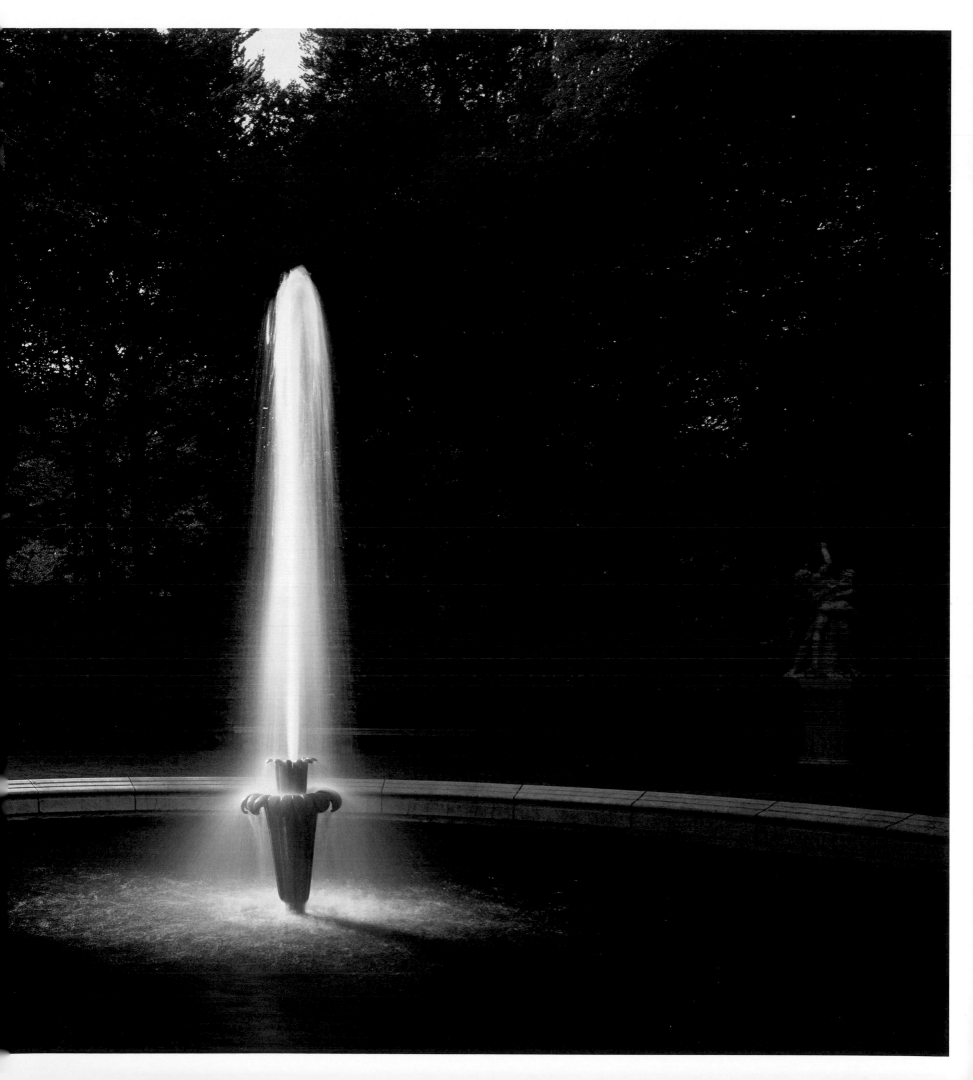

JORDAN

**ROYAL
BOTANIC
GARDEN**

Princess Basma's Garden for the Future

This IMMENSE 445-ACRE GARDEN IS LOCATED IN TELL AR-RUMMAN NEAR JORDAN'S LARGEST dam. It was created in 2005 by Princess Basma bint Ali, cousin of King Abdullah II, and is a work in progress, a garden for the future. The area is in a wind corridor between the Mediterranean and the desert, culminating at over 1,500 feet above sea level. Because of this, it serves as a stopover for migratory birds that rest and water there. Once the base of the Ministry of Agriculture-Forestry Department, this arid territory is being transformed into Jordan's top botanical garden with a research center dedicated to plants and natural habitats, a place for experimenting with renewable energies, and a destination for ecotourism with an environmental education center. This project attempts to tackle a big challenge in a country where desertification is intensifying and natural habitats are shrinking as they are consumed by sprawling cities and uncontrolled grazing.

Princess Basma, who was honored as "Hero for the Planet" by *Time* magazine in 1998, has gathered a thirty-member team, whose mission is to list and conserve more than 2,500 species of indigenous flora, display them to boost public awareness, and then set up specific research projects for the trees, flowers, and medicinal plants that they have documented. The areas of the garden that will be used for these activities are currently in the process of construction. Horticultural displays, natural habitats, zones used by researchers for experiments, and areas for visitors that will include hiking trails, information pavilions, and even an eco-lodge and café are all a part of the plan. The scientific groundwork is already being laid by implementing grazing-management programs; collecting information on traditional practices; studying local plants; gathering biomass, seed, and specimen collections for the herbarium and the seed bank; and creating an indigenous plant nursery. Preparations are also under way for many thematic gardens including water-conservation gardens, traditional medicinal plants and Islamic gardens, an ecological garden, and an olive grove. Five of Jordan's natural habitats will soon be re-created: forests of deciduous oaks, pines, juniper trees as well as a fresh-water habitat and a habitat from the Jordan Valley corridor. When it is complete, this botanical garden will be a paradise for visitors and a considerable help for shepherds, farmers, and their families. This is undoubtedly how Princess Basma sees the future. Seated beside her favorite tree, she reflects, "I have a special place where I like to go at dawn when all is peaceful… And where in the silence, you are alone but never lonely."

(Hillside covered with pines.)

I founded the Royal Botanic Garden because I didn't know the plants of Jordan and wanted a place that could teach me. I saw the destruction of beautiful landscapes, and I realized that the natural habitats of Jordan were disappearing quickly. I felt an urgent need to do something to protect our native plants.

Plants are a gift from God. So many mysteries remain yet to be discovered in nature! We must respect and celebrate our plants, and give ourselves a chance to do research and make discoveries. Allowing for their destruction would be shameful.

It is my hope that all of Jordan will become one great garden to be passed on to future generations. I believe gardening should become a way of life, and then "conservation" will no longer be necessary.

—Her Royal Highness Princess Basma bint Ali

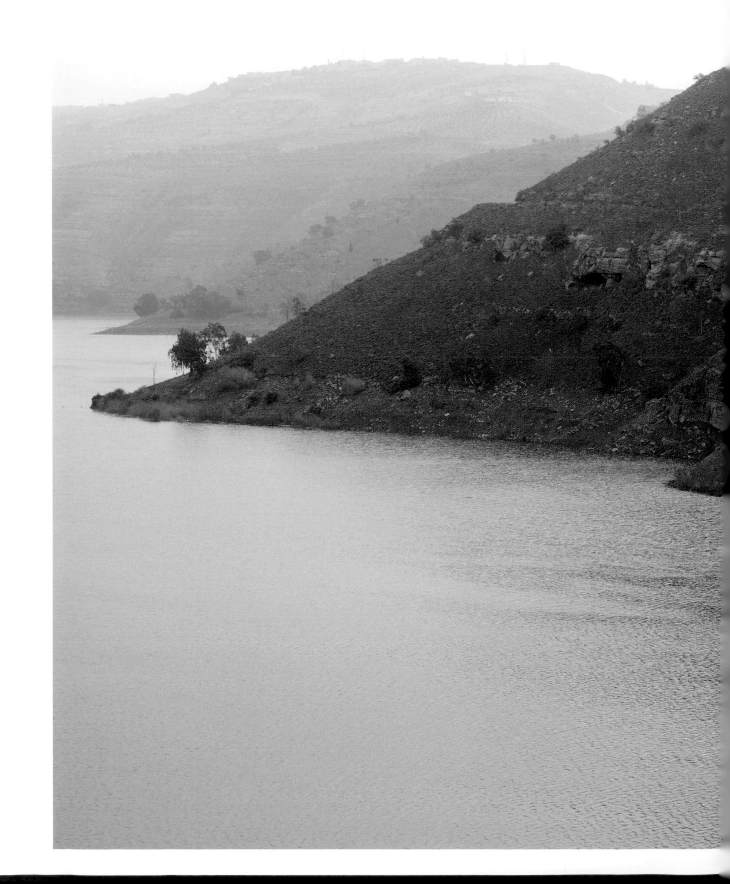

(View of the garden from the north
section of the King Talal Dam.)

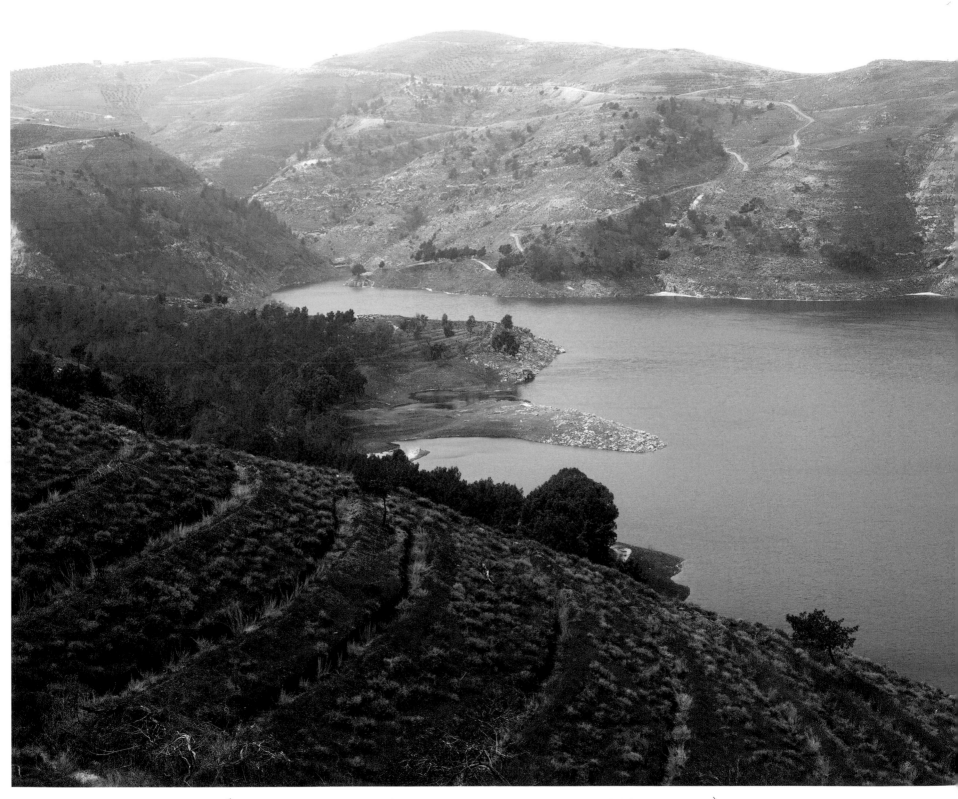

(Water recovery is an important aspect of Princess Basma bint Ali's community rehabilitation program.)

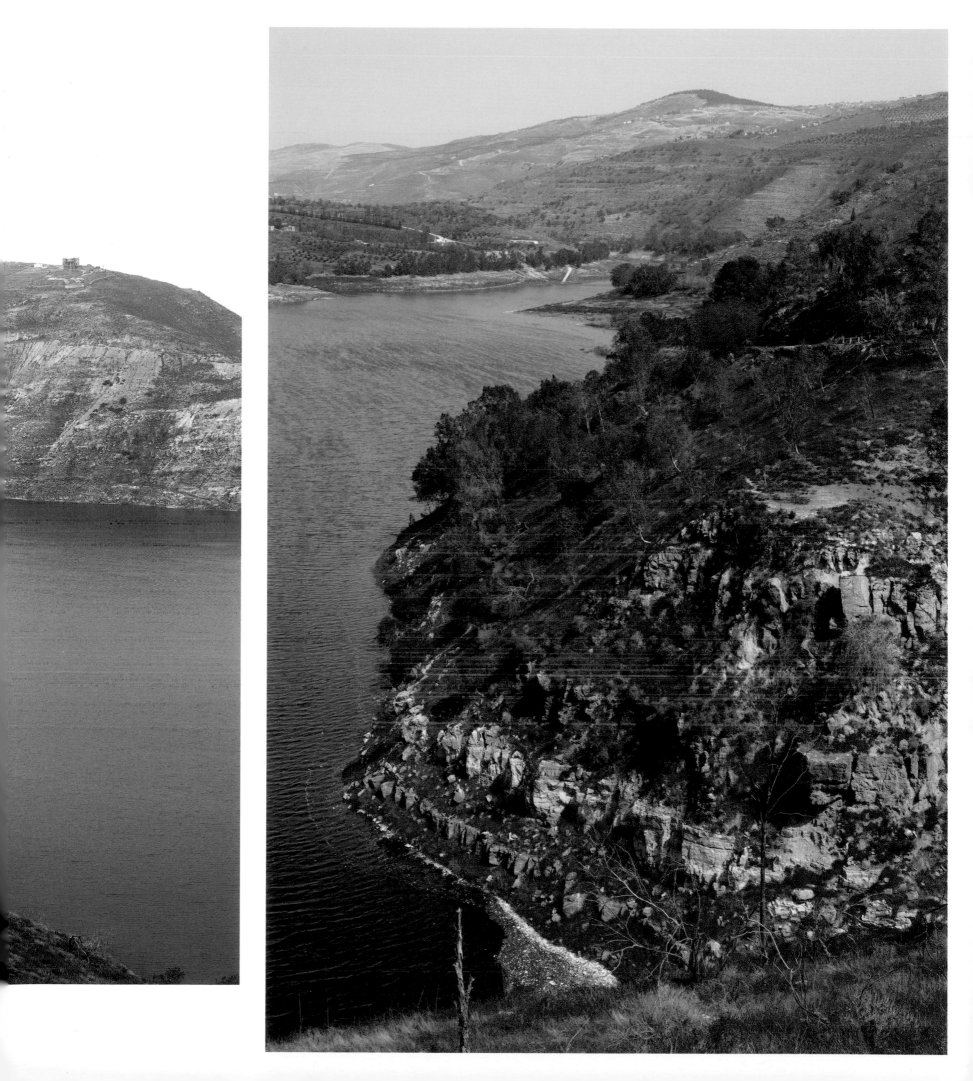

(*Retama raetam*, a bush in the broom tribe, native to North Africa, with white flowers, beside the road.)

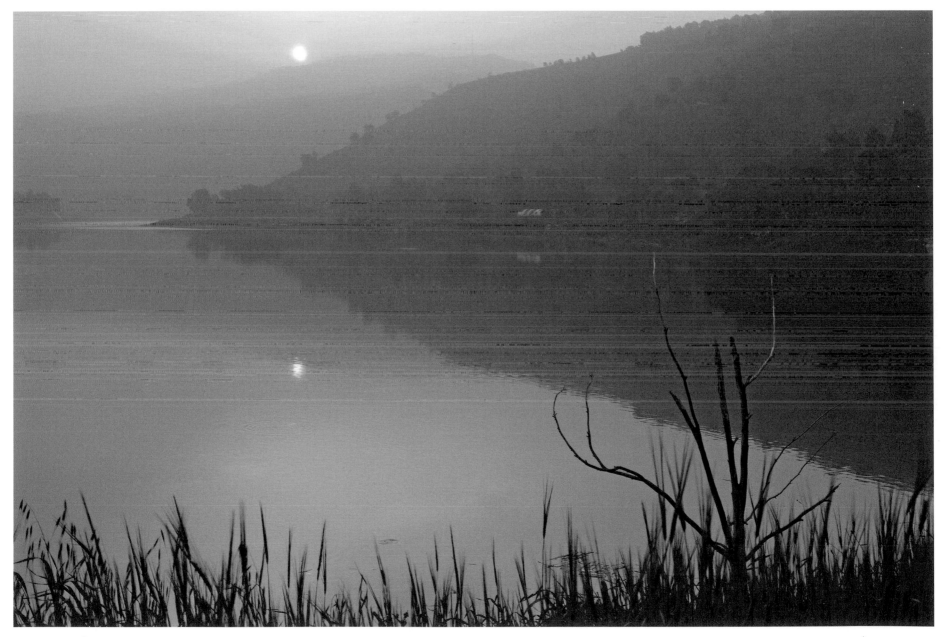

(OVERLEAF In this view of the dam from the top of one of the hills, the dryness of landscape is apparent, underscoring the importance of water conservation for the site.)

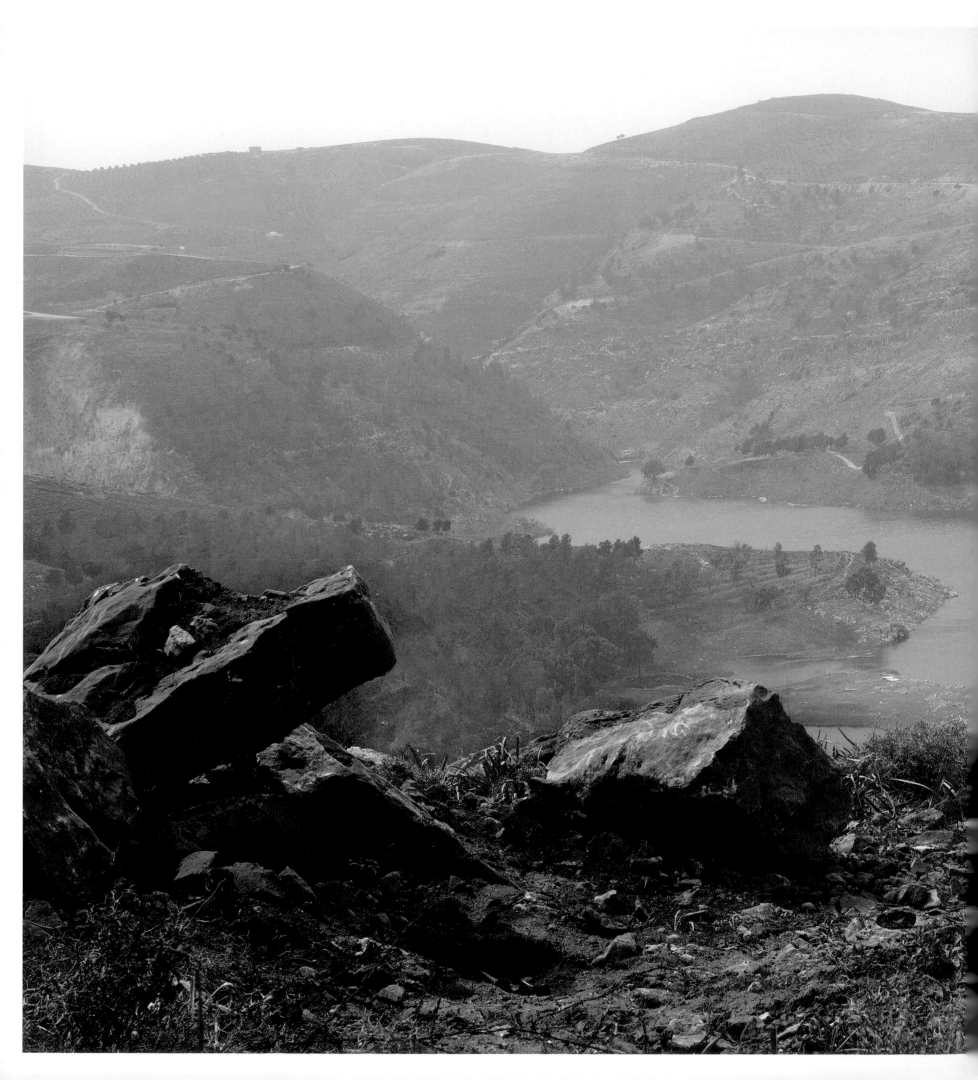

FRANCE

CHENONCEAU

Two Leading Ladies and Their Garden Stage

I N 1547, WHEN DIANE DE POITIERS ARRIVED AT CHENONCEAU, AN ESTATE SHE RECEIVED AS A gift for being a favorite mistress of King Henri II, there was only a vegetable garden here. This was no doubt useful to Katherine Briçonnet and her husband Thomas Bohier, who built the castle, but it lacked a necessary element of grandeur. At the time, Italian gardens were all the rage in the Loire Valley and the Italian style can be seen in many of her renovations. To adorn her new property with spectacular finery, the now Duchess of Valentinois cut pathways through the woods, and installed a hedge maze but focused most of her attention on a field located on the right bank of the Cher River, where she built retaining walls to protect the garden from flooding. It involved considerable work, the majesty of which can still be admired from the tree-lined promenade that is flanked by the two sphinxes as it approaches the castle. The original design remains to this day; eight pathways radiate from a central fountain to delineate eight triangles. Only the plants have changed to reflect today's tastes. Peach, apple, and mulberry trees, strawberries, currants, artichokes, and melons once grew alongside hawthorn and wild hazel, while today cypress trees dot the lawn along with yews, hibiscus, box trees, Japanese spindle trees, laurustinus, and Portuguese laurel.

When Henri II died in a tournament, Diane had to hand over Chenonceau to his widow, Catherine de Médicis, who took over with celebratory panache, holding lavish parties at the estate. Wanting to surpass her rival in opulence, she ordered Bernard Palissy to create a "delectable garden" across the Cher River from Diana's Garden. She had the bridge that spanned the Cher and connected the castle to the gardens covered with a roof. Catherine had cases of orange and lemon trees brought in, and created Italian-style "wonders" with caves, fountains, and follies. Today Catherine's Garden has five grass sections trimmed with flowerbeds around a large circular basin.

Other gardens on the estate include the Flower Garden, which provides the bouquets used to decorate the castle as well as grow the flowers used elsewhere on the grounds, and the Green Garden, which is planted with diverse species of trees. Promenades through the gardens are lit up at night, boat trips are available along the Cher, and the Donkey Park is open to the visitors, all of which make for an enchanting visit, courtesy of the Menier family, who have been taking loving care of this Renaissance jewel for more than sixty years.

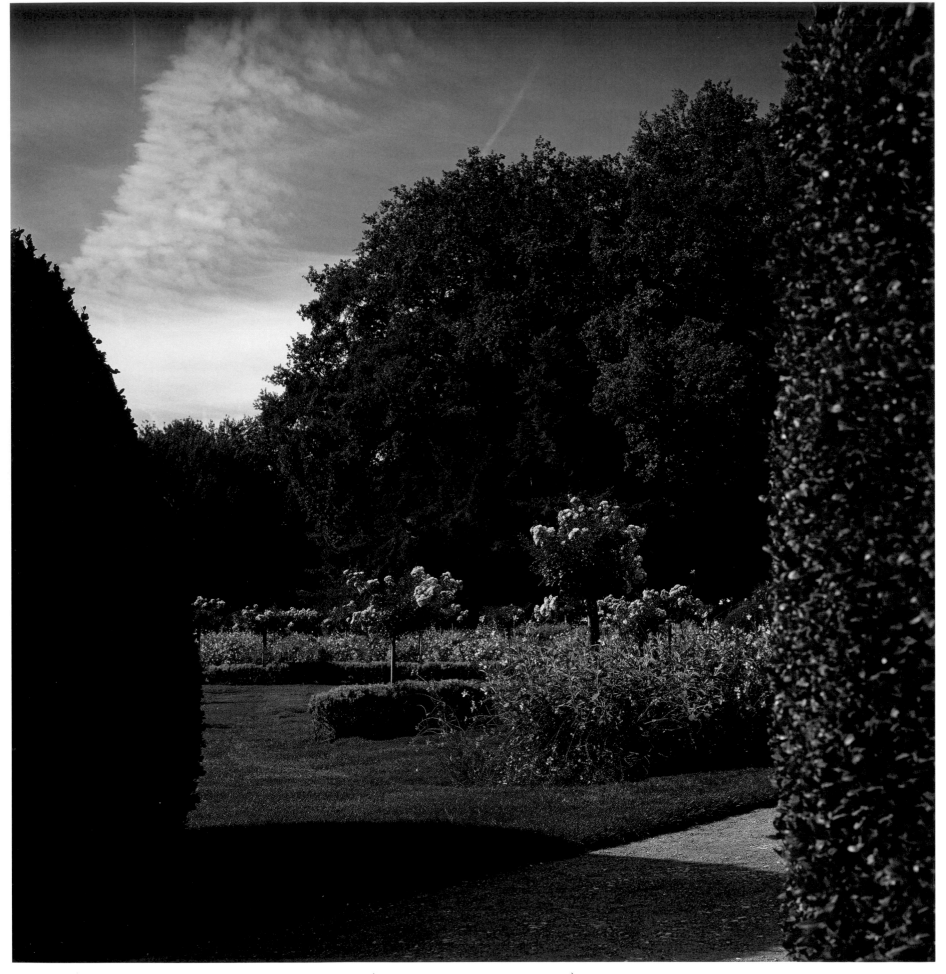

(ABOVE AND OPPOSITE Catherine's Garden.)

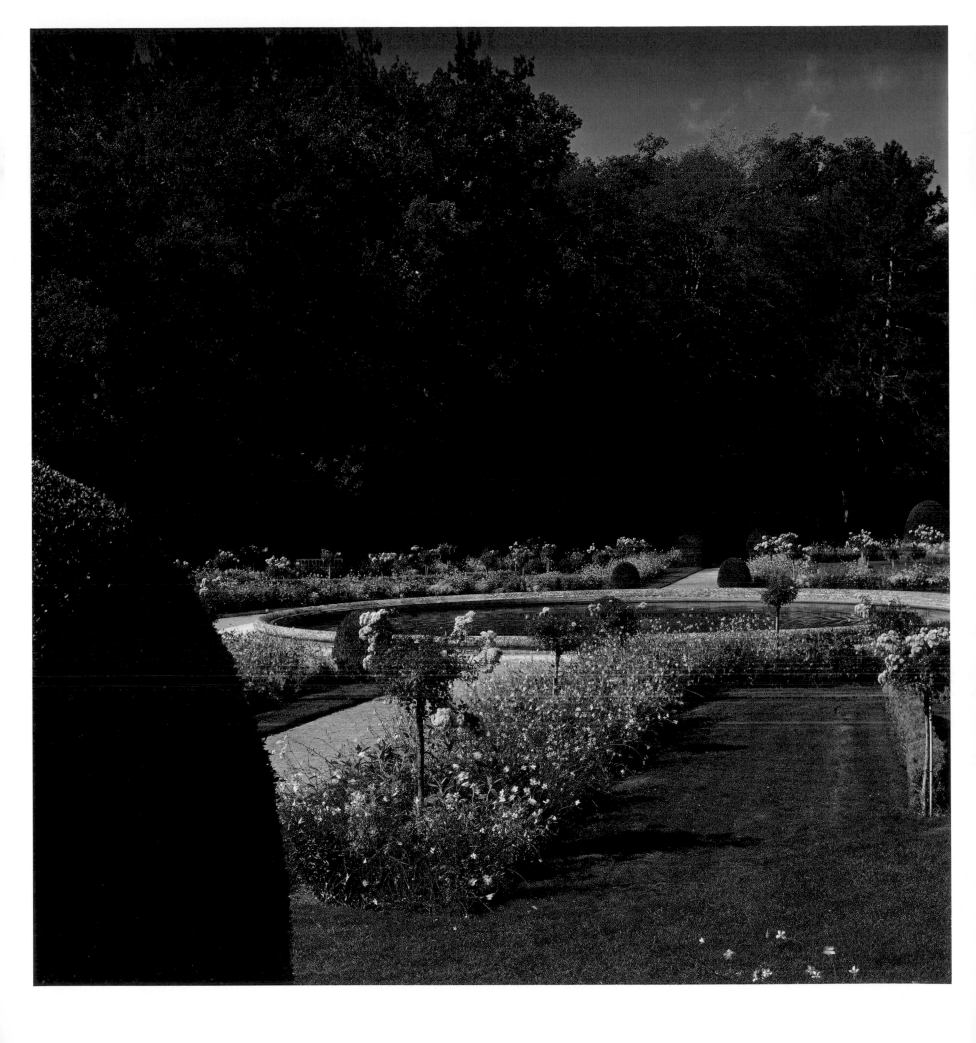

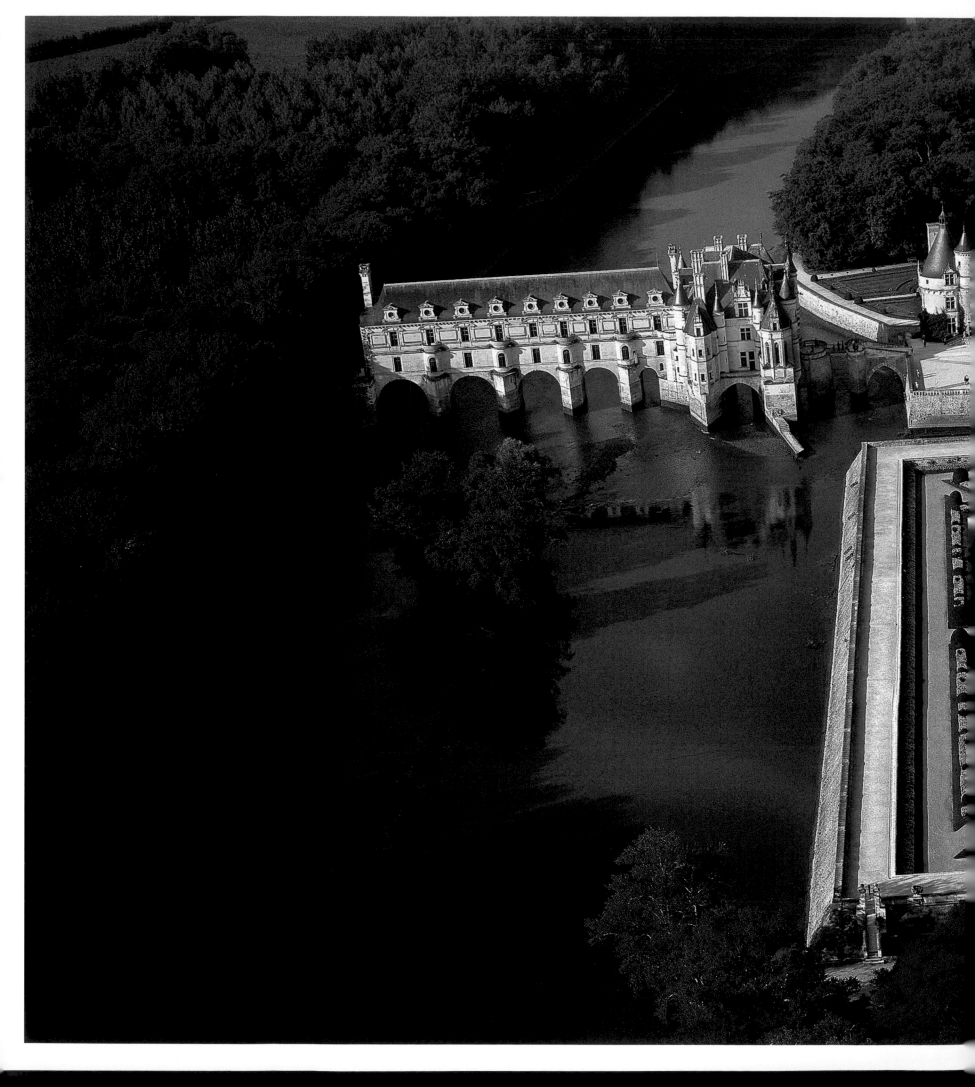

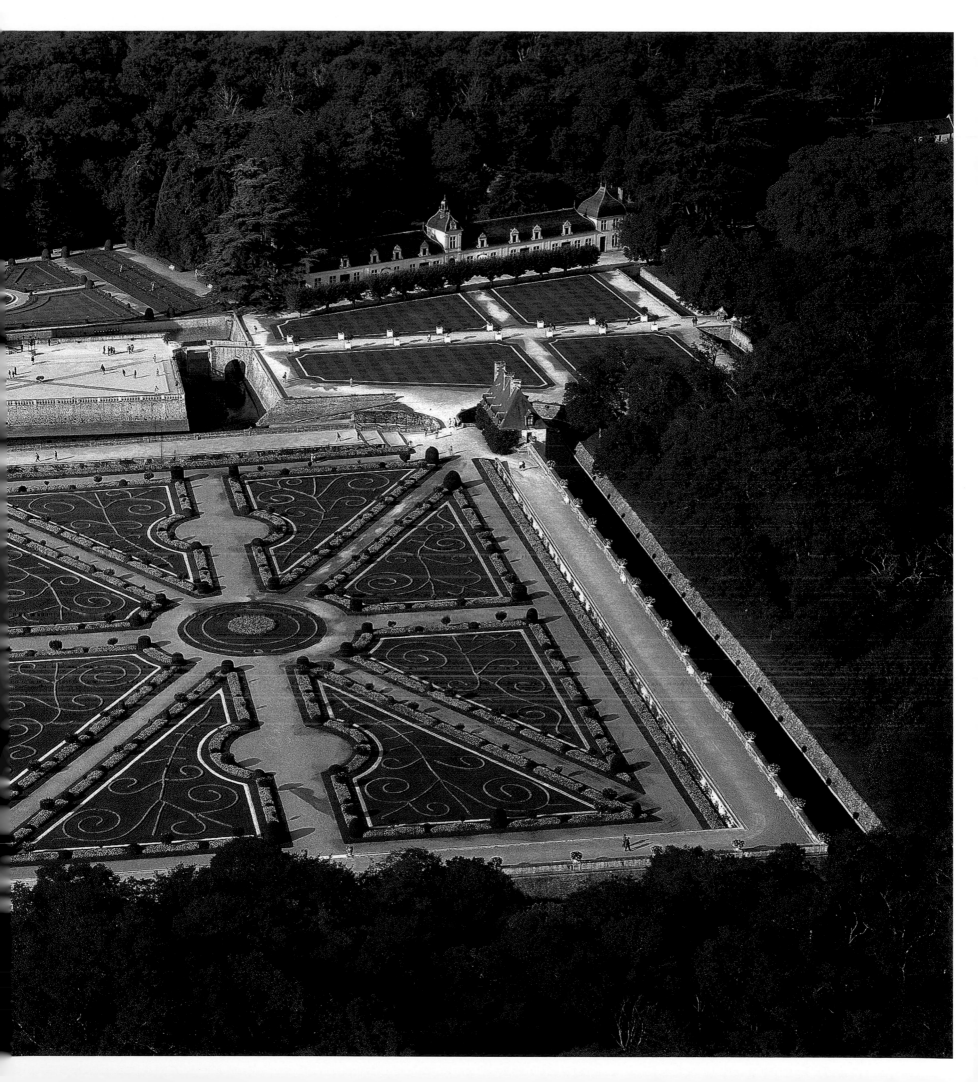

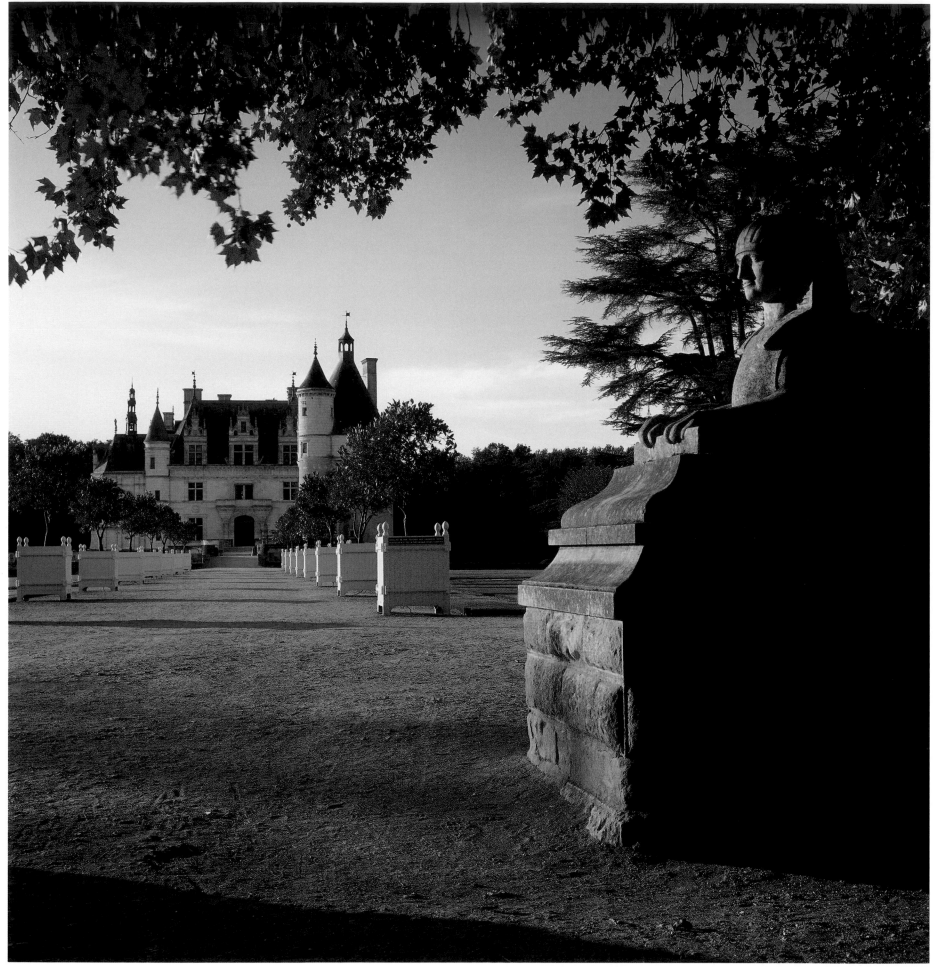

(The entrance of the castle, under the watchful eye of the sphinx.)

In 1547, when Diane de Poitiers arrived at Chenonceau, an estate she received as a gift for being a favorite mistress of King Henri II, there was only a vegetable garden here.

(Diane's Garden.)

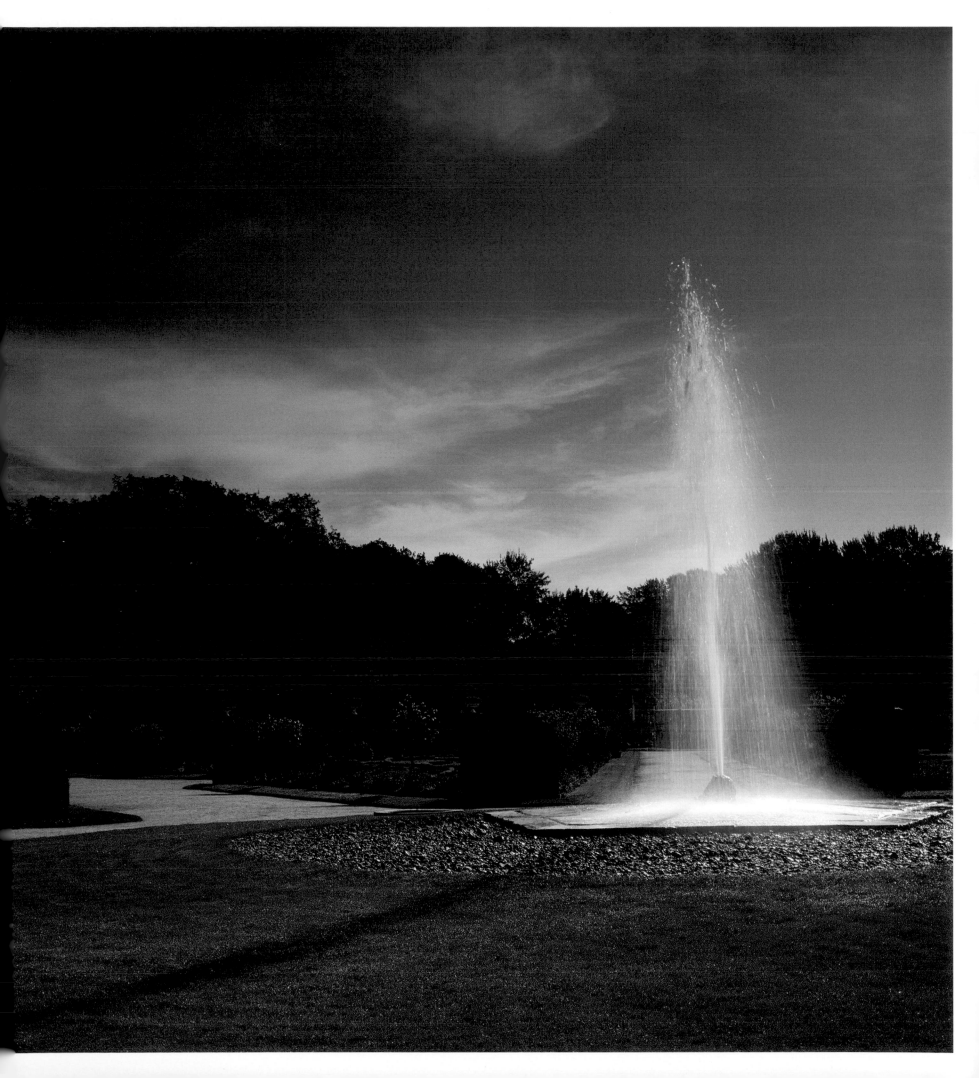

BADIA
A
COLTIBUONO

The Gourmet Estate of Lorenza de' Medici

D ONNA LORENZA DE' MEDICI DEI PRINCIPI DI OTTAJANO, A DESCENDANT OF THE MEDICI family, began her career as food journalist for the magazine *Novitá*, which was later integrated into *Vogue*. In the late 1980s, she began writing cookbooks. As the wife of Piero Stucchi Prinetti, heir to Badia a Coltibuono (Abbey of the Good Harvest) in Tuscany, she could fine-tune her preferred activity, cooking, while her husband developed the estate's wine and olive growing.

In the heart of a site encircled with conifers, at the summit of the highest hill of the Chianti region, this Benedictine abbey was built in 1051 by monks of the Vallombrosan Order. These self-sufficient monks were the first to introduce grapevines to the region. In the fifteenth century, Lorenzo de' Médici became pope, assuring Badia a Coltibuono's patronage and allowing it to have new prosperity. But in 1810, the monks left due to Napoleon's occupation of Tuscany. The abbey was sold by lottery, and later acquired by a Florentine banker, Michele Giuntini, an ancestor of the current owners.

Surrounded by walls, the garden still evokes the medieval *hortus conclusus* (enclosed garden). The transformations brought by the Stucchi family, who bought the abbey in 1846, and the work of Lorenza have changed it into a pleasure garden without disturbing its first purposes: self-sufficiency and meditation. A beautiful view of the garden can be seen from the terrace, which is shaded by a large *Magnolia grandiflora* and adorned with wisteria, a profusion of yellow Banksia roses, and a row of lemon trees planted in ancient pots. Down below, a parterre of geometric box-tree hedges surrounding a central basin reflects the style of an Italian garden. Pergolas covered with vines separate the basin from other parts of the garden, including a space planted with flowering bushes. The building, renovated in 1973 by the celebrated architect Franco Albini, has an enchanting exterior from spring to autumn when its ivy covering takes on shades of scarlet. The vegetable garden, which Lorenza laid out in triangles and squares and surrounded with aromatic plants as the monks had done, abounds with the fruits of the season and perfumed herbs that are used in traditional and delicious Italian recipes. Today, the estate is managed by Lorenza's children. A restaurant, presided over by a Tuscan chef, offers dishes that pair with the organically grown wine and olive oil from the estate. The abbey is a magical place where time seems to stand still, permeated by the feeling of a quiet monastic life that takes its time to embrace life's sweetness.

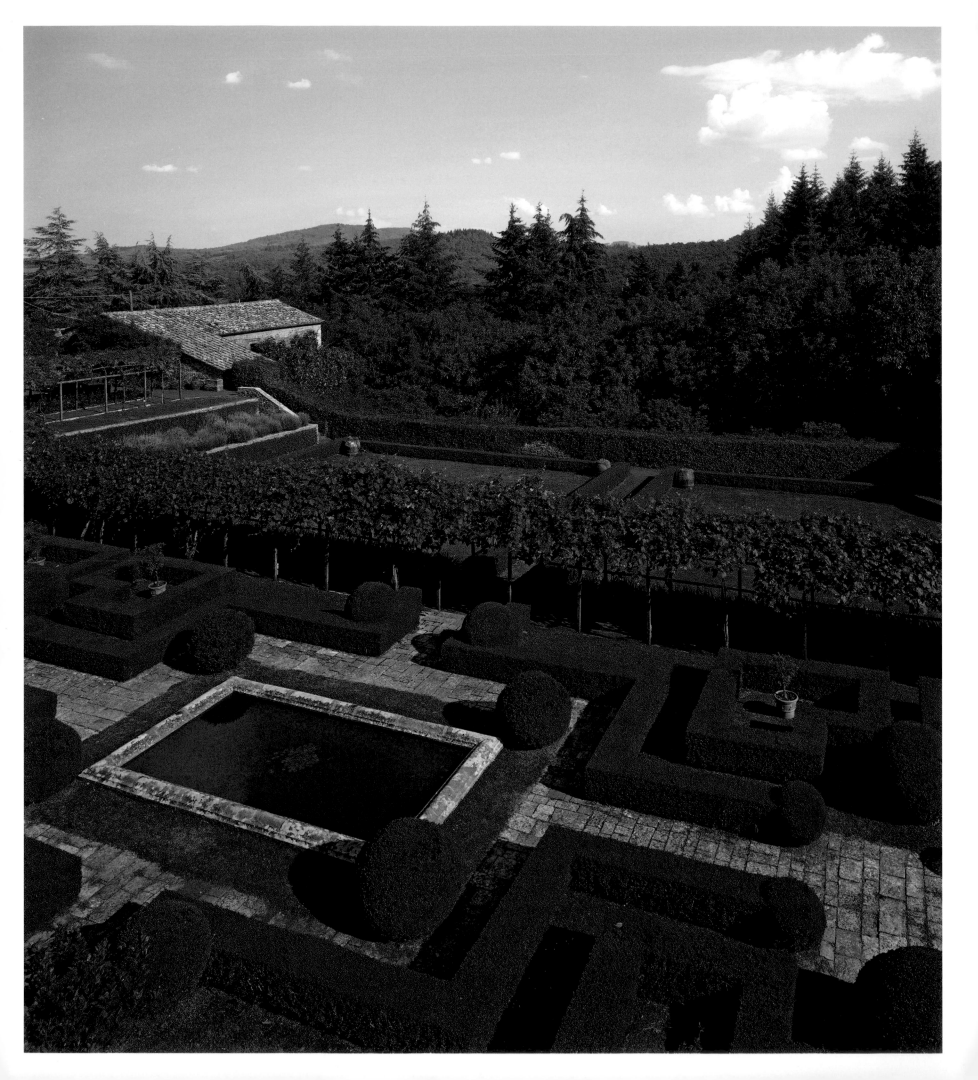

Years ago, when for the first time, I climbed the winding roads that lead to Badia a Coltibuono, I was breathless, bowled over by the extraordinary charm of the abbey, which is surrounded by an incredible grove of fir trees. When I arrived at the abbey, I was captivated by its bell tower, wall, courtyards, its long hallway lined with the monks' cells, the frescos in the refectory, and the fascinating garden with a pergola—a real hortus conclusus *[enclosed garden] of the Renaissance. As described by an abbot in 1492, it produced cabbage, leeks, lettuce, and grapes that were intended for consumption and not for the production of wine. The* hortus conclusus *has remained the same, encircled by walls that hide the view of the valley. It is a charming place where a visitor is easily tempted to take a walk, read, meditate, or simply to contemplate the beauty of the place.*

After some years spent as a gardener's apprentice alongside my mother-in-law, who was an expert in the field, I have started to leave my footprint, particularly with the small path at the entrance surrounded by white hydrangeas, a field with a mix of rose bushes and peonies, a long access terrace covered with yellow Banksia roses (which form a compact wall at the end of spring), and a small lush vegetable garden that exudes the aromas of typical Mediterranean herbs such as basil, mint, parsley, tarragon, sage, and rosemary. I realized as the years passed that this is both a lovely flower garden in summer and a very nice place to be in winter, thanks to the restoration of the house in the 1970s, by the architect Franco Albini, when heating was installed. We really enjoy coming here at Christmas and Easter with the children and their friends as much as we do in summer. For more than forty years, the year has ended with a concert followed by a dinner in the garden. This concert, which has become an event we look forward to, is given by members of Berlin's renowned philharmonic orchestra. Like all the rest of us, they are attracted as much by the wine and olive oil as they are by the very special charm of this place that I am privileged to be a part of.

—Lorenza de' Medici

(View of the Italian garden from one of the abbey's bedrooms.)

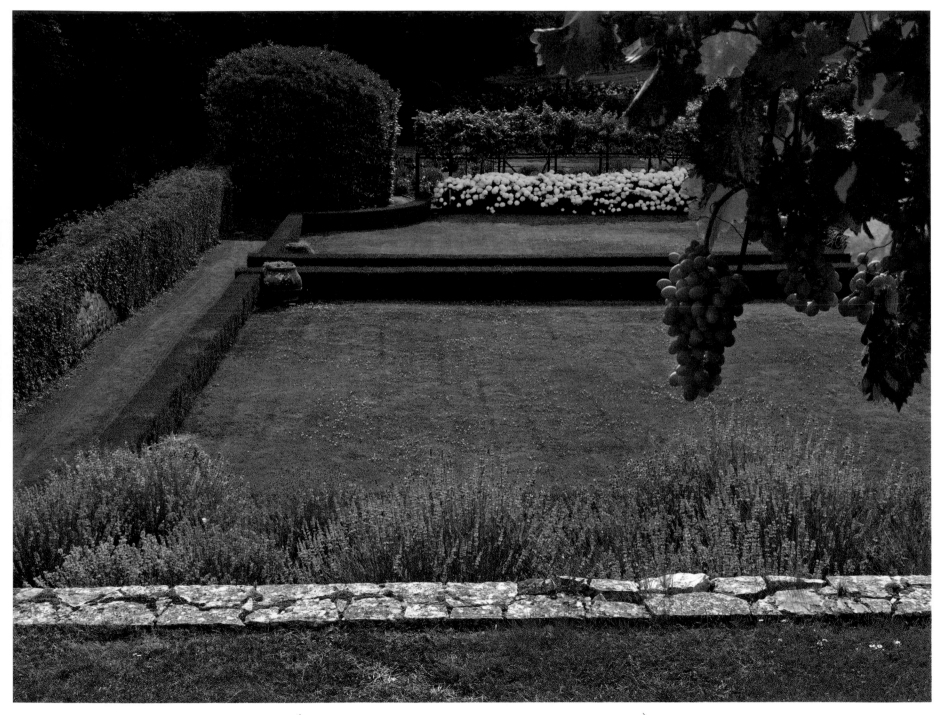

(Terrace trimmed with lavender; in the background, a row of hydrangeas.)

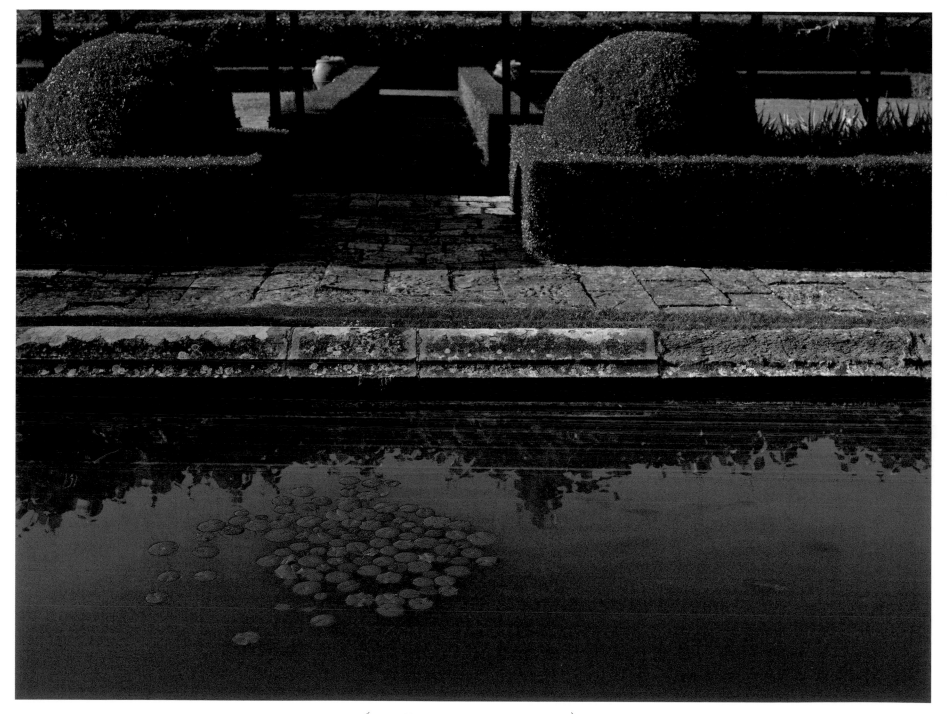

(Central basin filled with fish and lily pads.)

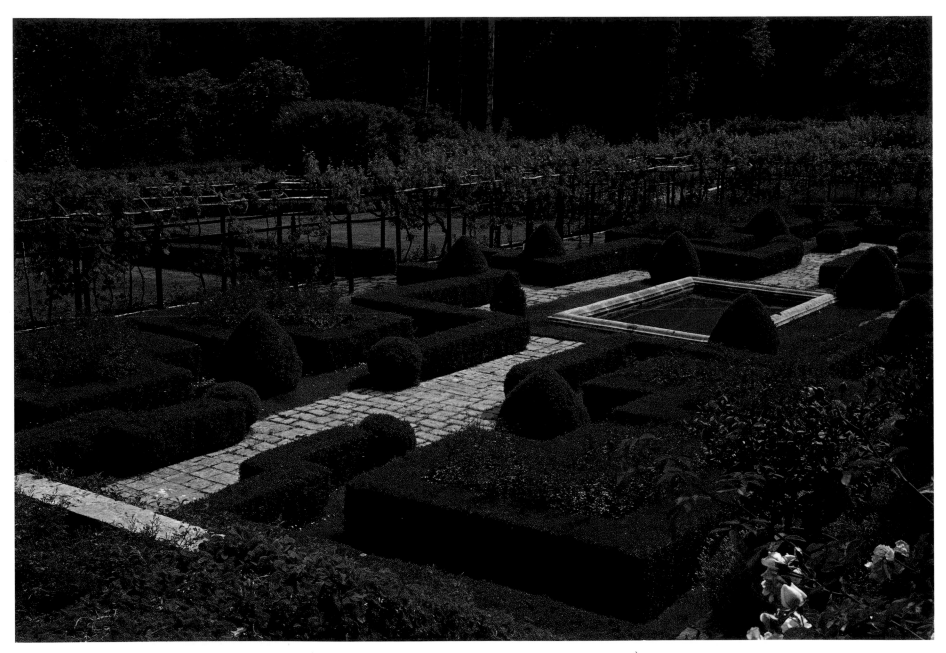

(The Italian garden and its wild rose bushes between the box hedges.)

(Vegetable garden with a forest of fir trees in the background.)

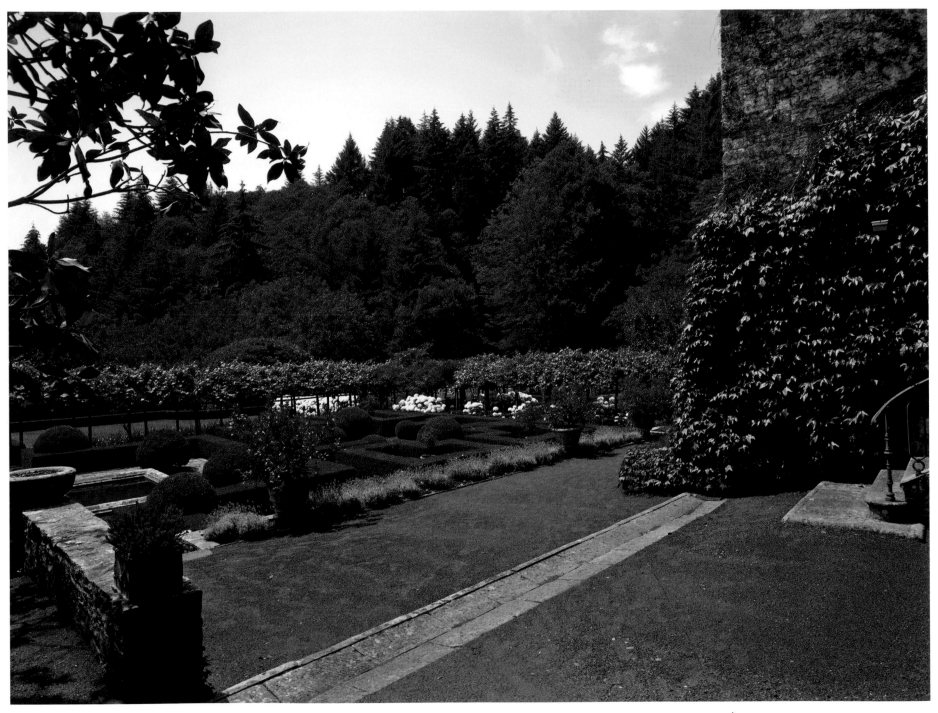

(Lavender and lemon trees in pots along the terrace and portion of the abbey wall covered with Virginia creeper.)

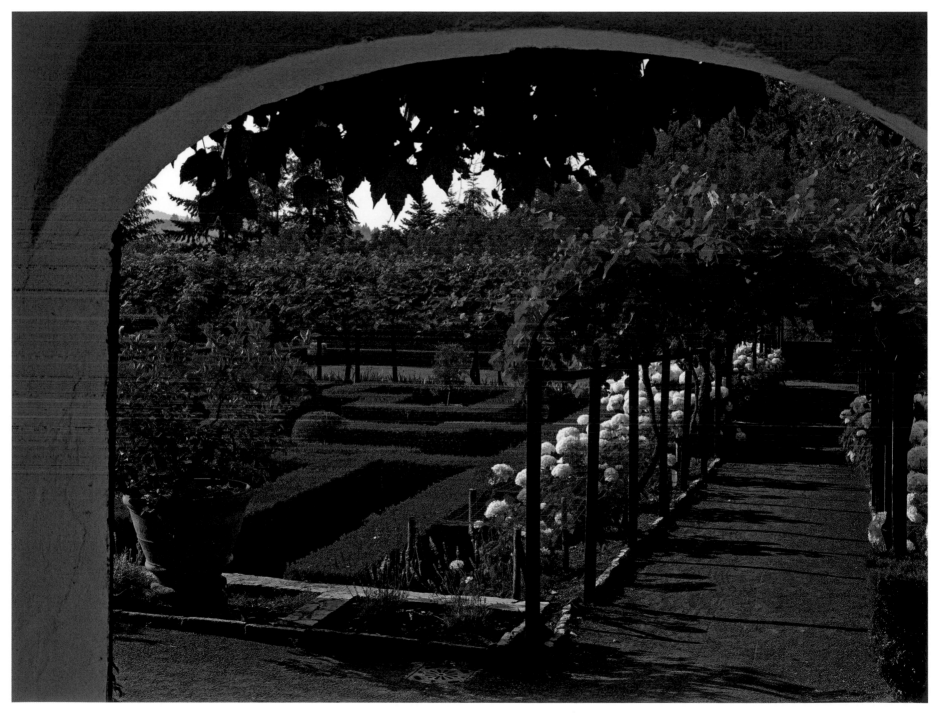

(Entrance to the garden from the courtyard.)

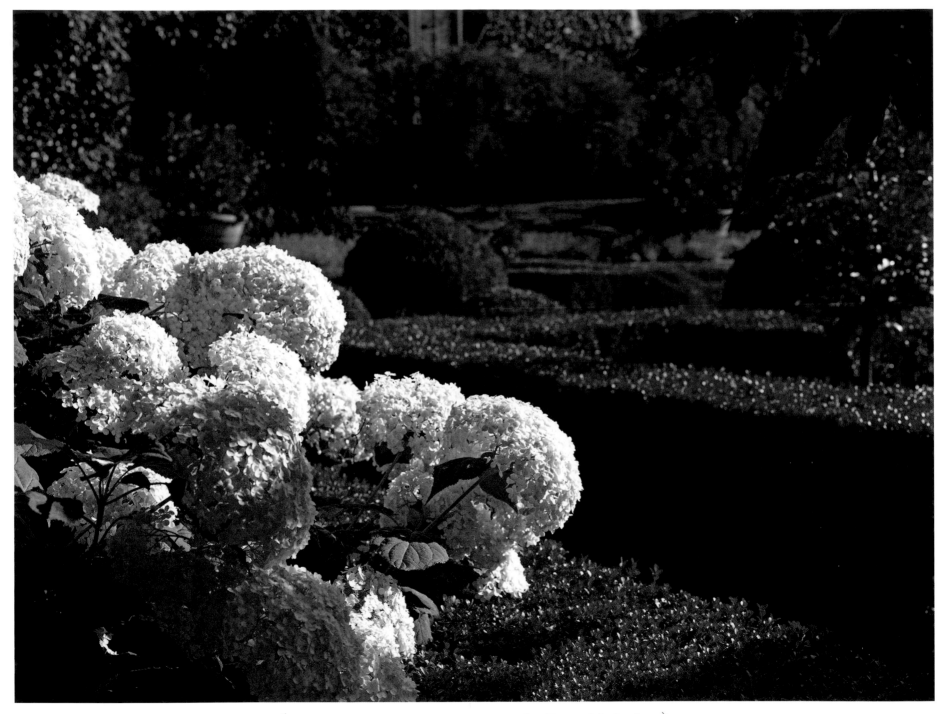

("Annabelle" hydrangeas turn bright green in the fall and last until the first frost.)

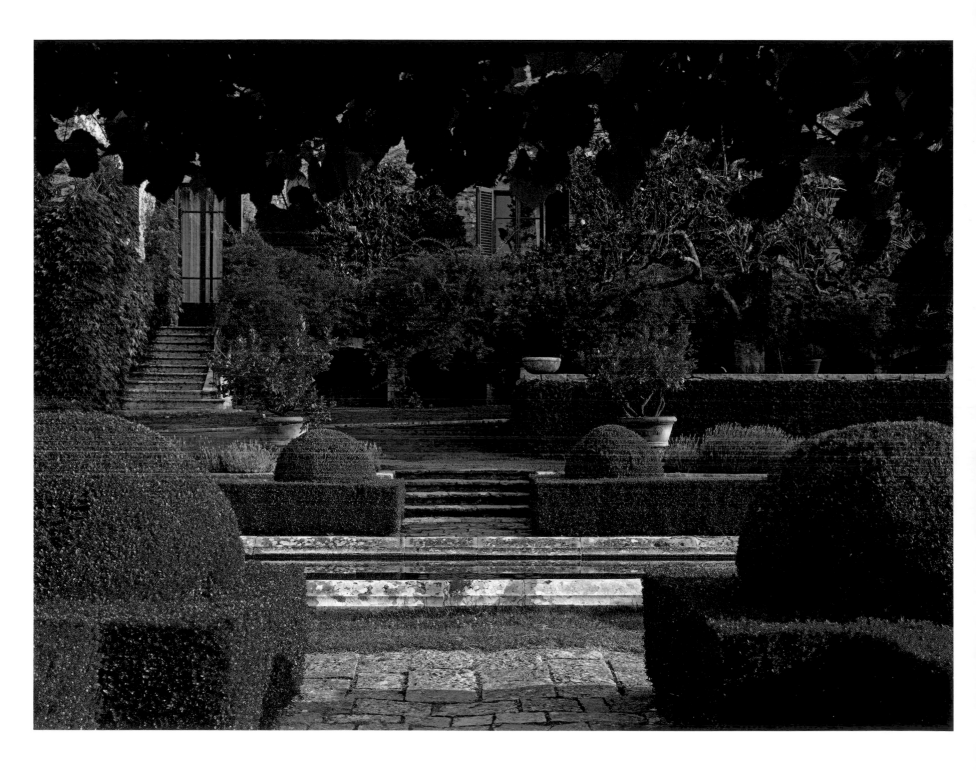

SPAIN

LA GRANJA
DE
SAN ILDEFONSO

The Fountain-Filled Retreat of Philip V of Spain

A STEEP TERRAIN, FORESTS, WATER FOR FOUNTAINS—THE GRANDSON OF LOUIS XIV HAD A spectacular landscape with the necessary elements to re-interpret the gardens of Versailles outside of Segovia, Spain. But the story of this garden in the foothills of the Sierra de Guadarrama began simply and centuries earlier. In 1450, King Henry IV had a hunting lodge built there and a hermitage dedicated to Saint Ildefonsus who had, in his mind, saved him from a wild boar during a hunt. The premises were enlarged by monks from the Order of Saint Jerome who added a farm, La Granja. This feature is what later attracted Philip V, the first Spanish king of the Bourbon Dynasty to the spot. He purchased it from the monks in 1720 with the plans to build a retreat.

Work on the Royal Palace and its gardens began in 1721 and lasted for twenty years. This beautiful location would become the summer residence of his successors. For the garden, the French architect René Carlier, and later Didier Marchand, and the gardener Etienne Boutelou had to conform their work to the topographical features of the terrain. According to Saint Simon, who visited the site in 1722, "Picks had to be used, and quite frequently gun powder, to excavate all the water basins and decorative pools, holes for all the trees, trenches for the fences, and all the earth for the planting beds."

The result was worth the investment, and its magnificence can still be seen on the rare days when all the fountains are active. Looking between the sphinx and the cupids bordering the façade of the palace reveals a wonderful view of the Grand Cascade of multicolored marble and its eleven fountains— Amphitrite and the Three Graces among others. Visitors can climb a small, nearby hill adorned with a baroque-style music pavilion and cross parterres and groves to arrive at a lake called the Sea, which serves as a reservoir for the fountains.

To the left of the Grand Cascade is a sequence of terraced fountains; the Horse Race Basin, containing the fountains of the Fan, the Snails, Neptune, Apollo, and Andromeda; and next to that is a maze. To the right, a network of pathways cut in right angles leading to still more fountains including the Frog Fountain, which is a variation on the Bassin de Latone at Versailles, followed by the Bath of Diana. Returning to the castle, to the west, a parterre of trimmed shrubs surround the Fountain of Fame, where the jets trumpet water over 120 feet into the air. This is the garden's highest water jet, and it can be seen from Segovia, almost 8 miles away!

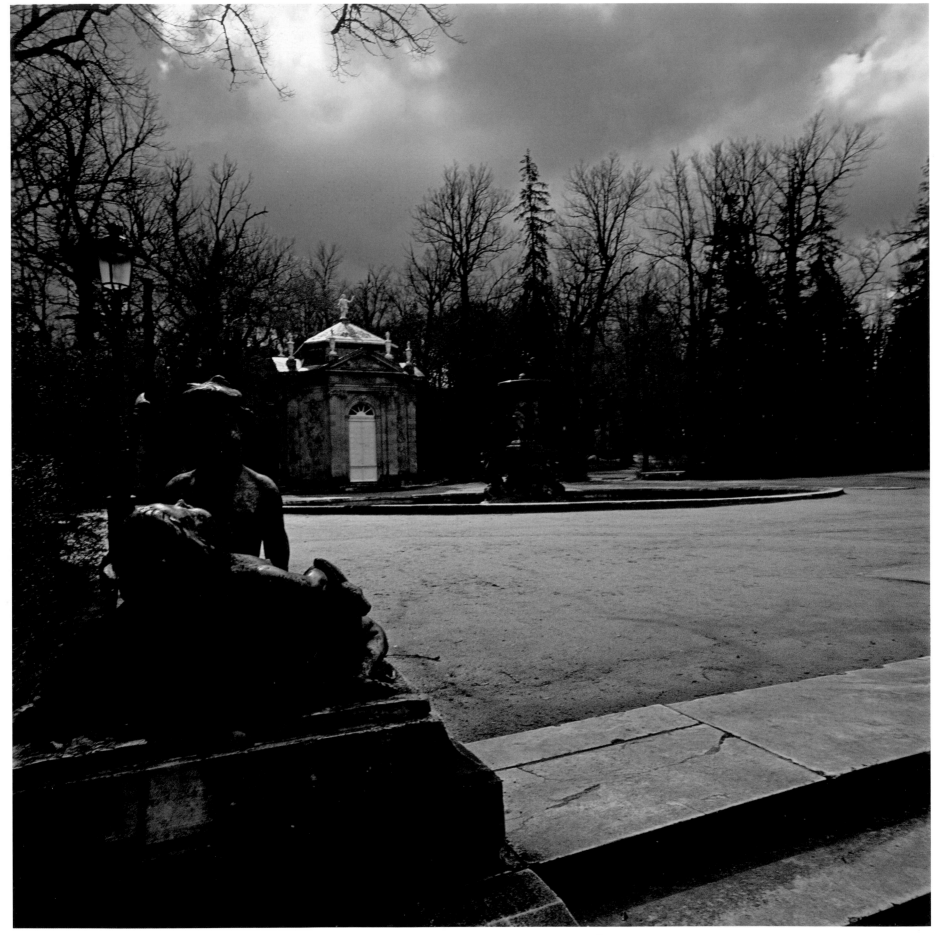

(Music Pavilion and the Fountain of the Three Graces.)

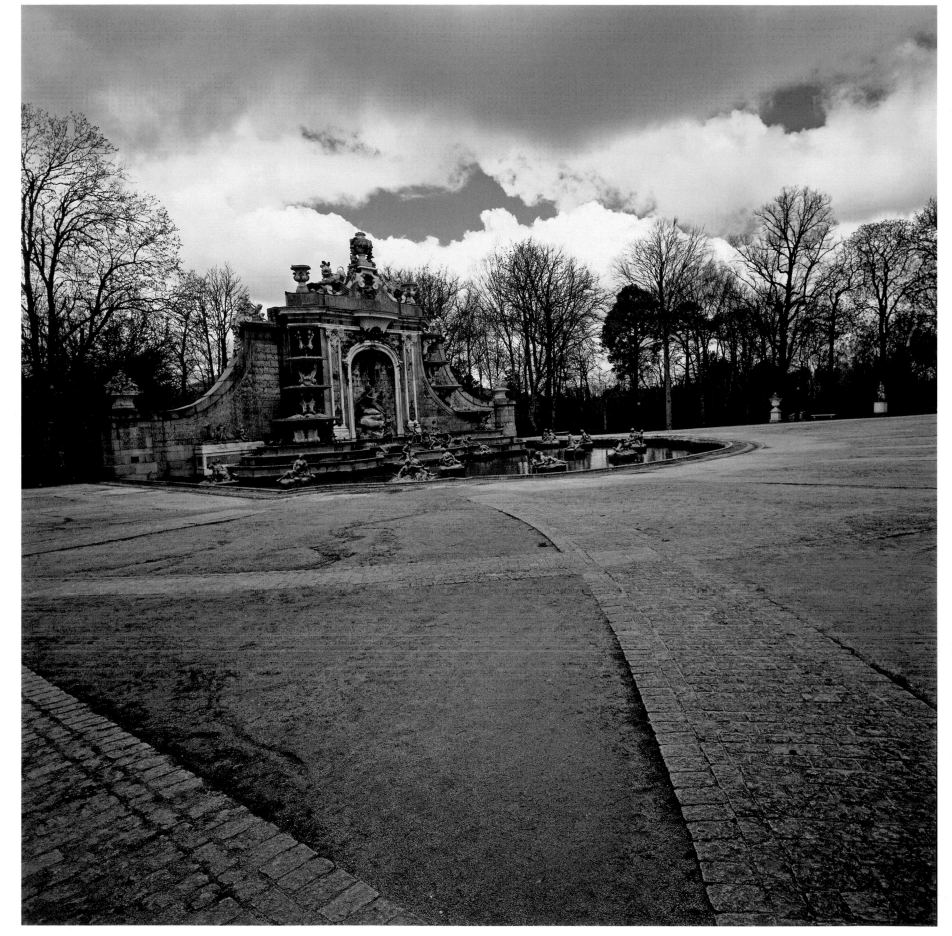

(The Bath of Diana.)

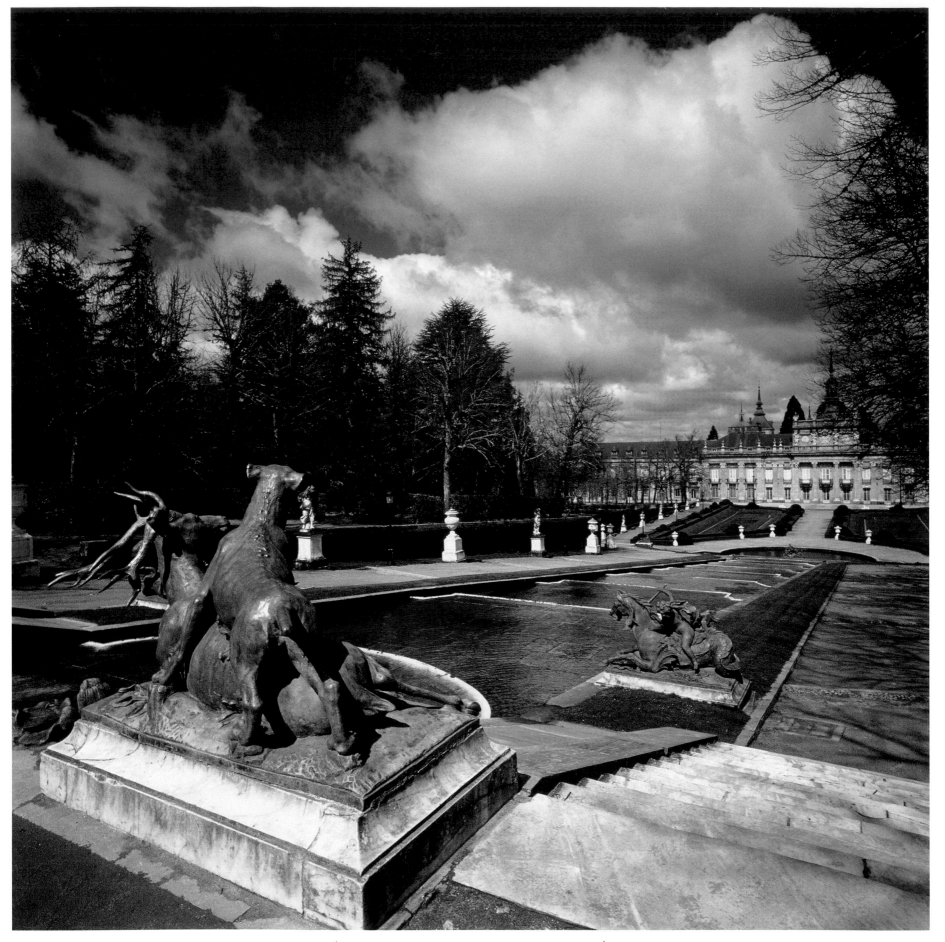

(The multicolored marble steps of the Cascade Fountain.)

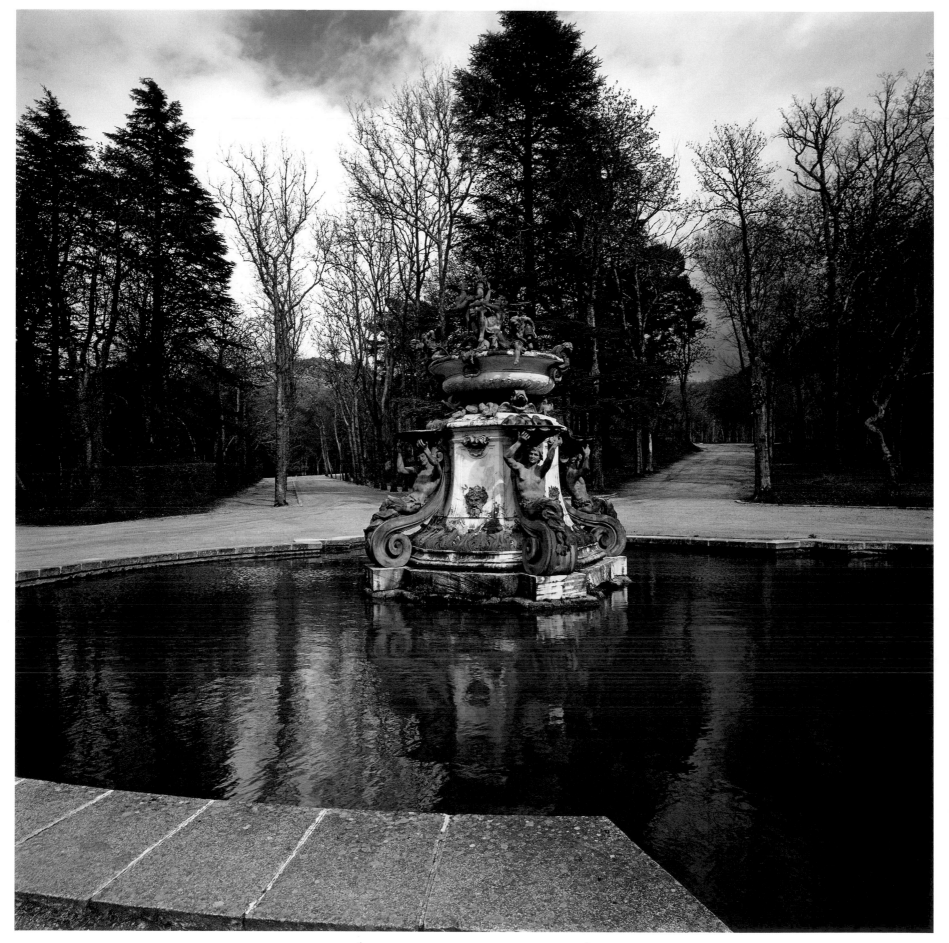

(Fountain at the intersection of the radial paths.)

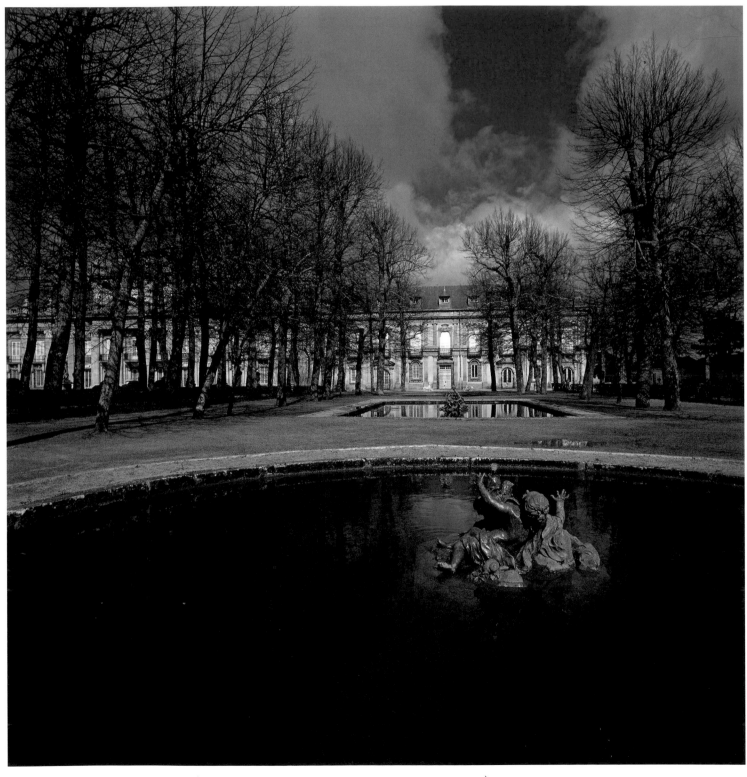

〔 Decorative pools along the secondary axis, facing the palace. 〕

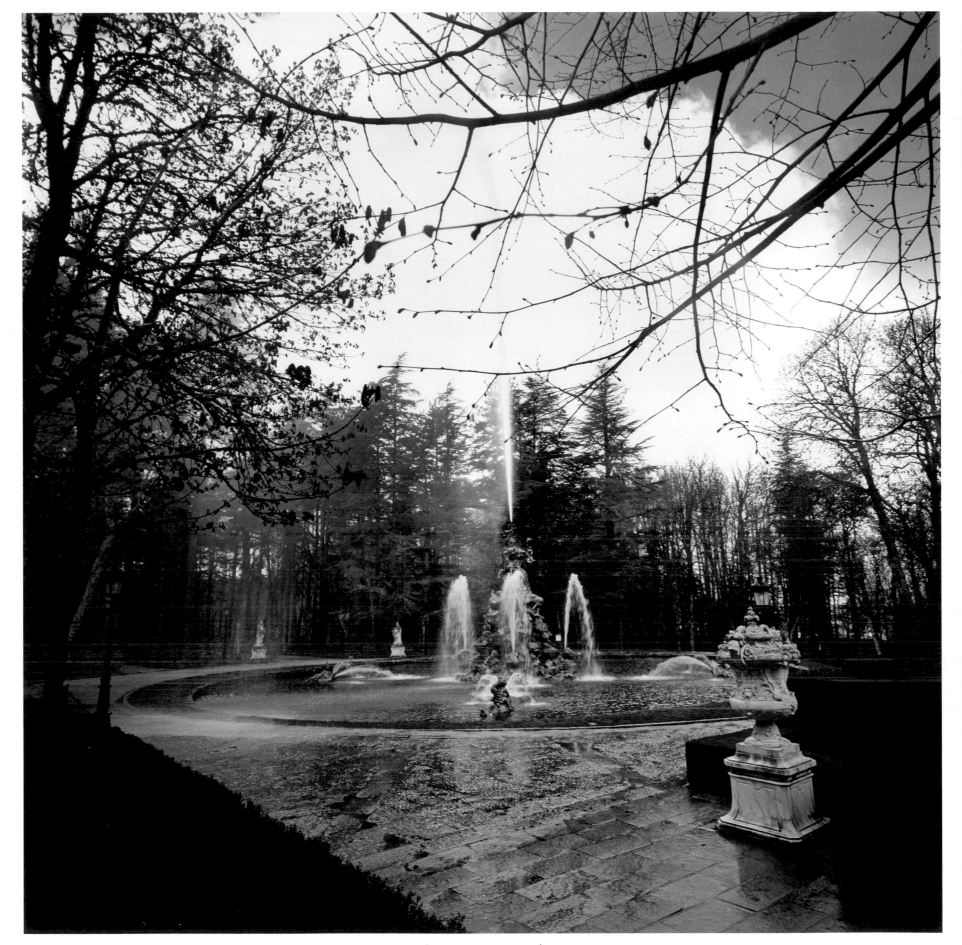

⟨ The Fountain of Fame. ⟩

FRANCE

PALACE
OF
VERSAILLES

The Dream of Louis XIV Brought to Life

M ANIÈRE DE MONTRER LES JARDINS DE VERSAILLES IS A GUIDEBOOK FOR THE PALACE gardens by Louis XIV. There were six versions made, some written by hand by the king himself. This underscores the importance the king attached to his gardens, which were intended for prestigious visitors such as the queen of England and ambassadors from Siam, Morocco, or Persia. The royal itinerary proposed a tour that allowed the fountain workers to display the full splendor of the dancing waters to corteges of passing dignitaries—a fairy-tale setting and a privilege enjoyed by courtiers!

The garden we see today is very much the same as the original garden designed by André Le Nôtre in 1662. A main axis from the center of the castle façade passes through the Water Parterres down the steps to the Latona Fountain, through the band of grass of the Tapis Vert (green carpet), and leads to the Apollo Fountain, the Grand Canal, and the park's East Gate. A transversal axis leads back to the Water Parterres, and ends at Neptune Fountain and the Pièce d'Eau des Suisses (Swiss Ornamental Lake). Secondary axes form a grid of more secret sectors of woods, bordered by trellises and hornbeam hedges. The Grand Canal also has a transversal branch whose extremities connect to the former Royal Menagerie and the Grand Trianon. At the crossings of secondary lanes, fountains dedicated to the seasons play out the myths of Bacchus, Saturn, Flora, and Ceres.

Groves, fragile creations subject to the caprices of style, have often been changed. Of the works of Le Nôtre, the open-air Cascade Ballroom, or Rocaille Grove, is the closest to its original state with its water staircase of rocaille encrusted with lapis lazuli and seashells brought back by sailors from their expeditions. The Enceladus Grove shines with all its gold on a background created by large trellises, and the Grove of the Three Fountains, which was created in 1677, was returned to its original state in 2005. As for the old Springs Grove, it was replaced in 1685 by a colonnade by Jules Hardouin-Mansart.

In the grotto imagined by Hubert Robert in 1776, you'll find François Grardon's most famous work, *Apollon servi par les Nymphes* (Apollo Tended by the Nymphs), which is impressive in its intricacy even today. Starting in fall of 2014, visitors will be able to see the Water Theater Grove reinterpreted by the landscape designer Louis Benech and the artist Jean-Michel Othoniel. Othoniel's sculptures of Murano glass beads are directly inspired by the ballets performed by Louis XIV, who loved to dance.

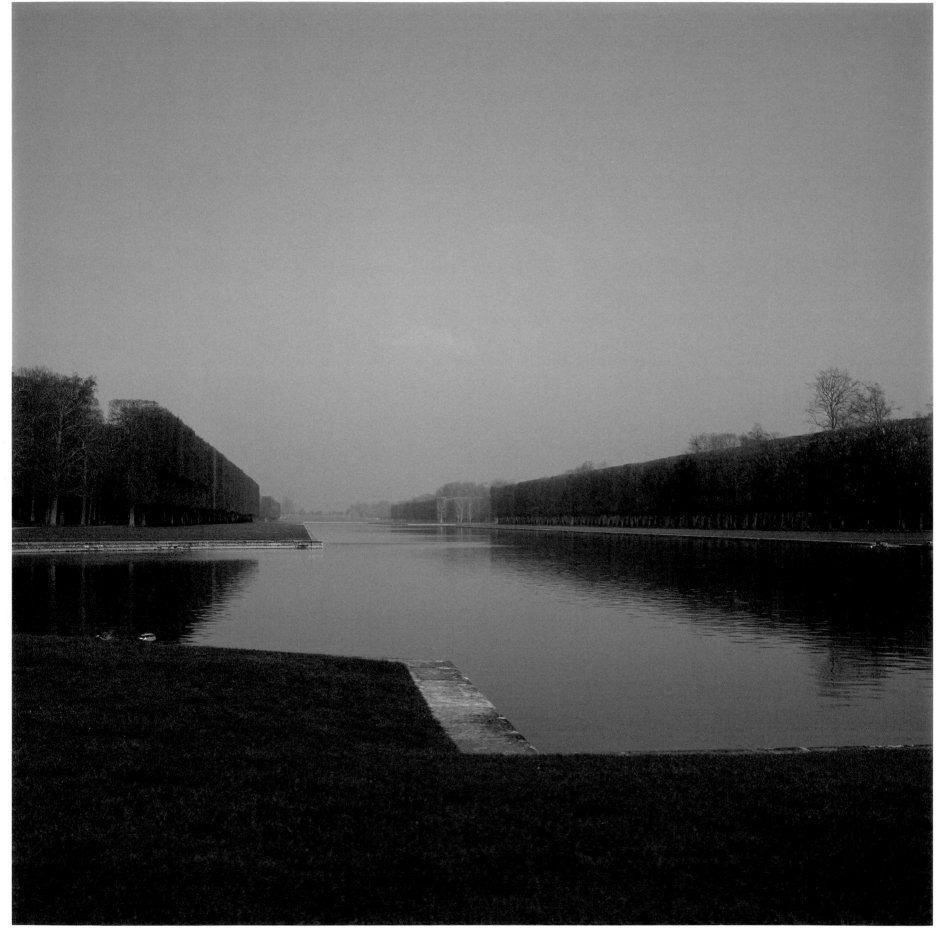

(The Grand Canal.)

Leaving the castle through the vestibule of the Marble Courtyard, going out on the terrace; you have to stop at the top of the steps to consider the layout of parterres, decorative pools, and the fountains. . . Next you have to climb straight to the top of Latona [Fountain] and rest to take in the Latona, lizards, ramps, statues, Royal Path, Apollo, canal, and then turn to see the parterre and the castle.

—Louis XIV

from his guidebook to the gardens

Manière de Montres Les Jardins de Versailles

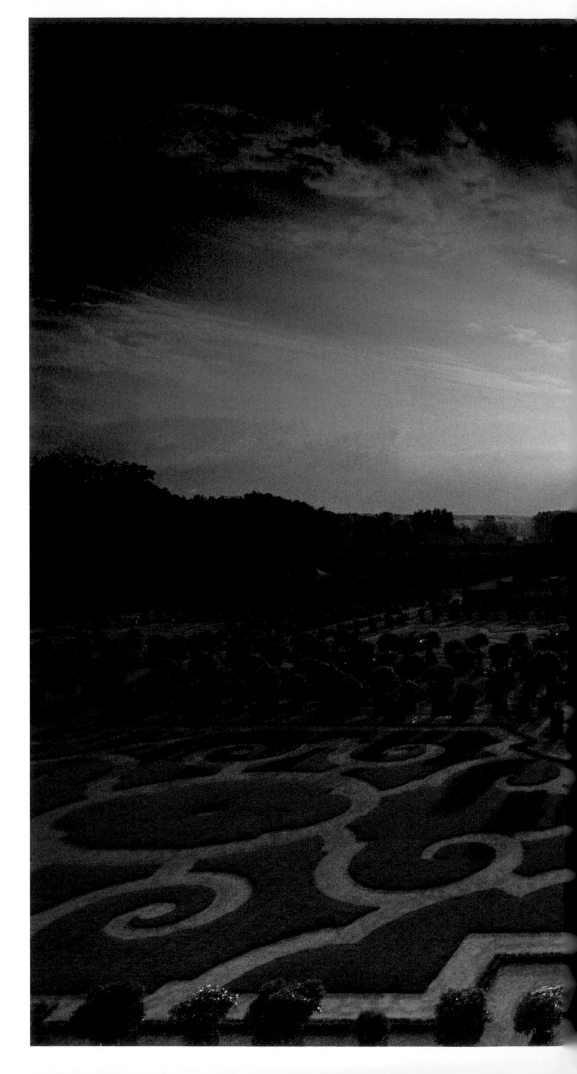

(Orangerie Parterre before a thunderstorm.)

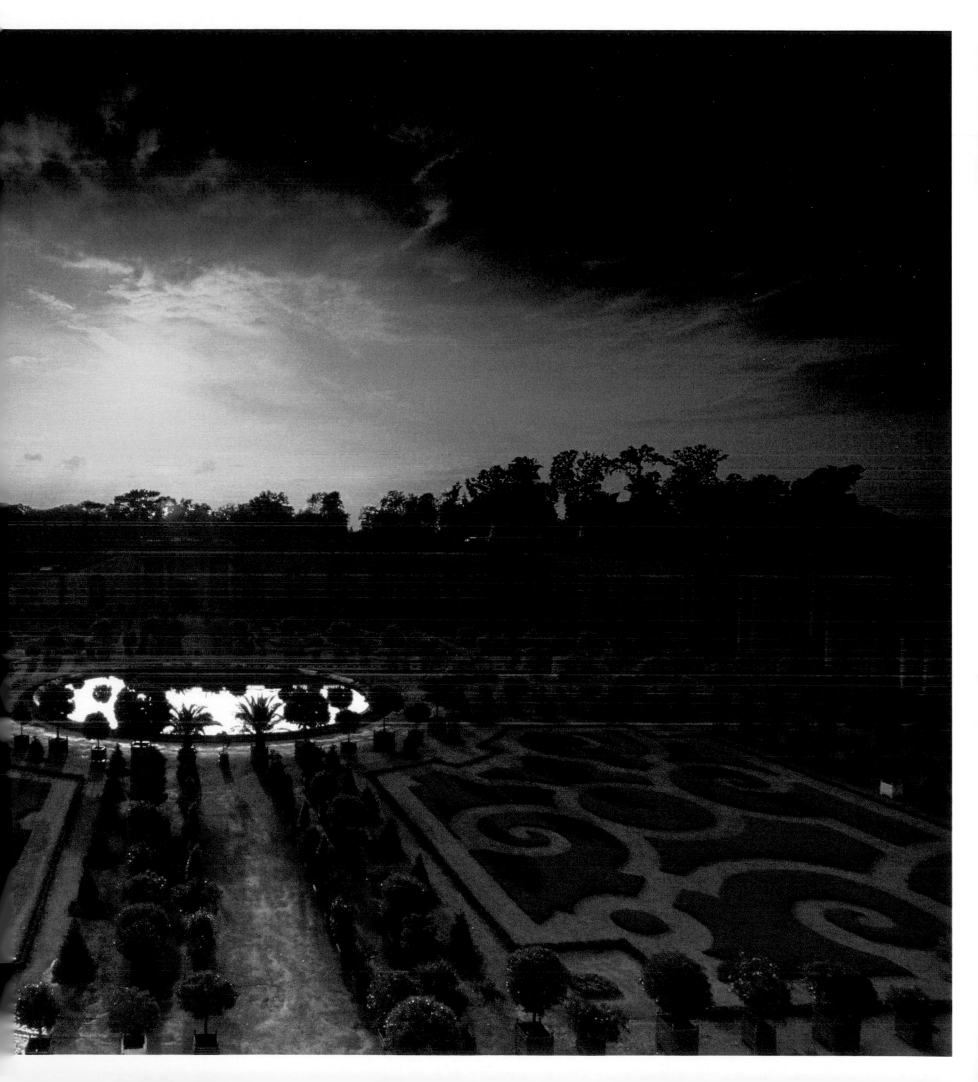

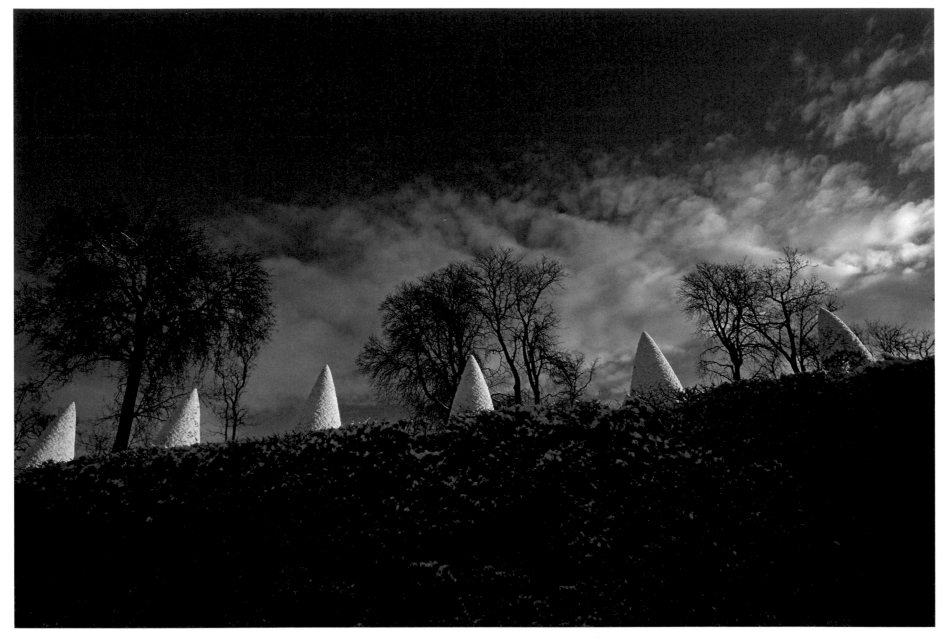

(Topiary just beyond the Latona Fountain in winter.)

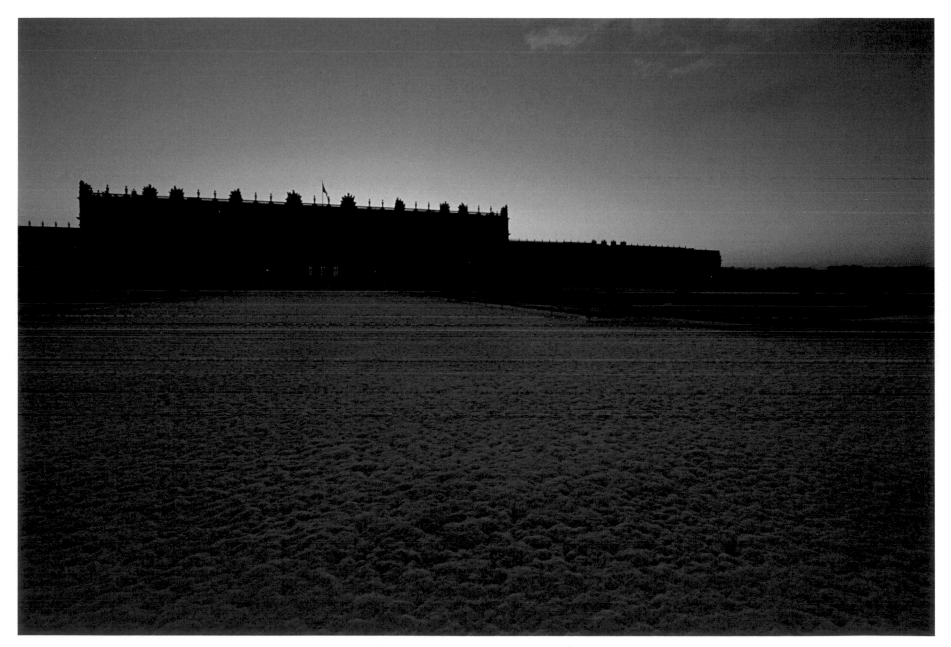

(The château from the Water Parterres.)

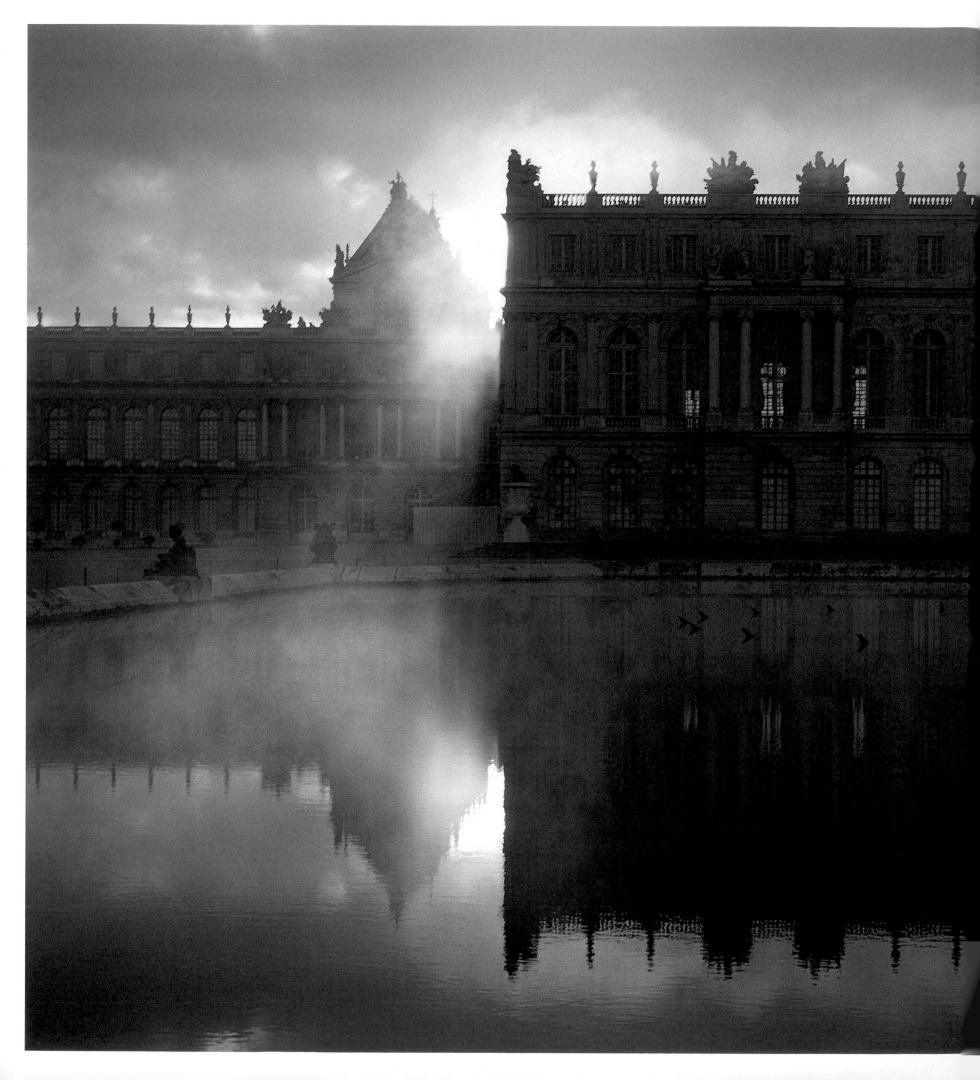

〔 Château and chapel at sunrise. 〕

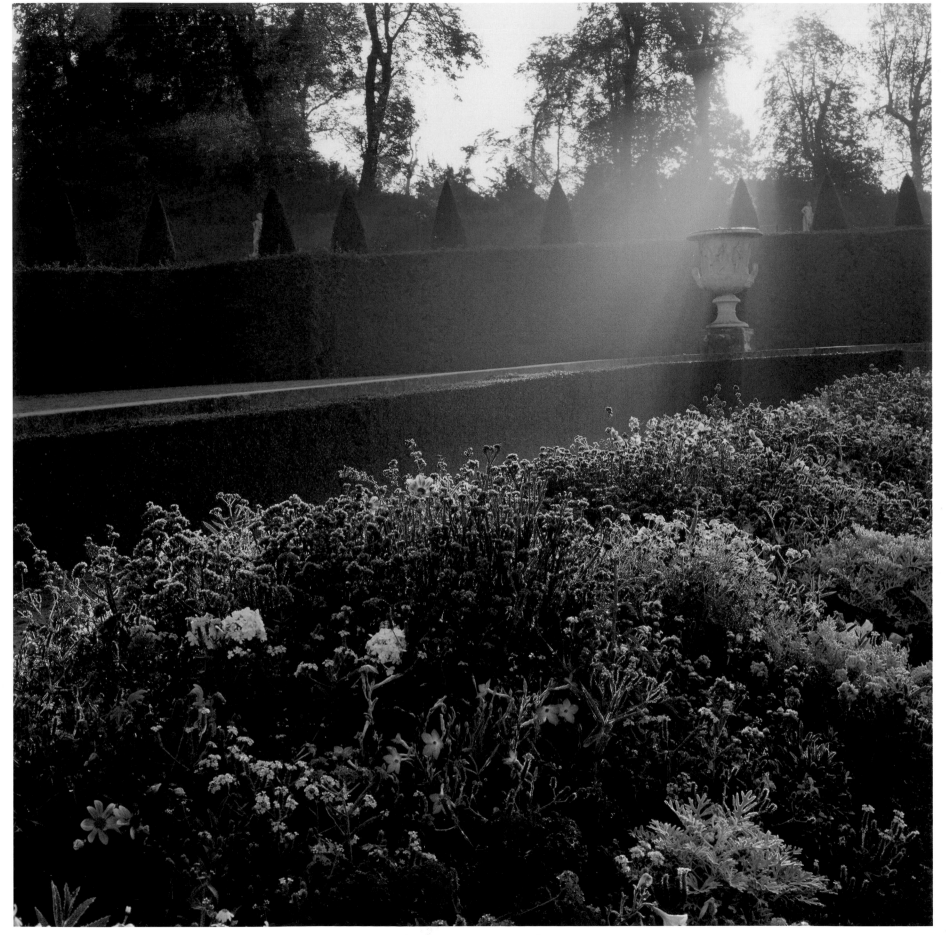

(Ramps near Latona Basin.)

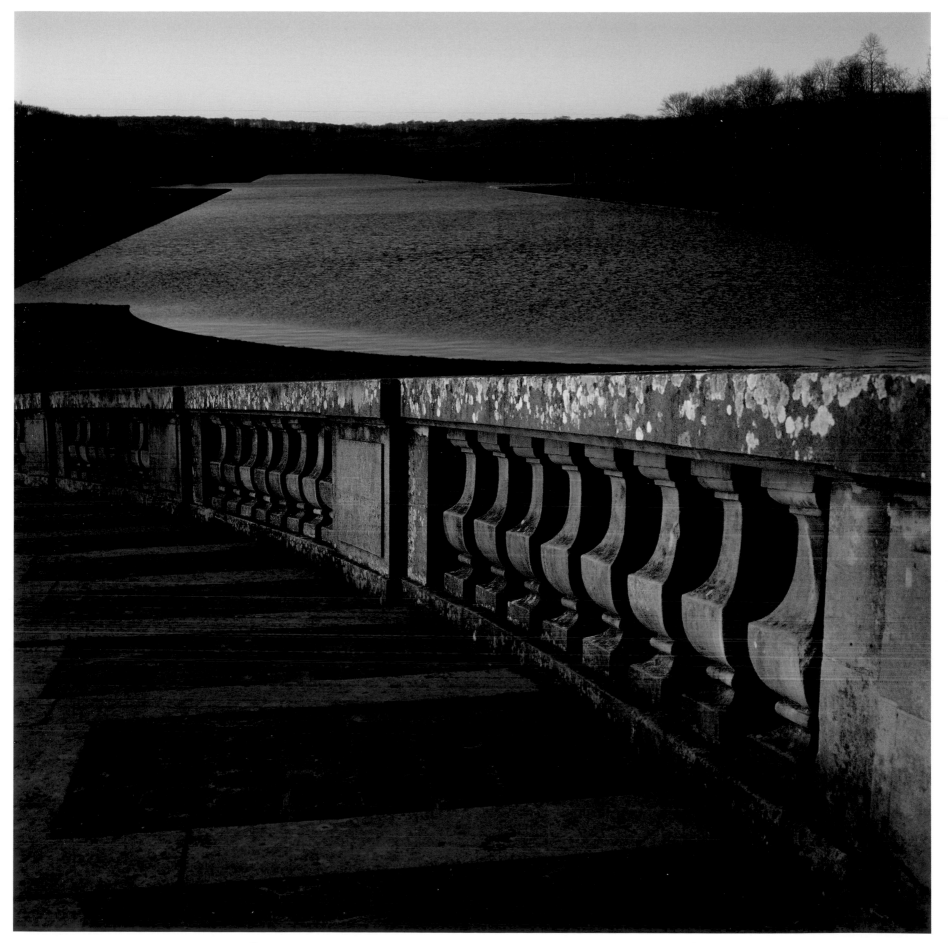

(At the Trianon, the transverse axis of the Grand Canal seen from the horseshoe-shaped ramp.)

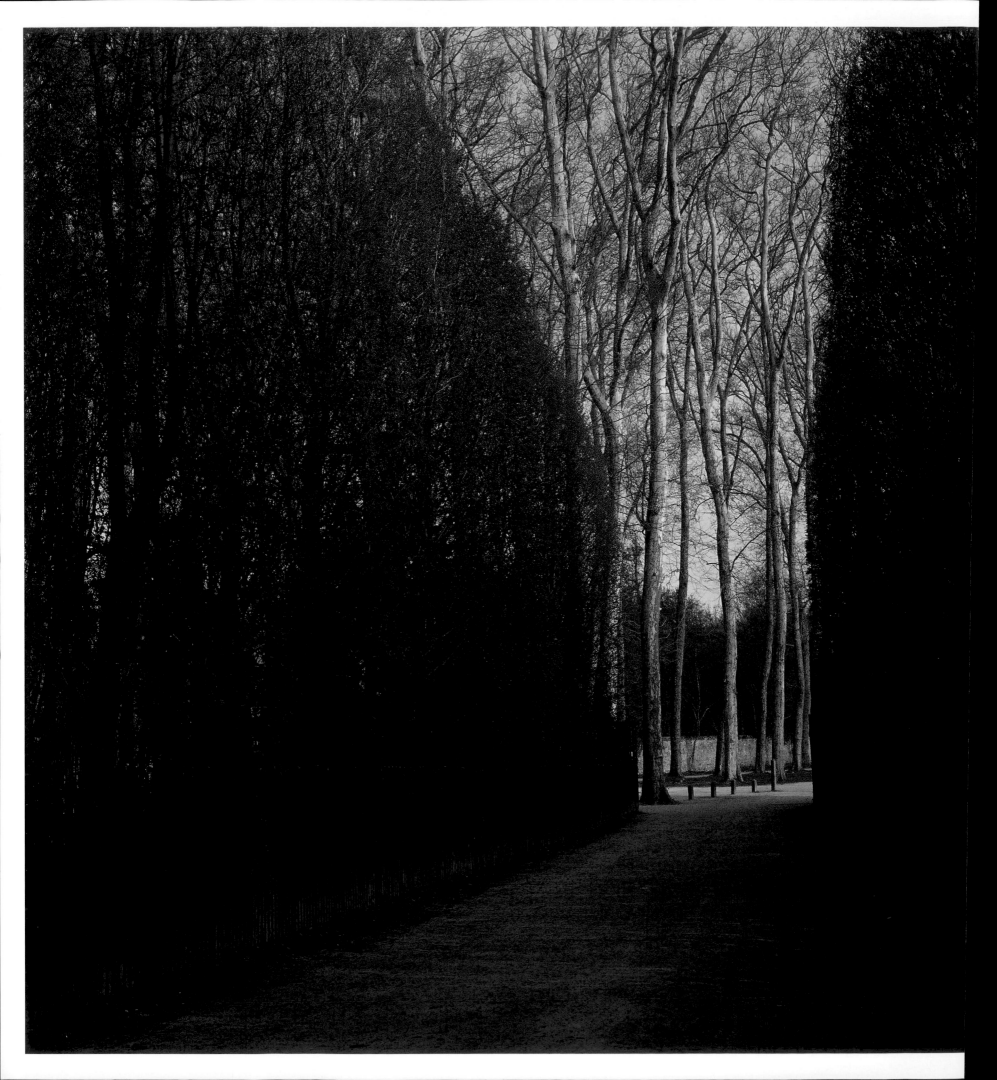

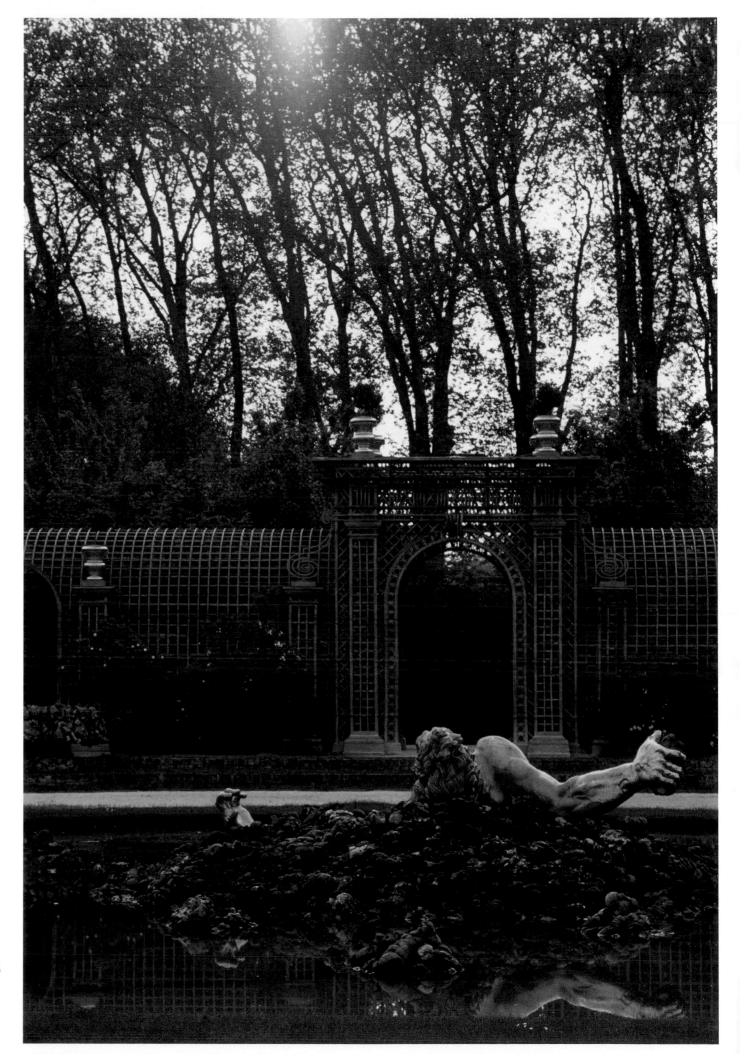

(Enceladus Grove.)

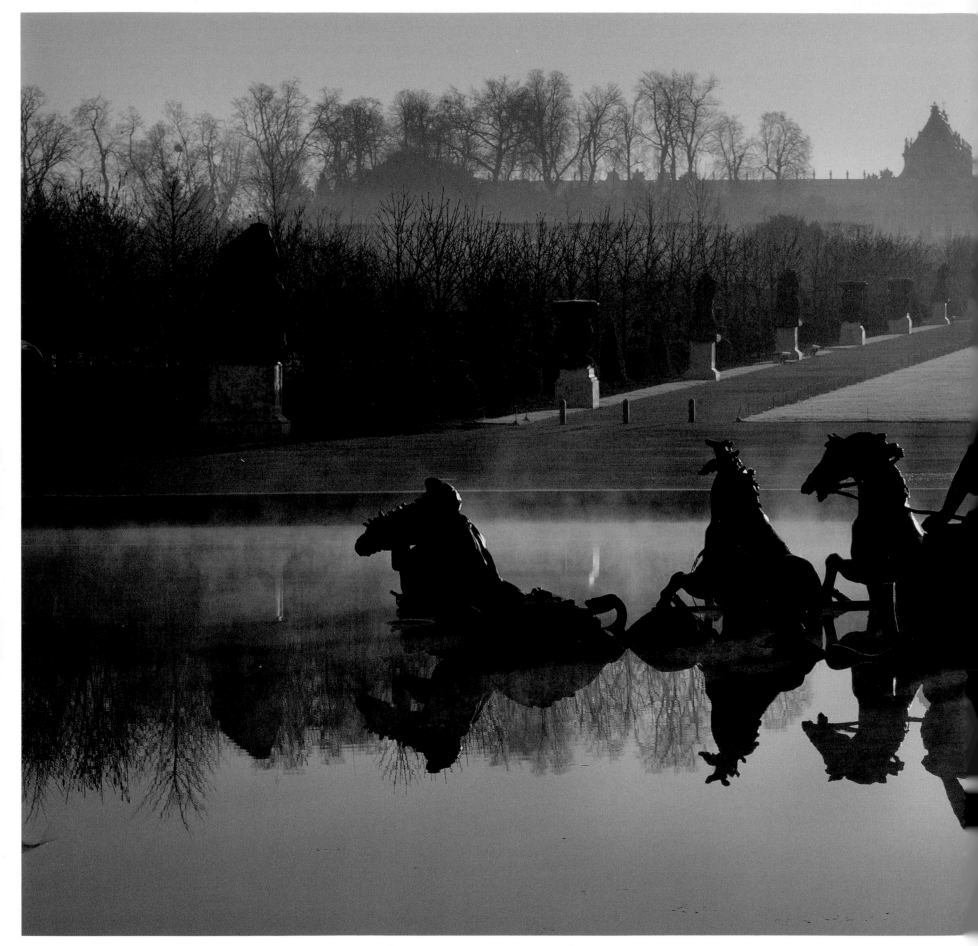

(Apollo's chariot one winter morning.)

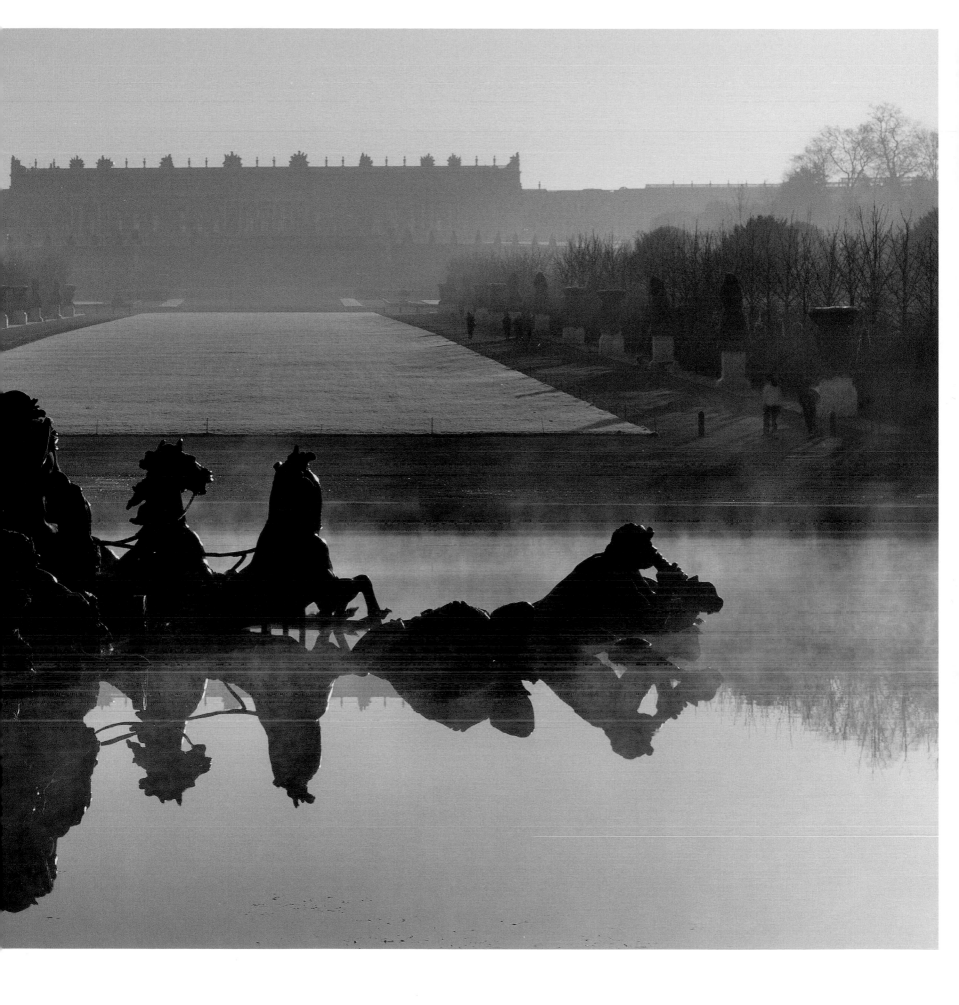

FRANCE

CHÂTEAU
DE
CAYX

The Private Estate of Queen Margrethe and Prince Consort Henrik

LA CIGARALLE—A WINE OF A PALE GOLD COLOR THAT GLINTS GREEN AND OFFERS AROMAS
of dried fruits, almonds, and hazelnuts—is cultivated on the limestone terraces around the castle and
the name should speak for itself. And yet many have not been able to resist the idea of clarifying this
enigmatic title given by Prince Consort Henrik to one of his Cahors wines. As owner of the estate with
Queen Margrethe since 1974 and a reputable winegrower, he invites those curious about the name to
immerse themselves in books of history and even literature to find out about his château's past. They
will find that La Cigaralle is the local name given to the Château de Cayx, which overlooks a curve in
the meandering Lot river. It was built in the eighteenth century by Jean-Jacques Lefranc, Marquis de
Pompignan, who was the owner of the property at that time. He was a magistrate, poet, playwright—
the author of *Didon*—and member of the *Académie française*.

The current owner was born Henri de Laborde de Monpezat to an old family of the region. He
became Prince Consort Henrik through his marriage to Queen Margrethe in 1967. He retired there to
read, write his poems, and dream in his green gem of a garden nestled along the river. This fifteenth-
century fort built on the hillside in the town of Cayx, in the district of Luzech, has kept watch over
navigation on the river throughout the centuries. It was expanded over the years, and the addition of
four towers with conical roofs and a square tower in the seventeenth century made it into a superb
cut-stone residence.

There is a breathtaking view from the vast southern terrace that soars over the vineyards as far as
the eye can see and overlooks a parterre planted with boxwood trees, roses, and Indian lilac. While
residing at Cayx every summer and at the time of the grape harvest, the royal couple indulges in the
arts, literature, painting, and sculpture. At the entrance to the château is a sculpture by the prince,
Cérès de Cayx, which depicts a buxom woman holding a bunch of grapes. Near the wine storeroom is
another bronze sculpture by the prince of a stylized human torso.

The estate's vintages have carefully chosen titles, labels, and enchanting colors: Château de Cayx
has a purple hue, the aroma of red fruits with a note of spice, and silky tannins; La Royale is ebony in
color with vanilla notes; the label for Gobelins has an illustration of a tapestry showing the famous
manufacturer recounting the history of the kings of Denmark; and *Le Rosé du Prince de Danemark*,
which has intense pink reflections, brings to mind the garden's flowers.

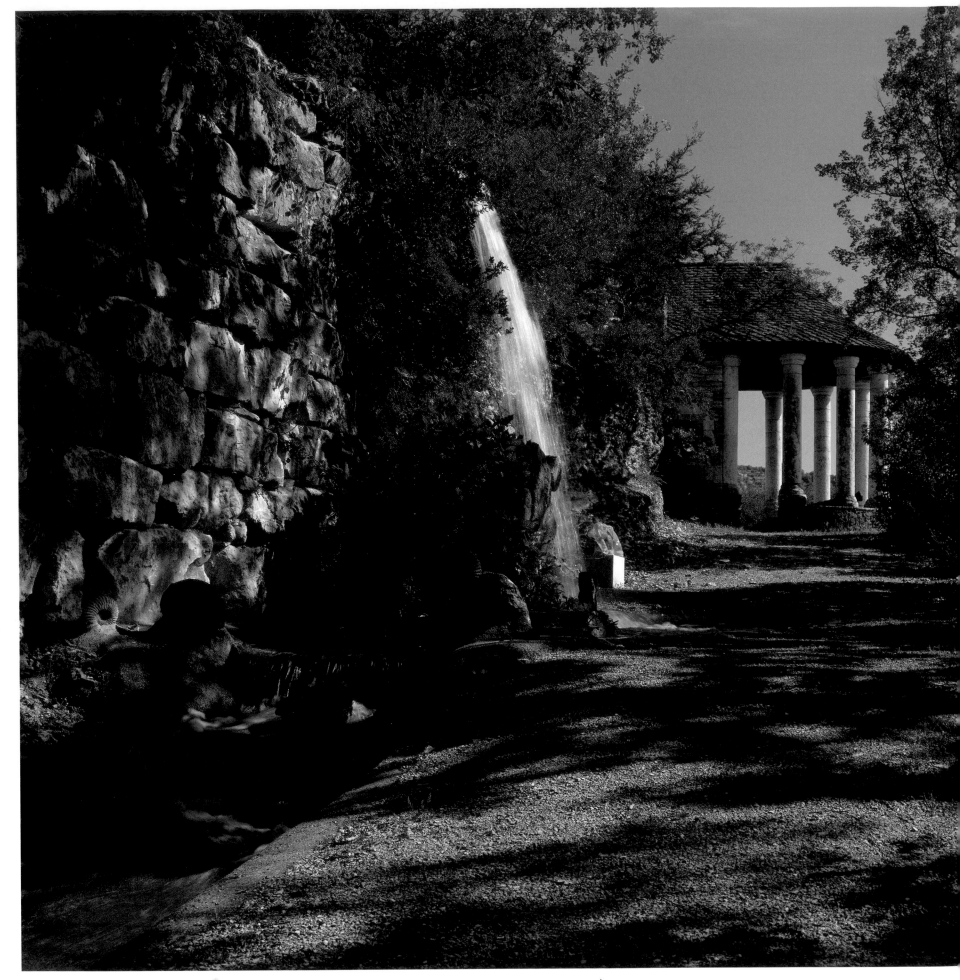

(Overlooking the Lot Valley, the estate's belvedere.)

When I meditate at the edge of the night

Near my belvedere

Close to the Lot River

I realize that I would risk death to retain

This feeling of repose.

And you the strange cicadas

Who have brought enchantment to my life

Will sing of my death

In strident tones

And those from Impernal

Along its arid slopes.

–Prince Consort Henrik

From his book of poetry *La Part des Anges*

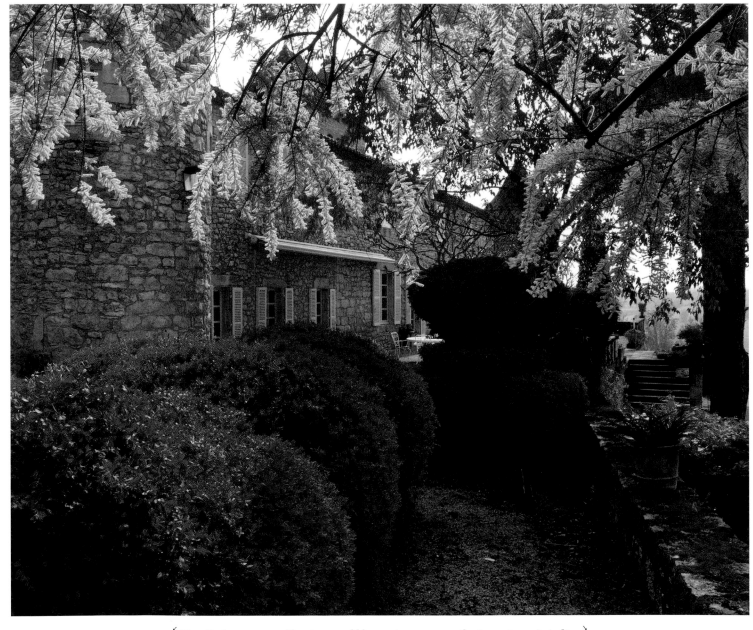

(Near the house, pruned box trees and blossoming crape myrtle, *Lagerstroemia indica.*)

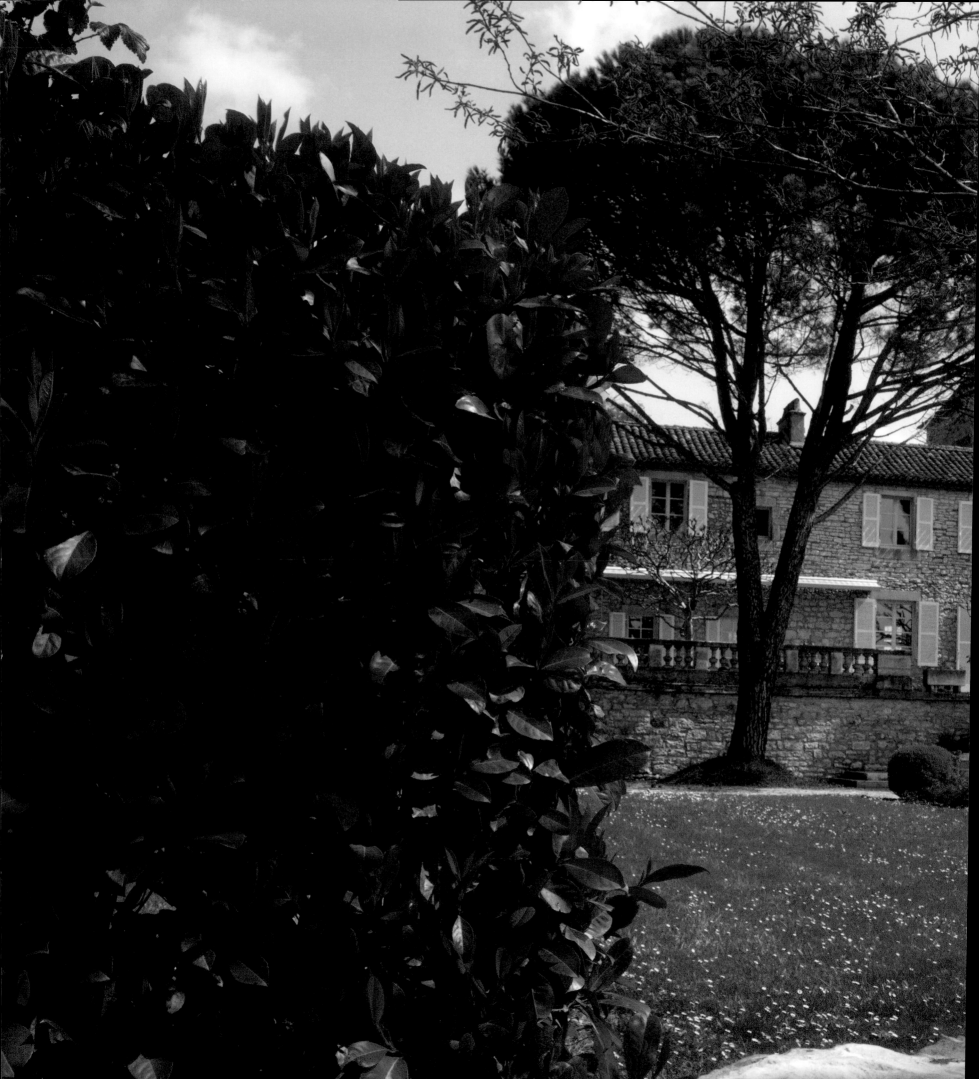

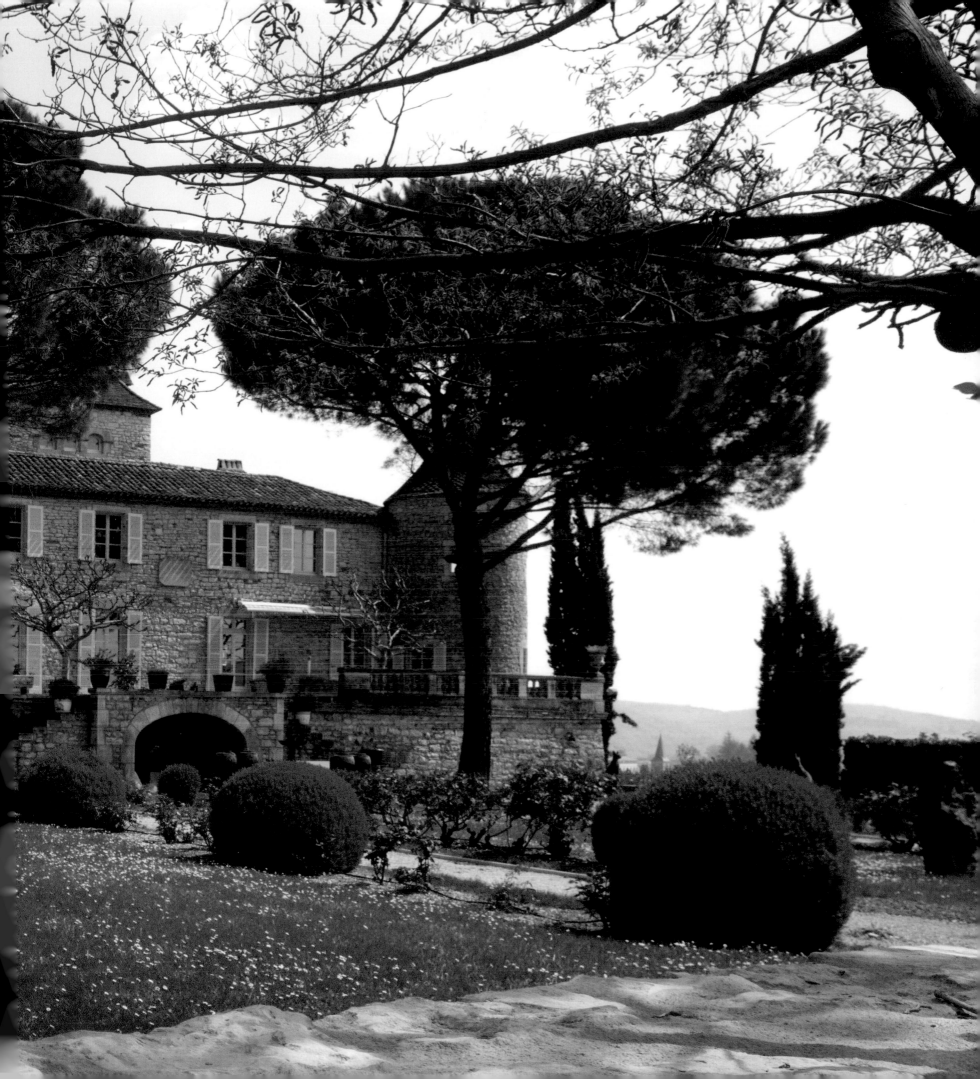

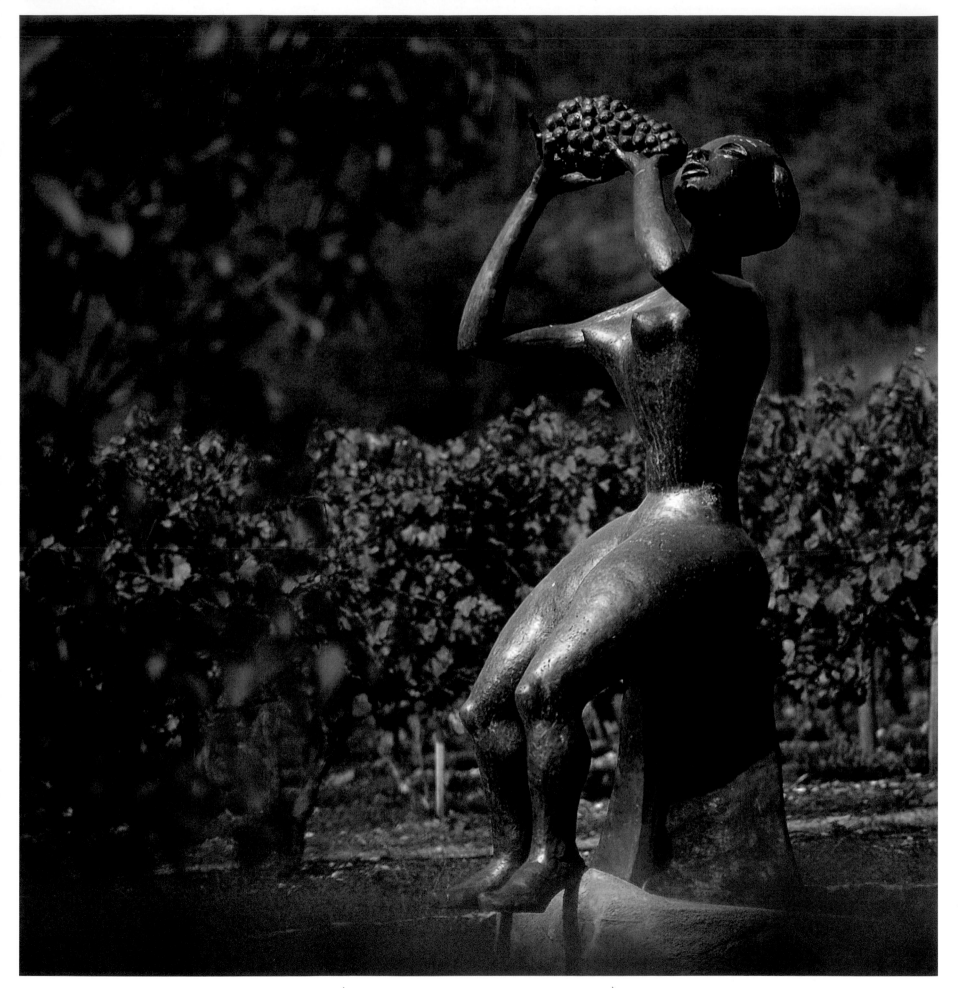

(*La Ceres de Cayx*, a sculpture by Prince Consort Henrik.)

(Along the Lot river, the superb village of Albas.)

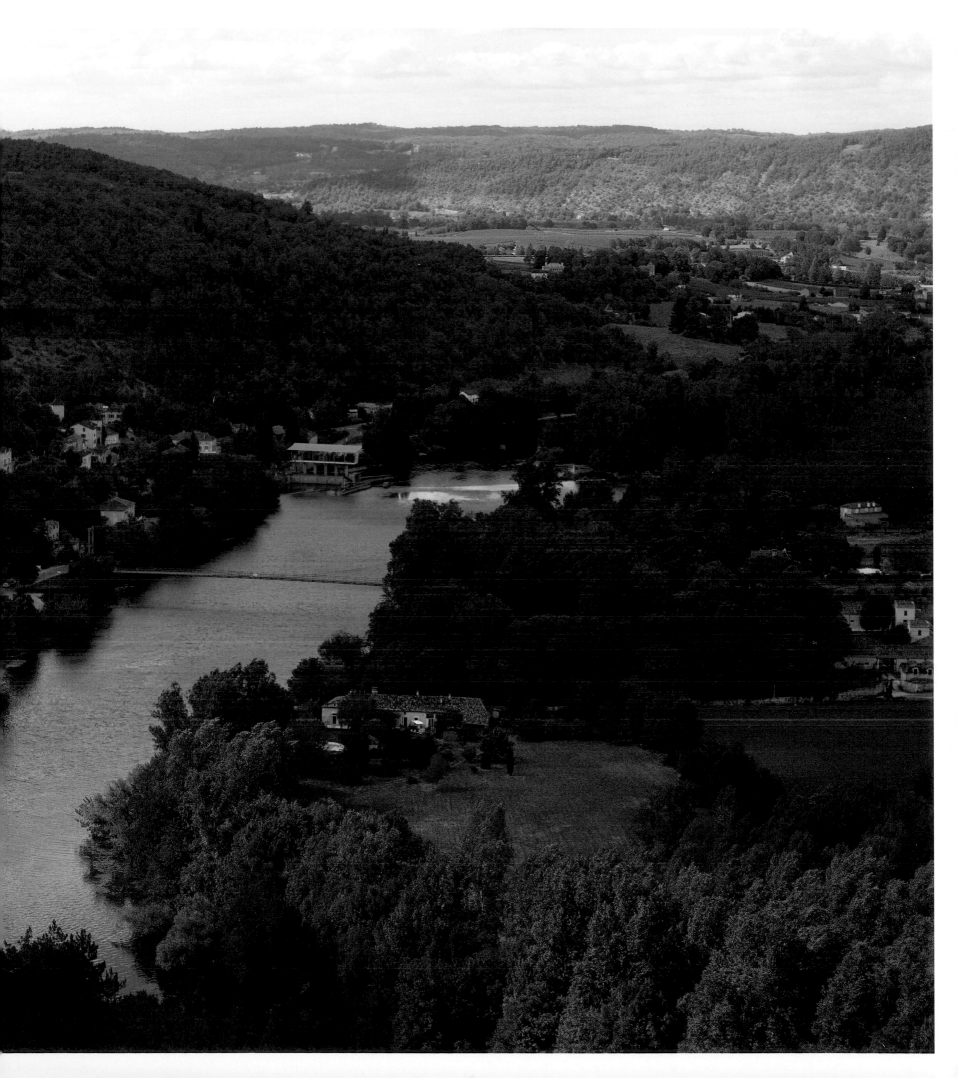

SWEDEN

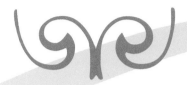

DROTTNINGHOLM
PALACE

The Enchanted Isle of Queen Hedvig Eleonora

ALONG THE SHORE OF THE ISLAND OF LOVÖN, IN THE STOCKHOLM ARCHIPELAGO, A BAROQUE garden lined with pathways and lime trees pays discrete homage to the castle of Vaux le Vicomte and Chantilly, France. This is the garden of Drottningholm Palace, the construction of which began in 1662 for Queen Hedvig Eleonora by the architect Nicodemus Tessin. The parterre, which extends under the windows of the castle and was originally created in an intricate embroidery pattern, has lost its scrolling hedge designs and trees sculpted to mirror the gardener André Le Nôtre's designs at Vaux le Vicomte. Today, it offers simple lawns trimmed with boxwoods and outlined with bands of crushed brick. Inspired by the basins and fountains of Chantilly, the fountain of Hercules by Adriaen de Vries underscores the influence of the French formal garden. The seven cascading fountains found there today freely interpret those imagined by Tessin, which were torn down at the beginning of the eighteenth century. Beyond these fountains are four hedge groves and a theater of leaves, where bushes form walls and a stage. Though the stage is still used for performances today, the star-shaped labyrinth of hedges that joined the theater to Muncken's Hill lost its shape and mystery a long time ago.

As in Chantilly, you can follow the history of gardens here. To the south of the baroque garden is a more open park adorned with the superb Chinese Pavilion, a holiday house given to Queen Lovisa Ulrika by her husband in 1753 for her birthday. Ten years later, she transformed it into the more permanent building we visit today. The queen, who was the sister of Frederick II of Prussia (Frederick the Great), wanted to give this section of the park a more natural look in line with the style of her times and built a garden in this manner around the Chinese Pavilion. In 1777, King Gustav III took over the palace and wanted to add an English garden. He commissioned Fredrick Magnus Piper, who had studied gardens in England, to create it. Decorative pools, small bridges, winding pathways, lawns, and groves were built to create an ideal landscape where walkers move from enchanting scenes to mysterious views. Here and there, in strategic places, marble statues that the king had brought over from Italy enhance the decor and leave vivid impressions that visitors carry away with them on the boat back to Stockholm.

(This visual punctuation, brought from Italy by King Gustav III, is a copy of an ancient statue.)

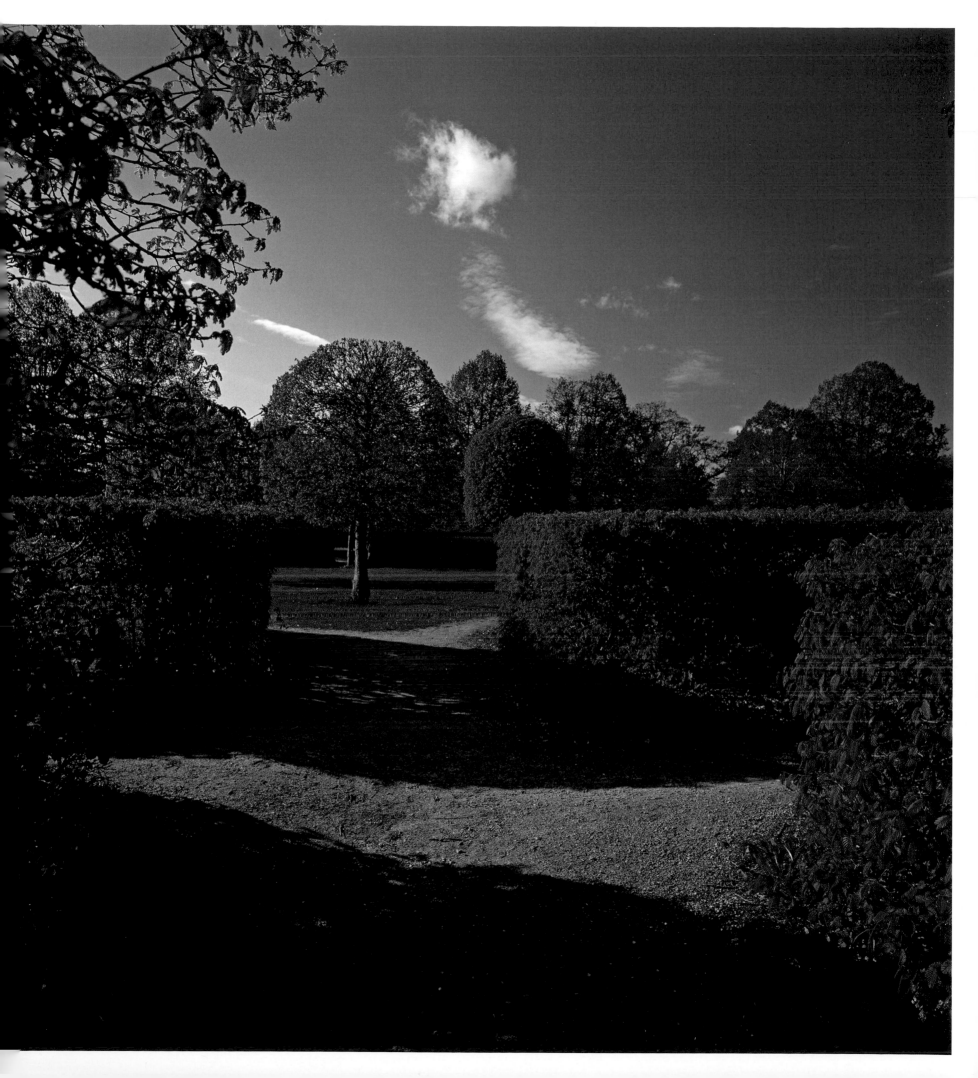

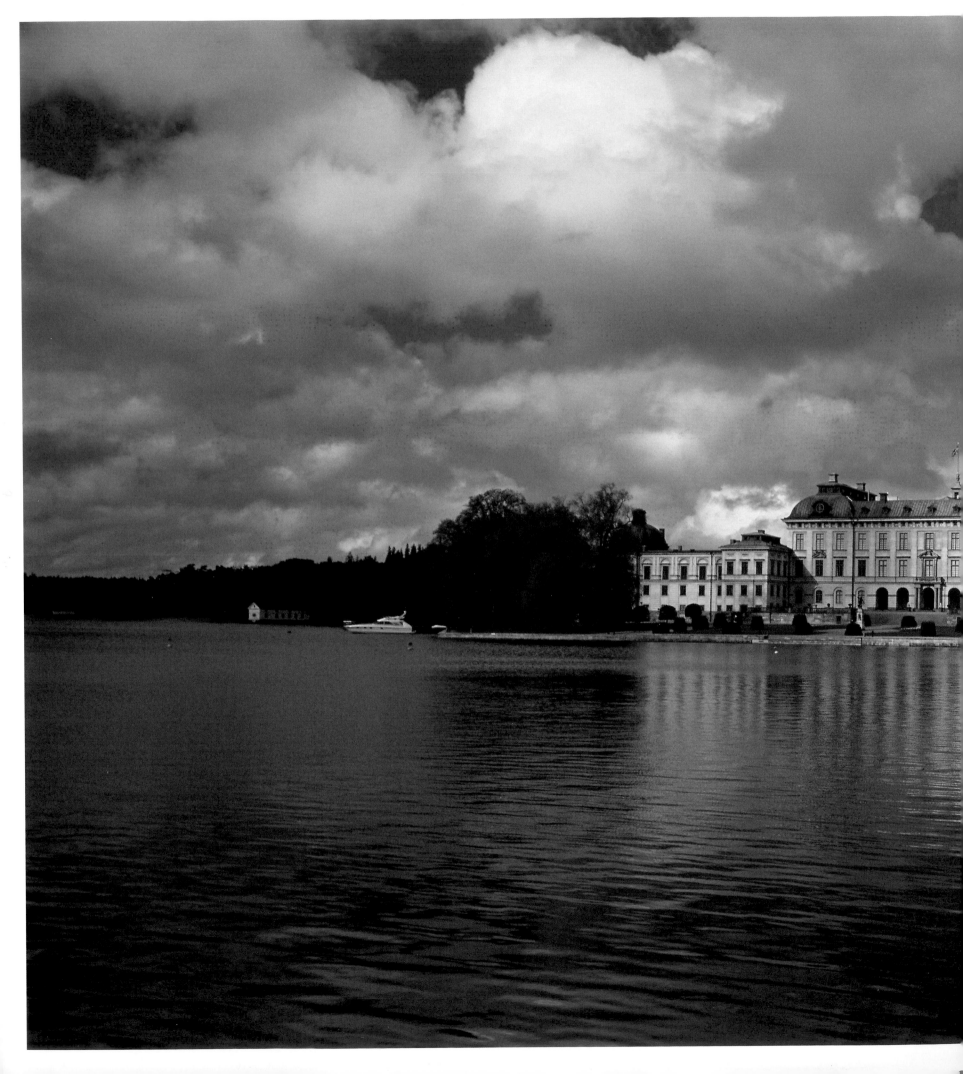

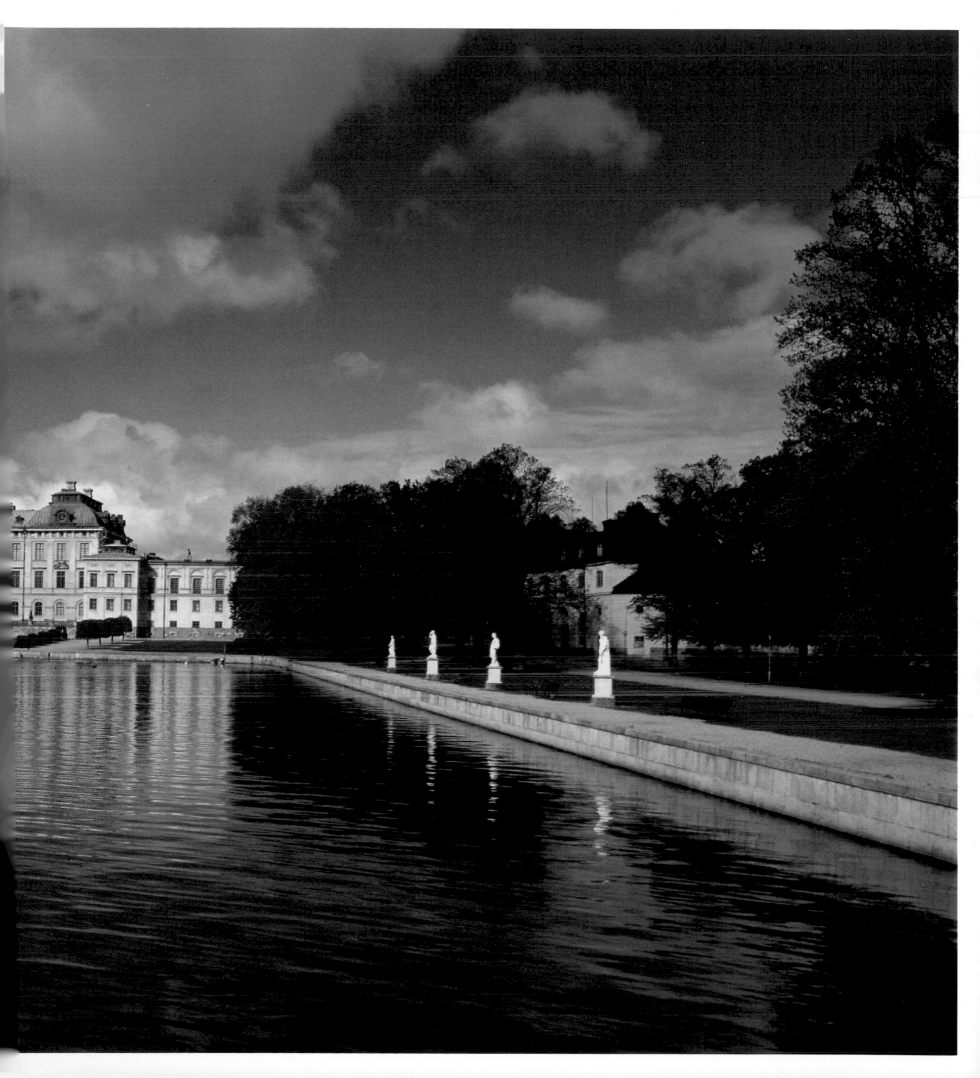

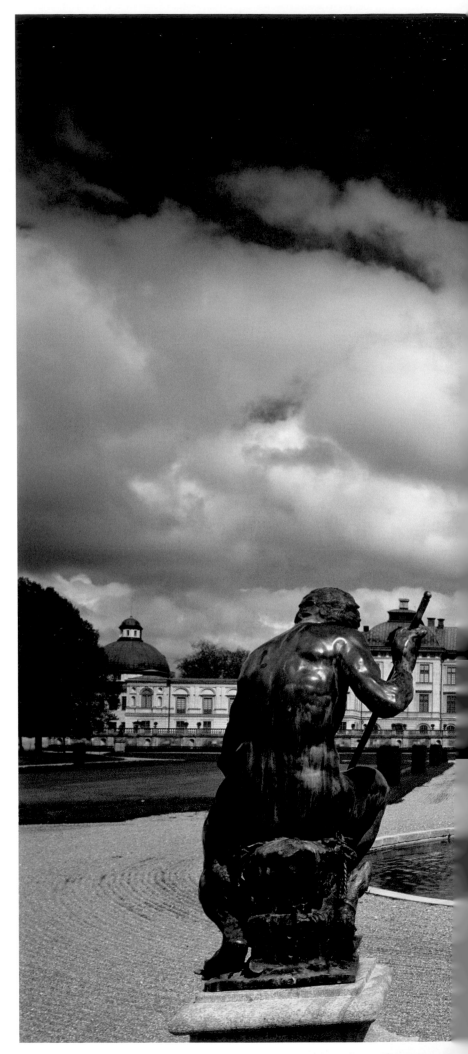

(At the center of the parterre, the fountain of Hercules by Adriaen de Vries.)

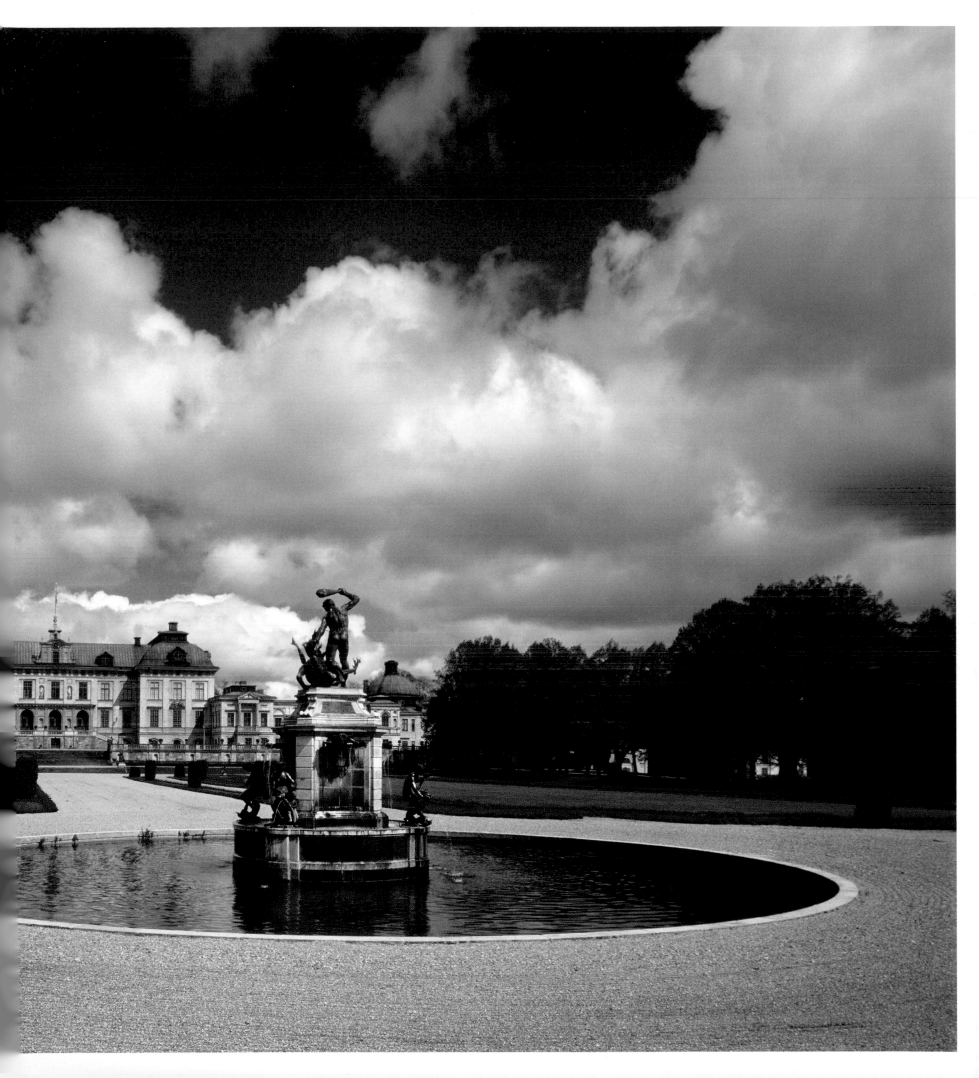

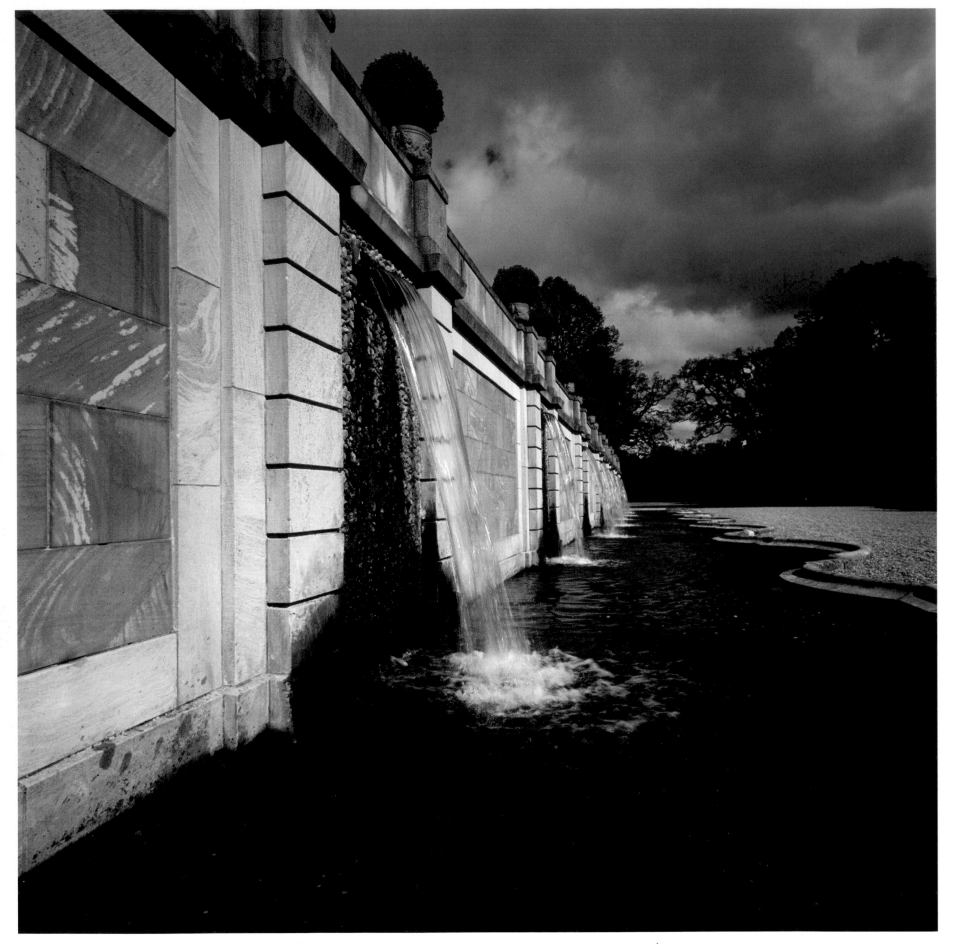

(The cascades and the terrace between the baroque parterres and the groves.)

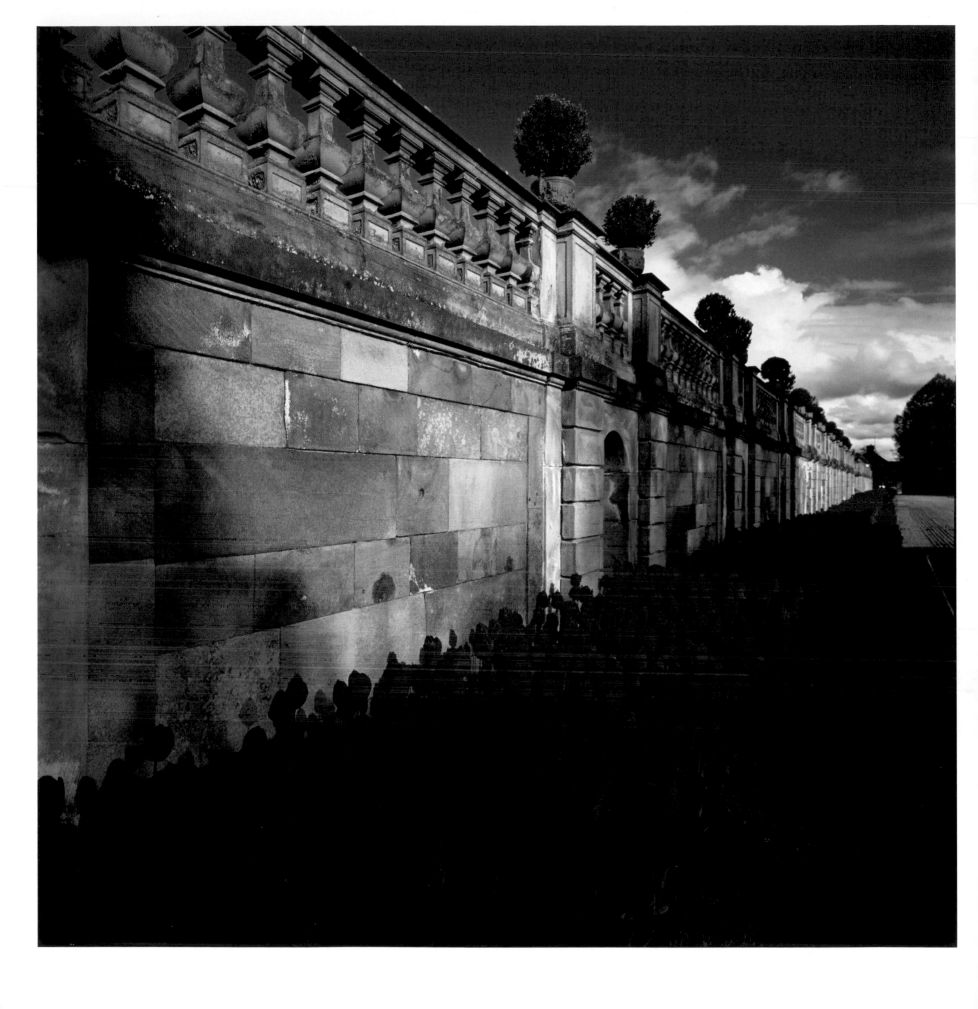

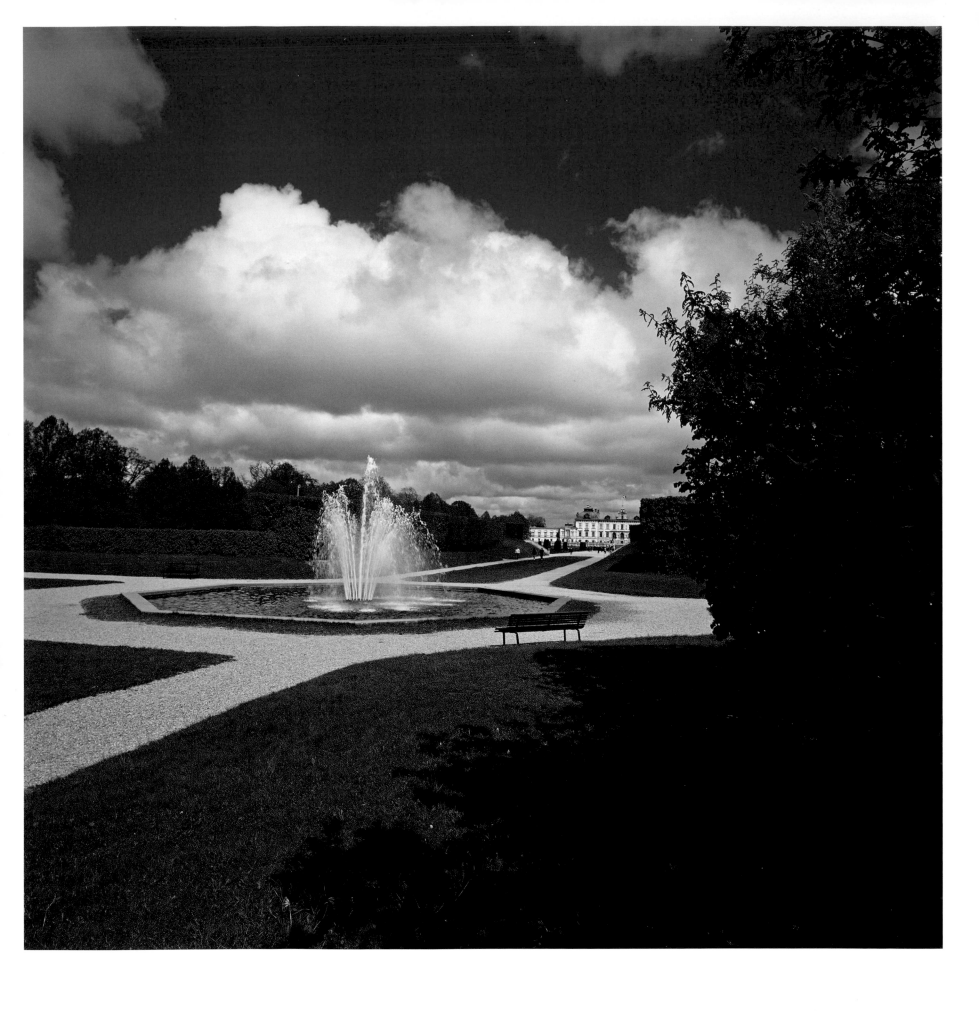

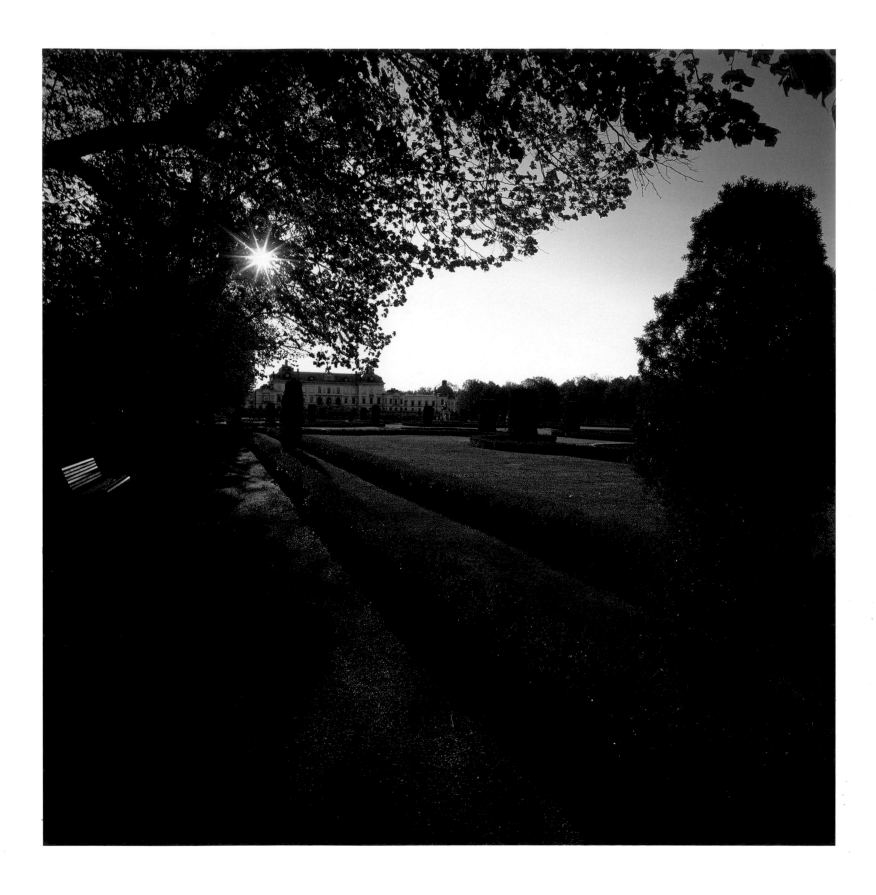

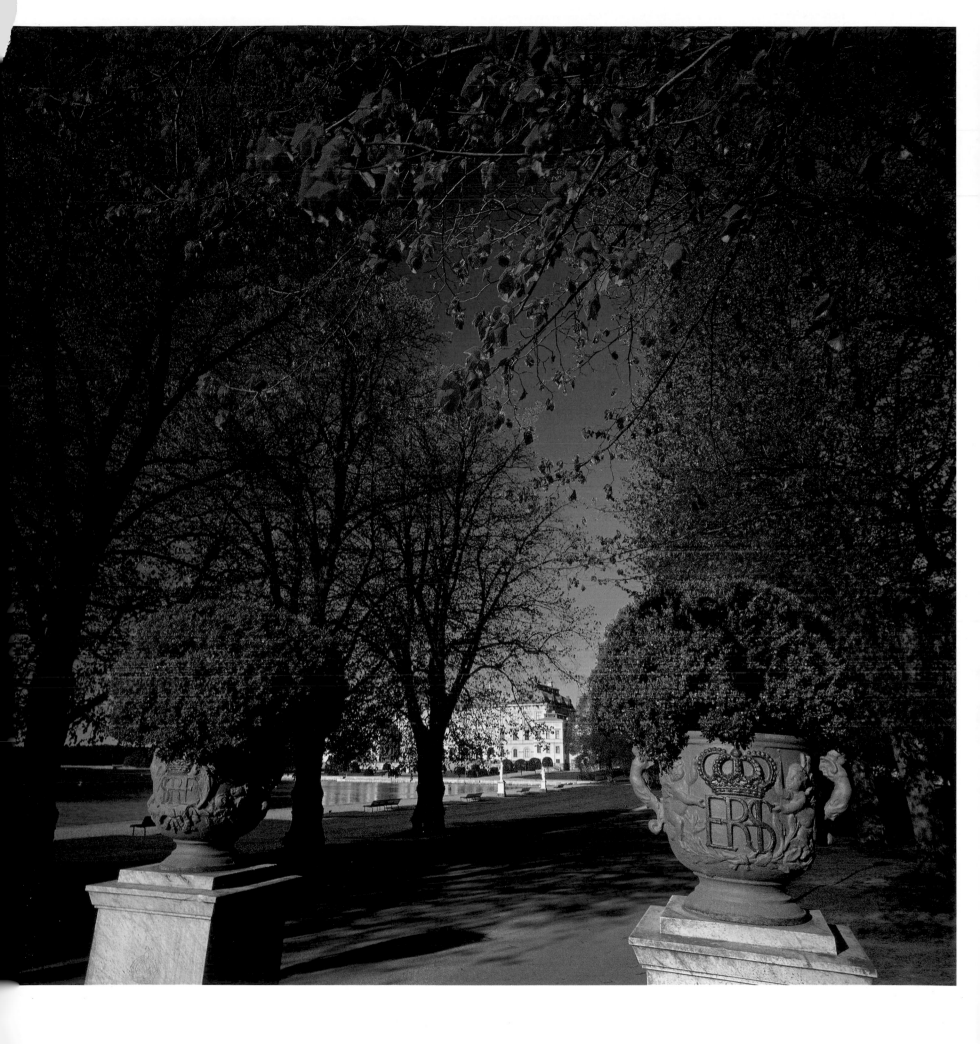

MONACO

ROC AGEL
ESTATE

The Untamed Retreat of Prince Albert II

U NLIKE THE GARDENS AT PRINCE ALBERT II'S PALACE—WHICH ARE HUDDLED IN THE CONFINES of the walls of that urban residence—the Roc Agel Estate basks in pure fresh air at 2,067 feet above sea level in the heights of Monte Carlo. This escape from city life is exactly what his parents, Prince Rainer and Princess Grace, wanted for their children when they acquired this old farm and its vast estate at the end of the 1950s. Beyond the gate are waves of green with a cedar tree and a weeping willow that stand before the lovely white villa with green shutters. The elegant simplicity of the building matches that of the rosebushes, saxifrages, *Iberis* (candytuft), and *Arabidopsis thaliana* (thale cress) that Princess Grace liked so much. "My mother had a lot of ideas," Prince Albert confides. "She was very involved. She loved roses but she always insisted on an untamed look for the planting layout. I have continued with this approach."

Down below, terraces harbor a greenhouse that provides the estate with aromatic herbs and vegetables in season, while an orchard has rows of ancient peach, plum, apricot, and cherry trees. Farther—beyond the grove of evergreens, white oaks, cedars, and fir trees—are facilities that allow the prince to indulge in his love of many types of sports. The road that leads from the house is currently bordered by a white fence along with lightly pruned spindle, laurel, and yew trees. Grazing around the property are sheep, goats, and cows, which were originally introduced by Prince Rainier to supply the estate with milk and cheese. The garden's tall grass, winding paths, steep cliffs, astonishing views, and large trees make an already rugged landscape seem more wild, though it still has all the attractions of a picturesque eighteenth-century garden, with its chapel and small stone houses playing the role of follies. In this idealic context, the prince restored La Ruine, a stone house that overlooks the sea and is lit by lanterns. This ecologically motivated venture, along with the estate's livestock and greenhouse, are completely in line with his commitment to the planet. This place of relaxation is far from the rigors of palace life. "A garden is above all a place of repose, serenity, in harmony with those who find themselves there, and with nurtured or wild nature. A place where continuous discoveries are possible...," explains the prince.

(La Ruine, a restored ancient shelter for sheep.)

Roc Agel was acquired by my parents a few months before the birth of my sister Caroline. And so we have a deep attachment to this place, a special relationship that goes back further than yesterday. It evokes memories of childhood, adolescence, and only good memories! Roc Agel is more than just a garden, it's a park that people have been shaping for fifty years with new trees, plants, rose bushes . . . all while leaving a large part to nature. My tendency is to lean toward what is natural.

—Albert II of Monaco

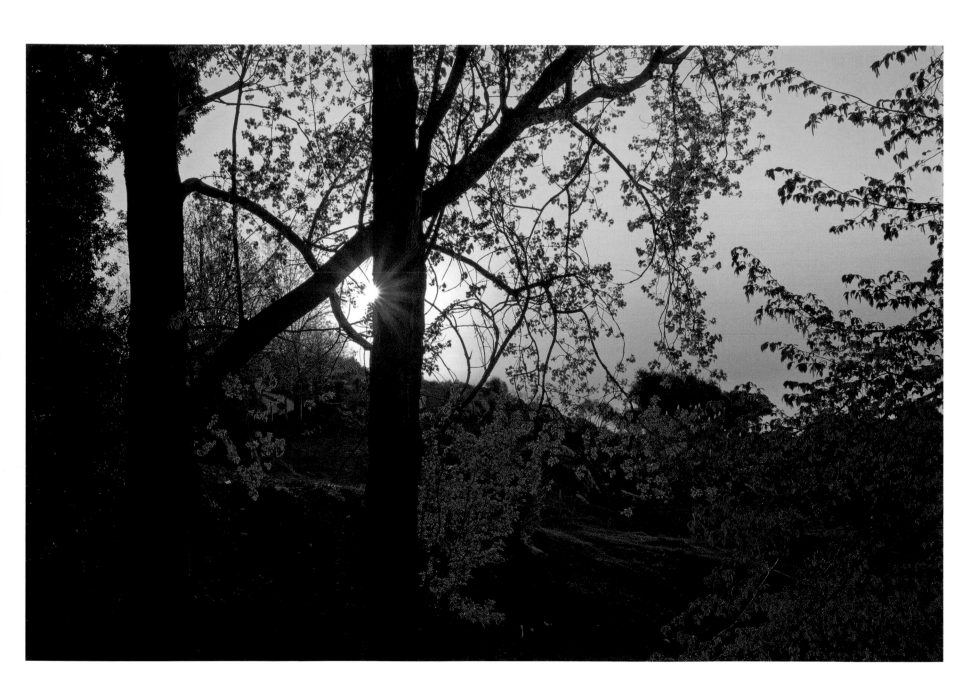

(**OVERLEAF** The view from La Ruine includes the Trophy of Augustus, the village of La Turbie, and in the distance, Cap Ferrat.)

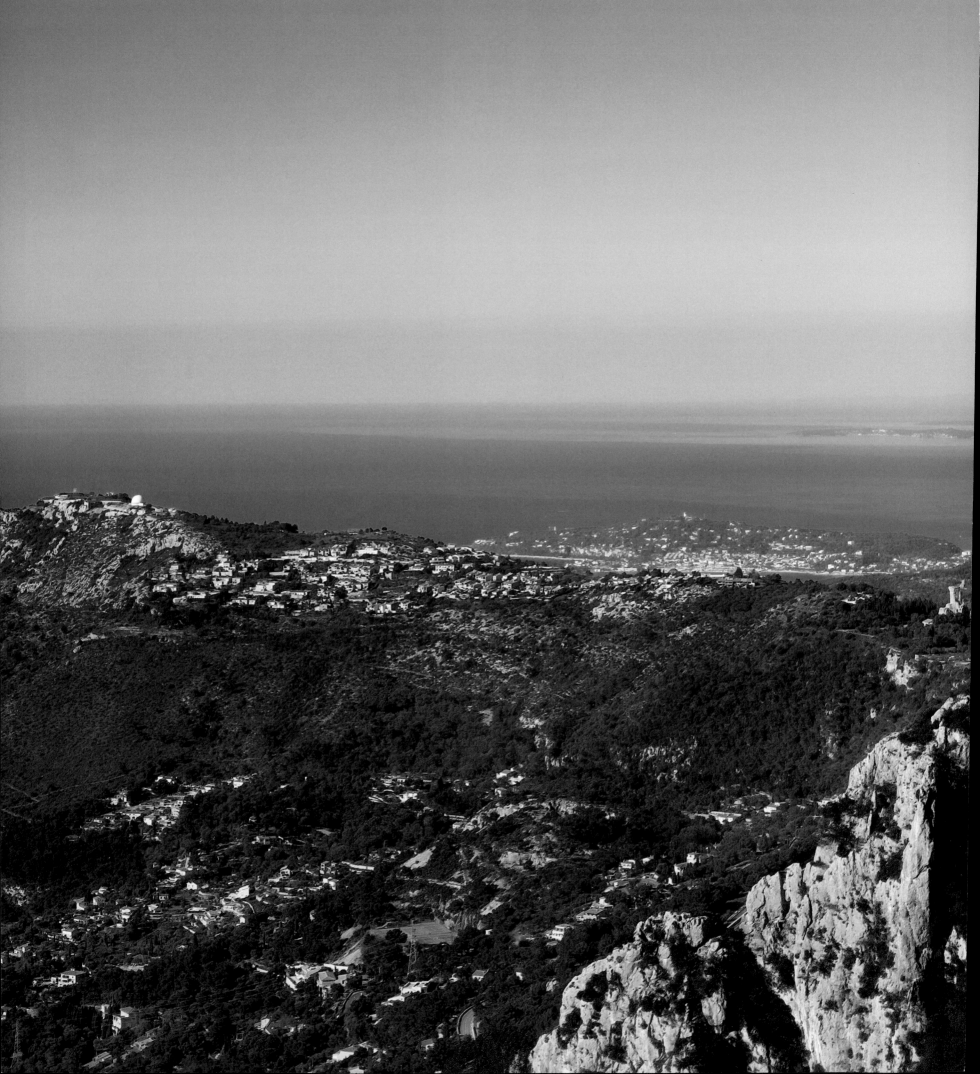

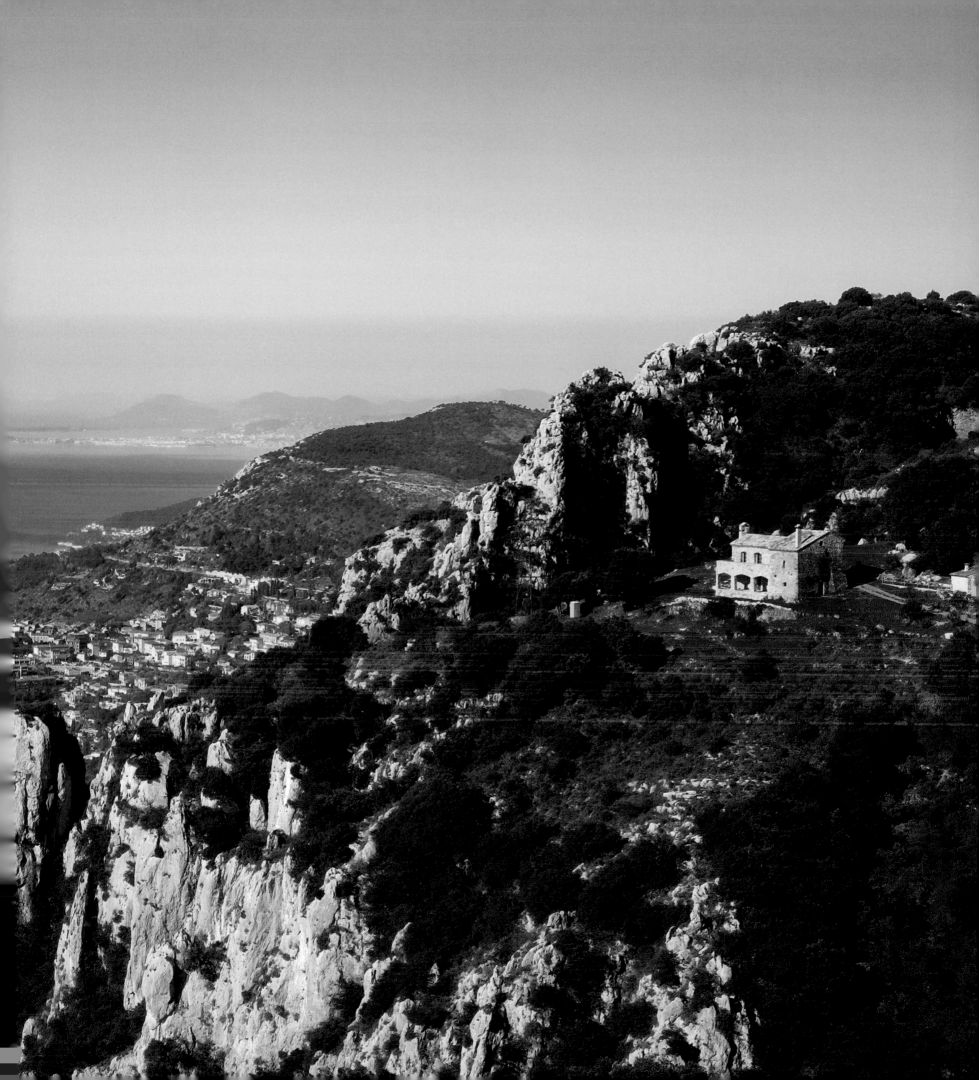

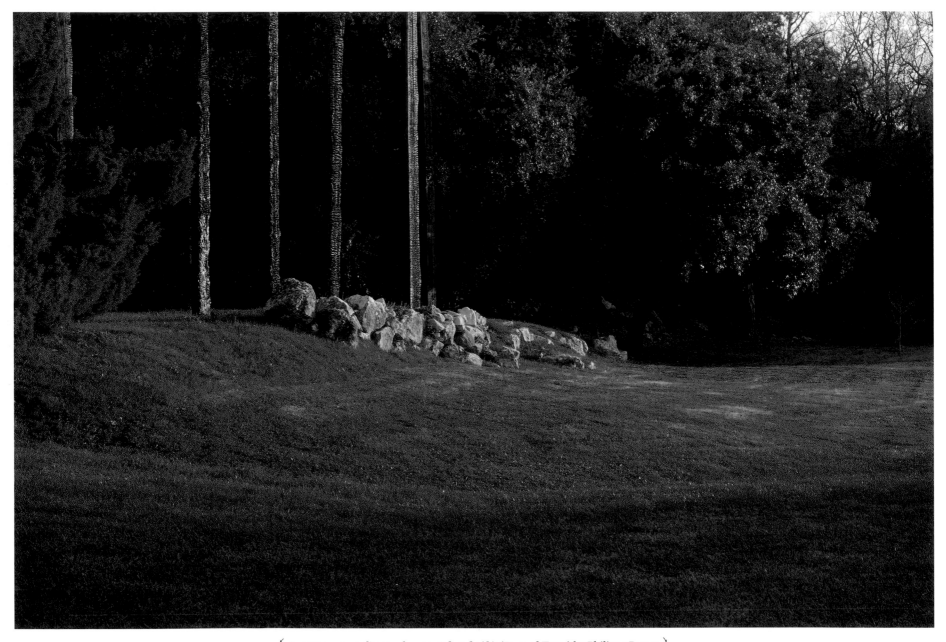

(A statement on climate change, *Arbres brûlés* (Burned Trees) by Philippe Pastor.)

(The terraced orchard and its ancient varieties of peach, plum, apricot, and cherry trees.)

FRANCE

CHANTILLY

The Many Different Gardens of the Princes of Condé

CHANTILLY OFFERS EXAMPLES OF MANY DIFFERENT GARDEN STYLES INCLUDING A FRENCH formal garden, an Anglo-Chinese garden, and an English-Romantic style garden. It offers a master's course in the history of gardens that can be taken in the great outdoors, bathed in the sounds of rustling leaves, chirping birds, and gushing water.

To the left after leaving the castle, you can see how the master of the French-style garden, André Le Nôtre, made Chantilly his favorite counterexample, breaking with some common practices. For instance, the major axis of the garden, which he designed for the Grand Condé in 1662, does not intersect the castle, a typical feature of French formal gardens, but rather the statue of Anne de Montmorency, heir to the property in 1522. The statue stands atop the Grand Canal and gives access to the parterres. The two grass and water parterres, restored in 2009, that flank the Grand Canal are adorned with mirroring pools, water jets, fountains, and statues along two planted rectilinear promenades called the Philosophers' Walks. The perpendicular axis of the Grand Canal extends over 1.5 miles from the Grand Rond cascade fountain in the east, to a hexagonal basin in the west, and is diverted to a three-tier cascade.

In 1774, the architect Jean-François Leroy created an Anglo-Chinese garden for Louis-Joseph of Condé around a hamlet of small cottages, including a barn, dairy, and a mill, linked by winding footpaths and lively serpentine streams.

During the French Revolution, a section of the French-style garden that featured the multi-basin fountain the Cascade de Beauvais was destroyed. In 1819, Victor Dubois designed an English garden decorated with romantic follies to replace it. Here you can admire the temple of Venus and the idyllic île d'Amour in which the statue of Eros is sheltered among the foliage under a trellised *gloriette*.

The promenade is inspiring in its beauty wherever it may lead, and it is full of surprises, such as Sylvie's House, built in the seventeenth century for the Duchess of Montmorency; the Château d'Enghien, erected in the eighteenth century to lodge the guests of the princes; and the Royal Tennis Court, built in 1756 near the Great Stables of Jean Aubert, which today houses the Horse Museum. And, of course, don't forget the castle itself, which the Duke of Aumale gave to the Institut de France in 1884. It has a splendid library and an exceptional collection of paintings.

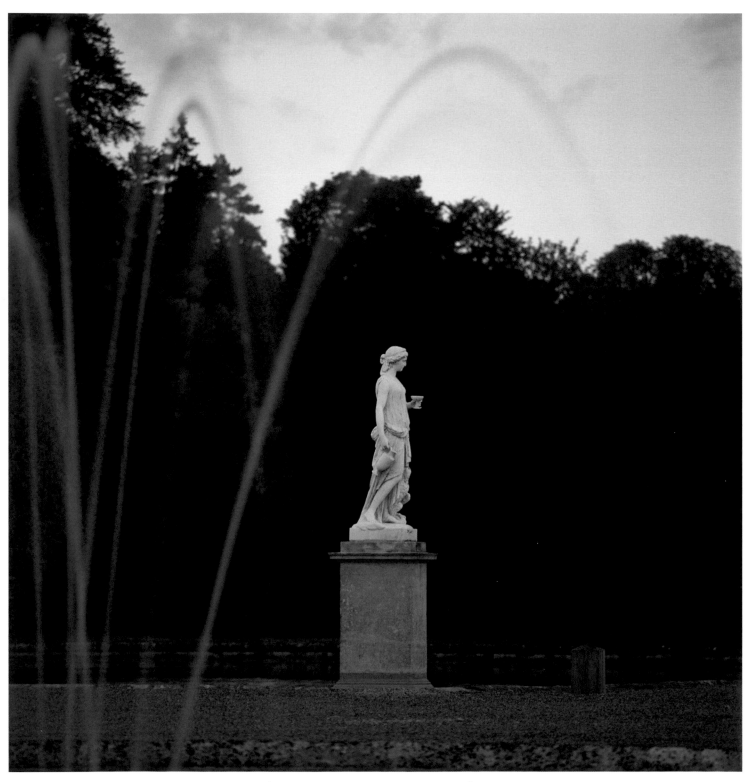

(*Hebe, Goddess of Youth,* by Deseine, 1789.)

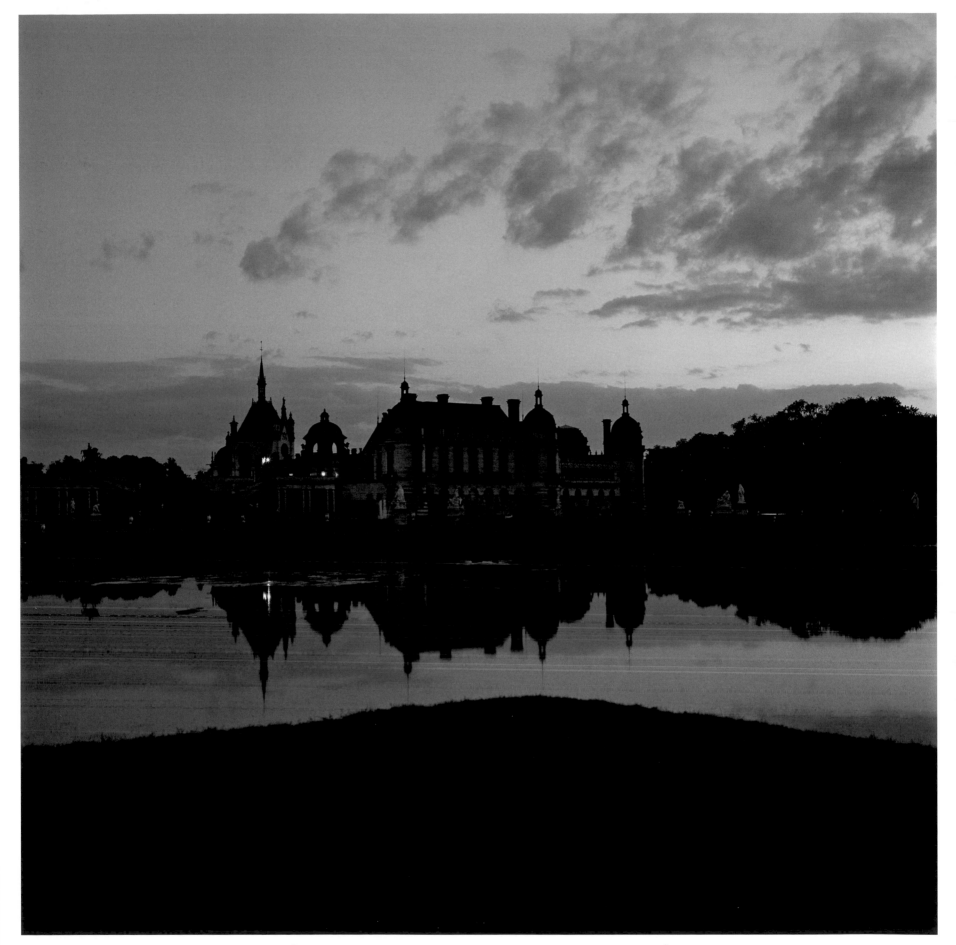

(At twilight, the château is reflected in the water parterre designed by Le Nôtre.)

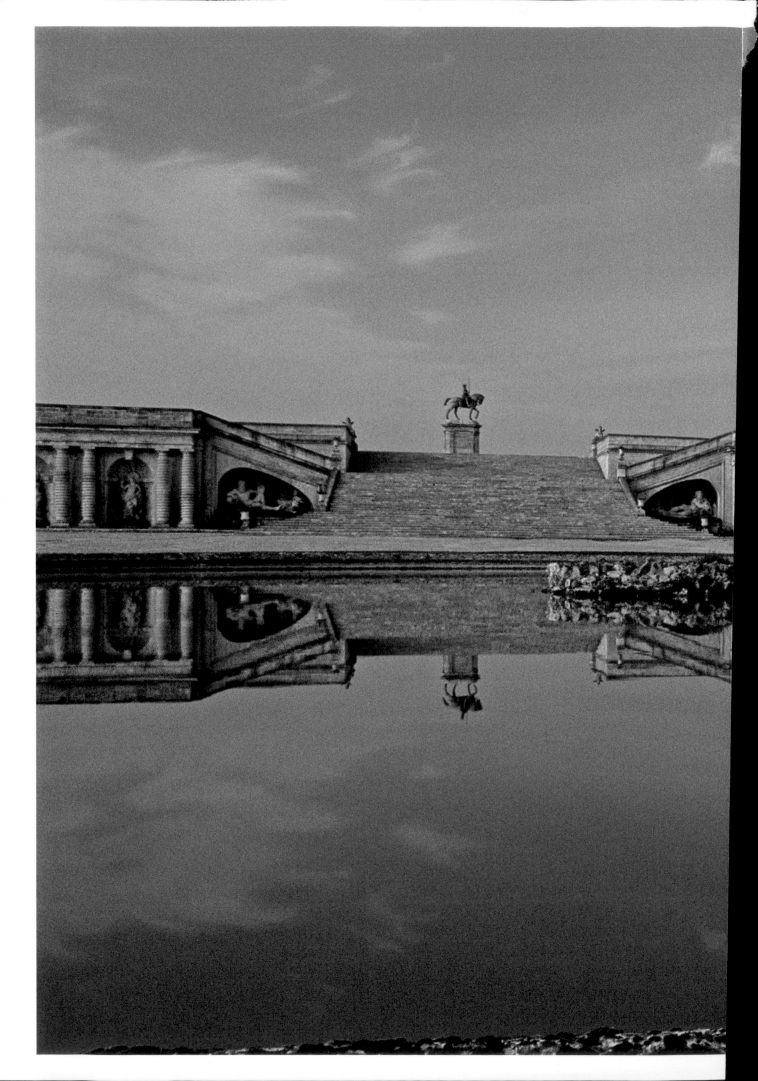

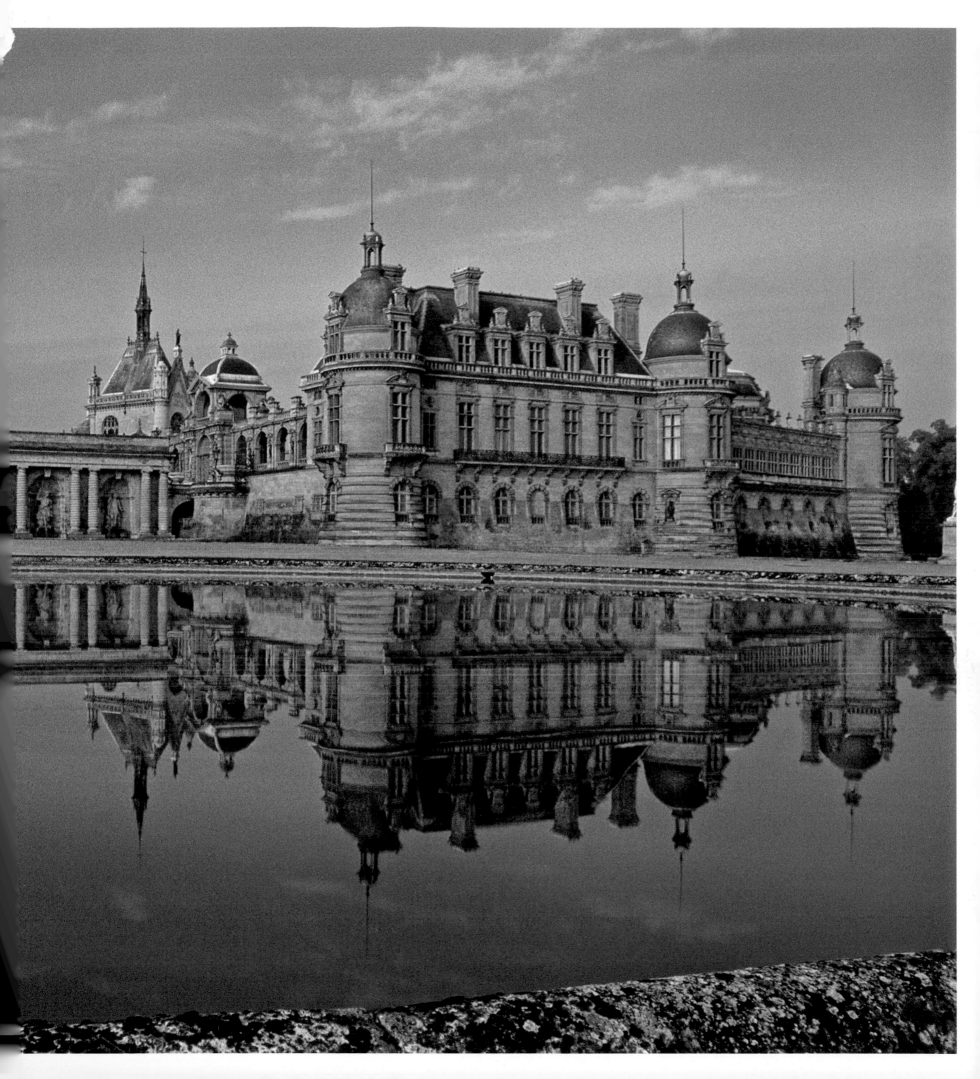

(On the north parterre of the Grand Canal, a marble statue of Silenus, companion of Dionysus, by an anonymous seventeenth-century artist.)

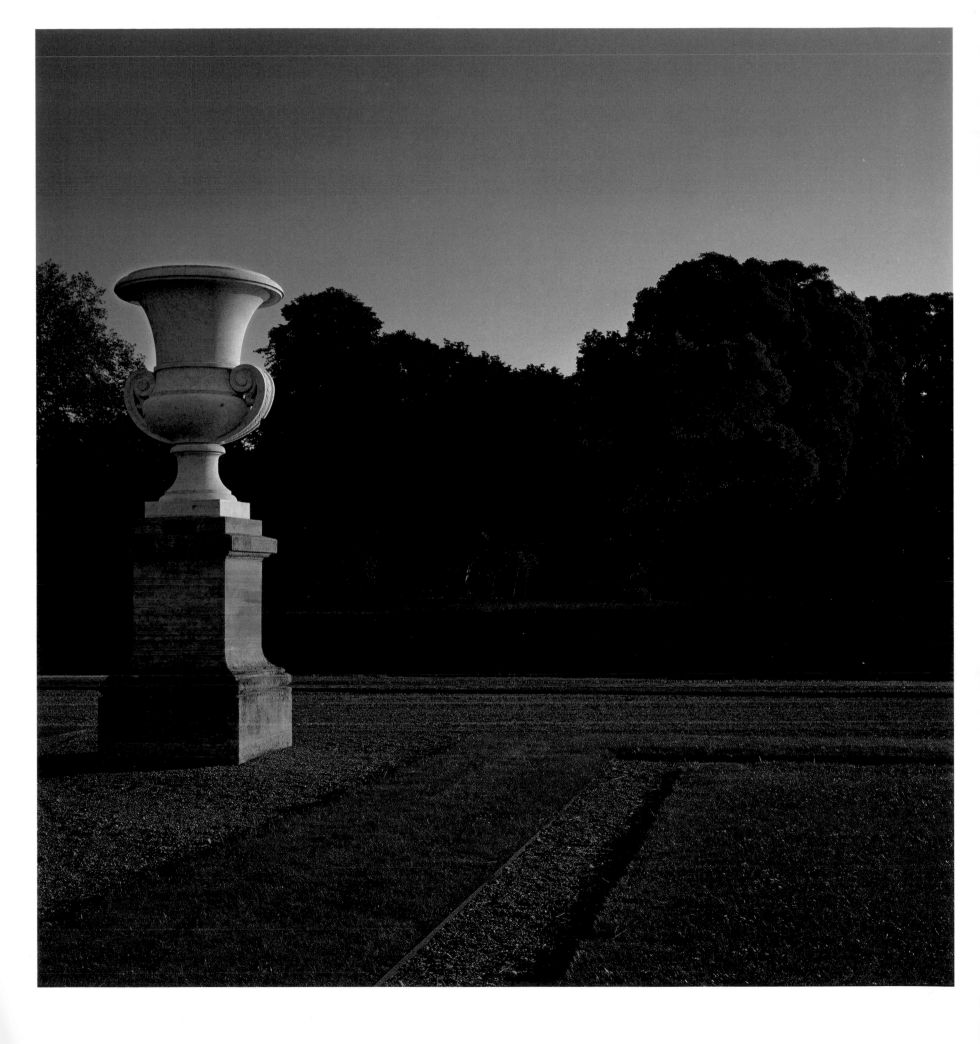

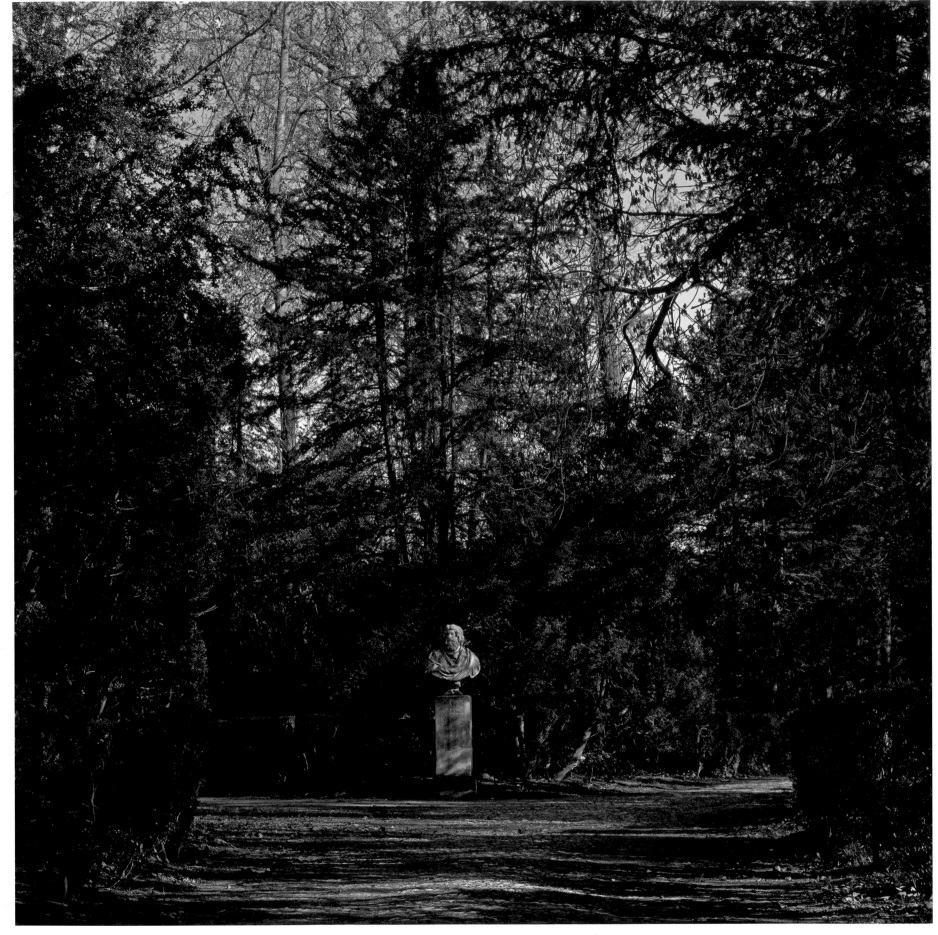

(At the crossroads of the pathways of the Petit Parc.)

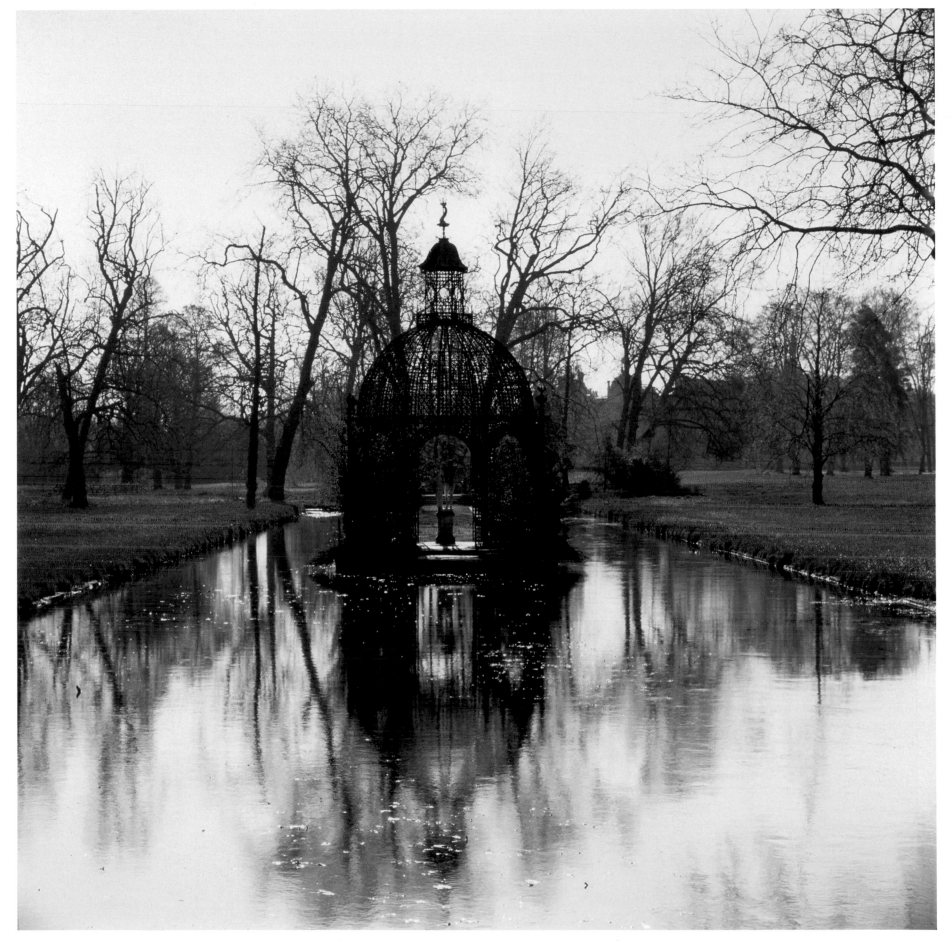

(The Île d'Amour and its gazebo sheltering a statue of Eros.)

RUSSIA

PETERHOF

The Summer Palace of Peter the Great

CONSTRUCTION BEGAN IN 1714 ON THIS GRANDIOSE DREAM DESIGNED BY PETER THE GREAT and the architects Le Blond, Braunstein, and Michetti. The enchanting site, only thirty minutes by boat from the pier of the State Hermitage Museum in Saint Petersburg, combines the elegant shoreline of the Gulf of Finland with a sophisticated garden, a grand palace, several smaller seaside palaces, fountains, and statues. Entirely restored after its destruction during World War II, the setting is equal to the ambitions of Tsar Peter the Great, who had visited many classical gardens in Europe including Versailles and Marly and participated in drawing up the plans for Peterhof, which would be his summer residence.

A canal lined with fountains and conifers leads from the sea to the palace, which is built on a bluff just above the extraordinary roaring Grande Cascade that plunges into an exceptionally large basin. There, the main fountain depicts Samson ripping open the jaws of a lion, symbolizing Russia's victory over Sweden at the Battle of Poltava in 1709. On the other side of the palace, Elizabeth, the daughter of Peter the Great, added two wings and two corner pavilions along with the upper garden and its basins, the fountain of Neptune, arbors, and trellises. This garden served as a prestigious main courtyard. Facing the sea, an immense lower park with a network of rectilinear promenades, which cut in at right and oblique angles, all lead to fountains or small palaces. A promenade parallel to the maritime canal offers a spectacular view of the Chessboard Hill Cascade, which is fed by water jets from three winged dragons, a water wall that is fed by vertical jets, and then the Roman Fountains. Farther on, turning on their axes like the automatons of a Renaissance garden, the Sun Fountain leads to other "trick" fountains such as the fountains Oaklet, Umbrella, and Small Benches, all of which spray unsuspecting guests. The Monplaisir Palace is on the seaside, where the Tsar would retire with his books and paintings. To the left of the canal, the Adam and Eve Fountains lead to the Hermitage, a small one-story palace surrounded by a moat. Farther still, separated from the sea by a dike with a procession of trimmed, ball-shaped linden trees, is the extraordinary Palace of Marly and its small French formal garden, which offers a view of the Golden Hill Cascade made of white marble and gilded copper—one of the true masterpieces of this city of fountains!

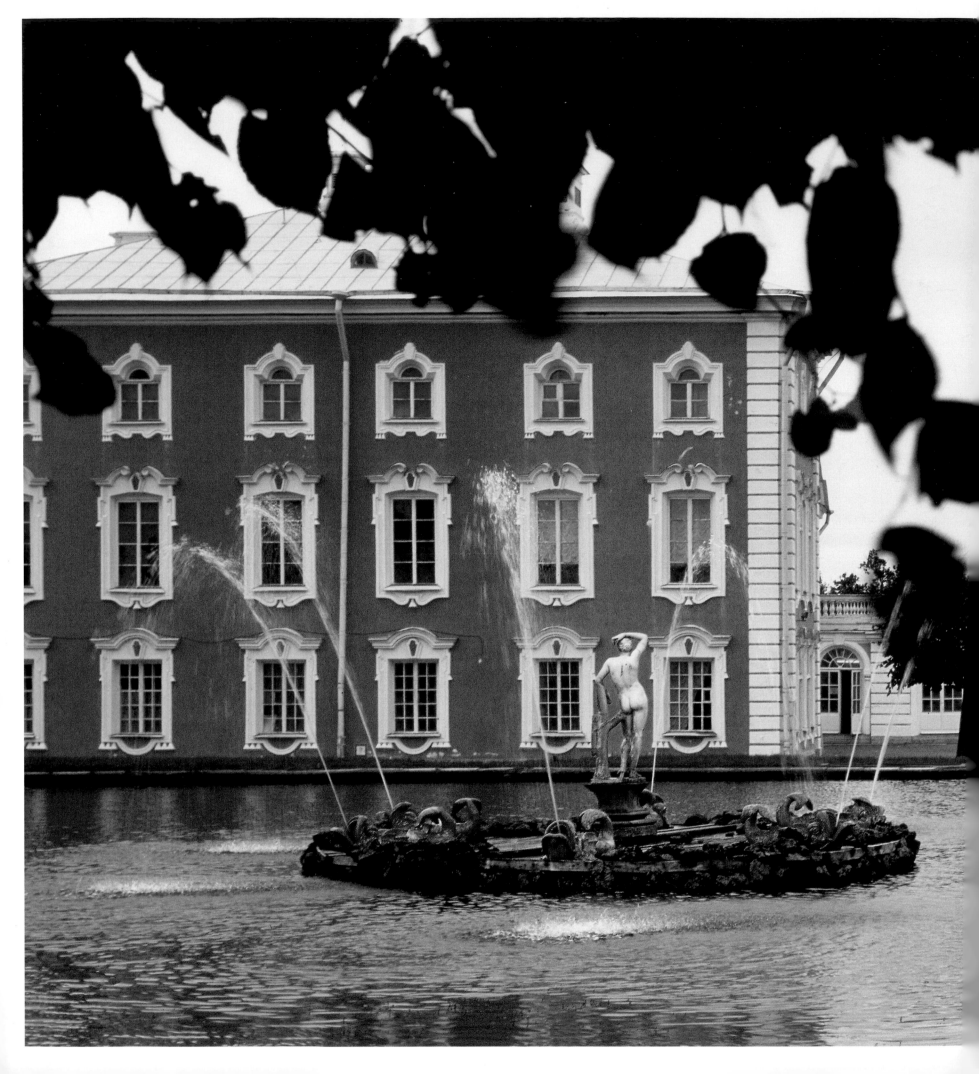

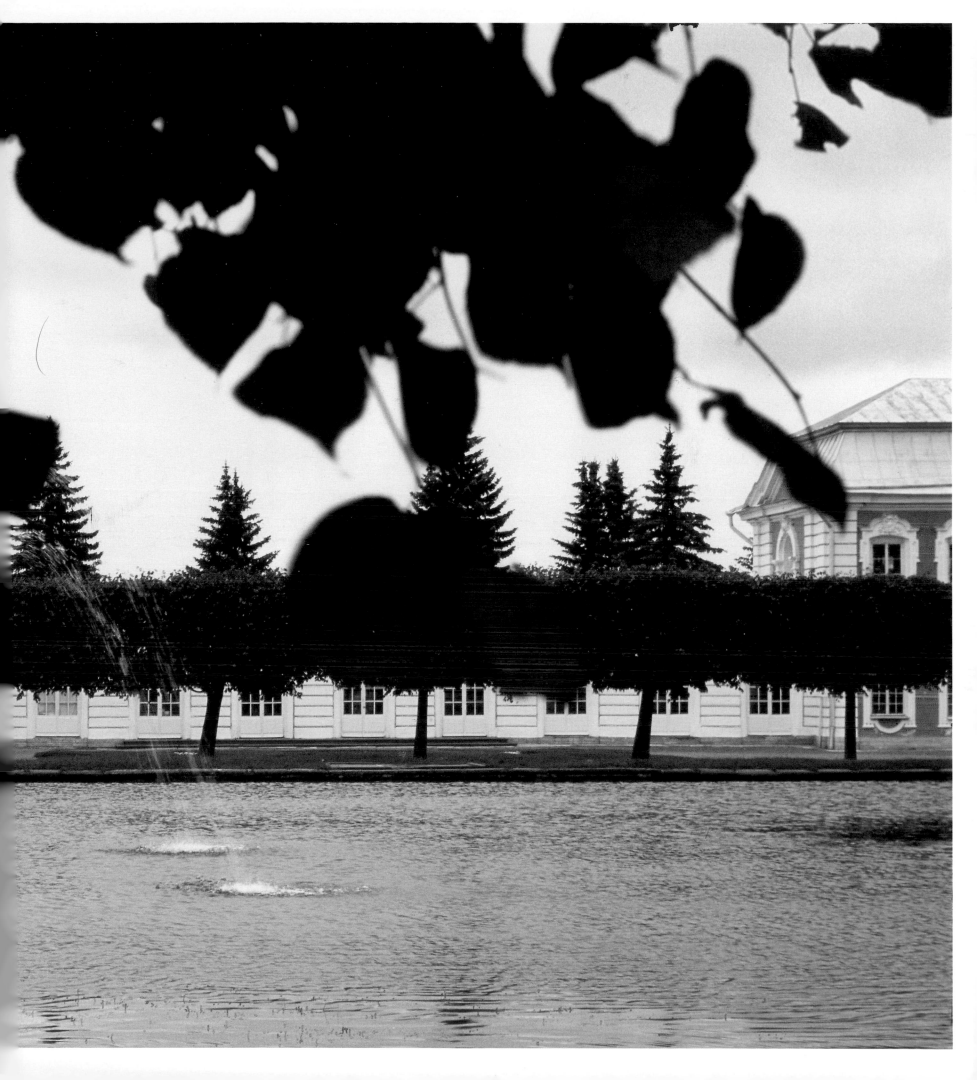

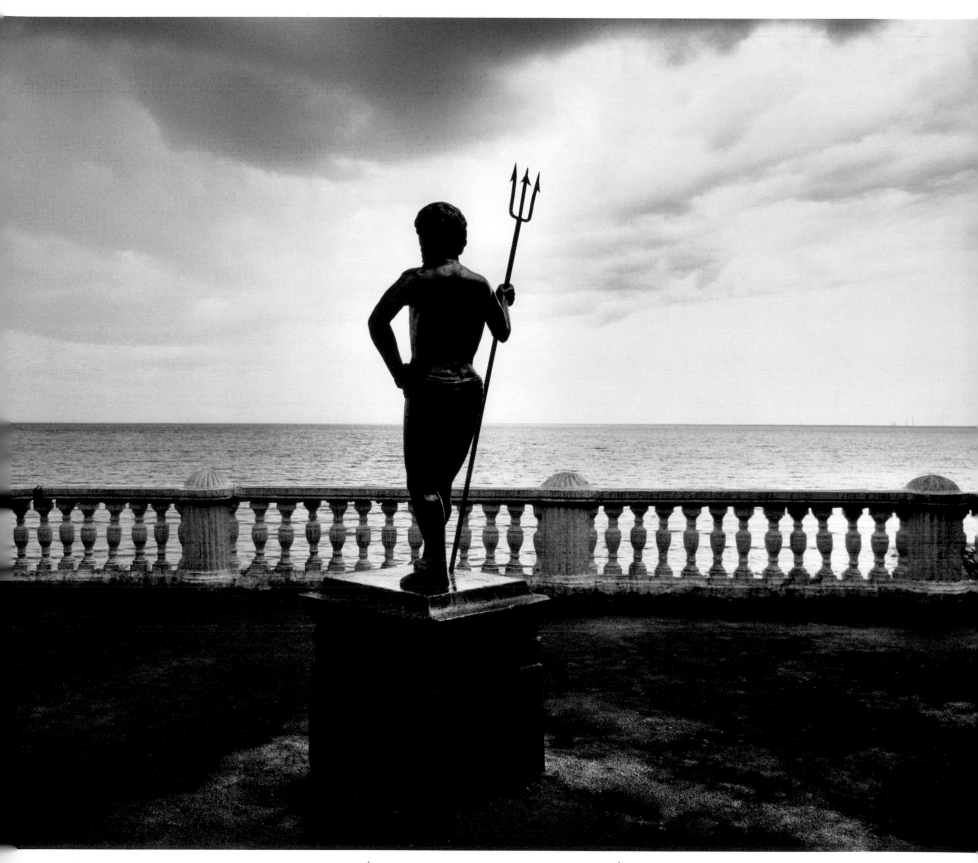

(PAGES 176-177 On the parterres of the Upper Garden.)

(OPPOSITE Hermitage on the Gulf of Finland.)

(ABOVE Neptune on the terrace of the Monplaisir Palace.)

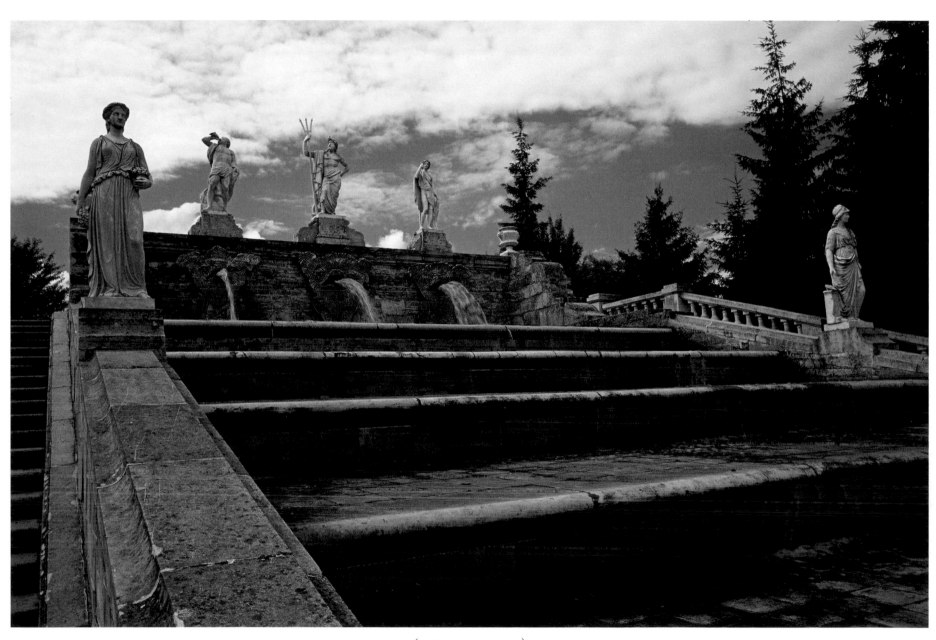

(Golden Hill Cascade.)

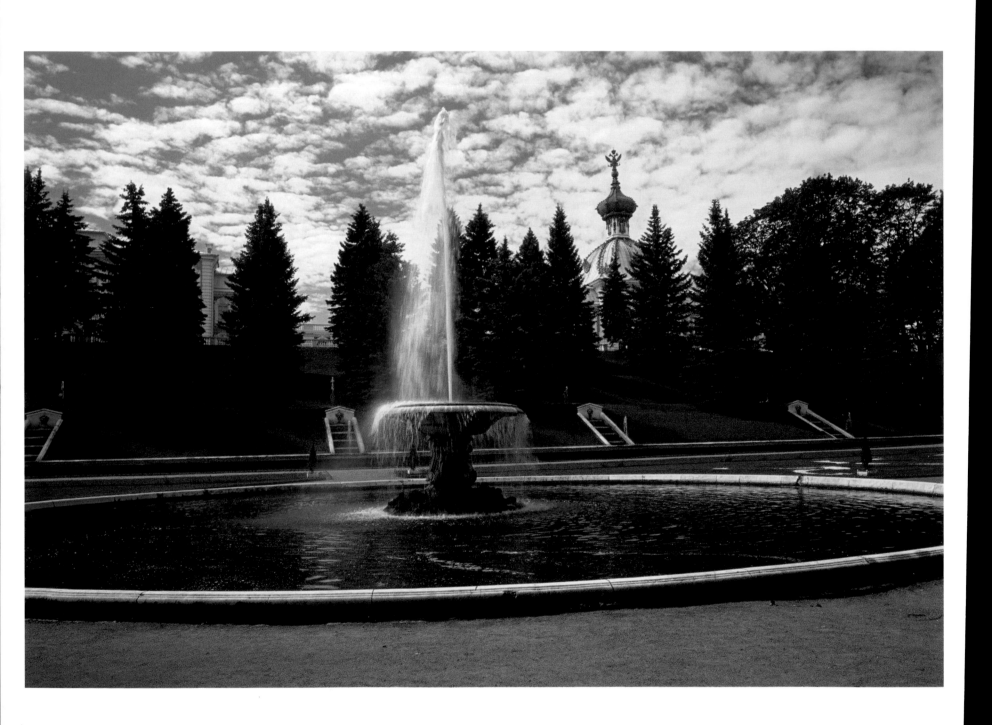

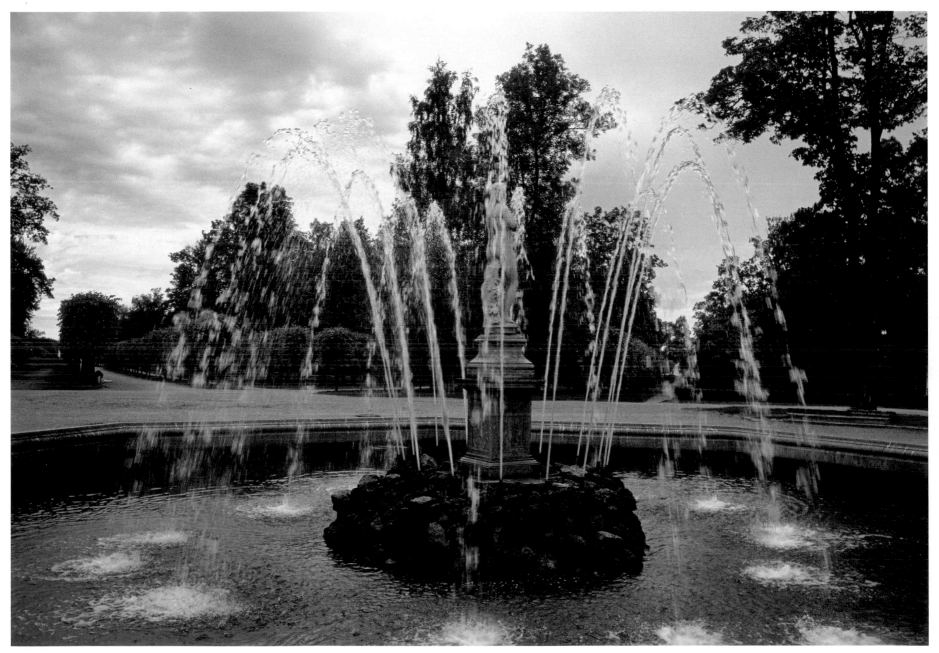

（ Eve Fountain. ）

BELGIUM

ROYAL
GREENHOUSES
OF
LAEKEN

The Eternal Springtime of King Leopold II

IN 1873, IN THE LANDSCAPED PARK OF LEOPOLD II'S CASTLE OF LAEKEN, FOUR MILES NORTH OF Brussels, this "Builder King" and the architect Alphonse Balat broke ground to bring to life the king's dream of an "ideal glass palace." Later the architects Henri Maquet and Charles Giraud would enlarge and modify the park, which served as the setting for formal receptions and the showcase for rare plant collections. Marvelously maintained and dressed in the colors of "eternal spring" that were so dear to King Leopold, these greenhouses welcome the public for three weeks every year. Visitors can stroll from one greenhouse to another, through half a mile of transparent pavilions and galleries covered with flowers including *Selaginella*, a plant native to South Africa.

A trip through greenhouses begins at the Débarcadère where a loggia leads to the subtropical Palm House with Kentia palms that date back to the time of Leopold II. A staircase then takes visitors to a gallery whose walls and domed ceiling house an overflowing abundance of *Pelargonium*, *Fuchsia*, *Heliotropium*, and *Abutilon* in the colors of the Belgian flag. From here you can enter the Azalea Greenhouse with its festival of fragrances, large flowers, and lovely assortment of hybrid plants. Next is the Geranium Gallery overlooking the Greenhouse of Diana, which is adorned with a marble statue of the goddess and large-leafed topical plants. A slight slope goes down to the Mirror Greenhouse and into a subterranean passage to the Embarcadère, the lowest section of the greenhouses, decorated with large Chinese vases brought back by the king during a voyage to the Far East. Another staircase takes you to the Congo Greenhouse that contains a collection of Howea palms and *Ficus elastica*, also known as the rubber fig. At the back of the greenhouse, tree-like ferns herald the most spectacular of the greenhouses, the Winter Garden. The colossal size of this structure allows the palm trees within to grow to amazing heights. It also shelters rare plants like *Aralia mexicana*. The orangery with its seven hundred fifty plants and camellia collection—an historic treasure and the largest greenhouse collection in the world—marks the end of the trip, leading visitors out along a path lined with orange trees, laurels, and blooming rhododendrons.

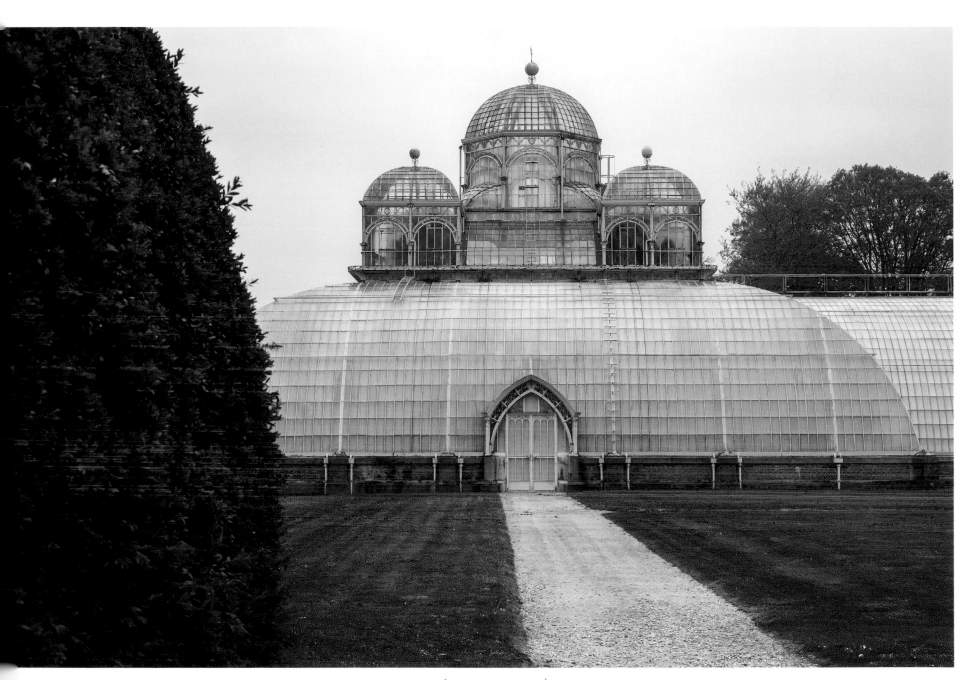

（ Congo Greenhouse. ）

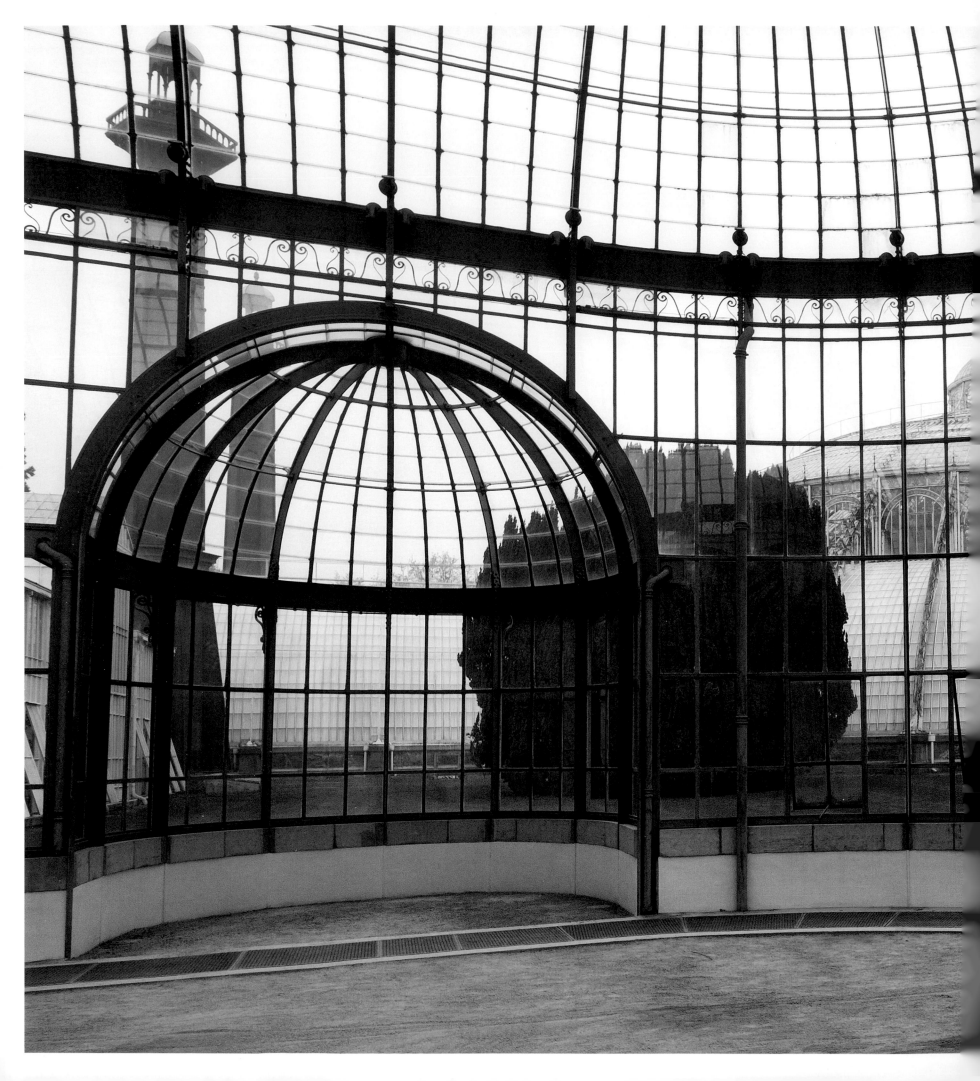

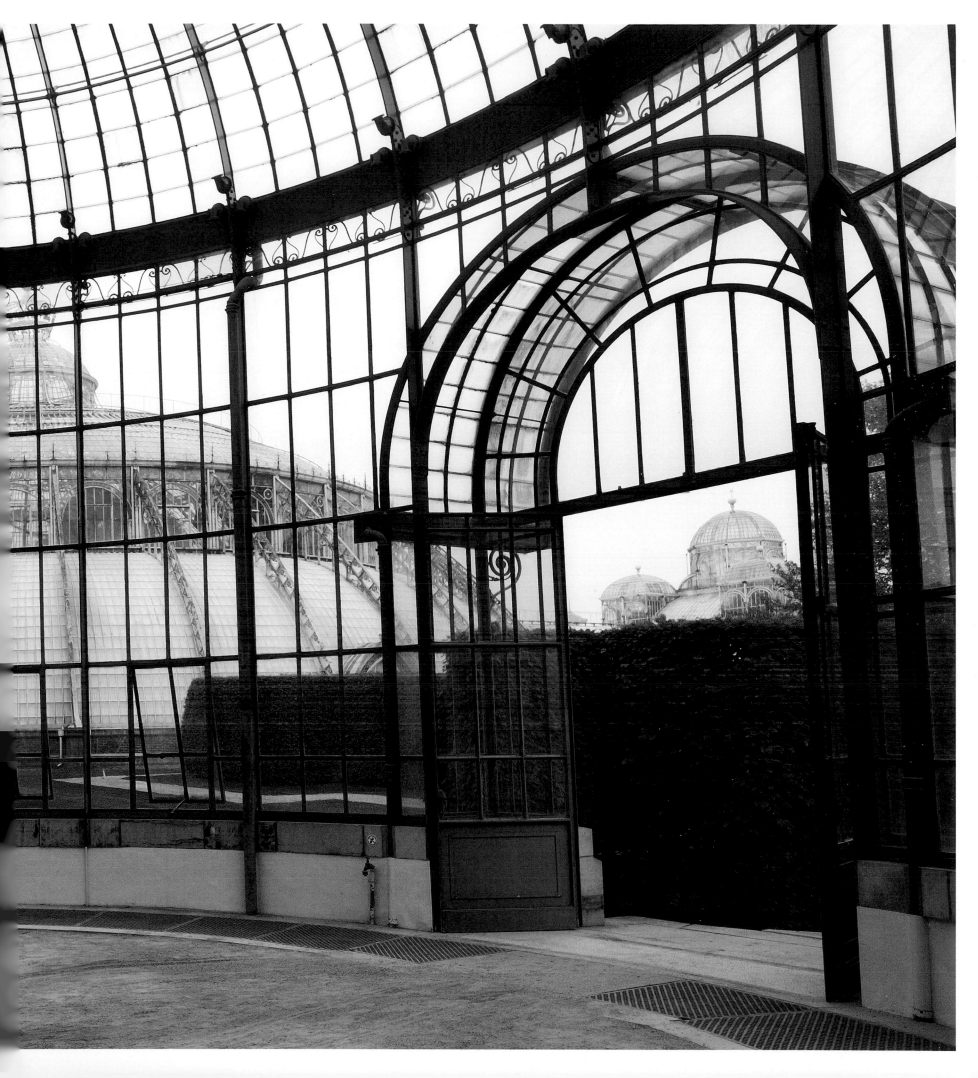

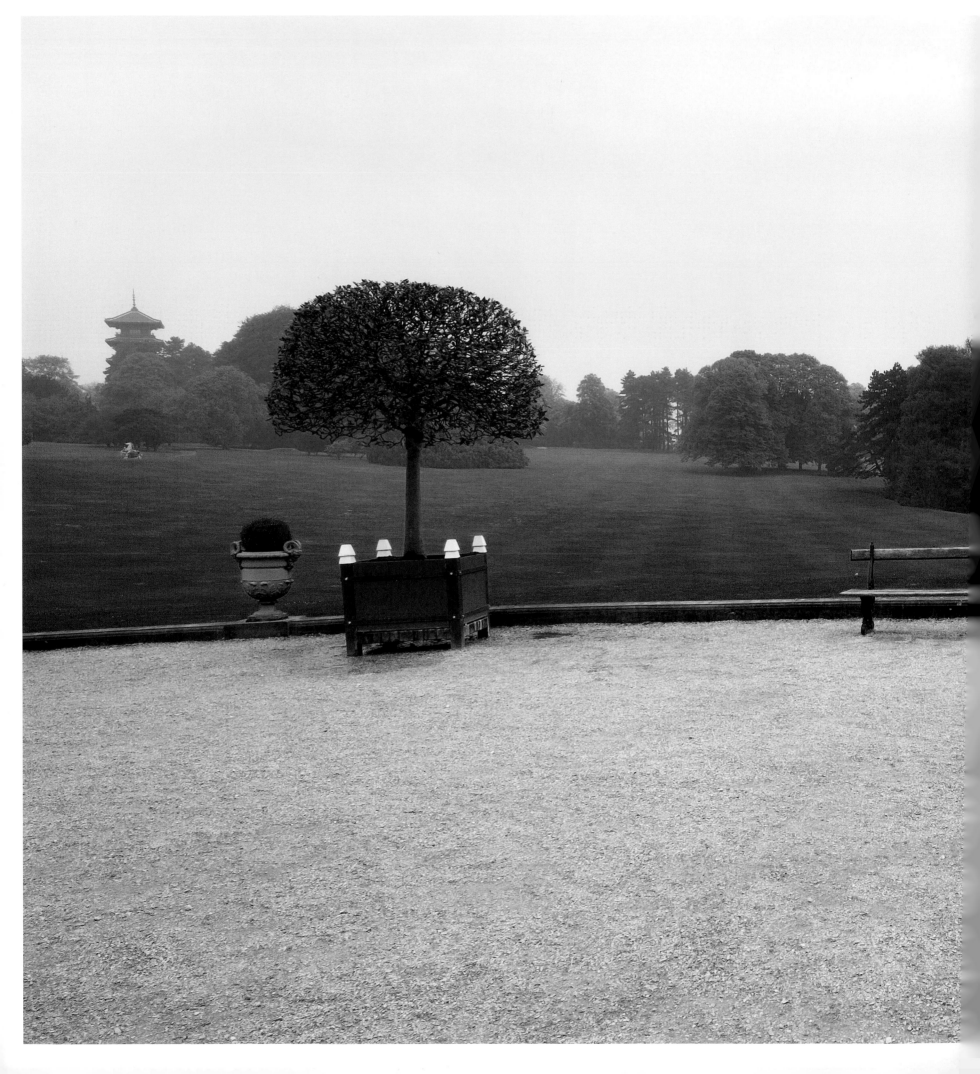

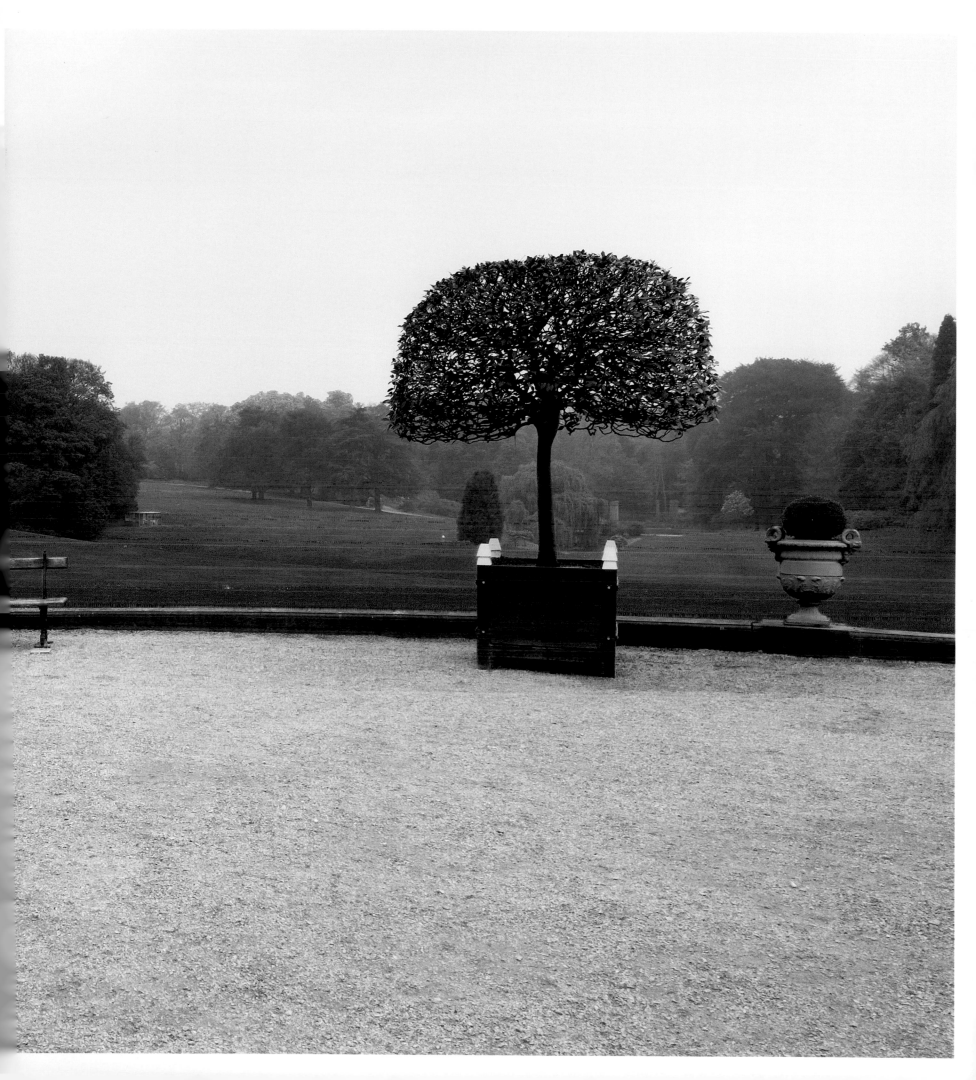

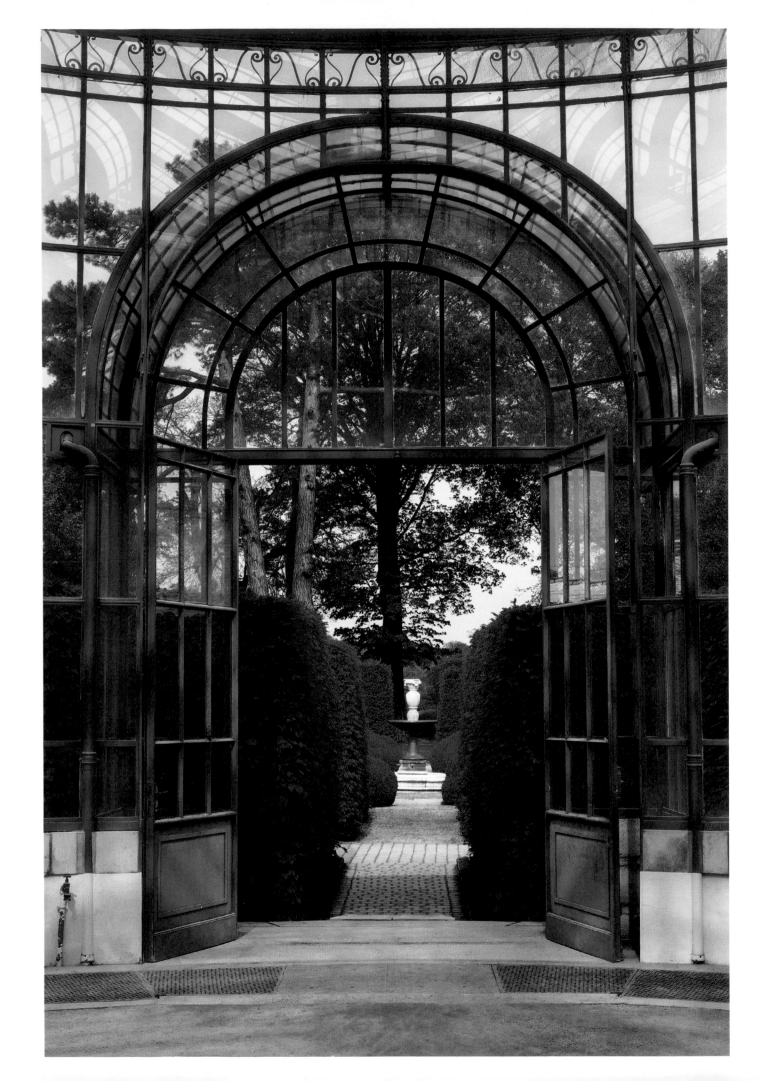

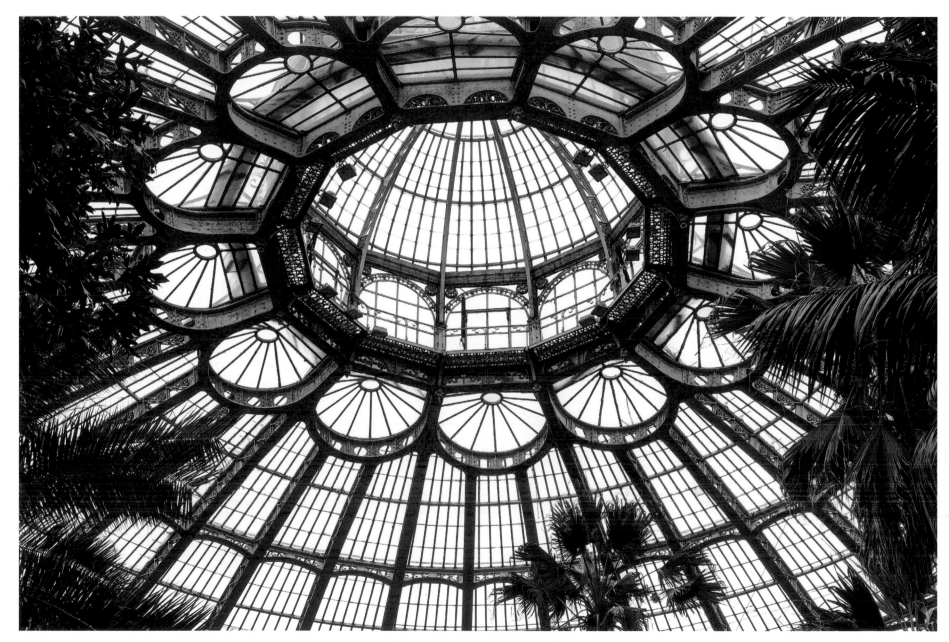

(The dome of the Winter Garden.)

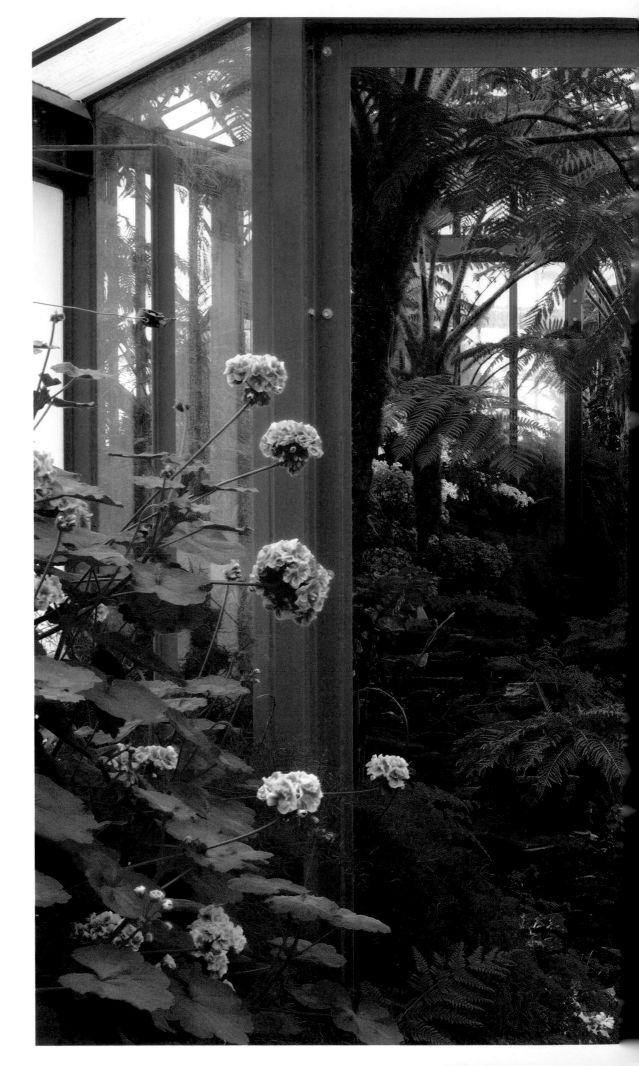

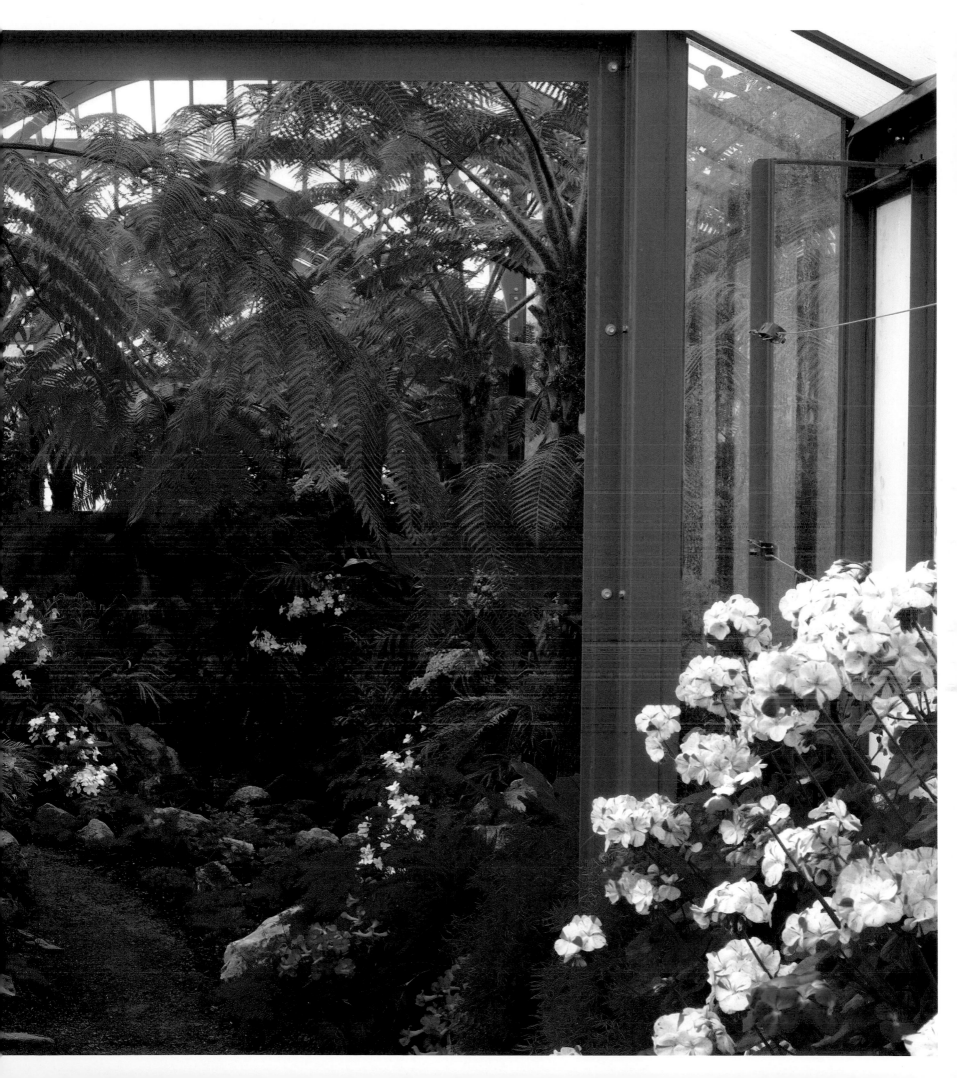

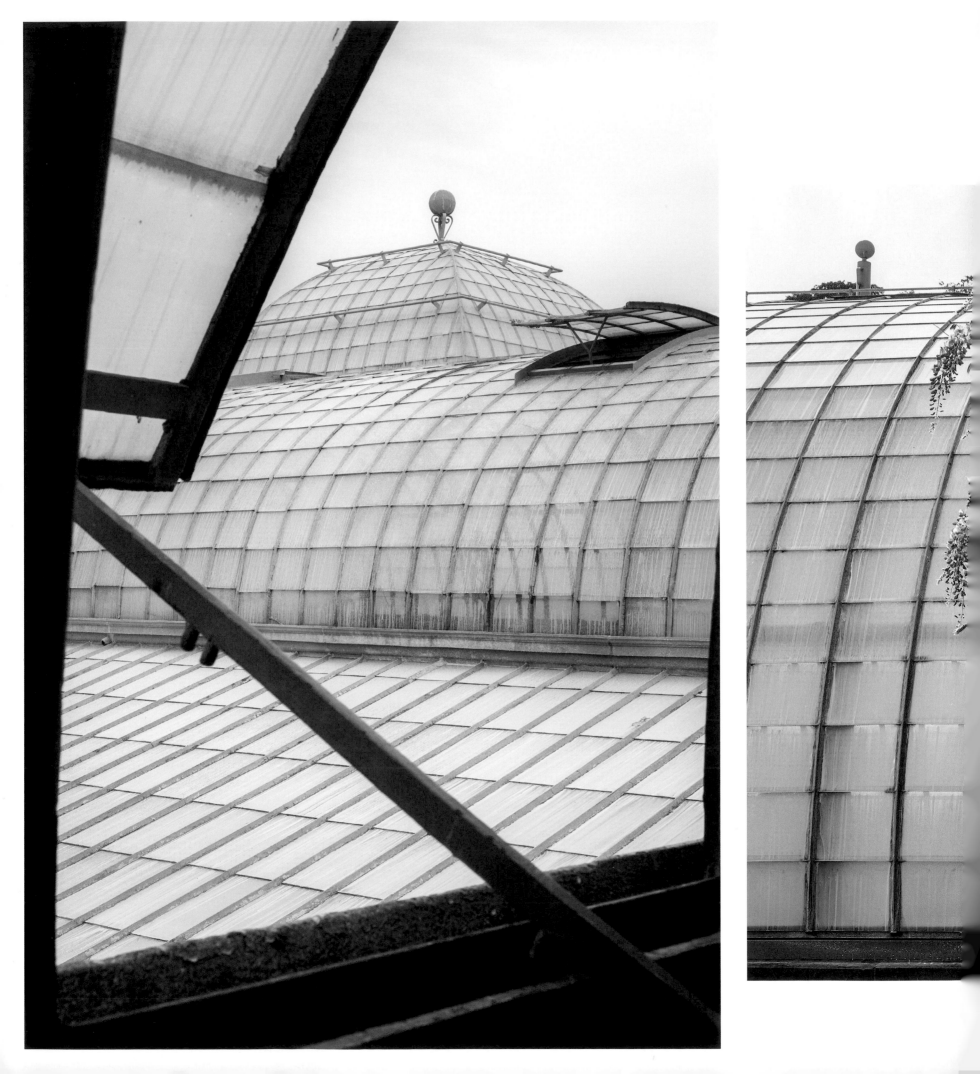

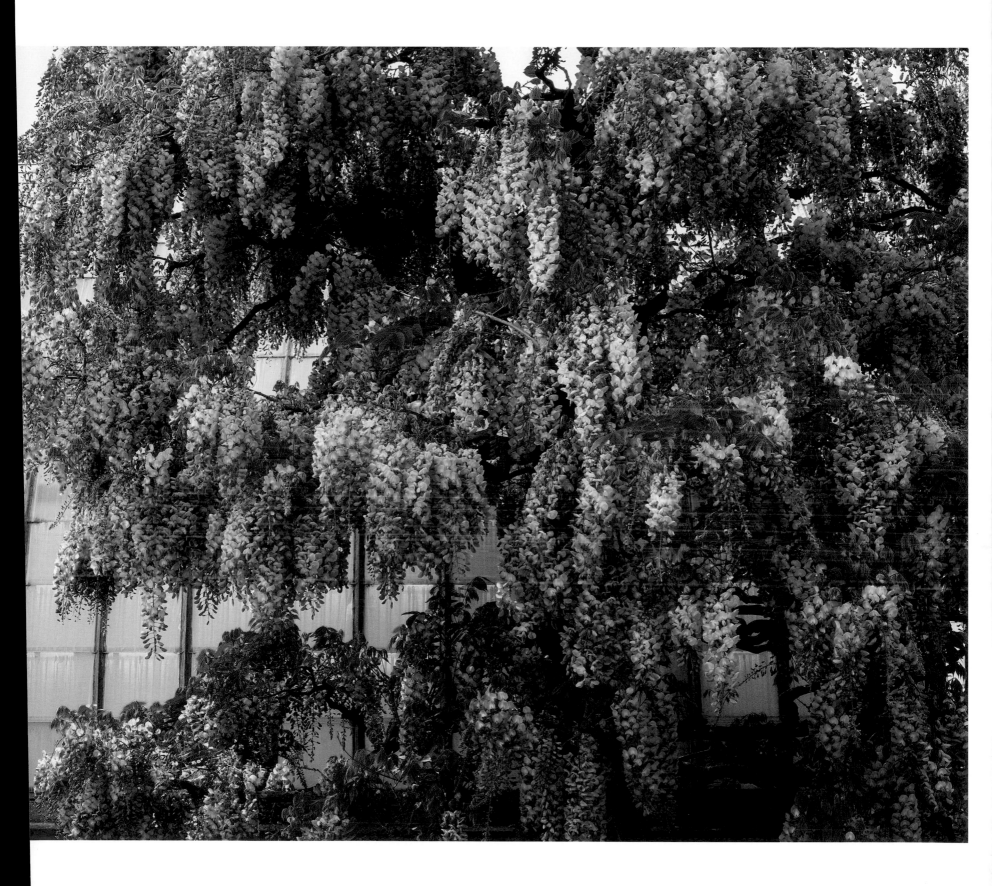

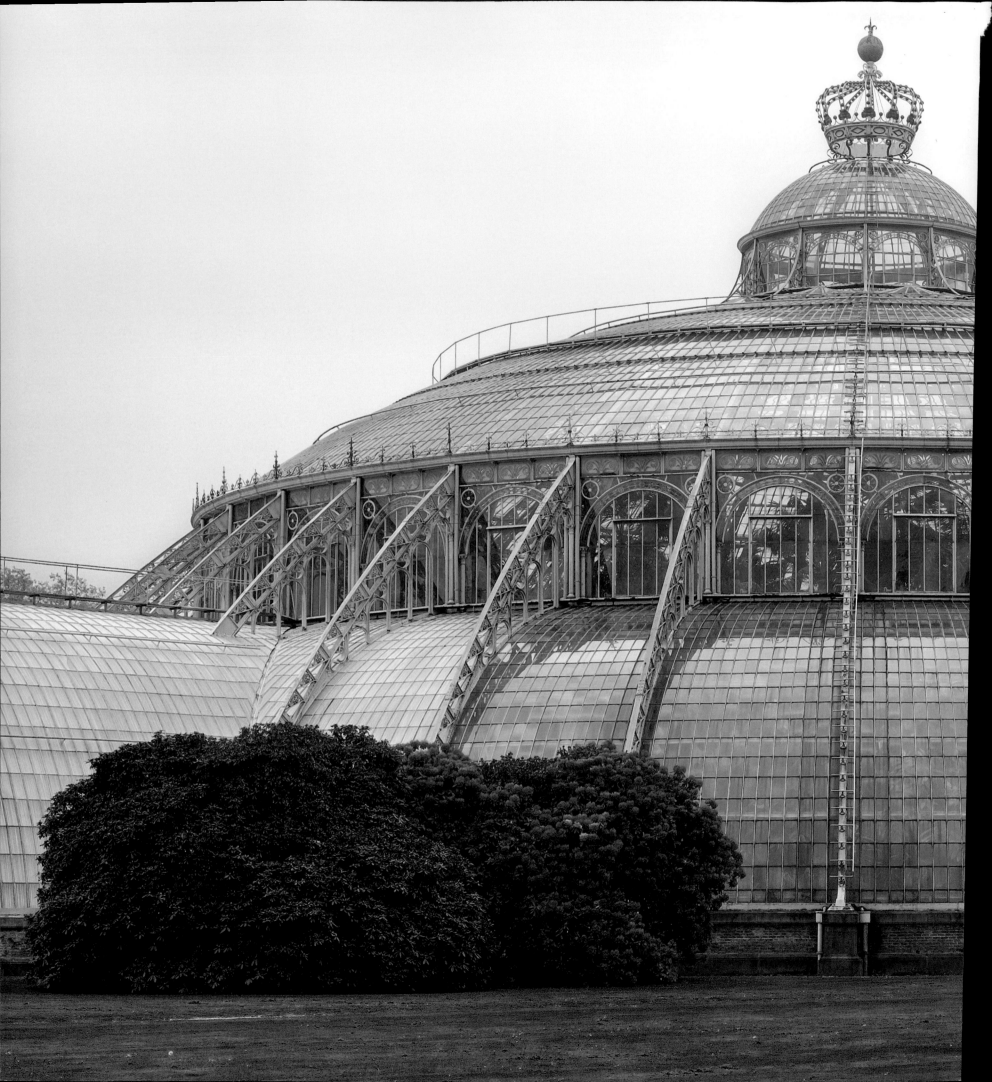

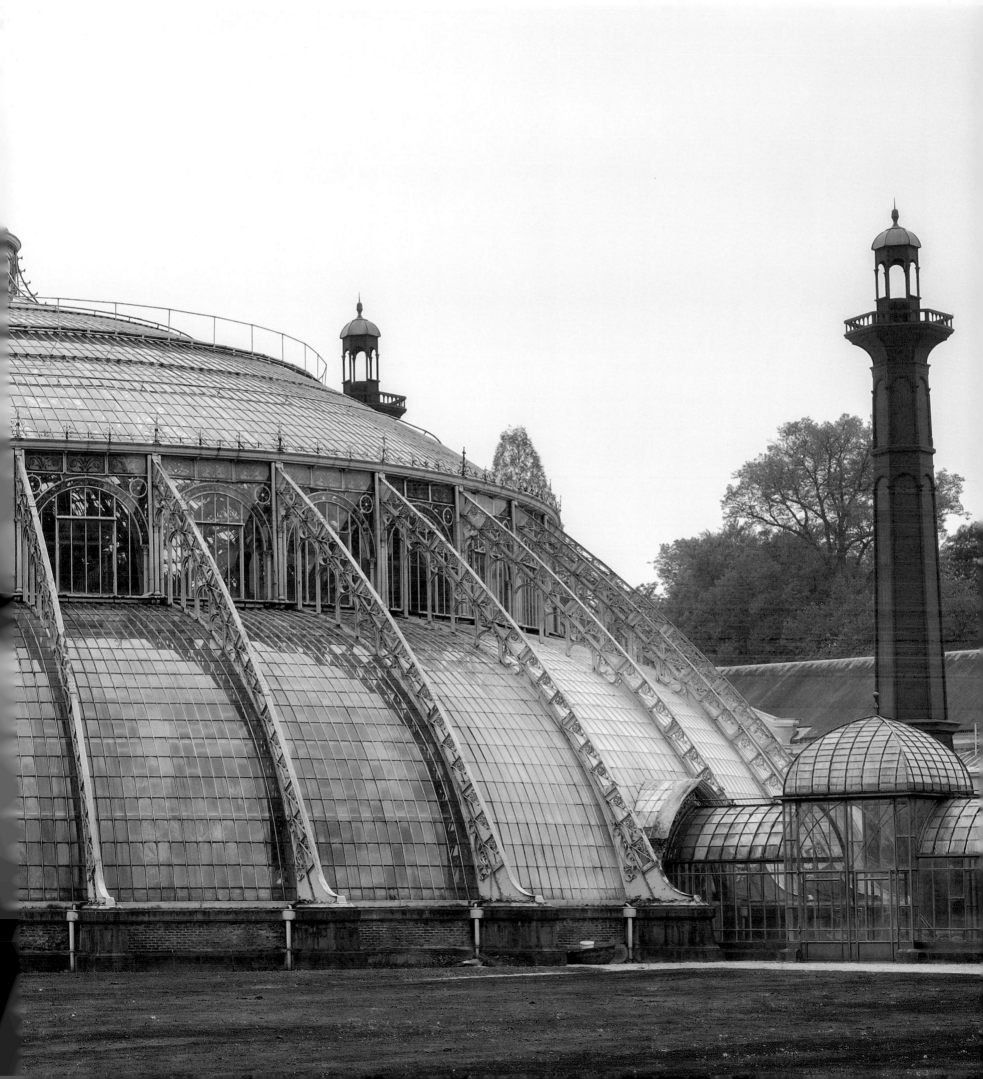

TSARSKOYE SELO

The Verdant Finery of Catherine's Palace

I F THE PETERHOF GARDENS AND ITS NUMEROUS PAVILIONS MANIFEST THE LIFE AND ASPIRATIONS of Peter the Great, then Tsarskoye Selo reveals the still-golden thread of the history of the tsars. The palace, located fifteen miles south of Saint Petersburg, is known as Catherine's Palace in homage to the wife of Peter the Great and first empress of Russia who reigned for two years after the death of her husband. It was only a modest two-story building when he gave it to her as a gift in 1710. Their daughter, the Empress Elizabeth, wanted to transform it into an impressive summer residence. She began a huge expansion project in 1743 with the architect Mikhail Zemtsov, who added two lateral wings and two pavilions. Later, Bartolomeo Rastrelli demolished the structure and created the palace we see today. The Amber Room, with its replicas of the famed amber-laden panels given to Peter by Frederick William III of Prussia, is a wonder to behold, and from the gallery designed by Charles Cameron, a colonnade for strolling and philosophical discussion, the view over the park and its follies is magnificent.

Near the palace, in the Old Garden designed by Rastrelli and adorned with interlacing parterres, is the Cold Bath built by Cameron and modeled after the baths of Emperor Constantine. Its Agate Rooms open to a hanging garden leading to the Cameron Gallery, whose colonnade decorated with antique busts is an apt setting for a philosophical promenade. Below is the Hermitage where Catherine the Great loved to receive guests. A large pond is dotted with follies—the Grotto dedicated to sailors, the Turkish Baths with its small minaret, and the superb marble Palladian Bridge inspired by the bridges at Stowe and Wilton. These are the signature elements of this landscaped park designed by John Busch. Its island, reachable by boat, houses the Hall on the Island, formerly used for concerts. Nearby is a rostral column commemorating the naval victory over the Turks in the Battle of Chesme. In the area where Catherine Park and Alexander Park meet are other follies, including the Creaking Summer House, and the Large Caprice.

Catherine the Great had a neoclassical palace built by Giacomo Quarenghi for her grandson, the future Emperor Alexander I, which became the preferred residence of the imperial family. His park houses the Chinese Village, which has ten pavilions around an octagonal pagoda.

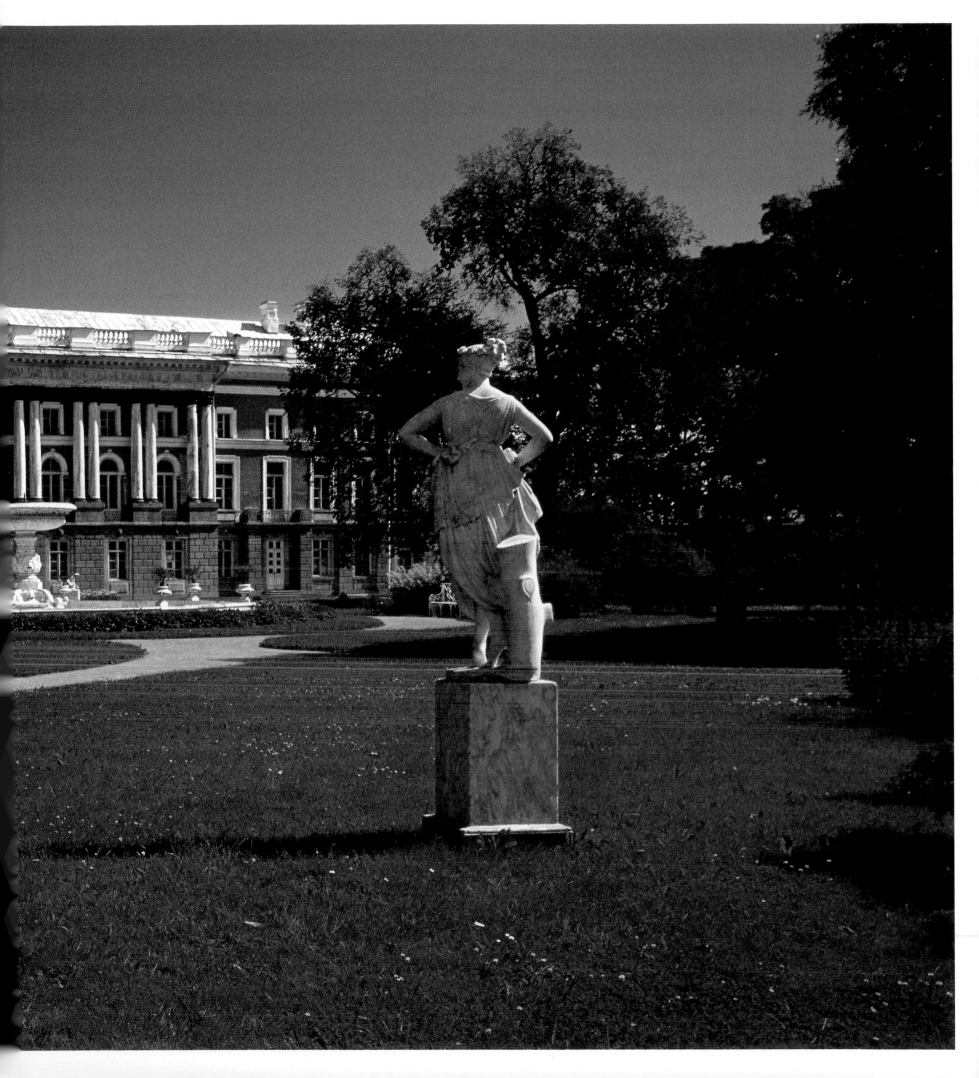

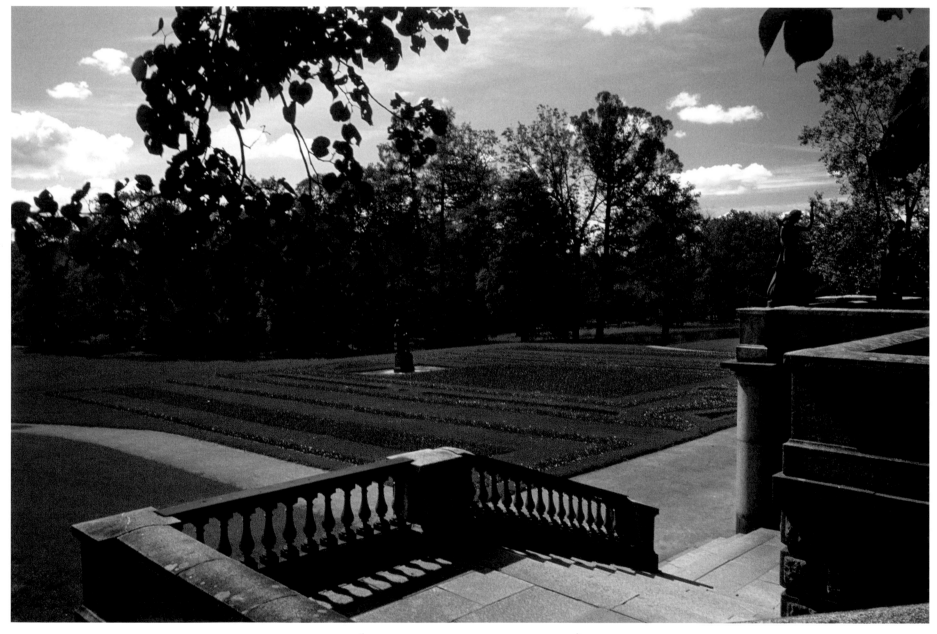

〔 Symmetrical parterres in front of the palace. 〕

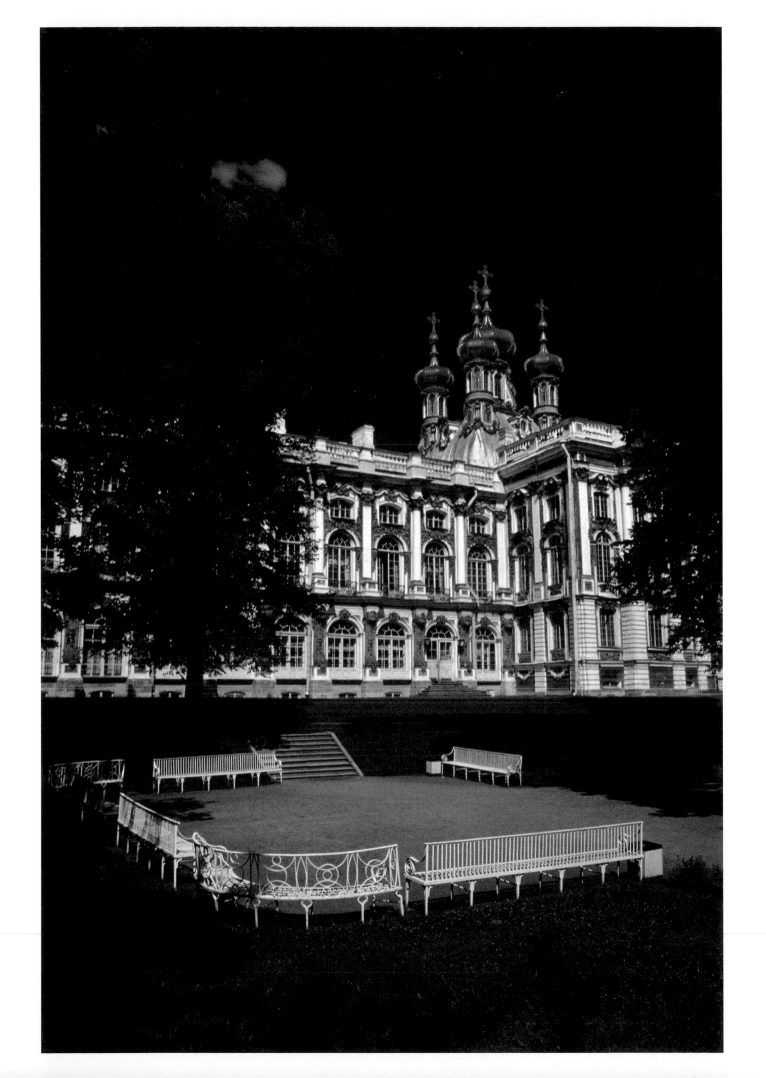

(Around the lake are a row of pleasure pavilions as well as the Turkish Baths, Hermitage, and Grotto.)

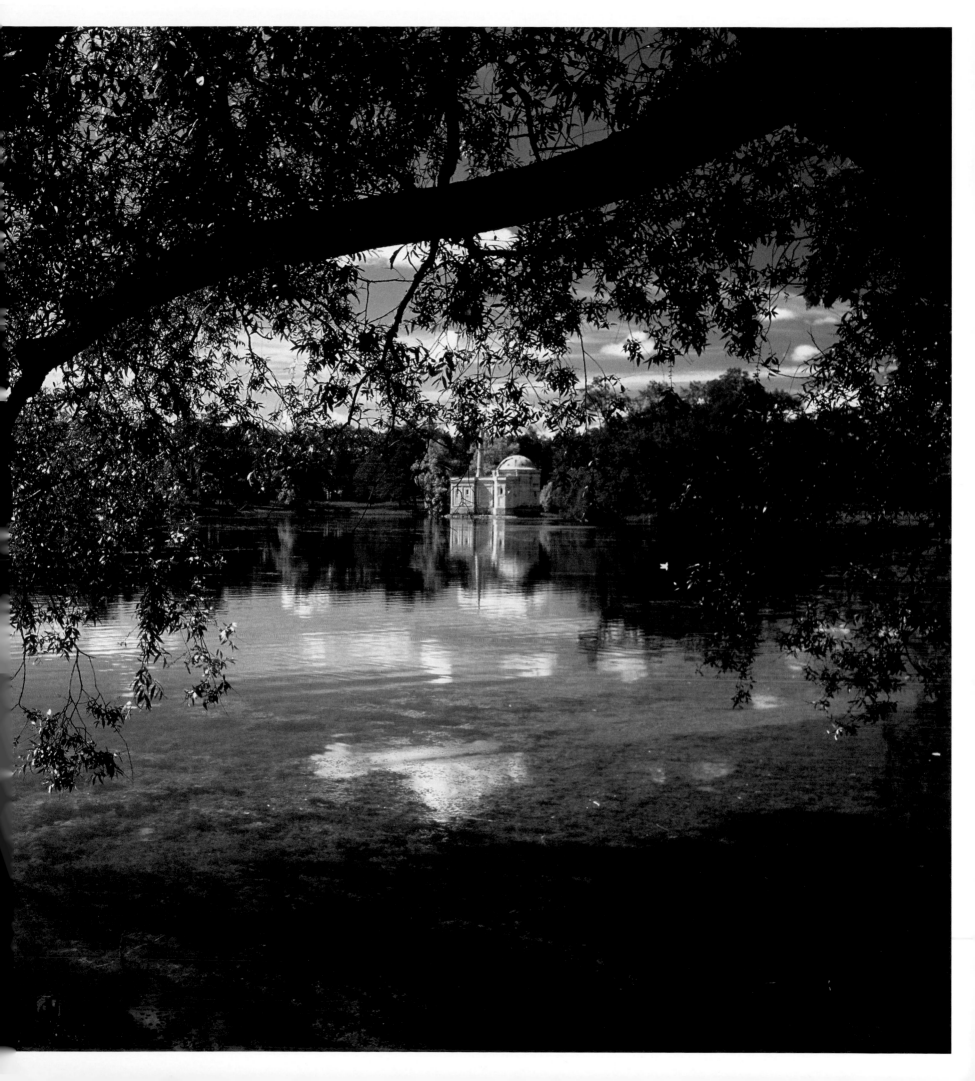

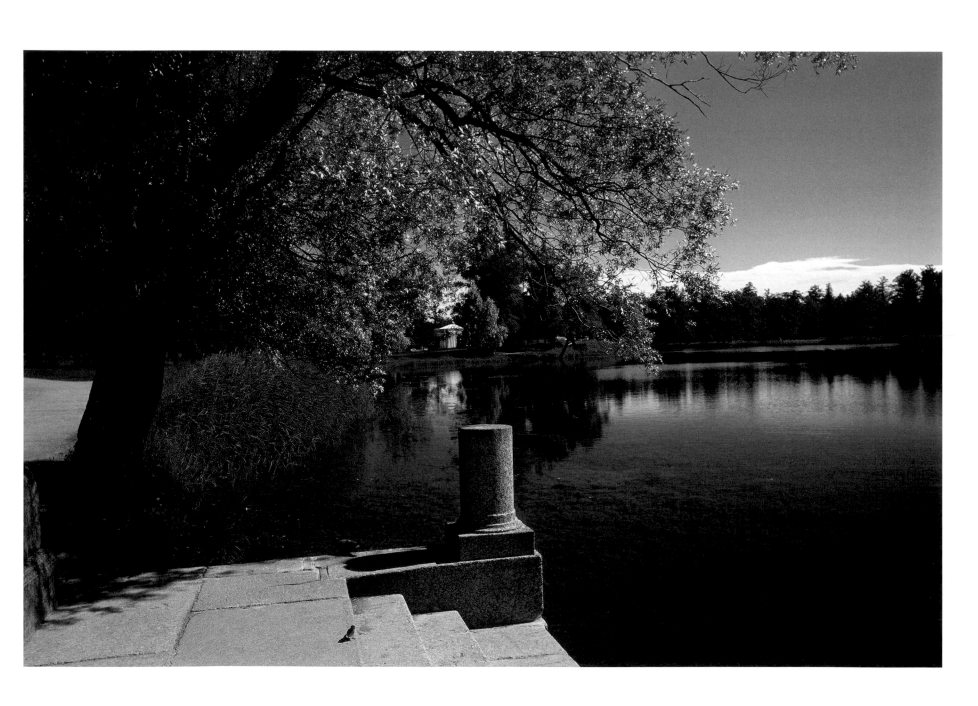

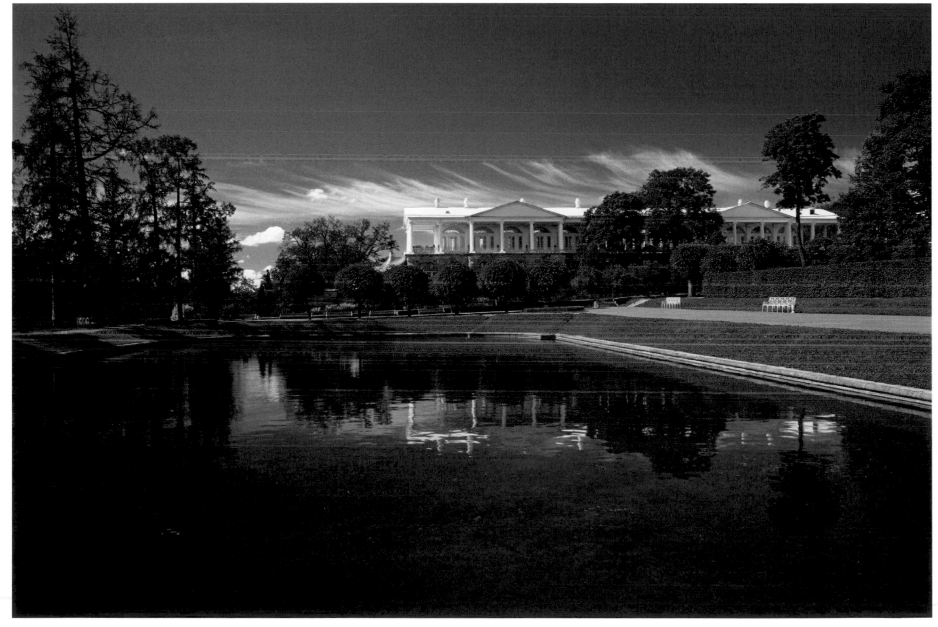

(Cameron Gallery beyond the Mirror Pond.)

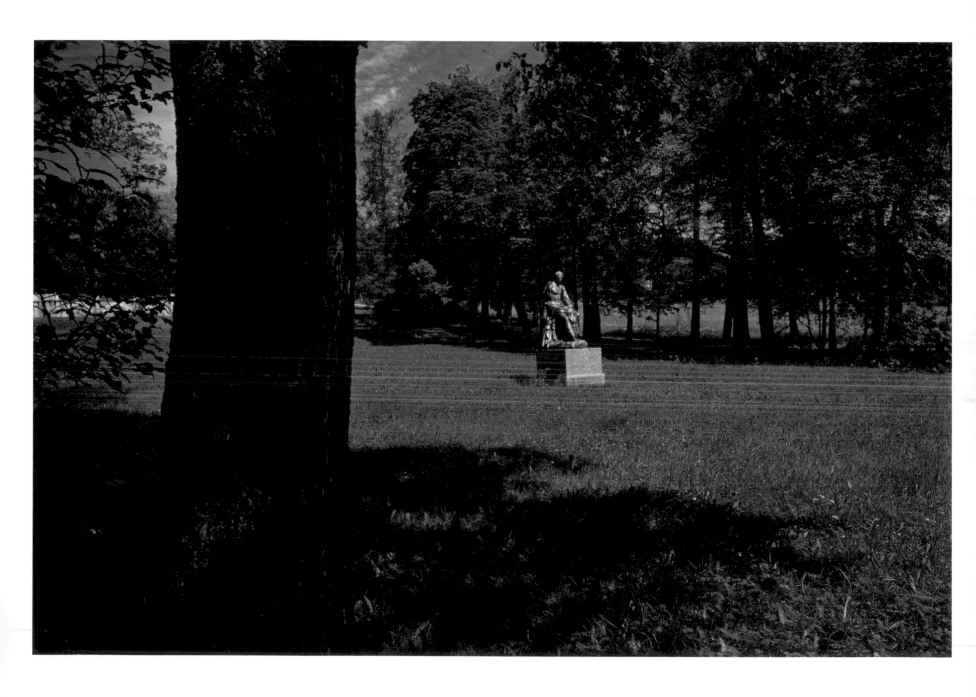

(Mythological and allegorical figures from the collection
of Peter the Great adorn Elizabeth's Garden.)

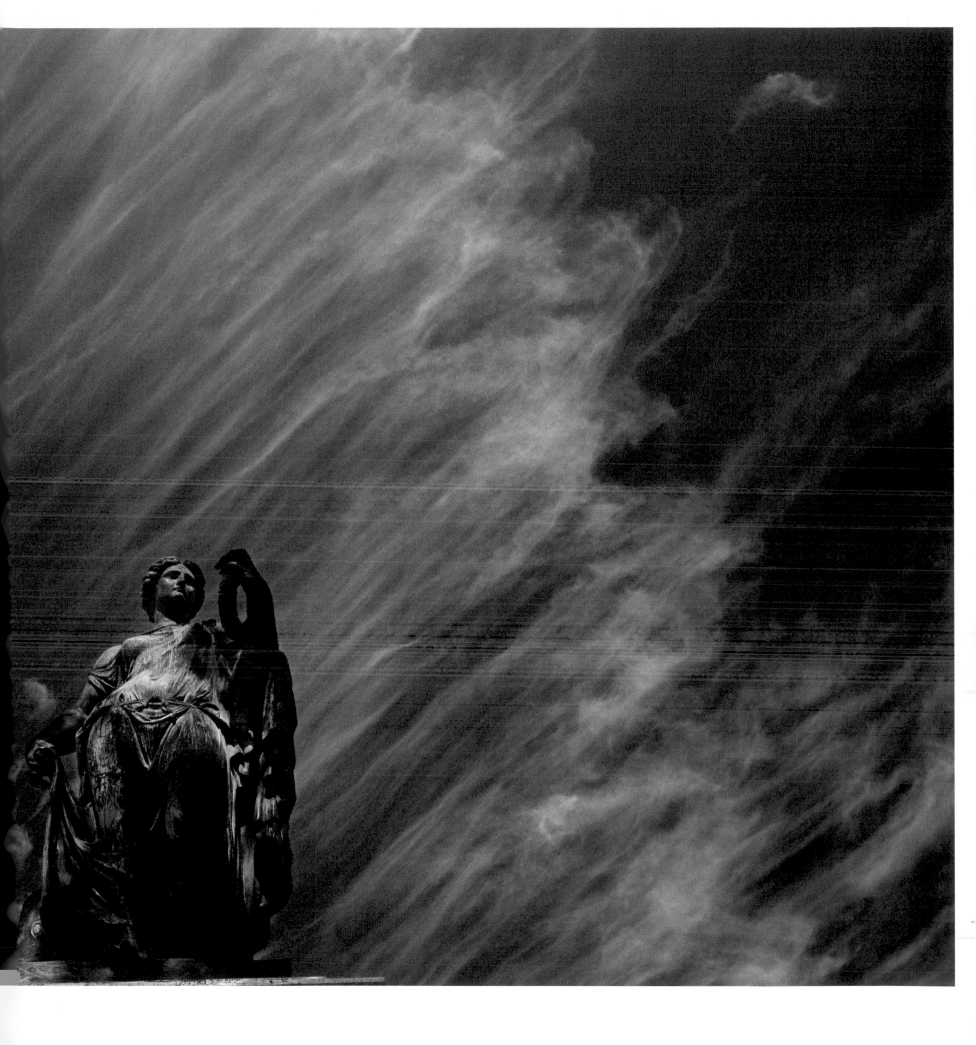

LUXEMBOURG

COLMAR BERG CASTLE

A Romantic Neo-Gothic Residence

A CASTLE HAS BEEN STANDING SENTRY ABOVE THE VALLEY WHERE THE ALZETTE AND ATTERT rivers meet since at least 1400. The castle was acquired in 1845 by William II, king of the Netherlands and grand duke of Luxembourg. In 1849, his successor, William III, transformed it into the neo-Gothic style. Between 1907 and 1911, it was entirely rebuilt, though still in the neo-Gothic style, by the Grand Duke William IV with the help of the architect Pierre Funck-Eydt. They meticulously followed the plans of the architect Max Ostenrieder. A 150-foot-high donjon overlooks four wings that encircle a central courtyard, and the motto of the grand ducal family of Nassau, *Je maintiendrai* (I shall maintain), is written on one of the two ocher towers with blue shutters.

Thirteen miles from the capital, this principal residence of the grand ducal family, surrounded by its well-manicured gardens, has the elegance of an aristocratic manor and the charm of a fairy-tale castle. The park that's there today was designed between 1909 and 1912, at the same time the new castle was being built. The parterres of the terrace that stretch along the east façade are the work of the architect Ostenrieder.

In 1964, after a major restoration of the residence due to its occupation during World War II, the parterre of the terrace was done in the English style with boxwood trees trimmed into smooth shapes and freestanding, mixed flower beds. Then, around 1974, an architect gave it a new structure that used squares edged with cedar boards enclosing free-growing and trimmed plants. Thus, from April to September, harmonious shades of pink, blue, and purple bloom from plants such as gromwell, ornamental garlic, wisteria, sage, verbena, lavender, hydrangea, larkspur, phlox, peonies, and roses…

On the north lawn is a greenhouse that was rebuilt in 1984 and contains a vegetable garden. There also, among showy wisteria and flowering crab apple trees, is an elegant rose garden. From the terrace and its supporting wall ornamented with a cascade of wisteria, lavender, and peonies, there are winding paths where you can discover a great variety of trees as you stroll southward to a decorative pool, crossed by a bridge with a wrought iron railing. Japanese cherry, beech, walnut, weeping willows, maples, oaks, cherry laurels, pine, plane, and chestnut enhance this romantic walk that comes to an end beside the water.

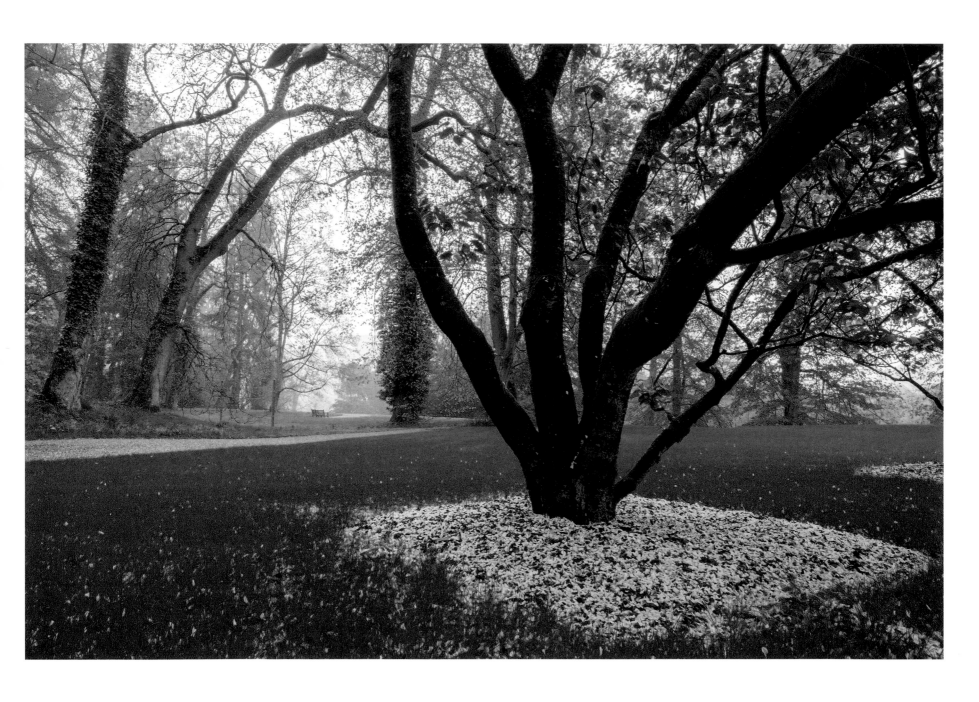

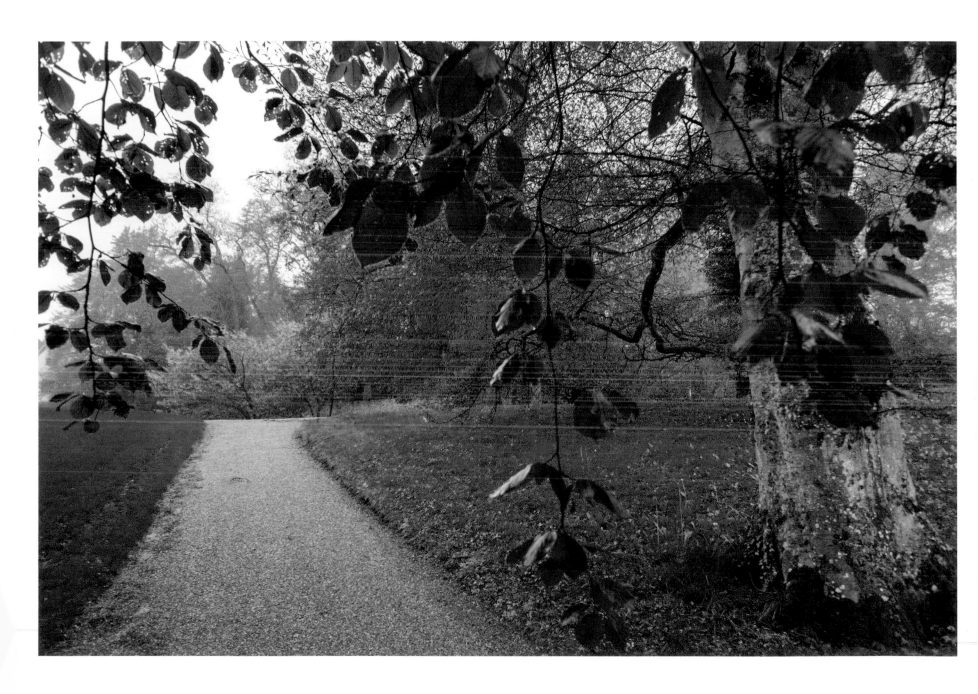

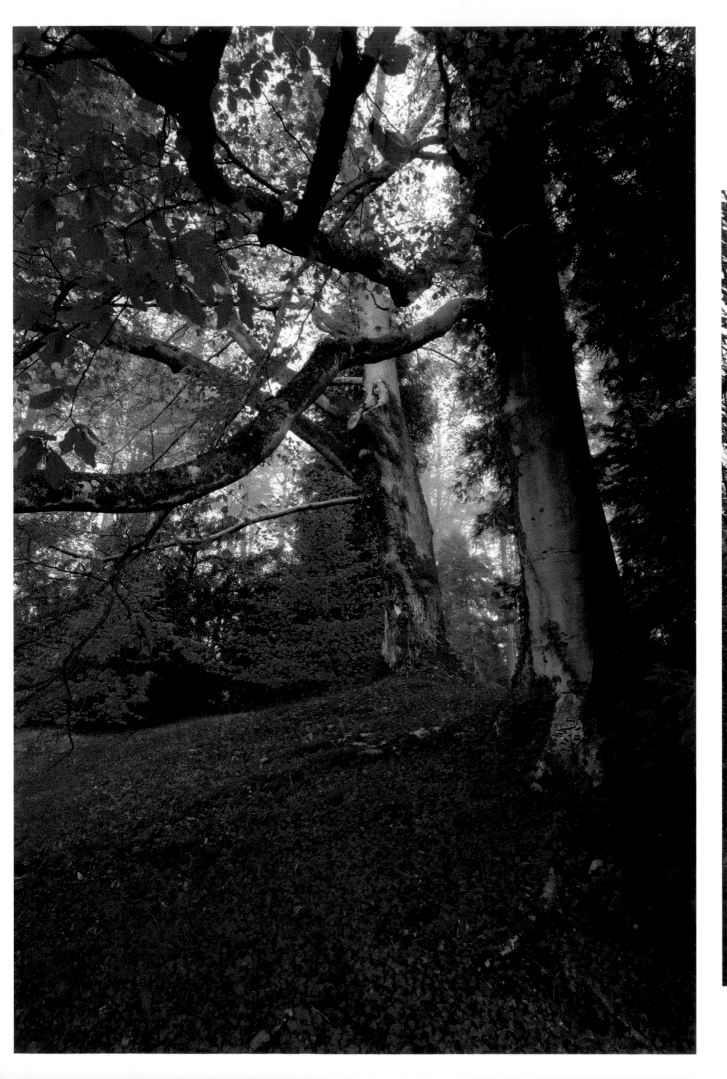

(Overlooking the landscape, the terrace in front of the château.)

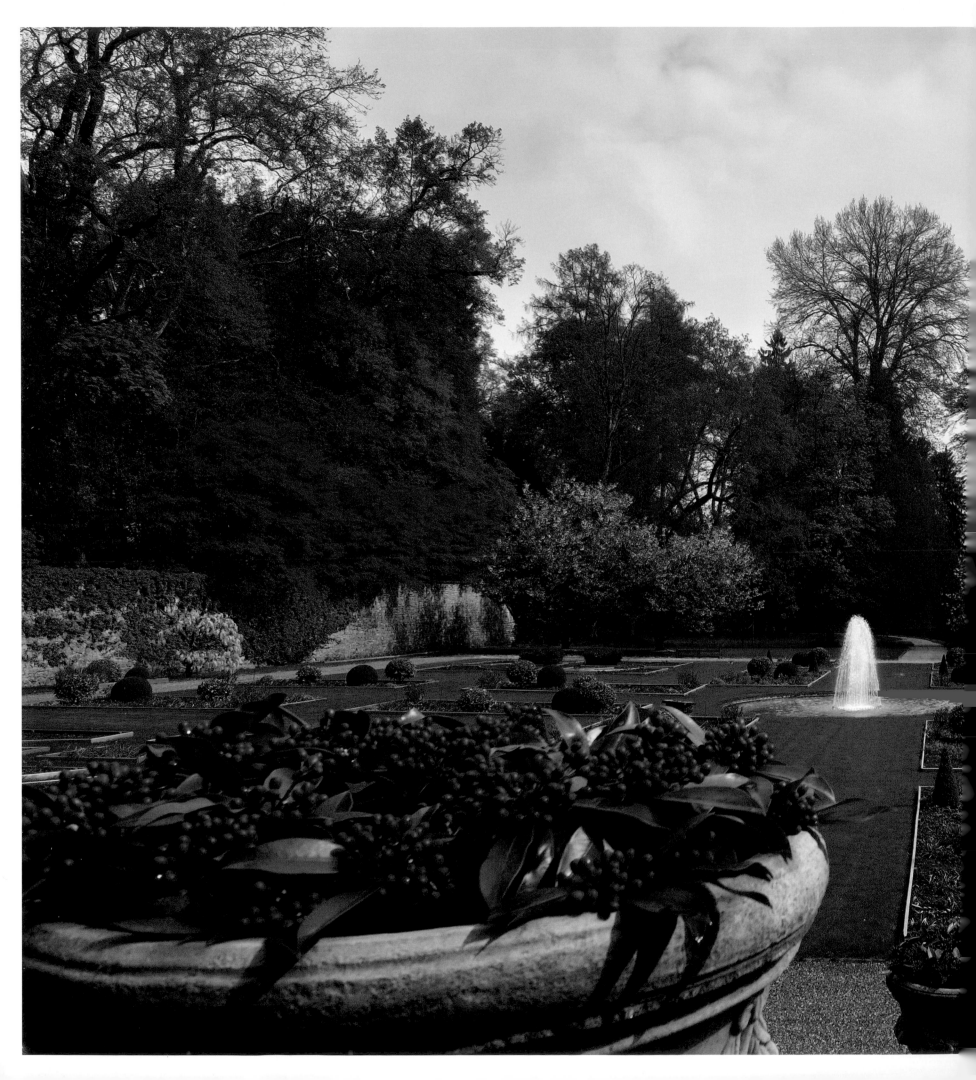

(**OPPOSITE** The 213-foot high donjon stands out above the foliage.)

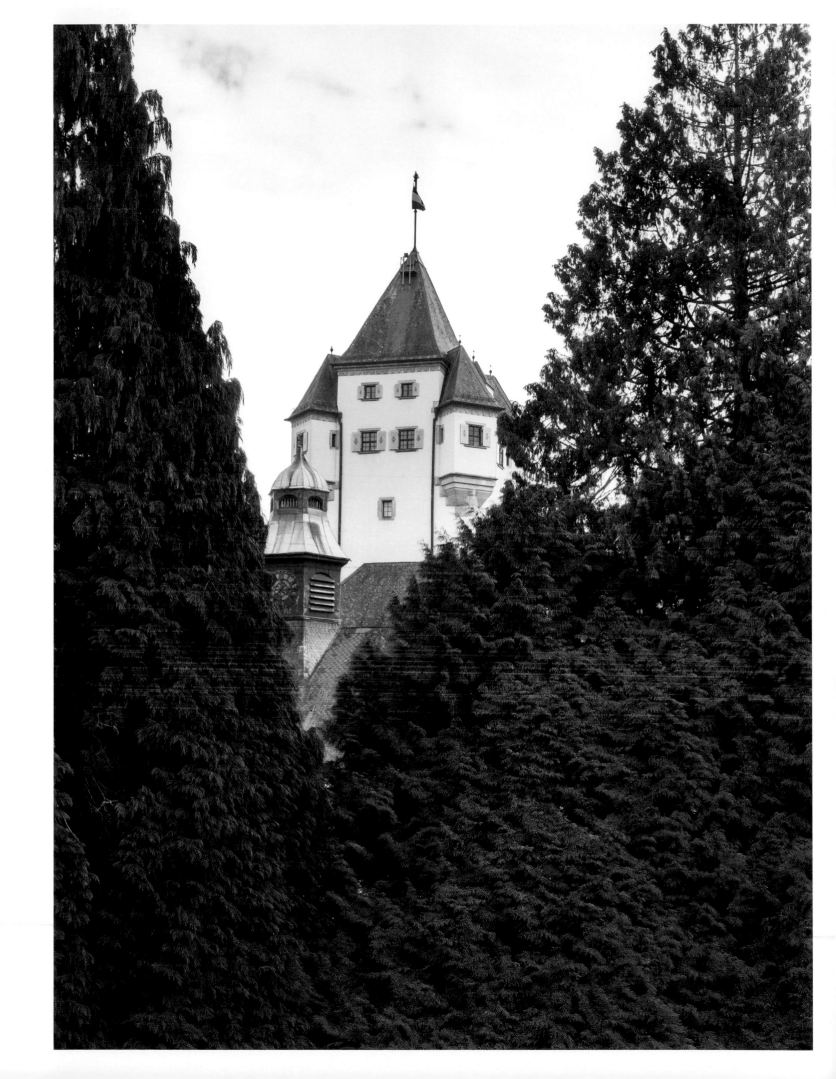

(From the reflecting pool, the castle
preceded by the terrace wall.)

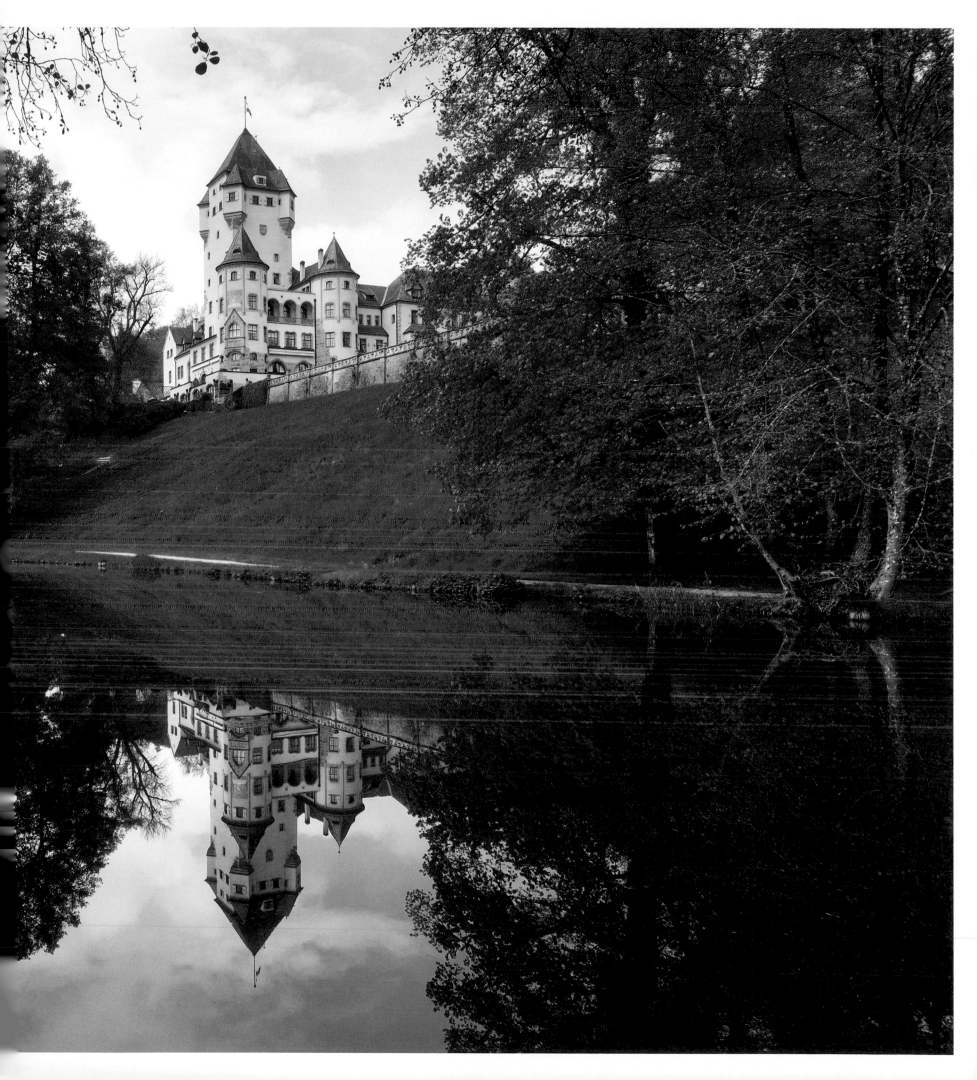

ITALY

ROYAL PALACE
OF
CASERTA

Charles de Bourbon's New Capital

IN 1734, THE KINGDOM OF THE TWO SICILIES—THE UNIFIED STATE OF SICILY AND NAPLES— became a self-governing kingdom, free from the rule of Spain. Charles de Bourbon, son of King Philippe V of Spain, was its king, and he decided to create a new capital in Caserta that could rival the other great cities of Europe in 1750. He called on the architect Luigi Vanvitelli, who submitted his plan for a palace the following year. The enormous rectangular building would be intersected by a long central promenade adorned with pools and fountains that stretched toward the mountain two miles away. A twenty-five-mile aqueduct would irrigate the estate's basins and fountains. Vanvitelli began work in 1752, and after he died in 1773, his son Carlo was left to finish the project.

Stepping out of the castle, you can go left toward Castelluccia, a small castle where the young Ferdinand IV, son of Charles, trained for battle. Nearby is Peschiera Grande, an artificial lake with an island where naval battles were simulated.

But, of course, Vanvitelli's most spectacular creation is the steps of water. These alternating areas of grass and fountains in multi-colored marble span almost two miles and are adorned with majestic symbols from mythology, many inspired by Ovid's *Metamorphoses*. The fountains featuring Margherita, Aeolus, Ceres, and dolphins—with their flowing sheets of water, bubbles, and lapping waves—enchant strolling visitors who puzzle over their allegorical meanings. After this astonishing and shimmering display, visitors come upon the Fountain of Venus and Adonis. Finally, the Fountain of Diana and Actaeon completes the collection. Fed by a waterfall flowing down Mount Briano, the fountain shows Actaeon transformed into a stag and being attacked by his own hunting dogs after surprising Diana, who was bathing with her nymphs. Two ramps enable visitors to climb the mountain to the source of the waterfall and admire the view of the extraordinary promenade that led them to this observation point. If you want a change of period and style, you can continue to the right of the Fountain of Diana and Actaeon to the English garden. Designed in 1785 by Carlo Vanvitelli and the English landscape gardener Andrea Graefer for Queen Maria Carolina of Austria, the wife of Ferdinand IV, it offers an ideal landscape, lushly planted and full of the ornaments and architecture cherished in the eighteenth century, including the Bath of Venus, the Cryptoportico, faux temple ruins in a grove named the Labyrinth, an English-style house, and a number of greenhouses. Here, for the first time in Europe, a camellia blossomed.

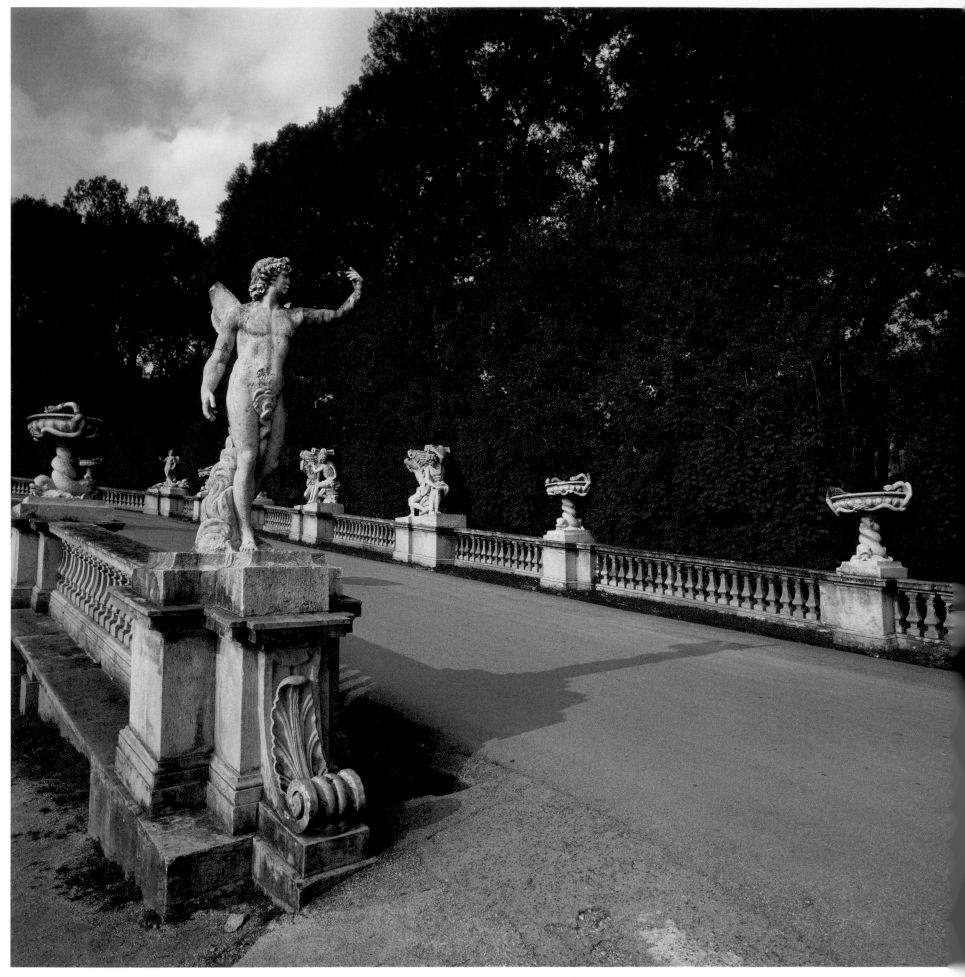

(Pathway encircling the Grotto of the Winds.)

Charles de Bourbon, son of King Philippe V of Spain . . .
decided to create a new capital in Caserta that
could rival the other great cities of Europe in 1750.
He called on the architect Luigi Vanvitelli, who
submitted his plan for a palace the following year.

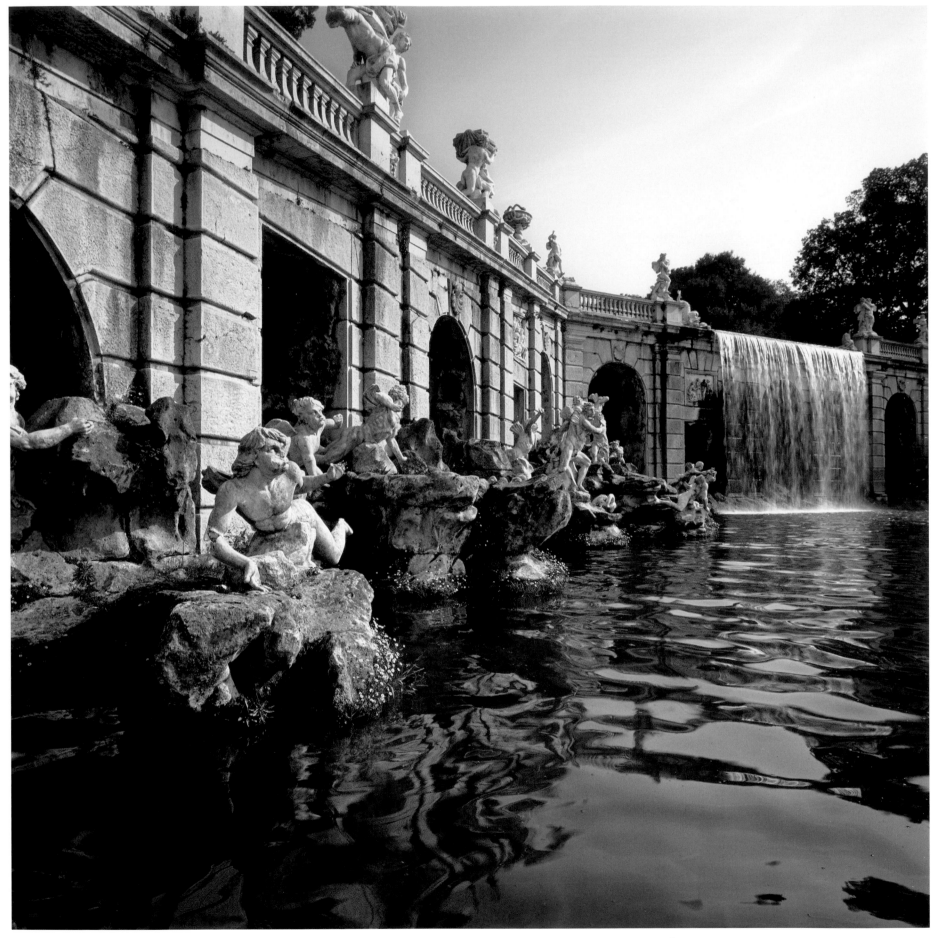

(Grotto of the Winds with an aquatic curtain concealing access to the world of Aeolus.)

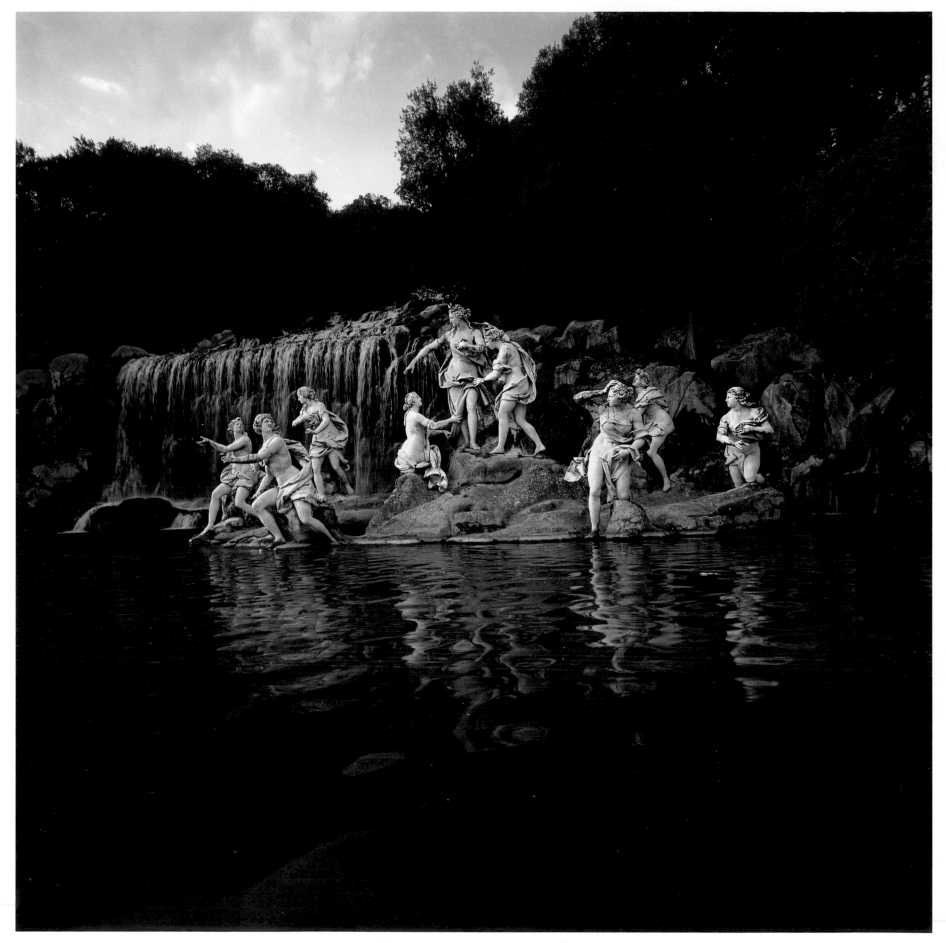

(The Fountain of Diana and Actaeon.)

(The artificial lake Peschiera Grande and its island.)

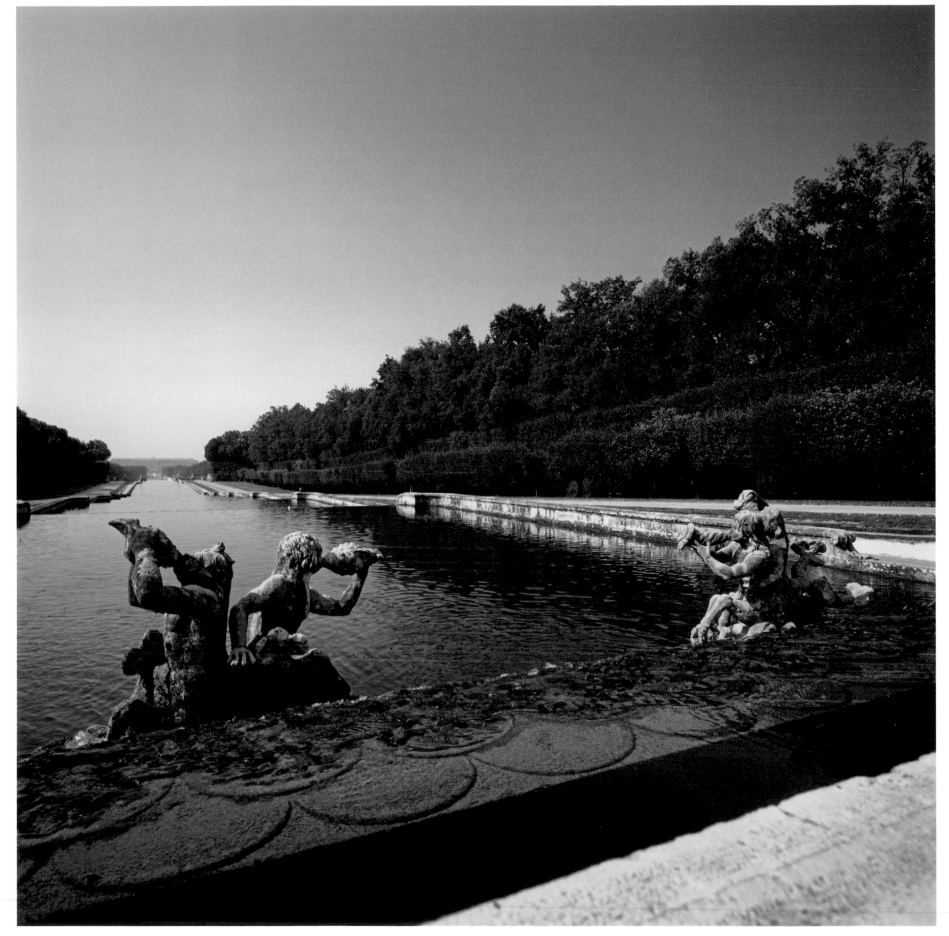

(Tritons of the Ceres Fountain.)

(Decoration on the balustrade of the Ceres Fountain.)

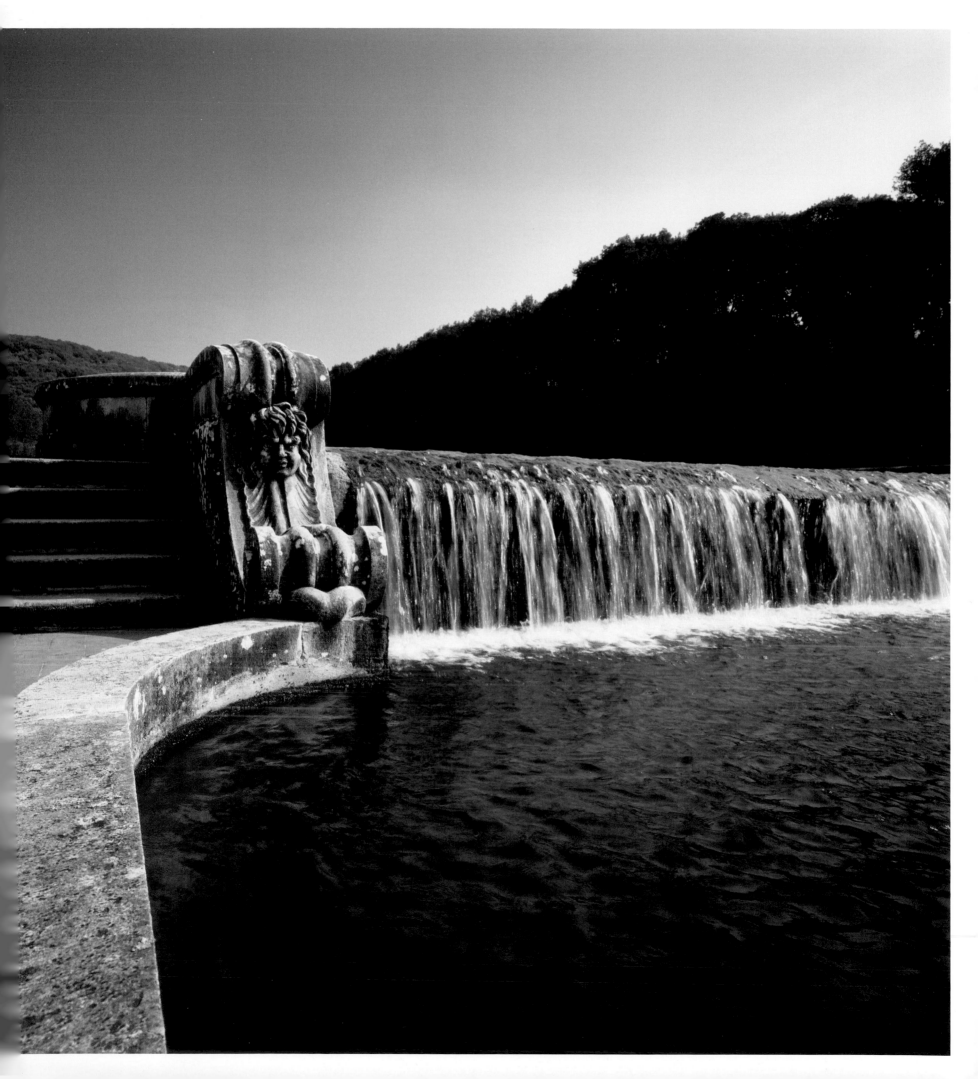

MOROCCO

THE ROYAL PALACES
OF
FEZ AND RABAT

Oases and Places of Power

A S ONE OF THE WORKS OF MOHAMED MÉTALSI—A SPECIALIST IN ISLAMIC CULTURE— explains, "The ideal sultan, according to a popular saying, is one who has a saddle for his throne and the sky for his canopy." This was why palaces flourished in Morocco. Each sovereign of the different dynasties—Idrisid, Almoravid, Almohad, Marinid, Wattasid, Saadi, Alaouite—chose his capital—Fez, Marrakech, Rabat, Meknes, etc.—while he kept a residence in other imperial cities in order to maintain peace and security throughout the kingdom.

Protected by ramparts, the traditional Arab-Islamic garden still calls to mind an oasis. It flows with precious water, ingeniously circulates refreshing breezes, is filled with birdsong, and artfully disperses the perfume of flowers. It also recalls the promises of celestial paradise made to the faithful: "[They will be] among lote trees with thorns removed. And [banana] trees layered [with fruit]. And shade extended. And water poured out. And fruit, abundant [and varied]. Neither limited [to season] nor forbidden. And [upon] beds raised high." *

Made of a succession of courtyards with enchanting canals and fountains, the grid work highlights the fascinating and rigorous simplicity of lines. Floral adornment and statues of human figures common in many of the other royal gardens in this book are replaced by interlacing stylized patterns and mosaics that convert natural forms into geometric designs. Parterres are laid out in right angles, while staggered rows of trees offer up occasional views. It is a model of the *art de vivre* (art of living) with its refined kiosks surrounded by nature and its loggias where moonlight and the scent of jasmine are intoxicating.

Fez is the most ancient of the imperial Moroccan cities, founded in 789 by Sultan Idris I, a descendant of Muhammad. The palace is located in Fez el-Jedid near the old city. In Rabat, the government capital, the palace was built in 1864 in the municipality of Touarga and is the headquarters of King Mohammed VI. Amidst its elegant gardens, it houses the royal cabinet, prime minister's offices, supreme court, royal college, royal barracks, and a mosque. Closed to the public, these mysterious palaces still evoke the splendors of *A Thousand and One Nights*!

* Quotation from the Quran, Chapter 56.

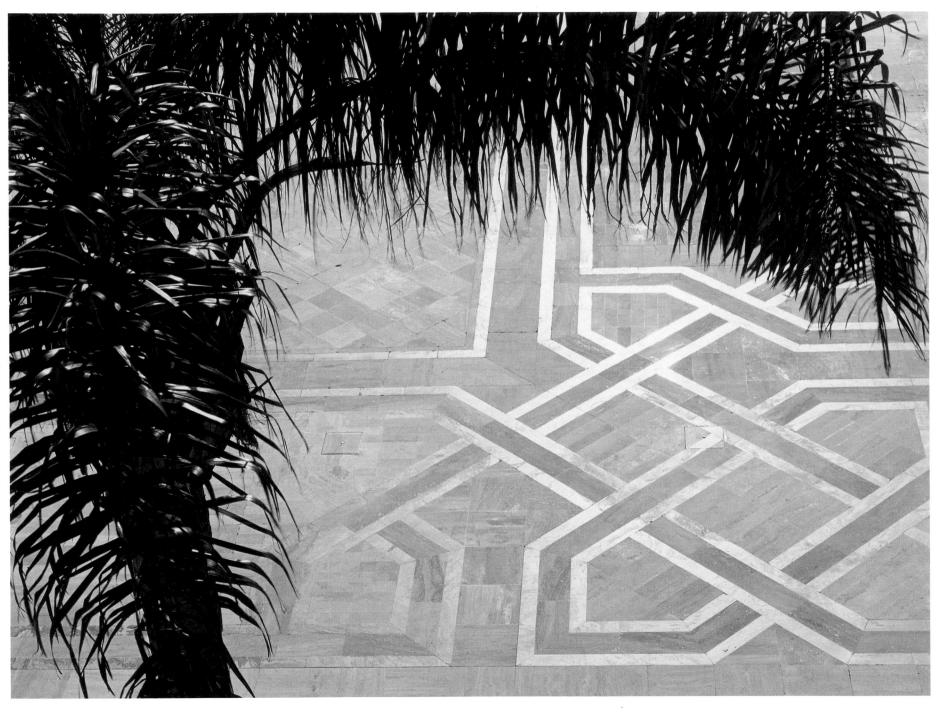

(Motifs on the Mechouar esplanade at the Royal Palace of Rabat.)

(The garden of the Royal Palace of Rabat's guest palace.)

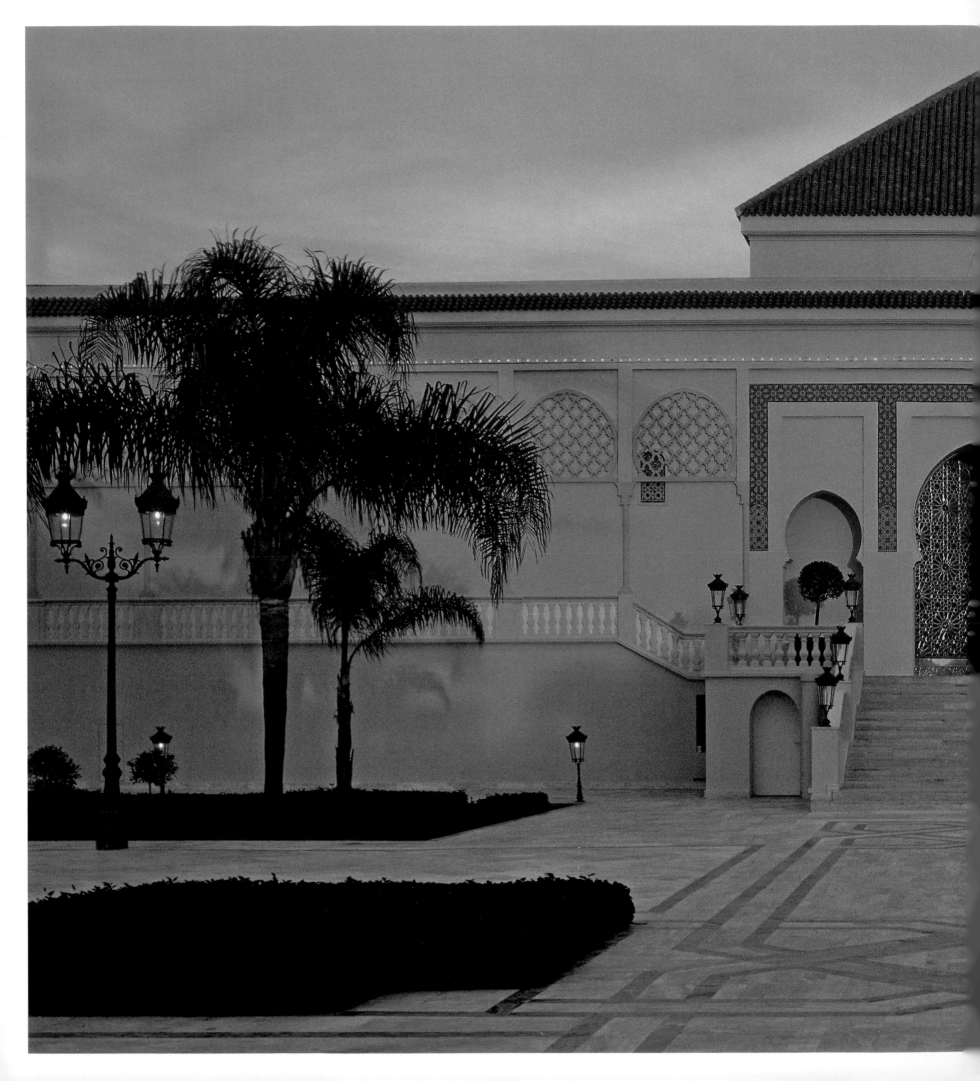

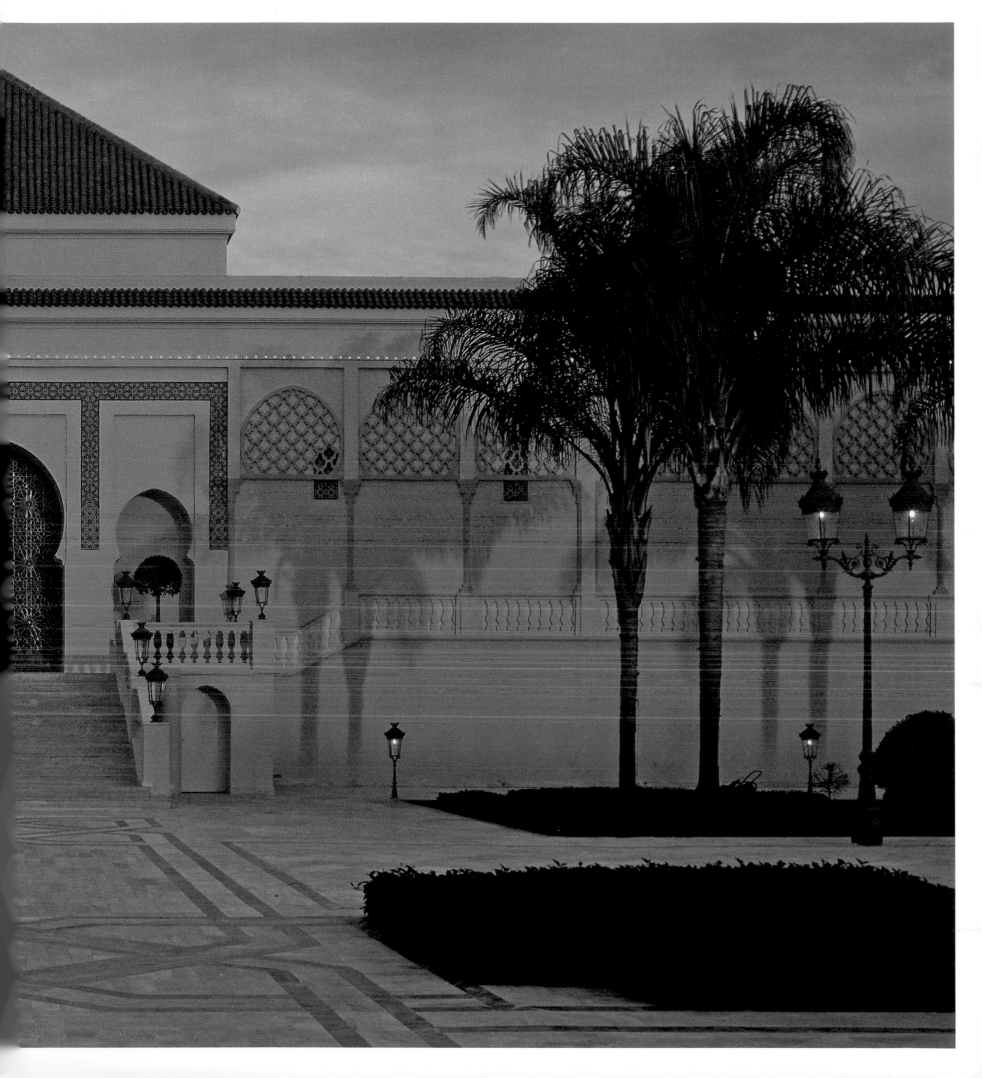

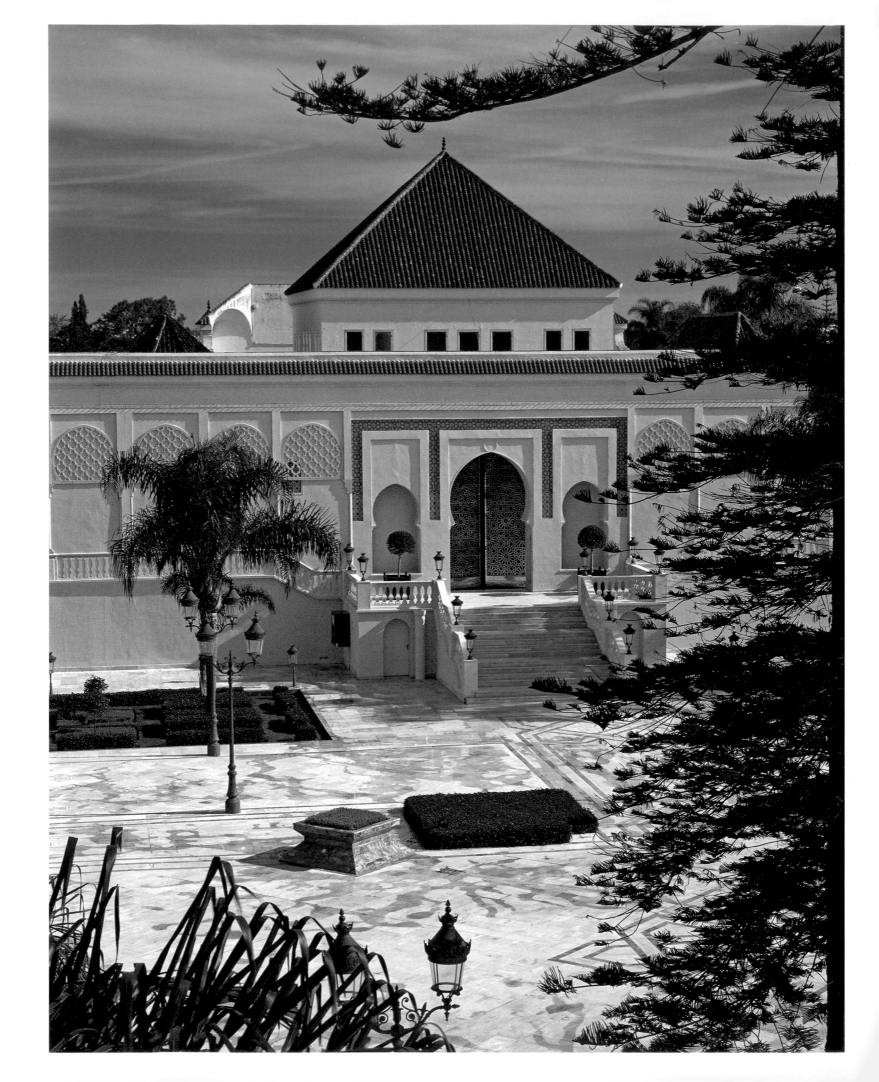

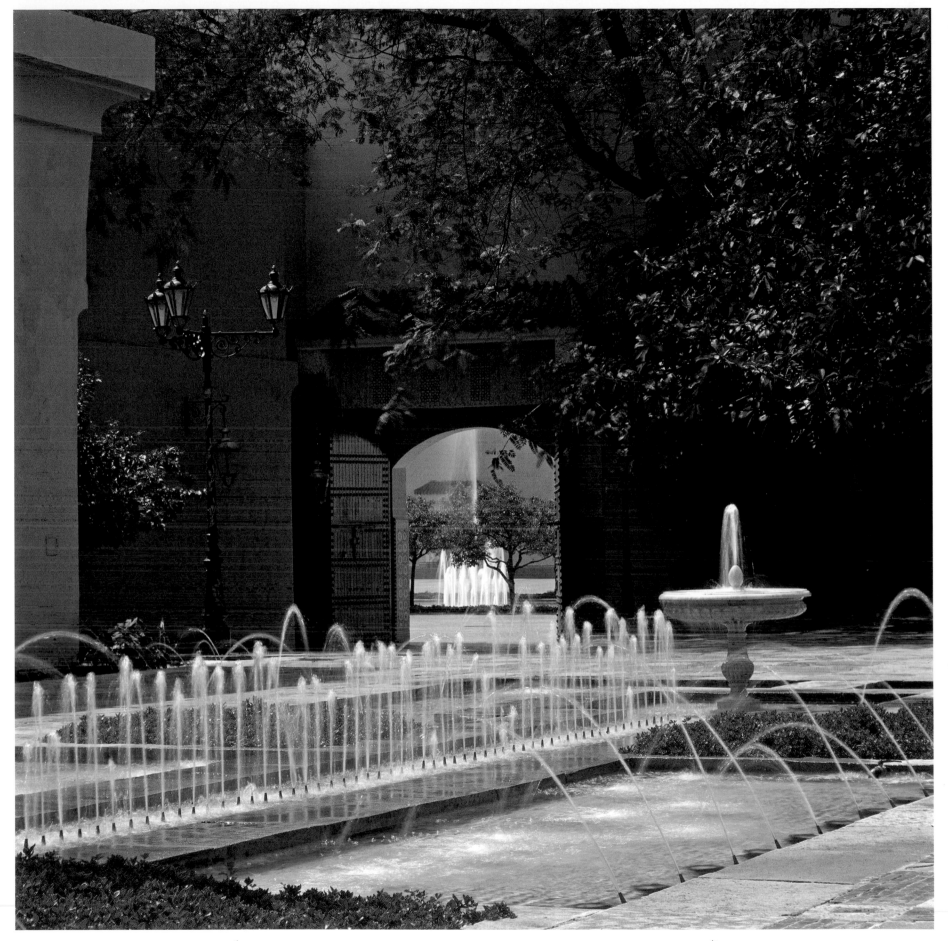

(**OPPOSITE** The Royal Palace of Rabat's Mechouar esplanade, a place to pledge allegiance to the sultan.)

(**ABOVE** Fountains in Prince Moulay Rachid's riad in the Royal Palace of Fez.)

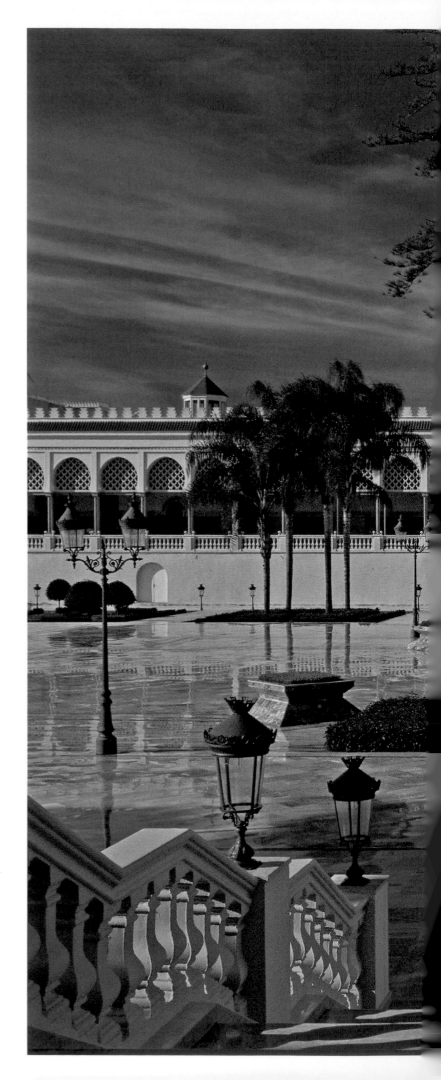

(The Mechouar esplanade, in front of the Royal Palace of Rabat, where lavish celebrations such as those for the birth of the crown prince in 2003, have been held.)

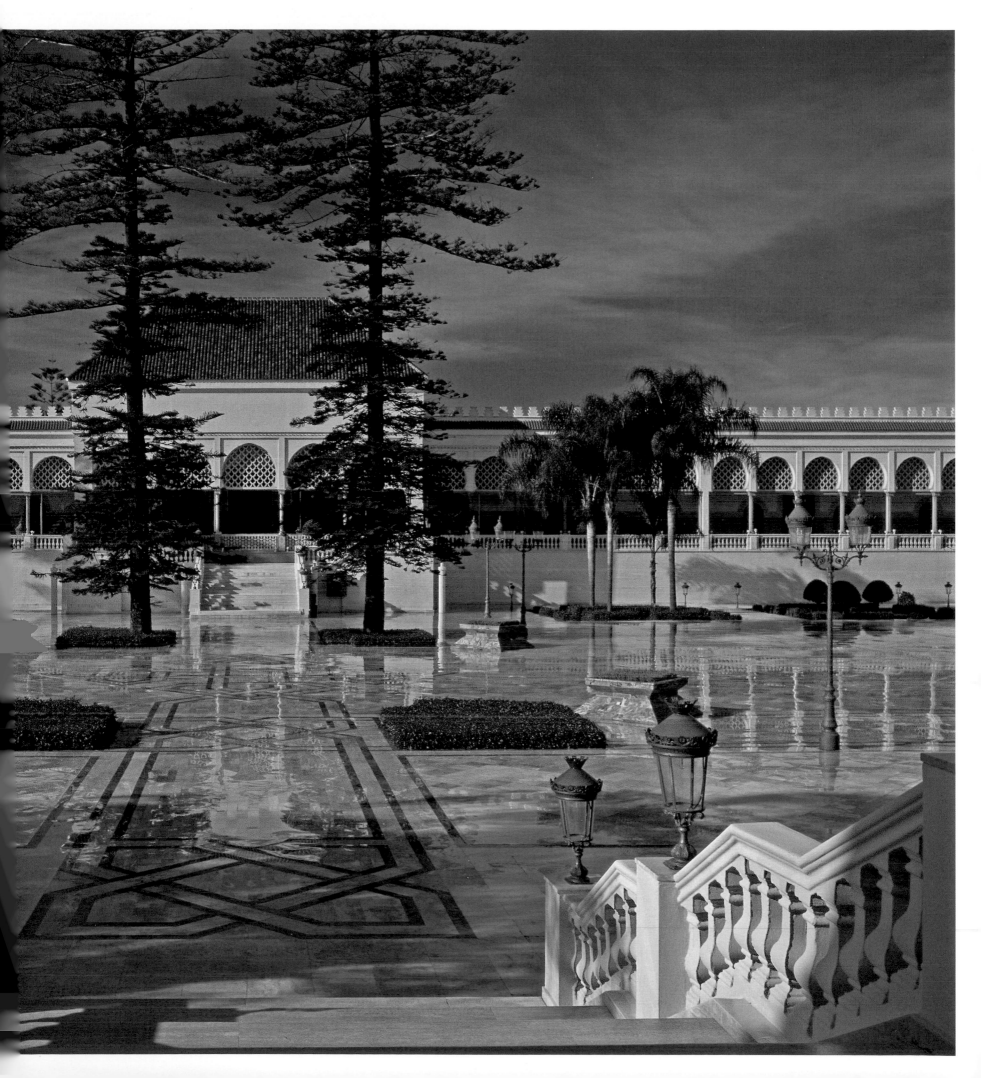

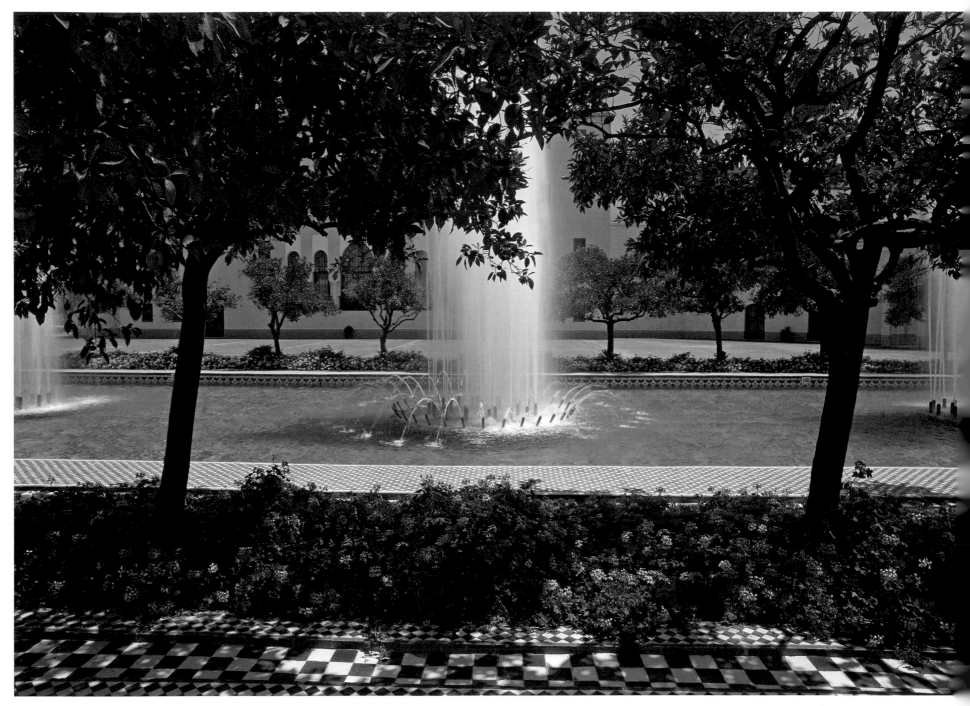

(The decorations of the Royal Palace of Fez owe their elegance to the skills of the Fassi craftsmen, ceramists, ironworkers, and ornamental plasterers.)

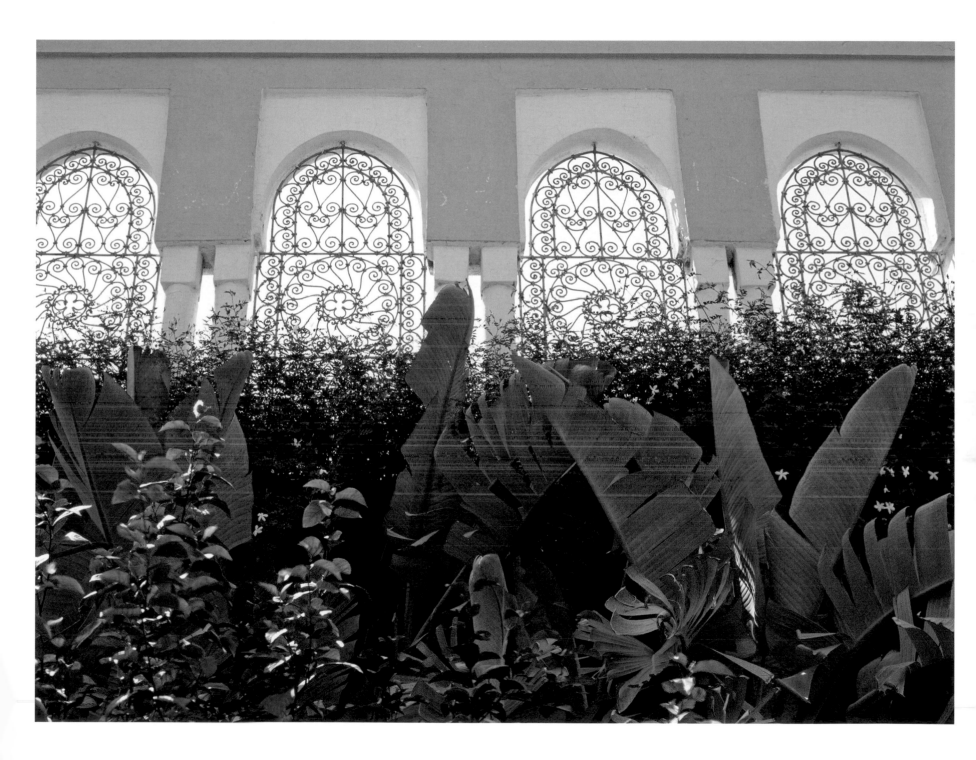

(Entrance gate of the Royal Palace of Rabat.)

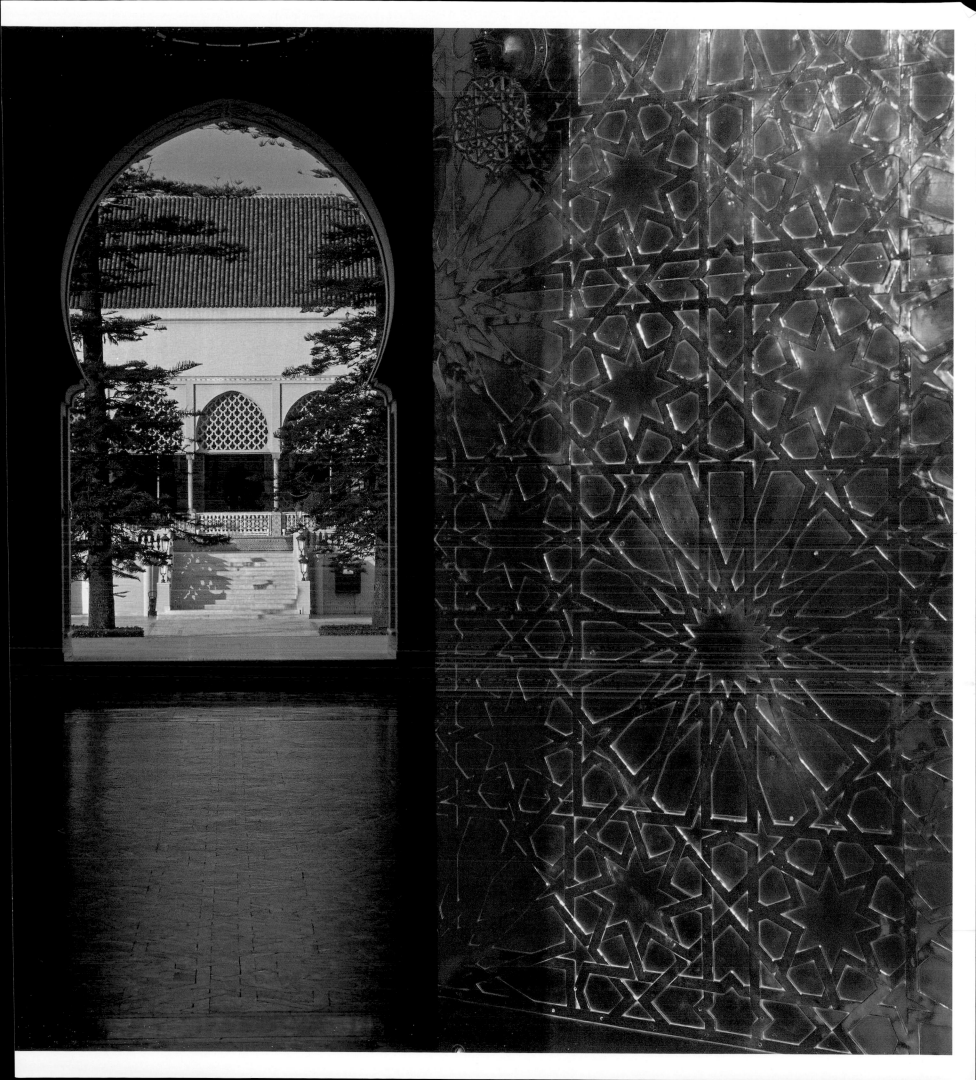

UNITED KINGDOM

BLENHEIM
PALACE

The Majestic Estate of the Duke of Marlborough

BUILT IN OXFORDSHIRE BY THE ARCHITECT SIR JOHN VANBRUGH BETWEEN 1705 AND 1722 on the site of the Royal Manor of Woodstock, the Blenheim Palace combines the aspects of a private manor and a historical monument. Indeed, the 1st Duke of Marlborough, John Churchill, received the ruined manor and its land as a gift from the Queen of England in gratitude for his military exploits, in particular against the troops of Louis XIV.

With its gigantic main entrances and its roofs that resemble a miniature city, this English baroque-style palace was built to be majestic. Its superb gardens and park have been redesigned several times by renowned landscape artists according to successive styles, reflecting the different influences and fashions of landscape art since the seventeenth century. At first Vanbrugh worked with Henry Wise, the queen's gardener, and created a French-style parterre to the south; a flower garden to the east for Sarah, the duke's wife; an enclosed vegetable garden 2,625 feet from the palace; and, at the foot of the monumental bridge spanning the Glyme River, a landscaped park that was planted with two rows of mature elm trees so the duke could enjoy them right away.

After the death of her husband, Sarah had the Column of Victory and the Arch of Triumph, marking the main avenue leading to the entrance to the palace, built in his honor. In 1758, Count George Spencer, 4th Duke of Marlborough, hired the famous landscape artist Lancelot "Capability" Brown, who is as important to the English garden as André Le Nôtre is to the French garden. He laid out grass in the main courtyard, did away with the southern parterre, and built a dam on the Glyme to feed a lake that branches out on both sides of the bridge. In the 1920s, Charles Spencer-Churchill, the 9th Duke of Marlborough, asked the landscape gardener Achille Duchêne to redesign the palace's parterre gardens. Thus, two monumental water terraces in the west and an Italian garden in the east with a parterre garden surrounding a fountain adorned with sirens were created. The lower terrace of the water parterre contains a model of the Fountain of the Four Rivers in the Piazza Navona in Rome. The model was given to the 1st Duke of Marlborough by the original fountain's designer, Bernini. A footpath leads from the lower terrace through an arboretum to the Temple of Diana, which was built by William Chambers on the spot where Winston Churchill, born at Blenheim in 1874, proposed to Clementine Hozier. Next is the rose garden and farther on, Capability Brown's Cascade. At Blenheim, grandeur and romanticism live in harmony.

(**opposite** On the second terrace, a model of a statue for the
Fountain of the Four Rivers by Bernini in Piazza Navona, Rome,
which was given as a gift to the 1st Duke of Marlborough.)

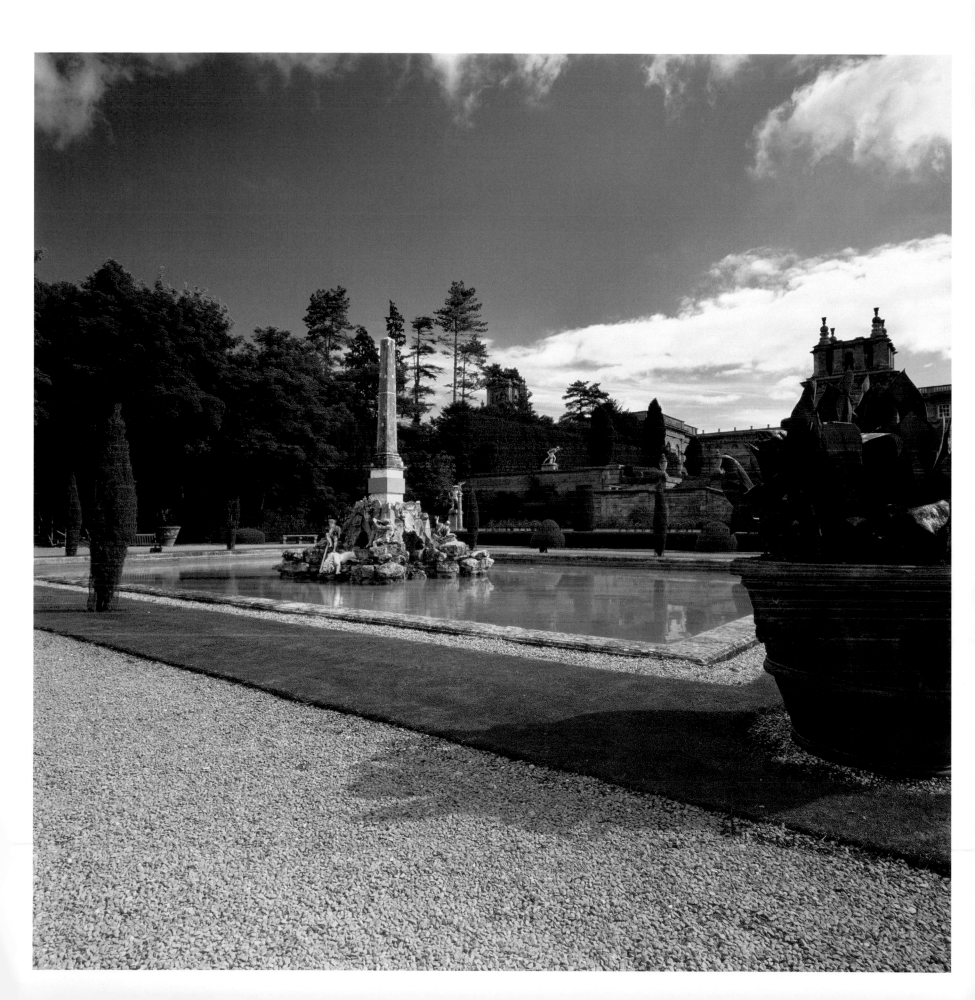

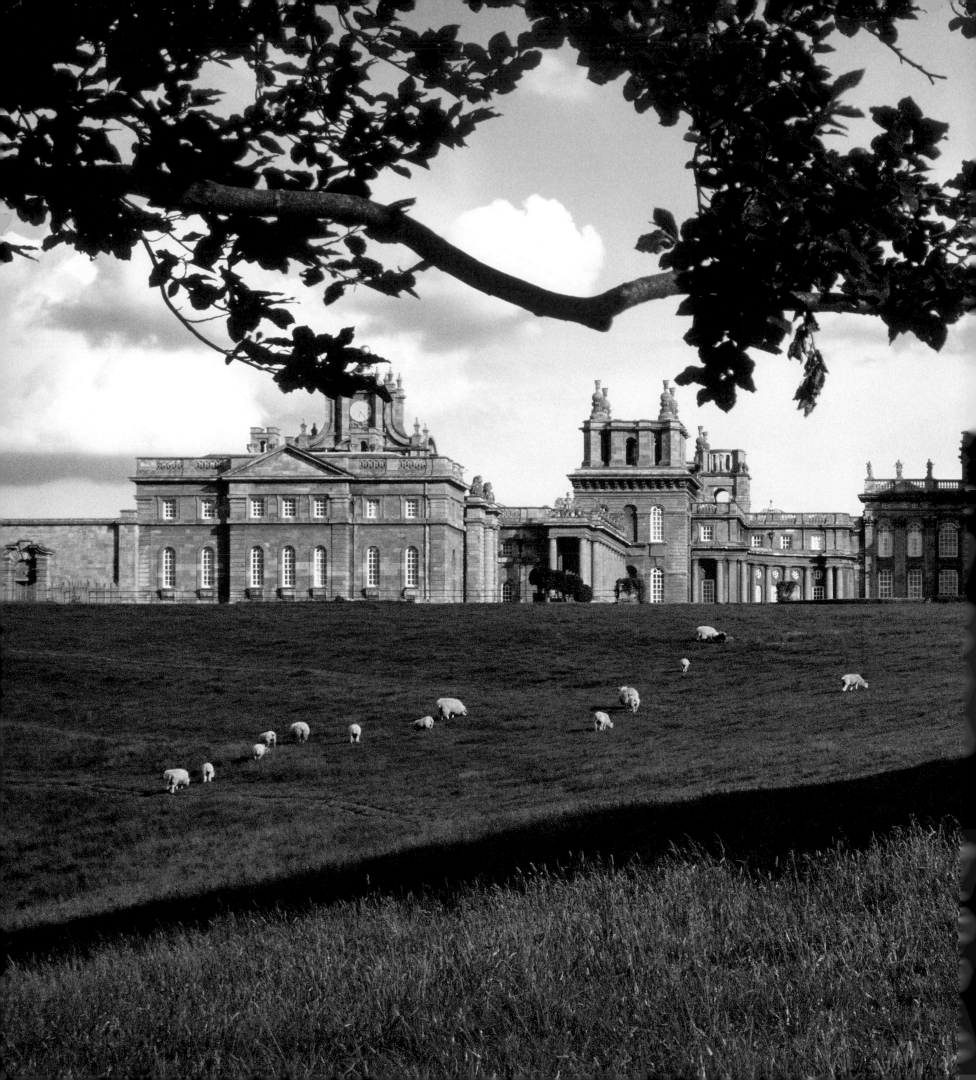

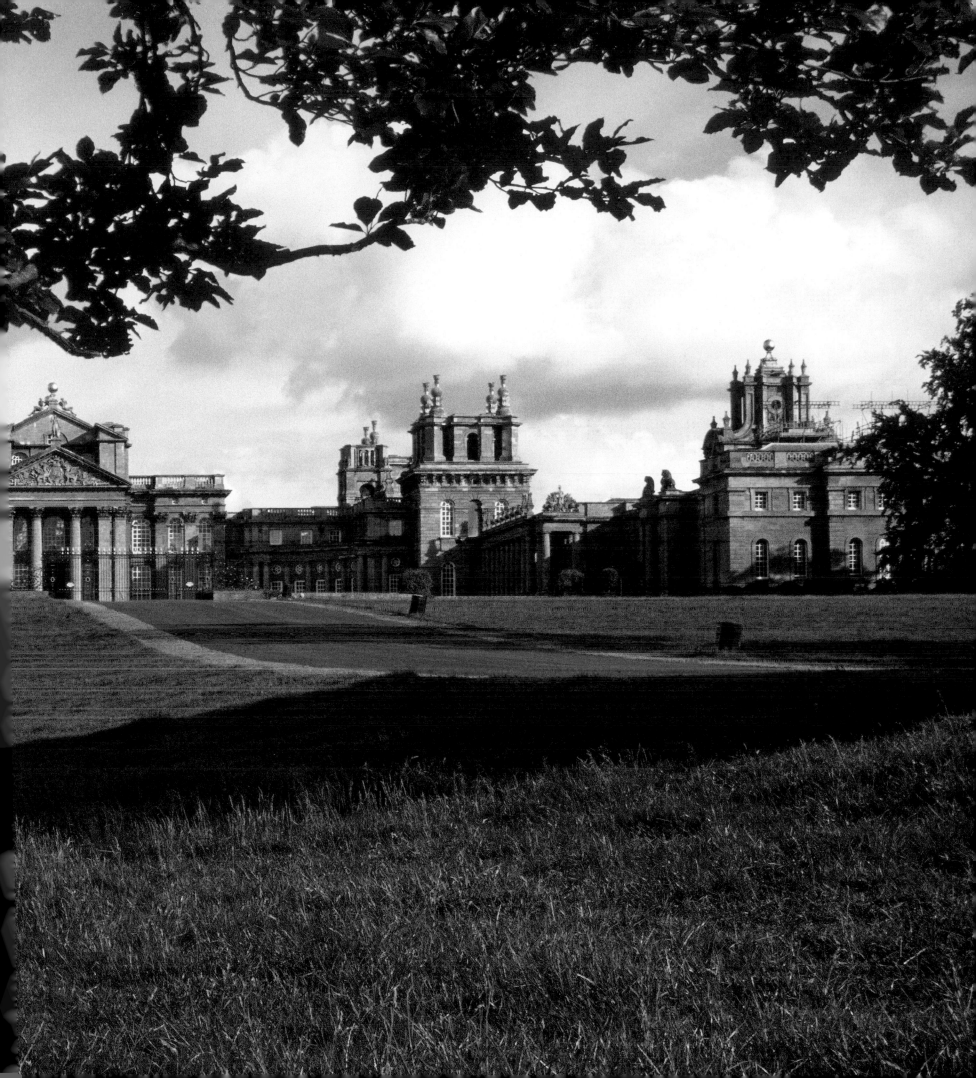

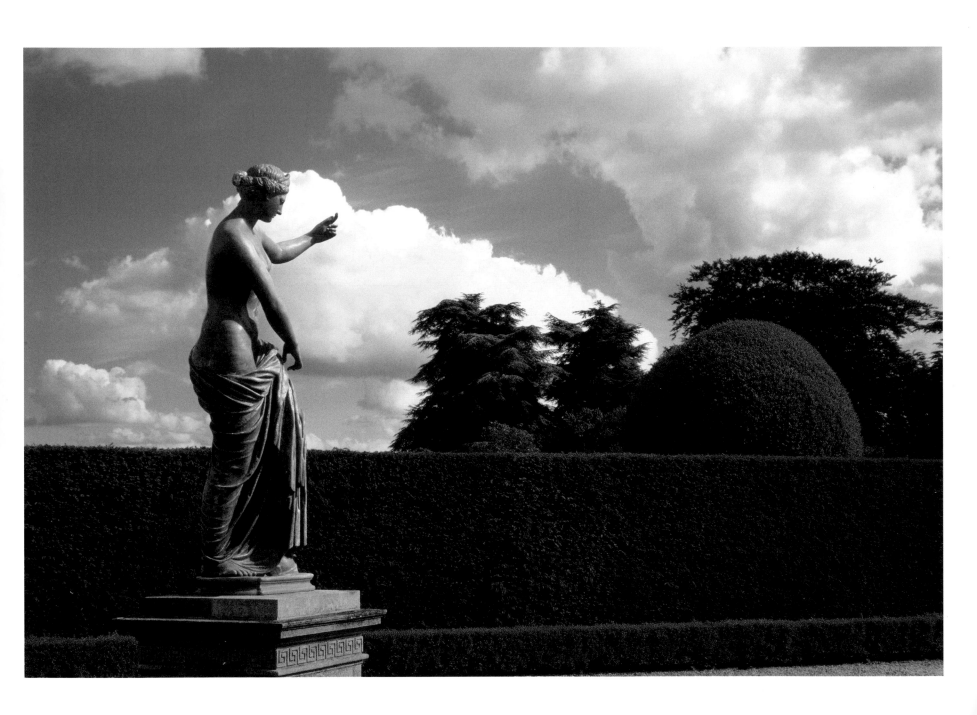

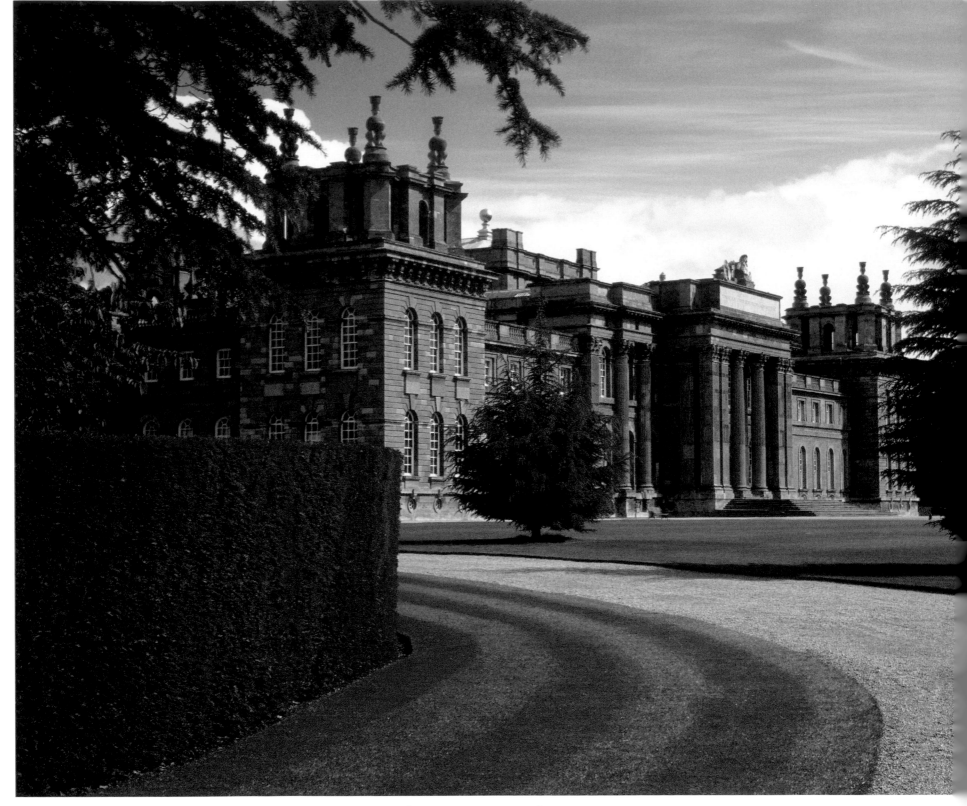

(South façade of the castle.)

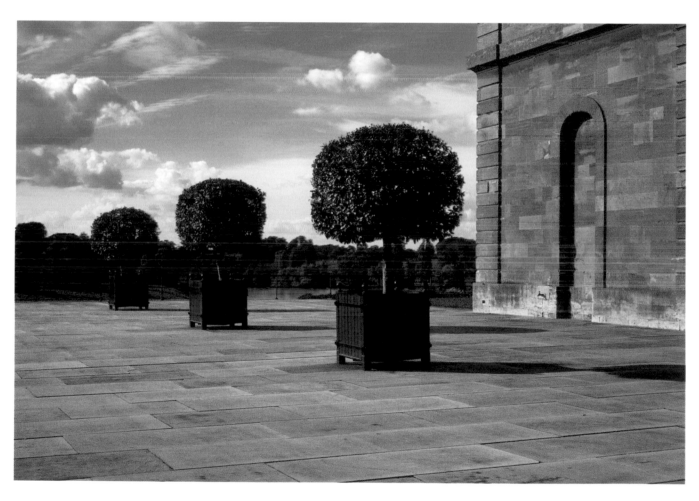

(OVERLEAF A large unfinished bridge by Vanbrugh, on the lake designed by Capability Brown.)

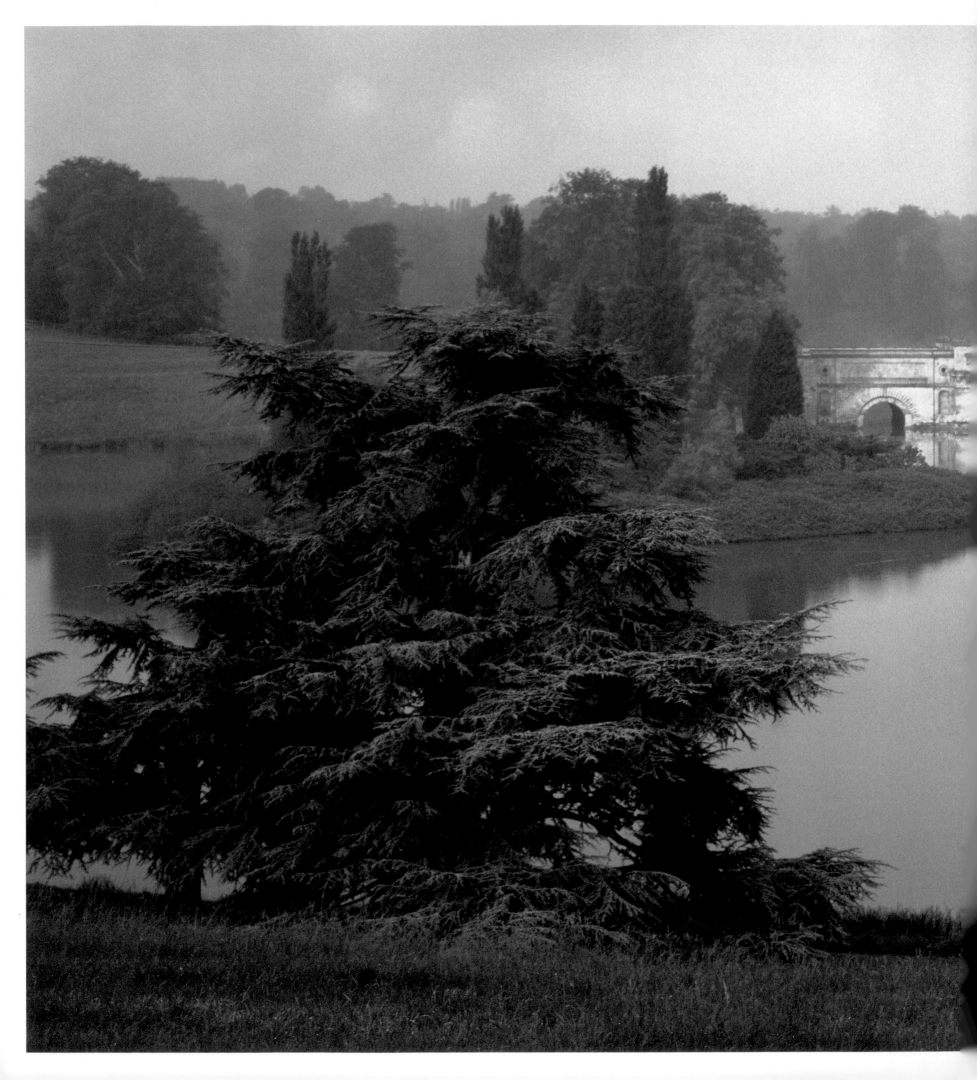

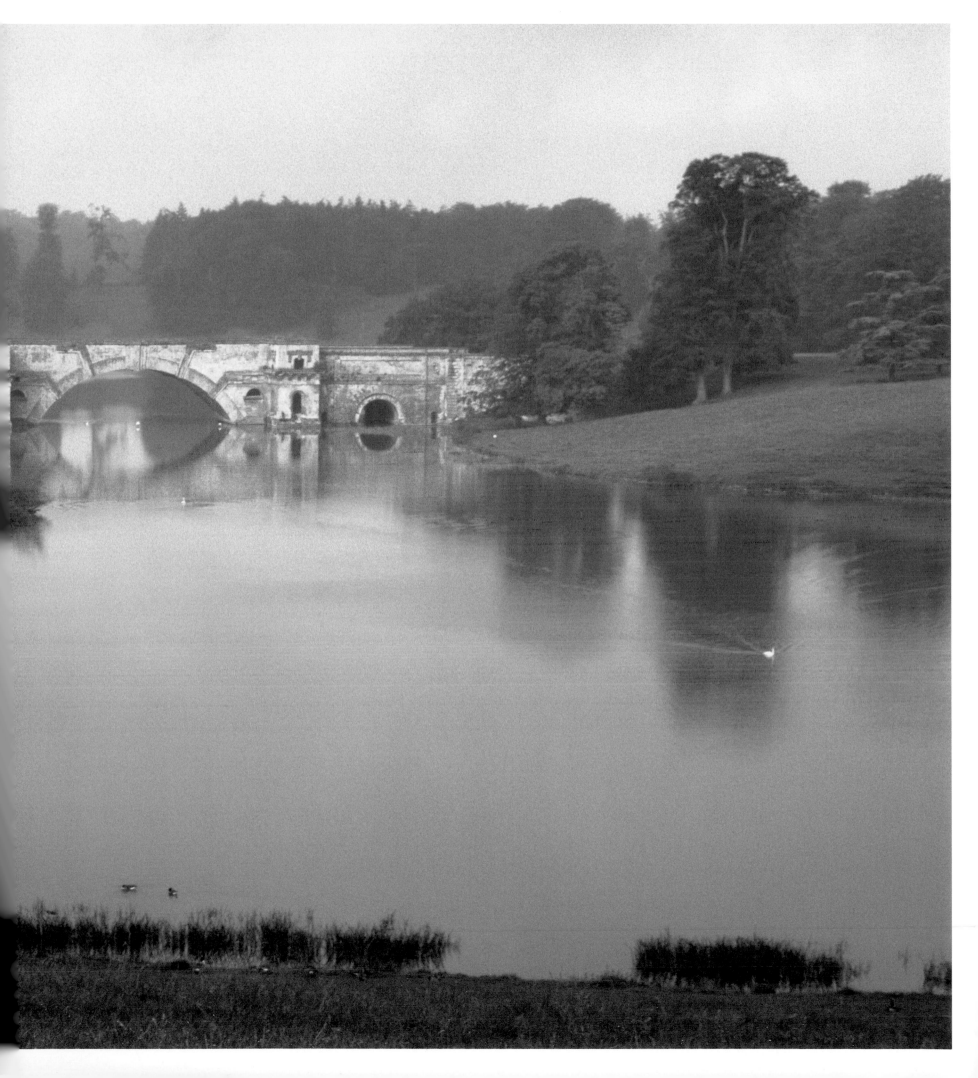

JAPAN

TOKYO
IMPERIAL
PARK

Within the Walls of an Ancient Edo Castle

H OW ENCHANTING IT IS TO GLIDE IN A BOAT ON THE CHIDORIGAFUCHI, ONE OF THE MOATS surrounding the ancient palace of the shoguns, as the silken petals of cherry trees float down, marking the arrival of spring in Japan. Or even better, to be immersed in a rain of different shades of pink on Sakura no Shima (Cherry Tree Island), which alone has thirteen species of trees.

In 1638, during the Edo period, this site had a multitude of gates, buildings, donjons, and court-yards inside its imposing walls. Today, it is home to thirty different varieties of this magical tree whose blossoms are well loved throughout the country. The two areas open to the public are Kokyo Higashi Gyoen to the east of the Imperial Palace and Kitanomaru to the north, both of which offer many plea-sures to visitors.

After the Meiji Restoration and the defeat of the Tokugawa shogunate, the country's capital was moved from Kyoto to Tokyo. Shortly after, in 1888, the emperor's residence was built on the site of an ancient palace of the shoguns that had been ravaged by fire in 1873. Bombarded during World War II, the palace was restored to its original Meiji condition in 1968.

Remnants of the ancient castle, moats, fortifications with monumental gates, watchtowers, and walls supporting ancient buildings, await discovery by visitors to the park. The walking tour begins at the Ote-mon Gate where vestiges of the main tower can be seen. Next is the Homaru sector where, according to the emperor's wishes, there is an orchard displaying diverse species of ancient Japanese fruit trees and wild plants, a rose garden, a bamboo grove, and Cherry Tree Island. The Ninomaru area has a traditional Japanese garden where trees emblematic of the forty-seven prefectures are planted as well as a grove of various species of plum trees, which are disappearing from the outskirts of Tokyo. Inspired by the gardens designed by the influential artist Kobori Enshū from the Edo period, a park that contains a lake dotted with lanterns and an iris garden among sumptuous pink waves of azaleas can be found in front of the entrance to the Museum of the Imperial Collections. Kitanomaru Park, accessible from the Kitahane-bashi-mon Gate, is famous for its remarkable trees, migratory birds, and crickets that sing in the summer. Among its wooded areas and open lawns are the Science Museum and the National Museum of Modern Art, providing educational cultural stopovers on this unforget-table botanical and historical walk.

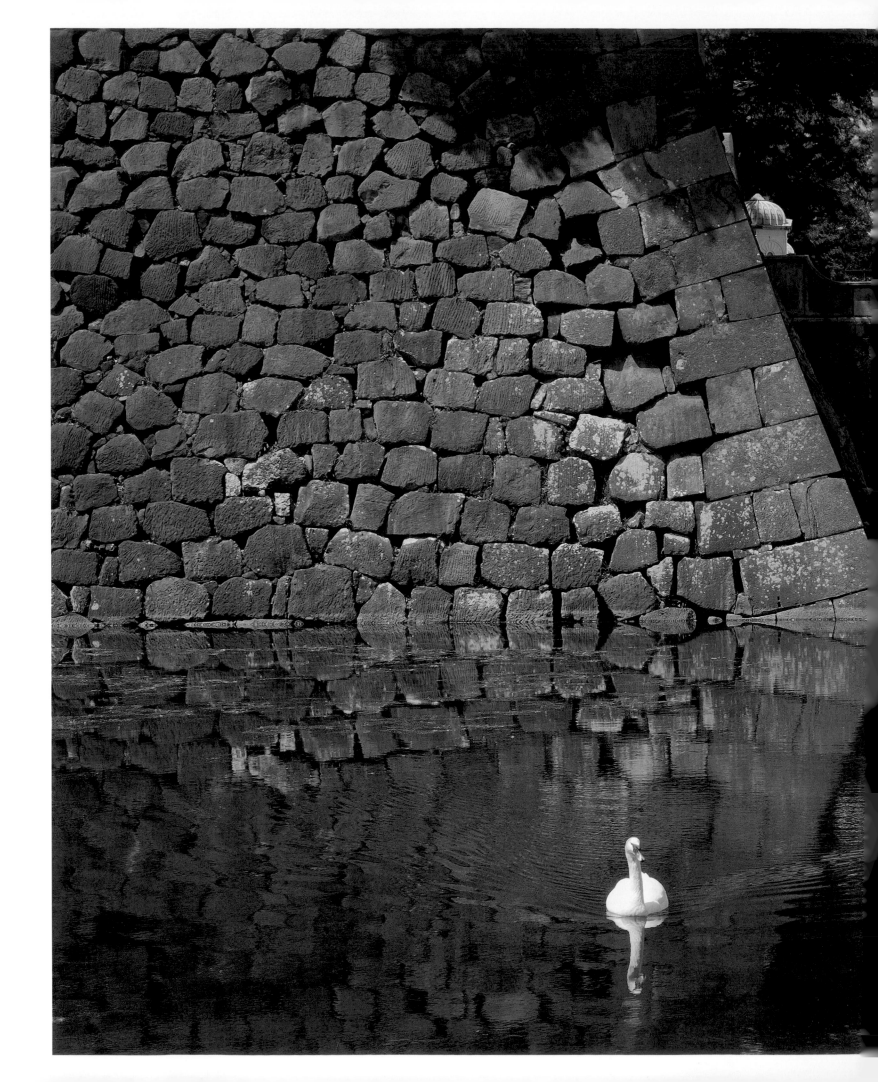

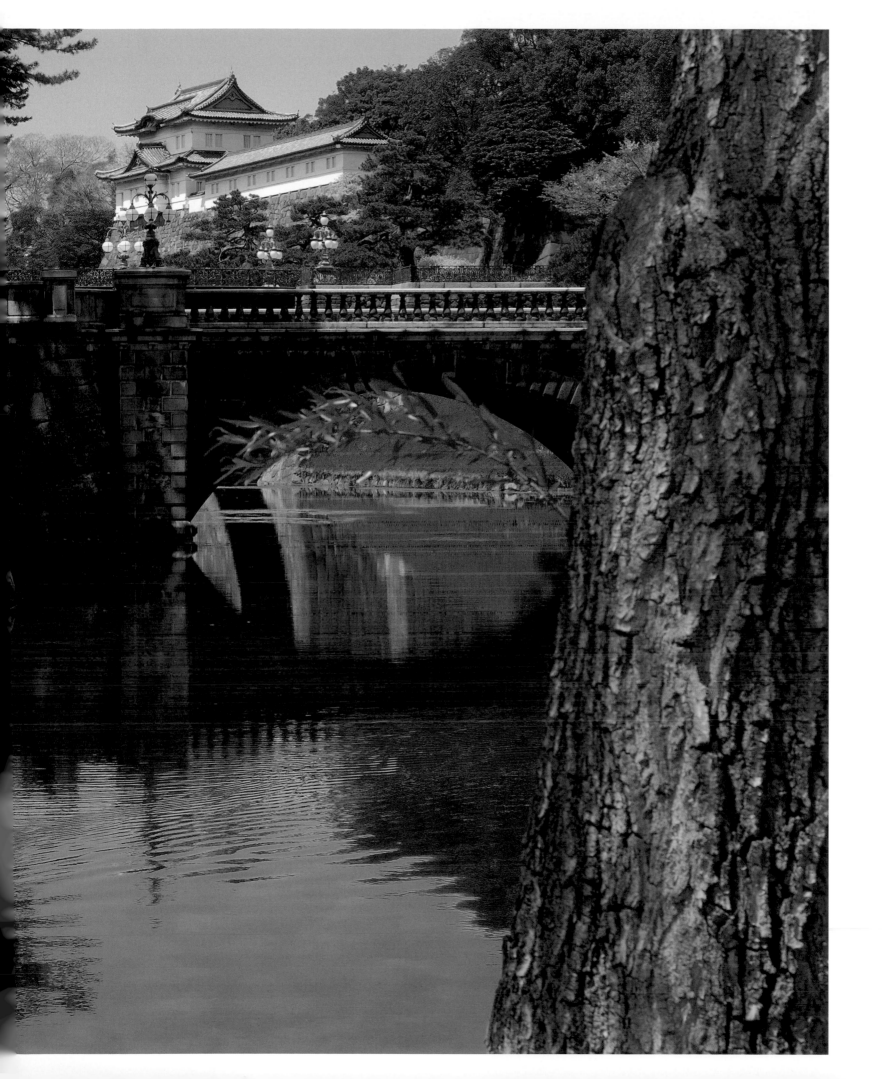

(**PAGES 266–267** Entrance to the Imperial Palace by the Nijubashi Bridge.)

(**ABOVE** Japanese-style pruning sculpts the trees and creates empty spaces that allow decorative elements to be visible.)

(The garden of Suwano-chaya Teahouse in the Garden of Ninomaru.)

The spring breeze scatters the flowers

Of my dream

My awakened heart is still reeling.

SAIGYÔ

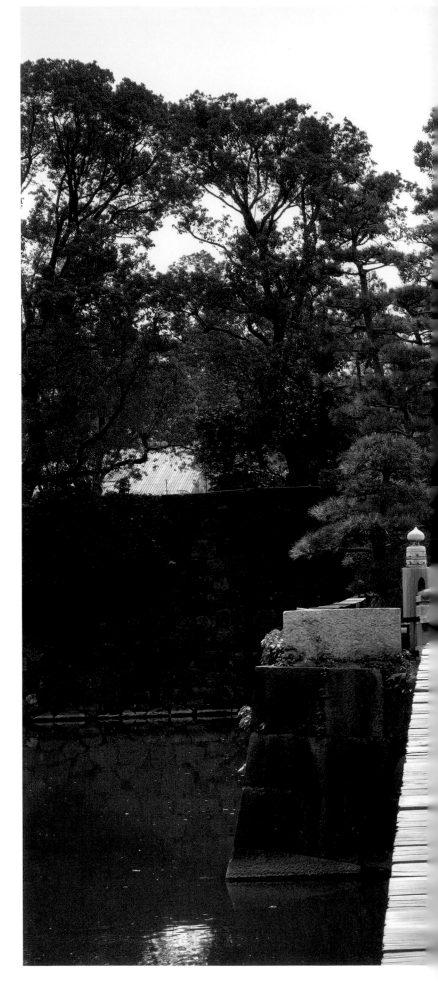

(Crossing the moat through the Hirakawa-mon Gate.)

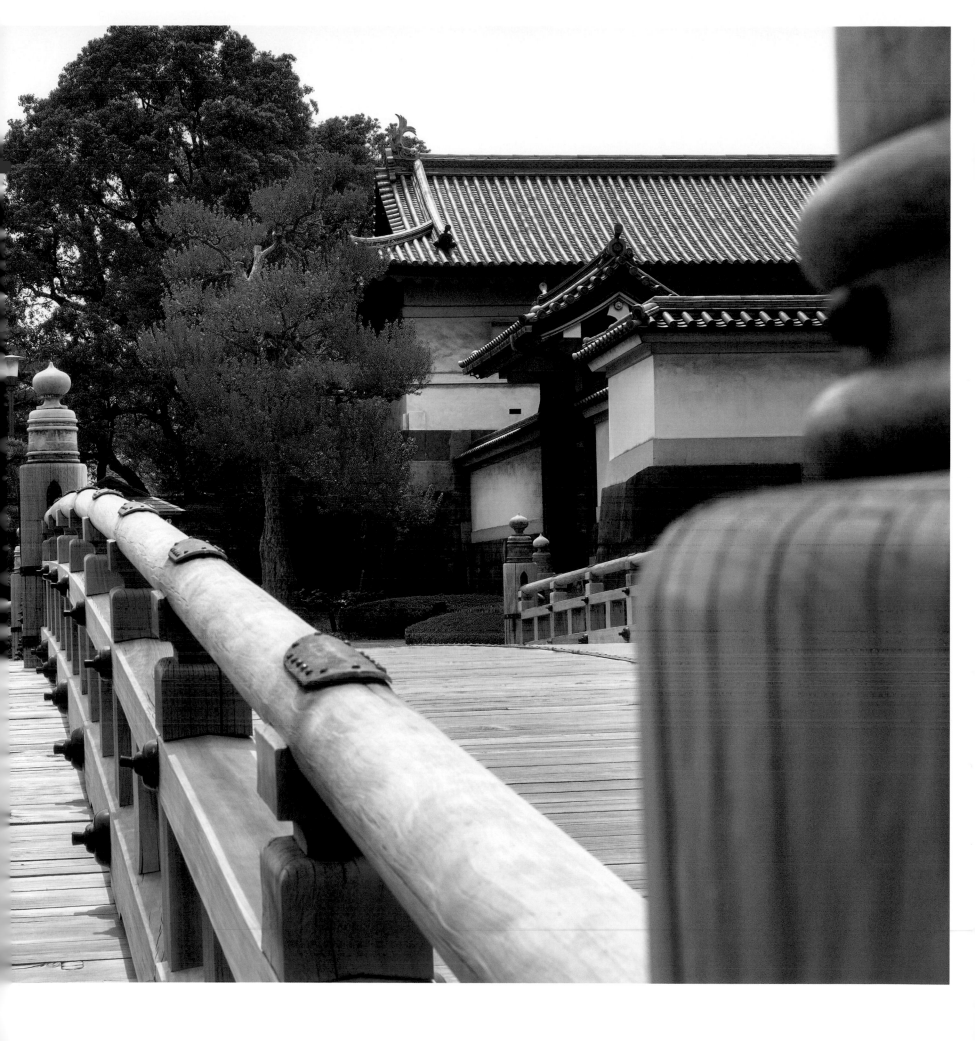

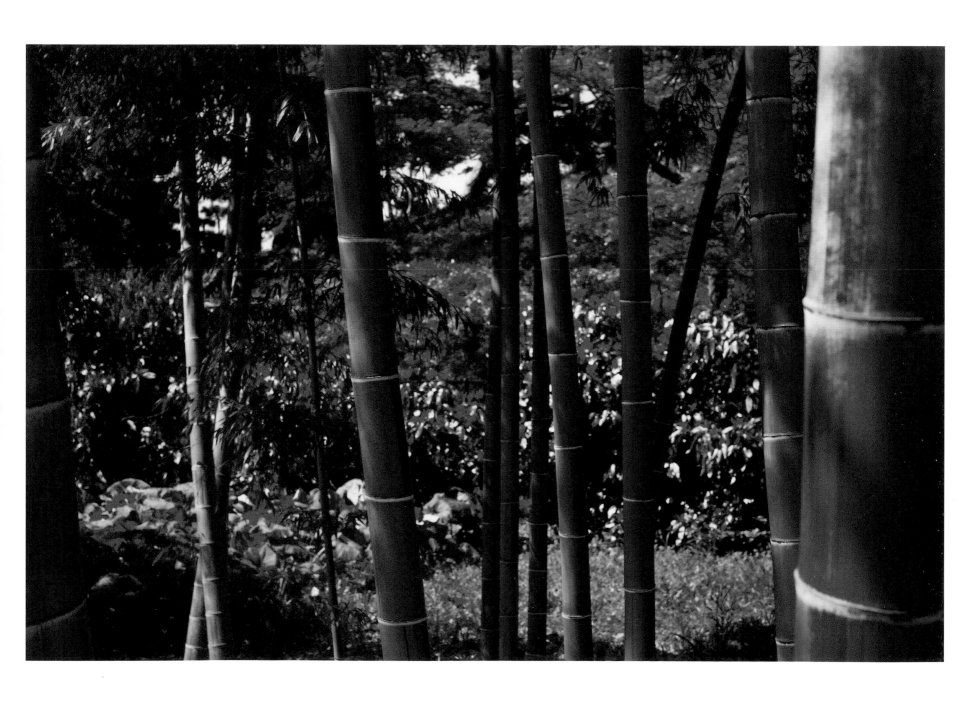

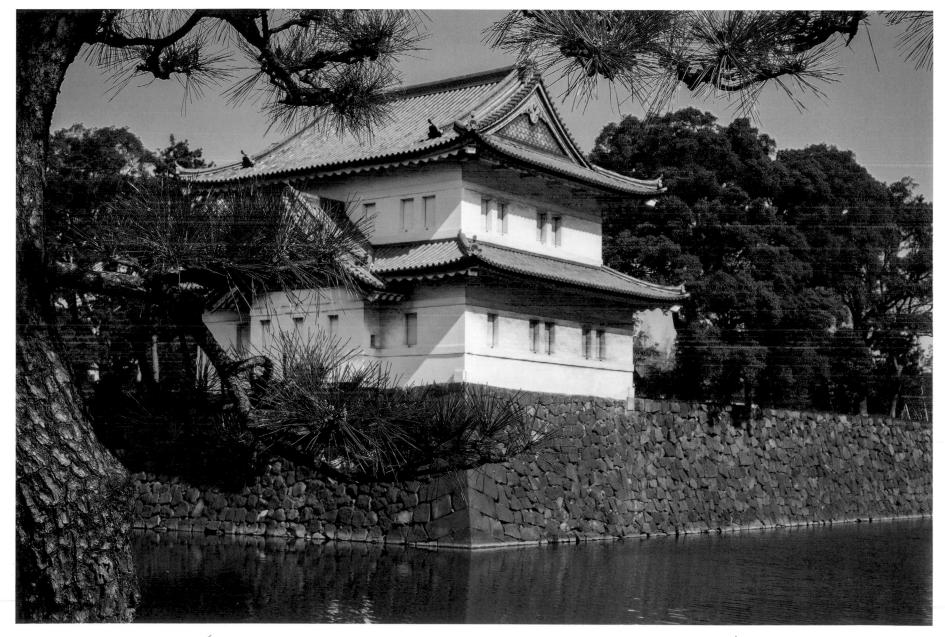

〔 The rugged foundations of the ancient Edo Castle are softened by the presence of water and numerous pagodas. 〕

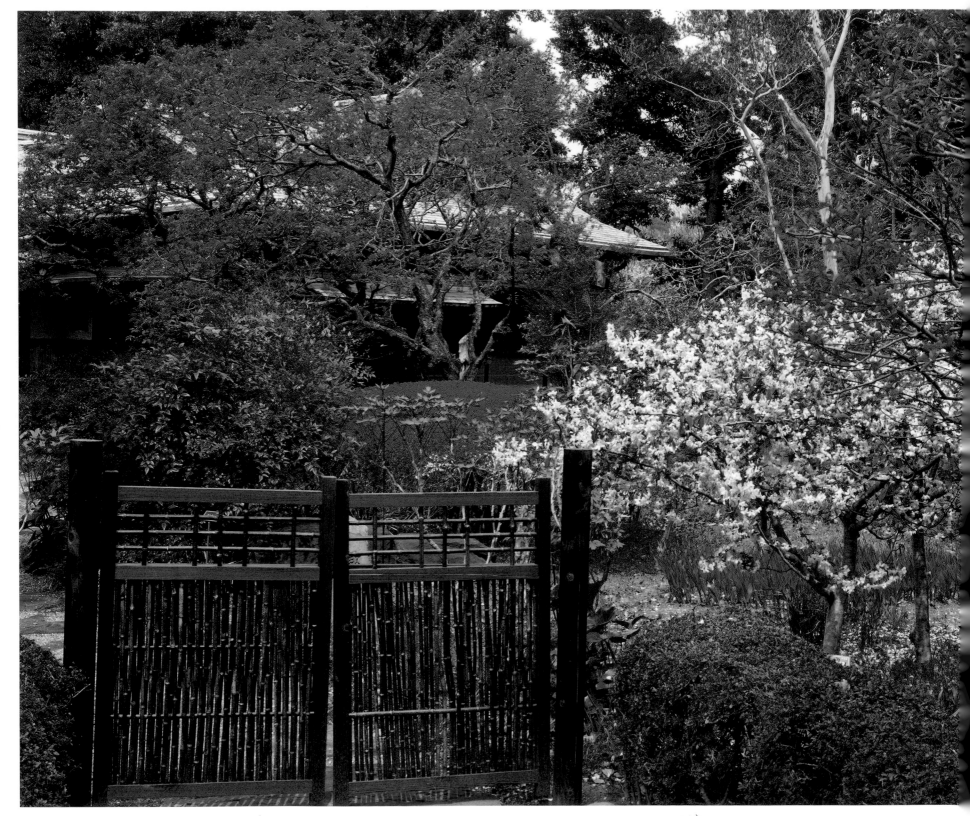

(In Japan, the flowering of the cherry trees is an occasion for a celebration known as Hanami.)

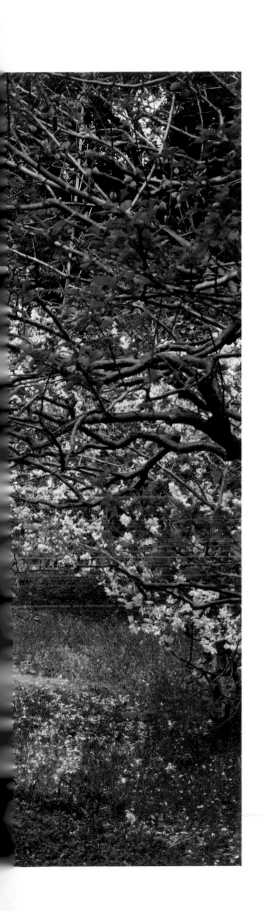
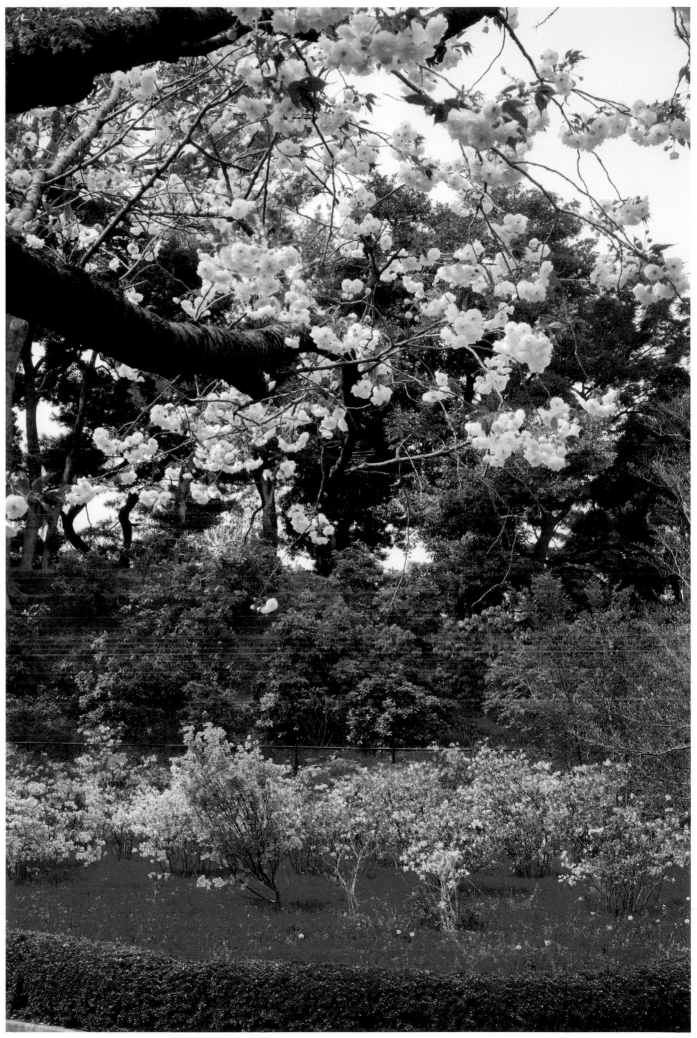

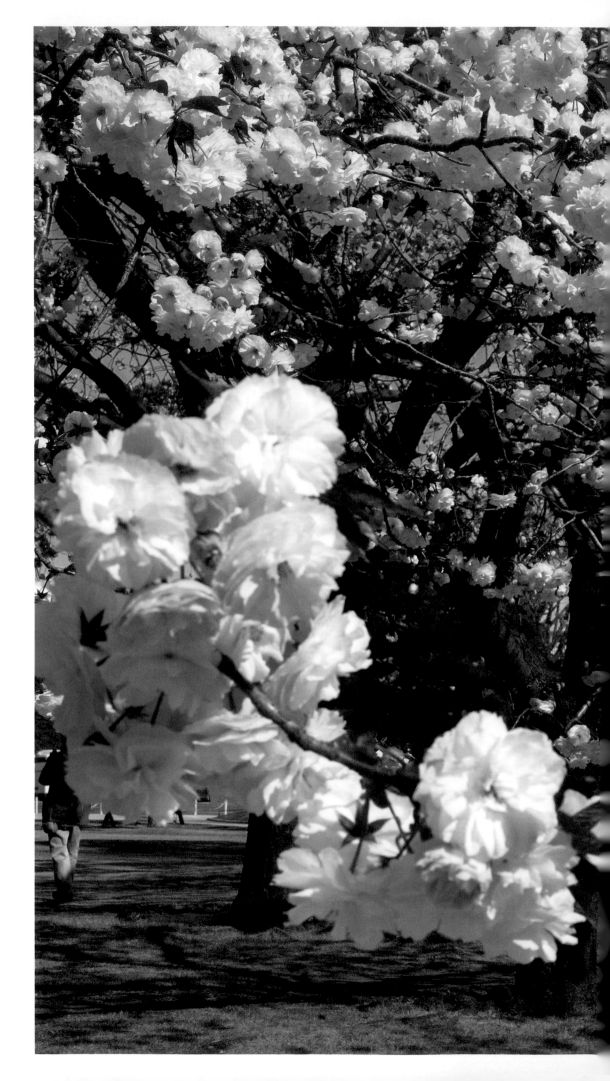

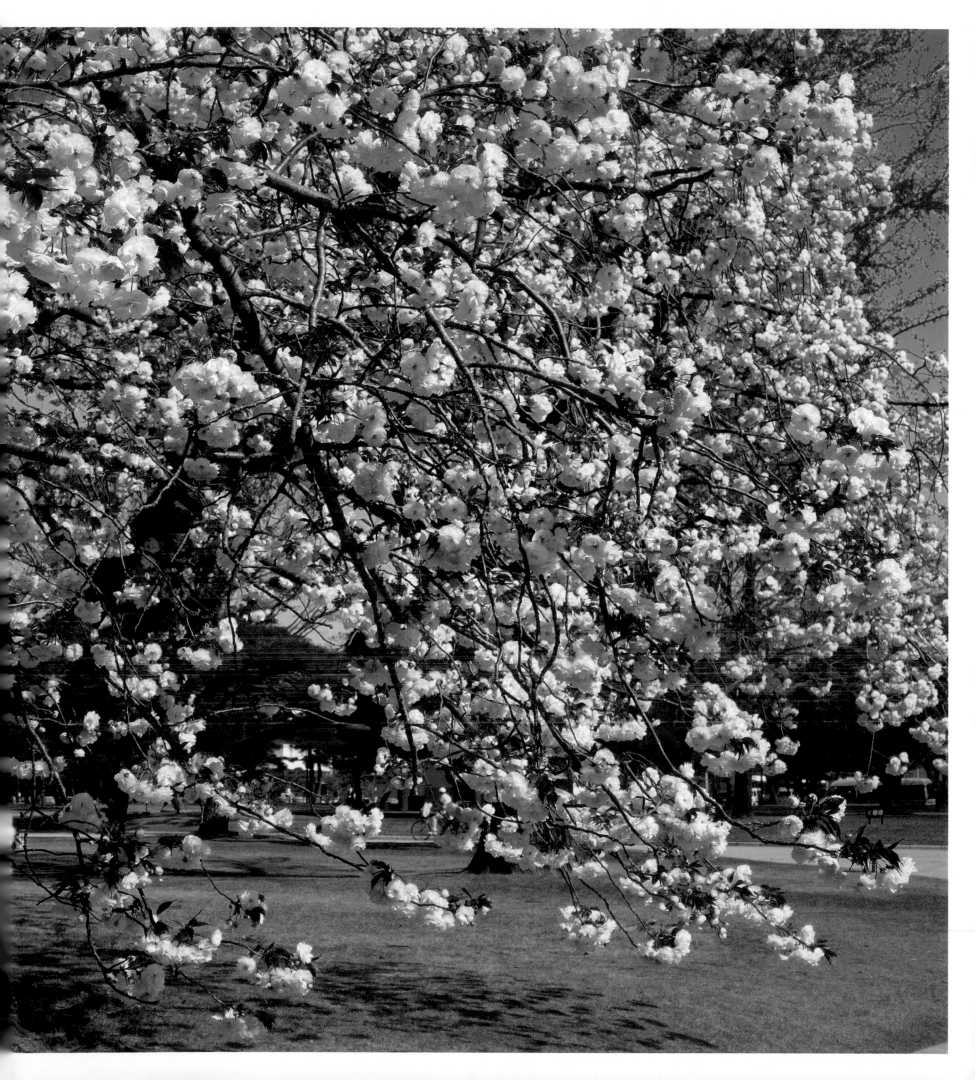

BIBLIOGRAPHY

Adams, William Howard. *L'Art des jardins ou la nature embellie*. Photographs by Everett Scott. New York: Abbeville Press, 1992.

Babelon, Jean-Pierre, and Mic Chamblas-Ploton. *Jardins à la française*. Photographs by Jean-Baptiste Leroux. Paris: Imprimerie nationale éditions, 2000.

——. *Le Château de Chantilly*. Photographs by Georges Fessy. Paris: Nouvelles éditions Scala, 2011.

——. *Le Nôtre*. Photographs by Jean-Baptiste Leroux. Paris: Imprimerie nationale éditions, 2013.

Baridon, Michel. *Jardins de Versailles*. Photographs by Jean-Baptiste Leroux. Arles: Actes Sud/Motta, 2001.

——. *Les Jardins: Paysagistes, jardiniers, poètes*. Paris: Robert Laffont, "Bouquins" coll., 1998.

Chamblas-Ploton, Mic. *Dans les jardins des Grimaldi*. Photographs by Jean-Baptiste Leroux. Paris: Éditions du Chêne, 2009.

de Ligne, Charles-Joseph. *Coup d'œil sur Belœil*, Paris: Les éditions de Paris Max Chaleil, 1998.

Gallotti, Jean, and Jean-Pierre Frey. *Le Jardin et la maison arabes au Maroc*, new edition. Illustrations by Albert Laprade, photographs by Lucien Vogel. Arles: Actes Sud/CJB, 2008.

Henrik, Prince Consort of Denmark. *Chemin faisant*. Poul Kristensen, 1982.

——. *La Part des Anges*. Copenhagen: Den Franske Bogcafé, 2014.

Hunt, John Dixon. *L'Art du jardin et son histoire*. Paris: Éditions Odile Jacob, 1996.

Lablaude, Pierre-André. *Les Jardins de Versailles*. Photographs by Jacques de Givry. Paris: Nouvelles éditions Scala, 1995.

Lesénécal, Olivier. *Le Château de Cayx*. Photographs by Jean-Baptiste Leroux. Paris: Imprimerie nationale éditions/Actes Sud, 2014.

Louis XIV. *Manière de montrer les jardins de Versailles par Louis XIV*. Paris: Réunion des musées nationaux, 1994.

Métalsi, Mohamed. *Maroc, les palais et jardins royaux*. Photographs by Jean-Baptiste Leroux. Paris: Imprimerie nationale éditions/Malika éditions, 2004.

Ollivier, Blandine. *Richard Wagner et Louis II de Bavière. Lettres 1864–1883*. Paris: Plon, 1960.

Orsenna, Érik. *Portrait d'un homme heureux, André Le Nôtre 1613–1700*. Paris: Gallimard, 2002.

Reinert, François. *Les Châteaux du Luxembourg*. Photographs by Vincent Merckx. Brussels: Vincent Merckx éditions, 2008.

Sancho, José Luis. *La Granja de San Ildefonso*. Madrid: Doce Calles, 2000.

Thacker, Christopher. *Histoire des jardins*. Paris: Denoël, 1981.

ACKNOWLEDGMENTS

I would like to thank the members of the royal families and managers of this cultural heritage for the trust they have given me for numerous years.

Places of relaxation, reflection, and memories, these gardens—or most of them—far from formal protocol, show the passion of these caretakers for nature.

I would also like to thank my partners who made this book possible: Mic Chamblas-Ploton, Stéphane Bern, Pierre Finot, Stéphane Brochier, Akiko Issaverdens, RMN/GP photo agency, Fujifilm France, Techni Ciné Phot, and Éditions de La Martinière.

—JEAN-BAPTISTE LEROUX

ABRAMS EDITION

EDITOR

Laura Dozier

DESIGNER

Shawn Dahl, dahlimama inc

PRODUCTION MANAGER

Denise LaCongo

Library of Congress Control Number 2014932018

ISBN 978-1-4197-1398-9

PRINTED AND BOUND IN ITALY

10 9 8 7 6 5 4 3 2 1

ABRAMS books are available at special discounts when purchased in quantity for premiums
and promotions as well as fundraising or educational use. Special editions can also be created
to specification. For details, contact specialsales@abramsbooks.com or the address below.

THE ART OF BOOKS SINCE 1949

115 West 18th Street
New York, NY 10011
www.abramsbooks.com